PRODUCING INTERACTIVE TELEVISION

Annesa Hartman

CHARLES RIVER MEDIA, INC.
Hingham, Massachusetts

Copyright 2002 by CHARLES RIVER MEDIA, INC.
All rights reserved.

No part of this publication may be reproduced in any way, stored in a retrieval system of any type, or transmitted by any means or media, electronic or mechanical, including, but not limited to, photocopy, recording, or scanning, without *prior permission in writing* from the publisher.

Publisher: Jenifer L. Niles
Production: Publishers' Design & Production Services
Cover Design: The Printed Image
Cover Image Design: Annesa Hartman, Sway Design
Book Illustrations: Ellis Neder

CHARLES RIVER MEDIA, INC.
20 Downer Avenue, Suite 3
Hingham, Massachusetts 02043
781-740-0400
781-740-8816 (FAX)
info@charlesriver.com
www.charlesriver.com

This book is printed on acid-free paper.

Annesa Hartman. *Producing Interactive Television*.
ISBN: 1-58450-022-0

All brand names and product names mentioned in this book are trademarks or service marks of their respective companies. Any omission or misuse (of any kind) of service marks or trademarks should not be regarded as intent to infringe on the property of others. The publisher recognizes and respects all marks used by companies, manufacturers, and developers as a means to distinguish their products.

Library of Congress Cataloging-in-Publication Data
Hartman, Annesa, 1968-
 Producing interactive television / Annesa Hartman.
 p. cm.
 ISBN 1-58450-022-0
 1. Interactive television. 2. Television—Production and
direction. I. Title.
TK6679.3 .H37 2001
621.388—dc21
 2001003908

Printed in the United States of America
01 02 7 6 5 4 3 2 First Edition

CHARLES RIVER MEDIA titles are available for site license or bulk purchase by institutions, user groups, corporations, etc. For additional information, please contact the Special Sales Department at 781-740-0400.

Requests for replacement of a defective CD must be accompanied by the original disc, your mailing address, telephone number, date of purchase and purchase price. Please state the nature of the problem, and send the information to CHARLES RIVER MEDIA, INC., 20 Downer Avenue, Suite 3, Hingham, Massachusetts 02043. CRM's sole obligation to the purchaser is to replace the disc, based on defective materials or faulty workmanship, but not on the operation or functionality of the product.

In solemn remembrance of Tuesday, September 11, 2001.
May the catastrophic events of this day forever remind us of
the fragility of human existence and serve as a catalyst of peace
for all living beings.

Contents

	FOREWORD	xv
	ACKNOWLEDGMENTS	xvii
	INTRODUCTION	xix
PART I	**MOMENTUM**	**1**
CHAPTER 1	**A GLIMPSE INTO TV PAST**	**3**
	AN IDEA	4
	AN INVENTION (1920s TO 1930s)	4
	A BUSINESS OPPORTUNITY AND PUBLIC DEPLOYMENT (1930s–1940s)	6
	A CODIFICATION (1930s–1950s)	7
	A UNIVERSAL ACCEPTANCE (1950s–)	8
	CHAPTER SUMMARY	10
CHAPTER 2	**TV NOW**	**11**
	SPEED IS IN	12
	THE BRIEF INTERNET HISTORY	13
	AN IDEA (1957)	13
	AN INVENTION (1960s–1970s)	13
	A BUSINESS OPPORTUNITY, PUBLIC DEPLOYMENT AND CODIFICATION (1980s–1990s)	14
	A UNIVERSAL ACCEPTANCE (2000s–)	14
	TV STANDS BY	15
	THE INEVITABLE SHIFT	15

	TRANSMISSION PRIMER	**16**
	TERRESTRIAL	16
	CABLE	17
	SATELLITE	18
	STEP ASIDE, ANALOG	**20**
	TYPE OF SIGNAL	20
	SPEED OF TRANSFER	21
	CONSISTENCY OF SIGNAL	22
	DTV STANDARDS	**22**
	ADVANCED TELEVISION SYSTEMS COMMITTEE	22
	DIGITAL VIDEO BROADCASTING	23
	NHK LABORATORIES	23
	MORE CHOICES	**24**
	HDTV	24
	MULTICASTING	26
	INTERACTIVE TELEVISION	28
	OPEN CONCERNS	**28**
	PUBLIC AWARENESS	**29**
	CHAPTER SUMMARY	**30**
CHAPTER 3	**ITV'S JOURNEY**	**33**
	ITV AS A DIGITAL PLAYGROUND	34
	IN THE BEGINNING	36
	LEARNING FROM THE PAST	37
	FIRST ATTEMPTS	37
	THE BOOM OF THE 1990S	39
	VIEWER-CONTROLLED TV (VCTV)	39
	QUANTUM	39
	VIACOM CABLE	39
	FULL-SERVICE NETWORK	40
	LESSONS LEARNED	40
	SERVICE CHECK	41
	PPV AND VOD	42
	PVR	42
	EPG	42
	TELETEXT	43
	ENHANCED TV	43
	INTERNET ACCESS	44

CONTENTS ix

	GETTING TO KNOW THE TEAMS	47
	GETTING DOWN TO BUSINESS	47
	CHAPTER SUMMARY	51
CHAPTER 4	**THE EXPERIENCE OF ENHANCED TV**	**57**
	THOSE WANDERING EYES	58
	THE EXPERIENCE	60
	SET-TOP BOX SOLUTION (STB)	60
	TV TUNER CARD SOLUTION	61
	2-SCREEN SYNCHED SOLUTION	62
	CONSIDERING THE SOLUTIONS	65
	STB	65
	TV TUNER CARDS	66
	2-SCREEN	68
	AN ULTIMATE SOLUTION?	69
	CONTENT IS KEY	73
	CHAPTER SUMMARY	73
	TIMELINE OF TELEVISION AND INTERNET EVENTS	76
PART II	**DEVELOPMENT**	**81**
CHAPTER 5	**CONTENT IS KEY**	**83**
	THE IMPORTANCE OF EYEBALLS	84
	TRIAL AND ERROR	87
	FEEDBACK AND EVALUATION	90
	EDUCATE THE VIEWER	91
	CHAPTER SUMMARY	92
CHAPTER 6	**DIVING IN**	**95**
	STARTING WITH CAKE MIX	96
	CONSIDERATIONS IN CREATING AN ENHANCED TV SHOW	97
	PURPOSE	97
	SHOW TYPES	98
	ENHANCEMENT ELEMENTS	104
	SHOW FORMATS	105
	PROTOTYPES, TEMPLATES, AND THE FULL DEAL	106
	THE DELIVERY MECHANISM	106
	THINGS TO CONSIDER QUICK LIST	**107**

	KEEP ALL DOORS OPEN	107
	CHAPTER SUMMARY	108
CHAPTER 7	**THE PROCESS**	**111**
	A PROCESS OUTLINE	112
	PLANNING PHASE	112
	PRE-PRODUCTION PHASE	114
	PRODUCTION PHASE	114
	TESTING	115
	SHOW LAUNCH	115
	EVALUATION	115
	FITTING IT ALL TOGETHER	116
	MISSION POSSIBLE	116
	CONTENT CREATION	116
	LINKING AND TIMING OF CONTENT	117
	TESTING OF CONTENT	118
	DELIVERY OF CONTENT	119
	ITV PRODUCTION ROLE QUICK LIST	121
	ITV EQUIPMENT QUICK LIST	121
	FOR CONTENT CREATION	121
	FOR TESTING	121
	FOR TIMING	123
	CHAPTER SUMMARY	123
CHAPTER 8	**THE CREATIVE TOOL SET**	**125**
	CONTENT STANDARDS	126
	OPEN STANDARDS	127
	PROCEDURAL VS. DECLARATIVE CONTENT	128
	MULTIMEDIA HOME PLATFORM (DVB-MHP)	128
	ATVEF	129
	ITV CONTENT PACERS	131
	STB SOLUTION PROVIDERS	131
	2-SCREEN SYNCH SOLUTION PROVIDERS	133
	DESIGN GUIDELINES	134
	KNOW THE FOUNDATION STANDARDS	134
	UNDERSTAND SCREEN RESOLUTION	136
	CENTER STAGE THE TV OBJECT	139
	DESIGN FROM A DISTANCE	139
	CONSIDER COLOR	140

Contents

	Watch Navigation	141
	Minimize Load Times	142
	Design Guidelines Quick List	143
	Chapter Summary	144
Chapter 9	**Timing and Delivery**	**145**
	Chapter Explanation	146
	A Common Binding	146
	What's IP?	147
	Transport A, the Here and Now Method (Return-Path Data via Triggers)	148
	Content Publishing and Delivery	148
	All about Triggers	148
	Ms. Manners on Trigger Etiquette	155
	ATVEF Trigger Recommendations	155
	Transport B, the Emerging Method	155
	(Broadcast Data via IP)	155
	IP Multicast	156
	IP Multicast Delivery Overview	157
	Chapter Summary	158
Chapter 10	**Hands-On**	**161**
	Part 1: Napkin Sketch Assignment	162
	Part 2: Constructing a Design	163
	Lesson Setup	164
	Design Dimensions	165
	Setting Up the File	165
	Choose the Background Colors	167
	Defining the Frameset "Look"	167
	Positioning the TV Object	168
	Adding a Background Element	171
	Inserting the Image Maps	172
	Adding Text	173
	The Full-Screen Look	174
	Test for NTSC Safe Colors	174
	Part 3: Building the Interface Functionality	175
	Lesson Setup	176
	Mock Demonstration of ITV	176
	Defining a Site in Dreamweaver	178

	Viewing the ITV Overlay Code	178
	The Important "tv:" Syntax	179
	Another Way to Integrate TV with Web Pages	180
	The Use of Cascading Style Sheets	180
	The Z-Index Attribute	181
	Image Width and height	181
	CSS Absolute and Relative Positioning	182
	Viewing the Frameset Source Code	182
	The Full-Screen Link	183
	Image Maps	183
	HTML Text vs. Graphical Text	184
	Trigger Receiver Object	185
	Chapter Summary	**185**
	Top 12 Suggestions for ITV Developers	**186**
	Rob Davis, Executive Producer, Spiderdance	186
	Eric Bangerter, ITV Developer, University of Wisconsin-Extension	187
	Danny Anker, Producer/Director, Anker Productions	187
	Anna Marie Piersimoni, Associate Director, New Media Ventures, AFI, Formerly Director, AFI Enhanced TV Workshop	187
	Scott and Brian Lillig, Founders of Spin TV	187
PART III	**Projects**	**189**
Chapter 11	**SpinTV**	**191**
	Words from Brian and Scott Lillig of SpinTV	192
	Overview of the SpinTV Studio Suite	195
	Tool Set Features for the Pre-Release and Soon-to-Be Released (December 2001) Advanced SpinTV Studio Suites	196
	Using the TV Embed Feature	197
	Sample Enhanced TV Content Interfaces	201
	About the NASA Case Study	201
Chapter 12	**The Wisconsin Vote Project**	**205**
	A Collaboration	206
	First Run—the Wisconsin Gardener	206
	The Wisconsin Vote Project	207

Contents

	Author Interview with Eric Bangerter, Interactive Project Manager for the Interactive Television Project	210
Chapter 13	**Spiderdance**	**217**
	About Spiderdance at www.spiderdance.com	218
	Author Interview with Tracy Fullerton, President of Spiderdance	218
	Development Phase	222
	Execution Phase	223
	Administration Phase	224
	Author Interview with Rob Davis, Executive Producer of Spiderdance	226
Chapter 14	**Music from the Inside Out**	**235**
	Carolyn Carmines and Nancy Saslow Talk shop	236
	A Conversation with Danny Anker	238
	The Ensemble Interactive Sequence	241
	About PushyBroad	241
Chapter 15	**AFI Enhanced TV Workshop**	**245**
	A Conversation with Anna Marie Piersimoni	246
Chapter 16	**Two Way TV**	**255**
	Interview with Heidi Bruckland	256
Chapter 17	**Showtime Networks**	**265**
	Author Interview with David Preisman, Director of Interactive Television, Showtime Networks	266
Appendix A	**Acronyms Alert**	**277**
Appendix B	**ITV Resource List**	**281**
	Content Development and Education	281
	Company-Specific Developer Sites	281
	Web/HTML Guides	282
	ITV Terminology	282
	News and Discussion	282
	Statistics and Research	283

	STANDARDS AND FORUMS	283
	INSIGHTFUL READING	284
APPENDIX C	**ABOUT THE CD-ROM**	**285**
	SYSTEM/SOFTWARE REQUIREMENTS FOR SPINTV'S DREAMWEAVER ITV EXTENSIONS	285
	SYSTEM REQUIREMENTS FOR HANDS-ON LESSONS, DEMONSTRATIONS, AND MACROMEDIA TRIAL SOFTWARE	285
	GLOSSARY	**287**
	INDEX	**295**

Foreword

For the weary and wary of television, Interactive Television (ITV) promises more of a medium they already disparage. Will ITV offer the erosion of privacy, cash cow shopping channels, incessant irrelevant ads, nonstop talking heads, and a purely product-placement primetime? Content broadcasters and multiple systems operators (e.g., cable, satellite, and digital broadcasters to come) are beginning to explore with extreme caution these options and other interactive services via new fiber-optic and worldwide satellite broadcasting networks.

Fortunately (or unfortunately, according to one's opinion), interactive technologies deploying these digital TV networks will not only allow for multicast, niche channels and interactive services to emerge packaged to the individual's tastes or to interest groups, but will also deliver more choice, control, and a voice in the two-way broadcast stream. Although some operators, for example, are just now beginning to trial or commercially deploy a range of early stage services such as multiple camera angle switching applications, "walled gardens," digital video recording, access to the Internet, and original content and special services, some cable and satellite operators are also experimenting with applications that require "return path" interactivity.

Such experiments include two-way transactions inside virtual malls, and clickable polls that ask viewers to give their vote concerning controversial issues or opinions on political candidates. ITV advertisers, without a doubt, are exploring how to create an ad that can easily request viewers' e-mail addresses in exchange for free merchandise. In the future, we may witness the emergence of personal video broadcasting technologies in which a home viewer could produce a video on his or her TV system and broadcast it to a set-top box network or a spectrum of media devices. All such services, of course, are viewed with deep skepticism in the industry, as they may transform the very foundation of traditional broadcasting.

Broadcasters are both excited and nervous about this stage in the evolution of the television infrastructure. On one hand, MSOs are thrilled about the potential for higher subscriptions costs for more packaged TV channels and other services, lucrative revenues for targeted ad campaigns, and transactional revenues they may glean through interactive commerce. Knowing exactly what the viewer is choosing to watch is another attractive benefit. On the other hand, MSOs are very nervous about how these new offerings will change methodologies for generating traditional revenues until futuristic programming and business models clarify. Will television remain a broadcaster's medium in the end, they speculate? Without a doubt, MSOs are researching how to tightly control the flow of capital, programming, and interactive services, while spending millions to influence the vicissitudes of government legislation. These last points and costs to roll out such services greatly delay deployment.

The big picture: 1) The commercial broadcasting industry is comprised of highly balkanized networks that spend billions to protect the right to control them. Ultimately, these networks reject telecommunications common carrier status. 2) Free over-the-air "terrestrial" digital broadcasting technologies, in parallel, stifle due to the lack of robust standards. Bottom line: Commercial broadcasting networks face little competition. The days of the digital Internet frontier built rapidly on a culture of deregulation, standards, and public empowerment are unavailable. Will MSOs, one day, change their strategy and allow their networks to be networked? No topic is more controversial and, therefore, rarely discussed.

Viewers at home comfortable with quick-change remote controls will soon discover how these behind-the-scenes machinations will reinvent their relationship to their favorite source of entertainment.

How the television industry navigates from its place in the past to its stake in the ITV future will be an interesting story.

Tracy Swedlow, President
InteractiveTV Today

Contact Information:

swedlow@itvt.com
www.itvt.com

Acknowledgments

I have many people to thank for validating the word *producing* in the title of this book. The contributors to this publication are some of the most productive individuals I have ever met.

A big thanks to those who openly expressed their thoughts on the ITV industry (and let me print it!) in the viewpoint and interview portions of the book. It was a pleasure spending the day with Rob Davis at the Spiderdance offices in beautiful Manasquan, New Jersey. My lunch in mid-town Manhattan with TV producer Danny Anker was lively and informative, as was the Japanese dinner with Scott Lillig and Tonya Grochoske of Spin TV. I missed my flight to Wisconsin to visit Eric Bangerter (I was snowed in in Vermont), but we still managed to run up my telephone bill discussing the twists and turns of interactivity.

And thank goodness for e-mail. I must have written another 100,000 words in Outlook Express communicating and gleaning information from so many passionate ITV experts—Tracy Swedlow, Louis Barbash, Cindy Kelly, David Preisman, Heidi Bruckland, Bob Mariano, Carolyn Carmines, Tracy Fullerton, Anna Marie Piersimoni, and Jason VanSickel, to name a few—all of whom generously contributed to the pages of this six-month work in one way or another.

Finally, not to be overlooked in my line-up of endless "thank yous" are those people in my life who could care less about ITV, but supported me anyway—my dear friends, Anne, Brad, Ken, and, most of all, Ellis.

Annesa Hartman

Introduction

Writing about Interactive Television (ITV) is a lot like running a marathon, or at least how I imagine it—you have to cover a great distance in a short amount of time. On more than one occasion when writing this book, I thought about and sympathized with world-class runner Ludmila Petrova as she ran the 2000 New York Marathon. Her winning PR was 2 hours, 25 minutes, and 45 seconds; mine was 6 months, 1 week, and 2 days.

I felt myself, at each passing deadline, in Ludmila's shoes, Nike Air racing flats pounding the pavement (or, in my case, the keyboard), constantly looking over my shoulder in fear that another new ITV development would race ahead, leaving my every word in the dust and making this book obsolete before it hits the shelves. Eventually I learned, as I'm sure Ludmila already knows, to just keep looking ahead and with determined faith move forward through the obstacles, rather than have them overtake me. Moreover, this is the mind-set of the ITV content creator. If you are reading this book, be warned: you are entering the ITV marathon, the race has just started, your number is pinned on, and the endorphins are kicking in. The miles that make up this ITV journey are mapped on-the-fly. Eventually, there will be a finish line, but unlike the New York Marathon, the finish is undetermined, and there are many routes to get there.

Think of this book as a training manual, stuck in the elastic band of your racing shorts, providing some necessary background, production tools, and inspiration to help you energetically jog pass the critical, undefined moment of ITV today. It won't be the definitive guide or an exhaustive dissertation; subjects of those works are only learned from doing, particularly right now, in the flux of this metamorphic medium. It will, however, give you the carbohydrates to push forward, and the know-how to ask the right questions to lead you to the finish line.

For those new to the ITV race, there are two main obstacles, or challenges, in the understanding of ITV: the perception, and thus confusion of the topic, and the evolving technology and business.

PERCEPTION AND CONFUSION

For many, the idea of interactive television is rife with connotations, past failures, and impossible predictions. Ask a few friends what they think ITV is, and you may be surprised by the answers—usually initiating some sort of scratching of the head and a vague remembrance "uh, you mean, uh, WebTV?" or " yea, like, Web sites for television?" Well, kind of, but ITV can be so much more and it's not going away. Perceptions such as these are rooted in first impressions, never completely understood and too confusing to encourage further investigation.

It's true, what ITV was, is, and can be is confusing. This is because it is not fully realized, its potential is still incubating in the minds of forward thinkers, and the pieces are just beginning to grow together and move cautiously into the TV-centric world. To combat confusion and first impressions, this book aims to explain a few things—the ITV terms and implications, the players involved, and the tools and standards currently available to play with. It endeavors to get beyond that first look, do the investigation, and show that ITV is ever present, not just an apparition.

EVOLVING TECHNOLOGY AND BUSINESS

The other challenge of understanding ITV is keeping up with its evolving technology and growing business practices. Unfortunately, there is no easy way to get around this; it's the nature of the beast.

As history tells us, every great innovation has a growth and development period, a point in time in which technologies and practices have been defined but not codified (Figure 1). This is where ITV is now, a forward-growth period stemming from advances in telecommunications, and the fast bloom of personal computers and the Internet. These advances, technological possibilities, have opened the doors of opportunity for viable, new business initiatives; they propel the excitement of ITV, and motivate the runners up the steep hill of potentiality.

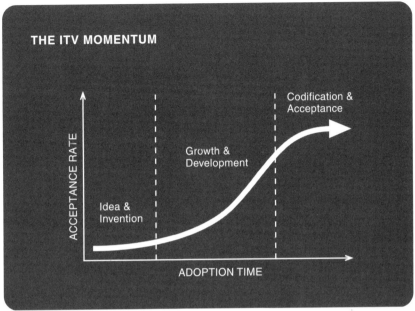

FIGURE 1 *As any innovation, ITV is progressing through an adoption and acceptance curve. Currently, the industry is in the growth and development period.*

THE THREE PARTS OF THIS BOOK

To fully address the challenges of the topic of ITV, its perception and confusion, its changing technology and business practices, this book is divided into three parts.

Part I, "Momentum," is an encyclopedic timeline of telecommunications technology, beginning with the invention of the television and moving through its historical shifts into color, digital transmission, and deployment of interactive and enhanced content. Providing the historical background and lessons learned to overcome first impressions, Part I attempts to unravel the confusion, and offer the necessary background information to take the next steps in producing content for this evolutionary medium.

For the success of ITV, Part II, "Development," expresses the importance of producing compelling content, and delves into content development specifics for enhanced television, the two-way interaction of TV programming with Web-like elements. ITV content development can be thought of as a synergistic effort between three roles: the creator, whose job it is to design the "look and feel" of a show and develop its back-end/front-end functionality and syncing mechanisms; the operator, who schedules and broadcasts the show; and the receiver,

the consumer, who provides the equipment necessary to watch and respond to the show (Figure 2). Without one role, you don't have the others; each is co-dependent on the others for the success of an interactive program. While Part II covers some aspects of each of these roles, the main focus is on the role of the creator, the idea-maker, and provides some starting tools for actual enhanced TV implementation.

A showcase of real-world ITV projects, images and commentary is the core of Part III, "Projects." Through author-conducted interviews, TV producers and ITV developers offer insightful advice on the pitfalls and successes of ITV content creation, and the overall industry itself.

ITV is a timely topic, and while this book provides the means to understand the daily news of the industry, it obviously can't keep up with it. However, to at least address this timeliness and the "here and now" of the topic, included in the book are areas called *Tune-Ins* and *Viewpoints*.

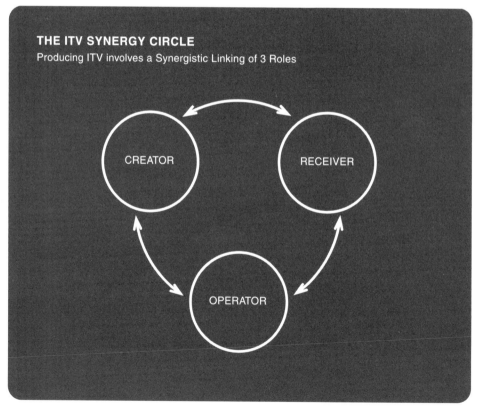

FIGURE 2 *Producing ITV content is a synergistic linking of three roles.*

Tune-Ins are topical news items that were announced during the course of writing this book, and Viewpoints are personal insights, from both the author and industry experts, on ITV's current status in the new millennium.

In addition, the back of this book includes a list of commonly used ITV terms and acronyms, a resource guide, and information about the included CD-ROM. Also available is a companion Web site with book updates, additional information about the ITV industry, and resources, located at www.swaydesign.com/itvbook.

As a whole, this book is a drilling down from big-picture to specific projects, providing the necessary understanding of what ITV was, is, and can be.

So, lace up those running shoes; the marathon is about to begin.

PART

Momentum

CHAPTER 1

A Glimpse into TV Past

IN THIS CHAPTER

- An Idea
- An Invention (1920s to 1930s)
- A Business Opportunity and Public Deployment
- A Codification (1930s–1950s)
- A Universal Acceptance (1950s–)
- Chapter Summary

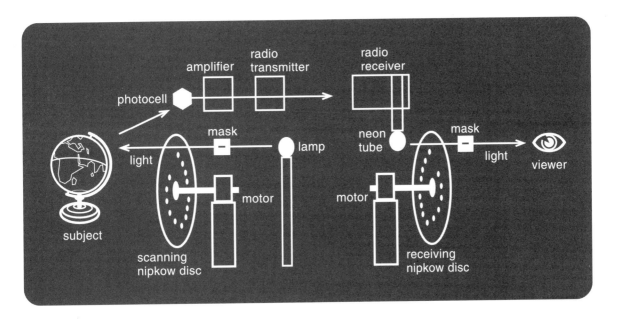

Whether we like it or not, the television is a mainstay of our world culture. It began, as most inventions do, as an idea with unimaginable potential; potential, as you will see, that will be reinvigorated in the burgeoning Interactive Television (ITV) medium. However, before we have a clear picture of what is happening with TV today, it helps to know where it came from in order to gain a bit of historical insight, a referential framework, to understanding what is about to emerge.

AN IDEA

In the early 1920s, an amazing invention infiltrated the homes of millions: a small box that when turned on and tuned in would, quite literally, pull out of thin air and play for the listener's ear sounds, voices, and even music from far-off places. The noise of the world, moving through electromagnetic waves, was suddenly in the living room, and it was called radio.

Guglielmo Marconi's radio invention was a slow but sure hit. His wireless telegraphy was originally introduced much earlier, in 1896, when it was married with Alexander Bell's new telephone. Suddenly, without the complication of wires, people could talk to each other over long distances. However, there was one main problem: privacy. There was no way to regulate this two-way communication amidst the free-flowing airwave space—intimate conversations were constantly interrupted by others dialing in on the same frequency. The next best thing for Marconi's wireless telegraphy was one-way communication. Instead of information being privately exchanged, it was openly and systematically supplied. In other words, the information was "broadcasted," and the mechanism was the radio.

By 1922, 25,000 radios were being sold each month in the United States. Transmission and programming stations were cropping up everywhere, and the government was busy making policy to regulate this new phenomenon. The world was experiencing its first taste of mass communication, mass entertainment, and mass advertising unhindered by the fact that this was just the beginning of more to come. The next miracle was the image tube.

AN INVENTION (1920S TO 1930S)

The radio phenomenon started many ingenious minds wondering—if sound can be transmitted through the airwaves, why not images? With a resounding "yes," the question was answered by a scientifically untrained Scotsman by the name of John Baird. In 1925, he introduced to curious shoppers at Selfridge's depart-

ment store in London a crude contraption he called the *Televisor*. Viewers witnessed in black-and-white splendor blurred shapes being transmitted from a few yards away. The Televisor's main component was the Nipkow disk, a mechanical scanning disk initially designed by Paul Nipkow in 1884. The device consisted of two spinning disks perforated with holes that when revolved at precisely the same time and speed could transmit, receive, and scan images (Figure 1.1). Here were the blurry beginnings of what eventually would be called the *Television*.

Not long after Baird's successful demonstrations of his mechanical Televisor, two competitors arrived on the scene: an Idaho farm boy by the name of Philo T. Farnsworth, and the Russian-born American, Vladimir Kosma Zworykin. Working independently, the two inventors experimented with electronic versions of television, boasting better functionality than Baird's rudimentary mechanical version.

The heart of Philo's electronic television was, quite appropriately, named the Image Dissector. It was a simple tube that, as the *San Francisco Chronicle* described on September 3, 1928, "sends twenty pictures per second, (with) 800 elements, or pin points of light, in each picture to insure detail." Philo's electronic TV was revolutionary in that it had no moving, mechanical parts, and created a visually accurate picture using only half of the wave length needed to prevent television broadcasts from interfering with each other.

Vladimir Kosmo Zworykin called his electronic device the Iconoscope (Figure 1.2). It worked similar to Farnworth's Image Dissector, with one exception: it

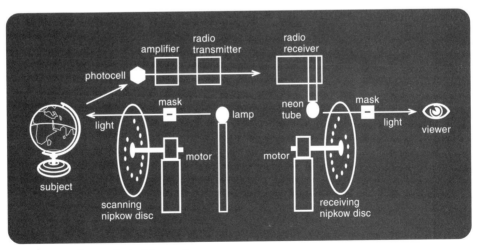

FIGURE 1.1 *A mechanical television system.*

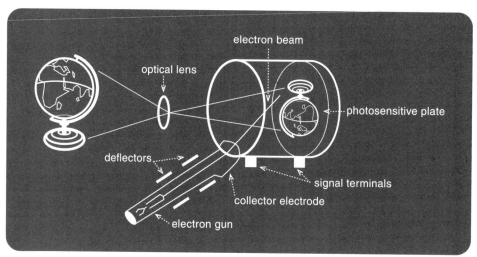

FIGURE 1.2 *The Iconoscope, an electronic television tube.*

contained a storage tube where "portions of the scene not being scanned stored their accumulating electric charge until the scanning beam swept over them.[1]"

The ingenious work of Baird, Farnsworth, and Zworkyin was proof that transmitting images through the air was amazingly possible. The next step was to put these interesting devices to use, and, by all means, profit from them.

A Business Opportunity and Public Deployment (1930s–1940s)

Just like Marconi's radio, Baird, Farnsworth, and Zworykin's ingenious image-making devices were slow to ignite public interest. Baird's mechanical television received some success, being the first to market, but it never quite took hold. The electronic television was eventually considered the more commercially viable solution, but not without its struggles. It took a good 10 years before the public could get their hands on it. The first obstacle was the patent race between Farnsworth and Zworkyin, both jostling to secure the unique components of each of their working models.

In the end, the TV unit that gained acceptance (still the working model of today) was a hybrid of Farnworth's Image Dissector and Zworkyin's Iconscope,

[1]Fisher, David E. and Marshall Jon Fisher, *Tube, the Invention of Television*, Harcourt Brace and Company, 1996.

and included an crucial, underlying component of both called the cathode ray tube (CRT)[2].

Meanwhile, as the technological specifics were being hashed out, the entrepreneurial and marketability interests of the TV were in full force.

Many business-minded individuals had their sights set on the TV's commercial potential and profitability, but it was one man, the persistent and powerful David Sarnoff, who led the pack. Sarnoff, the senior vice president of the most prominent radio broadcast company of the century, the Radio Corporation of America (RCA), took it upon himself to market TV to all. He consistently lobbied for commercial television to the public and nation's government agencies and, in a matter of time, Sarnoff had single-handedly convinced the American people that they were lost without television. By 1939, Sarnoff had managed to finance, manufacture, and market the first home electronic television. (Prices for a unit ranged from $200 for a radio attachment up to $1000 for a complete, new set equipped with a 7 × 10-inch picture.) To increase sales, he pushed content by continually improving RCA's broadcast offerings of live events and film. Sarnoff's home TV was a proven success, and secured the final NTSC (National Television Standards Committee) decision that all broadcast stations must convert to electronic transmission. The new standard was set and there was no turning back.

A Codification (1930s–1950s)

The call to electronic transmission, and the fact that boxes were now in the hands of the public, launched the growth of numerous experimental broadcast stations. However, it was the know-how of three networks, each stemming from the radio world, that pushed forward the budding TV industry—the infamous NBC, CBS, and ABC networks. The first to make waves was NBC (National Broadcasting Company), grown out of a partnership with RCA in 1926. Shortly thereafter entered CBS (Columbia Broadcasting System) headed by William Paley, who filed with the FCC to begin TV broadcasting in 1931. Then, a bit later, in 1943, RCA-NBC sold one of its networks, which soon became the third major broadcaster, ABC (American Broadcasting Company). Under the watchful eyes of the FCC and NTSC, these three networks, helped to mold and shape the programming we see today.

For the networks and their developing affiliates, there was a competitive learning period of *how* to create TV programming. It was one thing to invent the tube,

[2]The cathode ray tube was originally conceived in 1906 by German inventor Max Dieckmann. Its purpose is to focus incoming electrons into precise beams of light. Striking a fluorescent screen, these beams produce the thousands of pixels of light necessary to create an image.

but a completely different thing to create what to see on the tube. Suddenly, there was the great necessity to fill air space, and keep the viewing audience glued to whatever the networks could dish out. Initially, the content was a viewable version of radio, with projection of live news events, such as the New York World's Fair in April 1939 or the presentation of performers and speakers. Eventually, through trial and error, television began its own genre of entertainment—the television show, the half-hour sit-com, the one-hour drama—all shot, edited, and designed to fit specifically on a small viewing screen. Personalities such as Bob Hope and Jack Benny, first born as radio and movie personalities, became synonymous with their "television shows." Movie starlet Lucille Ball reinvented herself on TV with her *I Love Lucy* show, one of the most popular running shows in the 1950s (see *Tune In: The Booming Years*).

A Universal Acceptance (1950s–)

Over 20 years since Baird's Televisor demonstration, after the Great Depression, World War II, and the ever-lovable antics of Lucille Ball, the TV had finally made a home for itself in the living rooms of millions of Americans. It did, however, make a few evolutionary jumps after its public embrace. The first was its transition from black and white to color, another milestone for David Sarnoff's RCA, who won a tough battle with CBS for the rights to color technology.[3]

Almost 30 years later came the wonders of cable, and instead of transmitting through radio waves, stations began transmitting through wires. This method allowed for an increased number of channels and programming options—and with initial public reluctance—available for a monthly fee. With the increase in options came the necessity for a TV program guide and a quick way to click through the numerous channels. *TV Guide* magazine became more popular than ever, and a nifty new gadget called the remote control was on everyone's Christmas list.

Since the boom of cable, however, there has been little evolution for the TV. A few interesting technological advancements, such as closed captioning and teletext, were eventually introduced, and in 1987, NHK, Japan's public television network, presented the first high-resolution analog system called MUSE. Here were the inklings of ITV and HDTV, but none of these innovations took great hold. Nevertheless, TV has managed to retain the eyeballs of almost 100 percent of the human race, on average of seven hours a day. It's the most owned appliance of any household, a Mecca of the living room, bedroom, and perhaps even

[3]On January 1, 1954, Sarnoff had his Technicolor debut, presenting to the viewing public the first, coast-to-coast color broadcast of Pasadena, California's Tournament of Roses Parade.

CHAPTER 1 A GLIMPSE INTO TV PAST

the bathroom. Its popularity is not about to change, but its course in history is. (That's what this book is all about.) If David Sarnoff were alive today, he would be most impressed to know that TV is going digital.

Tune-In

The Booming Years
For your reading pleasure, here is a partial timeline of favorite TV events from 1940–1960, the booming years of TV. The timeline is extracted from the *Entertainment Weekly* article, "The 100 Greatest Moments in TV" (February 19/26, 1999).

1947—The World Series attracts the first mass audience in New York, Philadelphia, and Washington, D.C. (3.9 million watch).

1949—Milton Berle's *Texaco Star Theatre* is watched by 75 percent of the TV audience—a figure no other entertainment show will ever surpass. Then again, barely 9 percent of Americans have sets.

1950—News-program footage of the Korean War makes it the first "living-room war."

1952—March 14: Jerry Lewis kicks off his annual telethon, this one for the construction of New York Cardiac Hospital.

1953—Reruns begin when CBS puts repeats of ABC's prime-time hit *The Lone Ranger* on Saturday afternoons.

1953—November 22: RCA tests its new color system on the air, with a telecast of NBC's *Colgate Comedy Hour*.

1954—TV revenue finally surpasses radio's revenue.

1955-56—The *$64,000 Question* goes No.1, making it the only game show ever to do so.

1956—November 30: CBS replaces kinescope with videotape.

1959—Eighty-six percent of American households now own TV sets.

Chapter Summary

- From the invention of radio, the idea of TV was born.
- Mechanical and electronic televisions were created, electronic television having the competitive edge.
- The television went through a 20-year codification period in which standards, networks, and programming were introduced and developed
- The television underwent a few evolutionary changes—its transition to color and then cable—but its means of one-way entertainment and the technology behind it has remained essentially the same.
- Some background of TV's beginnings provides a referential framework for its current state of affairs.

CHAPTER 2

TV Now

In This Chapter

- Speed Is In
- The Brief Internet History
- TV Stands By
- The Inevitable Shift
- Transmission Primer
- Step Aside, Analog
- DTV Standards
- More Choices
- Open Concerns
- Public Awareness
- Chapter Summary

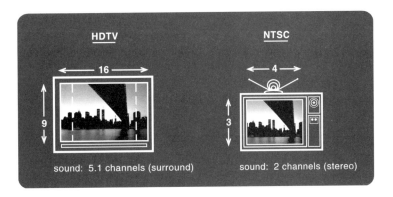

The revolutionary impact of digital technology, particularly the Internet, has positioned the Television industry into an opportunistic moment in history: a testing time period, very similar to its growing years between 1930–1950, where the newly formed industry struggled to win the hearts of the public and define its business, standards, and content. This time, however, it struggles to redefine its prominent existence in the marketplace, to find new ways to compete in our media-rich society. In short, to "catch up" with the digital technology that has so dramatically changed the way we get and receive information, and choose to be entertained.

SPEED IS IN

Many things have changed in the telecommunications world since color TV gained popularity in the 1960s. We talk on telephones while we drive, zip through ATMs for quick cash, and log on to the Internet to buy a book and check our stocks. Fast and convenient—the American mantra—is in full, wired force. Computers have learned our habits, providing us with personal, targeted information. Like an obedient puppy, customized Web portals welcome you each morning with an updated list of favorite stock and news items. On the road, the speed limit hasn't changed, but your travel is much more efficient. Zoom through a tollbooth and, in less than a second, an electronic EZ pass calculates the charges and e-mails you an itemized bill. Stop at the gas station, and with a swipe of a credit card, you're pumping gas while a small screen entertains you with music videos and targeted advertising—"just inside, 2 hot dogs for a dollar."

Even the terminology reflects our speedy, interactive way of life. We actively *log on* and *surf* the Internet, *browse* and *search* the Web, *chat* with friends. We *power up*, *navigate*, *drag*, *drop*, *click*, and *crash*. It has all become so pervasive, and as the Pointer Sisters would say, there's "no way to control it, it's totally Automatic."[1]

How did this happen? Two main events, one spawning from the other, contributed to this new breed of instant communication: the introduction of digital technology, and the Internet. These events occurred over a surprisingly short amount of time. An examination into the Internet boom demonstrates this swift but significant blip in the telecommunications timeline.

[1]From the song *Automatic*, by the popular soul singing group of the 1980s, the Pointer Sisters.

THE BRIEF INTERNET HISTORY[2]

AN IDEA (1957)

In 1957, the USSR launched Sputnik, the first man-made Earth satellite; a technology achievement that did not go unnoticed by the United States Defense Department. Without delay, the Defense Department, whose mantra was to maintain a global dominance, technologically and otherwise, formed the Advanced Research Projects Agency (ARPA). Its purpose: to research and advance cutting-edge technology that would specifically benefit the military and the American people.

In 1969, ARPA formed a special unit called the ARPANET, a fully funded think tank that explored the possibilities of a newly developed technology called *packet switching*. (Unlike TV, the Internet was funded from the beginning.) Packet switching, developed by Paul Baran of the Rand Corporation, was originally designed as an unfailing way for the U.S. military network to continue operating during a nuclear attack. Luckily, this never had to happen; instead, packet switching became the basis of the Internet functionality of today.

AN INVENTION (1960s–1970s)

Packet switching works like this: a networked computer sends messages (packets) that contain information about its route to another computer that knows where to forward (switch) the message. For example, think about an e-mail message you might send—how does it get to its recipient so quickly? Basically, it carries a map. The map is read by computers along the e-mail's networked journey, each computer dutifully directing the e-mail to its destination in the most efficient manner.

Using the packet-switching technology, the ARPANET built a series of Internet Message Processors that were positioned and tested at UCLA, Stanford Research Institute, University of California at Santa Barbara, and the University of Utah. This real-world deployment lead to the realization that in order for computers to switch packets with each other, they need to speak the same language. Out of this discovery developed TCP/IP, Transmission Control Protocol/Internet Protocol, the unified language of the Internet, a system of zeros and ones read by networked computers.

[2]Events in the Internet timeline were partially compiled from the book *Using the Internet* by Jerry Honeycutt, et al., published by Que Corporation, 1998.

A Business Opportunity, Public Deployment and Codification (1980s–1990s)

It took a bit of time to get the kinks out of TCP/IP, but by 1983 the ARPANET was running its network completely on this protocol (here marks the true birth of the Internet). Three years later, the National Science Foundation set up its own Internet, the NSFNET, with a backbone of five super-computing centers, running data between each other at 56 Kbps (kilobits per second). They are located in Princeton, Pittsburgh, UCSD, UIUC, and Cornell.

At this time, people outside of the auspices of the U.S. government and major universities started taking a keen interest in this amazing technology. Personal computers were publicly introduced only five years ago, and now you can get them to talk to each other?

By the end of the first year, NSFNET had 10,000 hosts online; a year later, 60,000 hosts running on a T1 connection (about 25 times faster than 56K!). The word was out, and there was more to come.

In 1992, we got the World Wide Web, introduced by Swiss physicist Tim Berners-Lee. Based on the HTML (HyperText Markup Language) protocol, the WWW became an easy way to distribute and organize the Internet's free flow of bits and bytes. Text—and later, images, sound, and animations—are graphically displayed and contain clickable links that guide a user nonlinearly through the Internet's web of digital data.

With the implementation of the Web, demand to get "online" increased dramatically, and within one year, the growth rate was estimated at about 340,000 percent. To help organize the growing infrastructure of the Web, the NSF formed InterNIC, providing domain name registration and database services through such affiliates as Network Solutions and AT&T. Now, there are hundreds of such Internet Service Providers (ISPs)—Earthlink/Mindspring, Verio, and XO Communications, to name a few (not to mention those ISPs that are now affiliated with TV services—WebTV or AOL/Time Warner, for example). To quickly search for the Web's rapidly expanding list of addresses, we also witnessed at this time our first browser system. Mosaic, later Netscape, developed by Marc Andreesen, became the portal that allowed a user to find and easily navigate through the expanding data of Web Land.

A Universal Acceptance (2000s–)

There's no question about the Internet's universal acceptance. In a matter of only 20 years, computers that can talk to each other have changed our lives. The way we mass communicate has been altered forever; through the language of zeros and ones we can see art, read literature, listen to music, send a photograph, transact a purchase, talk with friends from far-off places, and, above all, speak our minds.

TV STANDS BY

During the Internet growth period, the TV industry was a quiet observer; a passive giant standing secure while a youthful, digital community sped recklessly about its feet. It made a few evolutionary changes—introduced cable and the remote control—but mainly, it just did what it did best: provide us with the luxurious alternative of doing nothing. Working on computers meant business, activity, going somewhere fast. Watching TV meant entertainment, passivity, sitting on a coach with your feet up and a beverage in your hand.

TV's elusive stance is all changing, of course, the sign as clear as the words *interactive television*. The success of the Internet is beginning to plateau. If you dared to look at the NASDAQ at the onset of 2001, or experienced a .com downfall, you would know. The Internet craze is taking on a more realistic stature. It's leveling out and as a result creating an opportunistic time for the great TV giant to wake up from the sofa and take on a new and more active role, a digital role that will alter the way we receive, watch, and react to television programming.

THE INEVITABLE SHIFT

While a computer's central processing unit (its CPU, or brain) is calculating and creating images and text through the digital language of zeros and ones, most televisions continue to transmit signals and images through the analog, radio-wave dialect. Analog transmission, the standard mandated by the FCC in the Communications Act of 1934, is now taking a back seat to a new set of rules. Specified in the Telecommunications Act of 1996, the FCC has mandated the extinction of the analog television signal by 2006, requiring a complete industry switch over to all digital programming. Commercial and public broadcasting services are projected to be digital-ready by 2003.

The challenges to meet these digital deadlines are daily news items beyond the scope of this book, but not to be overlooked. In particular is the continued debates over which type of digital transmission will be the standard in the United States (see *Tune-In: COFDM vs. 8-VSB*), and how the new digital and existing analog spectrums will be allocated. Other concerns revolve around consumer response and adaptation of digital TV (DTV) technologies; for example, the added cost of digital television sets and services, and the deployment of these services into the needed market. Related to this concern is a stipulation in the Telecommunications Act of 1996 stating that if the DTV consumer penetration does not reach 85 percent by the proposed December 31, 2006 deadline, the requirement to go digital will render mute. (Although it's unlikely that the market will *not* reach this 85-percent consumer acceptability, it is important to

realize that if this were to happen, it would not negate, just slow down, the interactive TV momentum.) The digital conversion, however, is expected to happen—clearly indicated by the TV industry's current state of affairs, a promising bout of growing pains. For many cable and satellite companies, this inevitable shift is in full force, with broadcasters claiming their spending around $8 billion to get things up to speed. According to a January 2001 forecast [3] from Strategy Analytics, about 24 percent of homes have switched to digital transmission. The switch is also happening elsewhere—the UK has the most advanced DTV market, with 29 percent of homes having switched to digital, 15 percent for France, and 15 percent for Spain. As you read this sentence, these digital conversion percentages are increasing across the globe, and as they do, so is the progression of ITV. We'll talk more about that in the next chapter. First, let's get a bit more background on TV technologies.

Transmission Primer

Before we race into digital TV land, it's important to understand, from a technological standpoint, how we "get" TV. Television programming enters the home in one of three ways: terrestrial, cable, or satellite. The availability of a particular transmission method is dependent on the topography and population density of an area, and the economic and social factors of its community. Each of these methods has distinct advantages and disadvantages in its transition from analog to digital technology, and the vote is still out on which method (or hybrid method) will dominate the digital market (see *Tune-In: COFDM vs. 8-VSB*).

Terrestrial

Terrestrial has been the tried and true transmission method since the inception of TV broadcasting. TV signals are sent through local radio airwaves and are captured by an antenna atop a roof or a TV box (remember rabbit ears?). It is the least expensive method of broadcast, but airspace is limited and, thus, highly regulated, allowing a fixed number of available channels in any given location. Because it is localized, there is also the problem of obstructed reception or no reception—a big building in the path of a signal renders the viewer a fuzzy image, or for those in rural areas, no image at all.

Digital terrestrial transmission (DTT) signals were introduced only a few years back. DTT services are sent via frequencies of 300 MHz to 3 GHz, as compared to the standard analog UHF (Ultra High Frequency) of 8 MHz. Currently, the in-

[3] These reports are from a study conducted by Strategy Analytics, called "Interactive Digital Television: Worldwide Market Forecasts." For more information, visit www.strategyanalytics.com.

frastructure for most digital terrestrial transmissions is executed as part of already existing analog stations and transmitters (Figure 2.1).

Consumers wishing to receive DTT must have or upgrade to a modern antenna receiver and purchase a digital set-top box to receive and decode the digital signal.

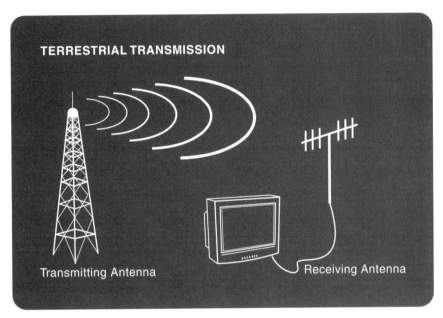

FIGURE 2.1 *Terrestrial broadcasting.*

CABLE

Standard cable sends programming through an analog, fiber-optic, cable network, and is advantageous in two ways: it can provide television access to individuals not living within a localized, terrestrial signal, and it allows for an increased number of channels and services for the viewer.

Cable is available through subscription services from a local cable operator, and requires the hook-up of a cable box (usually included in the cost of the monthly cable service).

On the digital front, cable networks are advantageous in that they can transmit analog and digital signals along the same path. For cable operators, this makes the transition from analog to digital more seamless and less costly than having to build a completely new infrastructure. The current infrastructure is also easily "expandable," allowing for the adding of more services as the market and revenue streams grow. On the flip side of all this, cable infrastructures are

not available to all consumers, so in order for the cable industry to meet the needs of the market, new networks must be built. This can result in higher costs to the consumer (Figure 2.2).

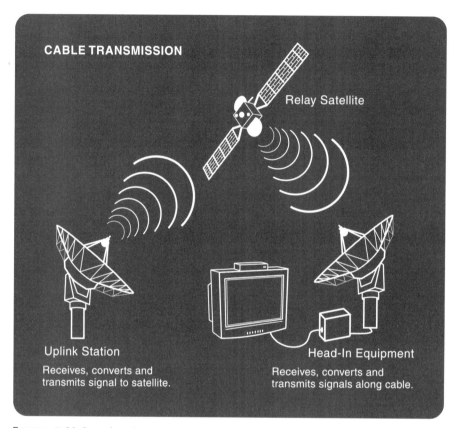

FIGURE 2.2 *Cable broadcasting.*

SATELLITE

Through satellite transmission, TV signals can be amplified, and carried long distance by an orbiting satellite receiver, located some 20,000 miles from the Earth's surface. Households equipped with a satellite receiver dish and decoder to unscramble the satellite's signal on or inside their television sets can obtain this wider coverage and channel selection.

Digital satellite transmission available through direct broadcast satellite (DBS) is now commonly available. For consumers it requires the installation of a digital satellite dish and digital decoder, and a monthly subscription to services (Figure 2.3).

CHAPTER 2 TV NOW

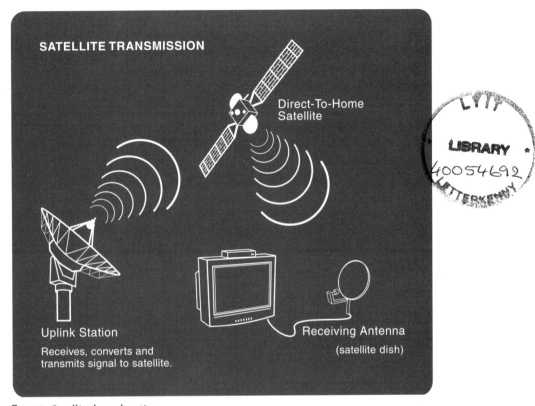

FIGURE 2.3 *Satellite broadcasting.*

Tune-In

Moving at Microwave Frequencies

Worth mentioning here is a hybrid transmission solution called MMDS, more commonly known as wireless cable. With MMDS (microwave multipoint distribution system), TV signals are transmitted at very high, microwave frequencies (2.5 to 2.7 GHz) that are then converted on the subscriber side to the normal UHF (Ultra High Frequency, standard 8 MHz) signal. The signals are sent via satellite, cable, off-air stations, or local programming to a central MMDS tower, which converts and then carries the higher frequency signal to roof-top antennas. For broadcasters, this higher frequency solution allows them to offer an increased number of channels to their viewers (similar to cable), but without the wiring.

STEP ASIDE, ANALOG

Digital and analog signals are television's two methods of sending data.

Analog is the first and most widely used method; digital is its robust successor. As mentioned previously, the TV industry is making the inevitable shift to digital. Why? Fundamentally, the quality and quantity of television services are determined by what is technologically feasible in the transmission of sound and picture information over a television channel. Comparable to analog, digital technology improves the effectiveness of television transmission, resulting in more and better services for the consumer. The effectiveness of digital over analog transmission is due to three significant advancements: type of signal, speed of transfer, and consistency of signal.

TYPE OF SIGNAL

A digital signal sends information using digital language. Computers have been speaking digitally since their inception, translating strings of zeros and ones into what we see as pixels of color, numbers, and letters. Each zero or one is a *bit*, and when combined together are bytes, kilobytes, megabytes, and so on. Because computers share the same digital language, they have the capability to talk with one another, to send and receive data locally, as within an office intranet, or remotely, as within the World Internet. Traditionally, televisions speak through a waveform (analog), limiting the flow of information to a one-way path, where info is being "broadcast" at a particular time—a passive experience for the viewer. With digital television, this experience can change. In contrast to a "broadcast," information has the option to be "broadcatched," meaning caught (and thrown back) by the viewer at anytime (just like the use of the Internet). Consequently, DTV creates a more active relationship between the viewer and the TV content, and how the TV communicates with other digitally speaking devices.

Tune-In

Broadband Definition
A term worth mentioning and clarifying here is *broadband*. The word *broadband* is most commonly used to describe the "broadening" of bandwidth for Internet data, but it can just as easily apply to the broadening of the digital TV signal, the capability of

CHAPTER 2 TV NOW

> a "single wire, cable, satellite dish, or antenna to carry several channels at once."[4]
>
> Also see *broadband* definition in Glossary.
>
> ---
>
> [4]From the article "Access to the Internet: Regulation or Markets?" by David Kopel for The Heartland Institute, September 24, 1999.

SPEED OF TRANSFER

Digital signals contain compressed data, similar to the compression schemes used by a computer. An average analog TV channel is uncompressed and requires 6 MHz of spectrum no matter how its signals are transmitted. With a digitized signal, 6 MHz of air space can carry 6–10 channels—more bang for the buck!

The means to digitally compress data was introduced in the 1990s with the development of MPEG. MPEG[5] (Moving Pictures Experts Group), formed in 1988, is the name of a family of standardized digital codecs (compression/decompression schemes) used for moving pictures and audio. The ever-popular Web audio format MP3 is one format of MPEG compression. In 1994, MPEG-2 became the standard codec for digital television. MPEG-2 uses lossy compression, which discards redundant or unnoticeable (and therefore, irretrievable) information and can reduce a file's bit count 55 to 1.

More recently, another, more versatile version of MPEG, MPEG-4 has taken the limelight. Becoming an international standard in 1999, MPEG-4 provides the standardization of technologies in three different areas.

- Digital television
- Web-related interactive multimedia
- Interactive graphics applications, such as 3D imagery and games

Think of a digital signal as a well-packed suitcase—more stuff in a small space makes for faster and more efficient travel. In addition, more room means more services for the consumer. Broadcasters will now have the ability to offer high-definition picture and quality sound, or "multicast," presenting two or more programs at the same time, using the same signal. In addition, non-television data, such as stock quotes, Web links, and customized content, can be sent to the viewer.

[5]For more information on MPEG, visit the official site at www.cselt.it/mpeg.

CONSISTENCY OF SIGNAL

Finally, digital is advantageous for its consistency of signal.

Effectively transmitting an analog television signal is the challenge of keeping the delivered waveform free from noise disturbances as it travels through space. It's a long journey—signals transmitting and amplifying, through cables or air, and then receiving and translating into viewable pictures. It's amazing that the information reaches its destination at all. For a digital signal, the journey is a bit less arduous—a digital signal never weakens as it travels, its zeros and ones remaining perfectly intact. If the data can reach your digital TV, the picture will be clear and "static-free" every time—no tuning necessary.

Tune-In

DTV—Coming to a Home Near You
In 1999, according to Strategy Analytics, 34.4 million homes worldwide were watching digital TV, 77 percent using a direct-to-home satellite service, 21 percent cable, and only 2 percent terrestrial. Terrestrial has a disadvantage due in part to its short-range reception capabilities.

DTV STANDARDS

The advantages of going digital are clear: more channels, high-speed data transfer, and better picture. For businesses, this is an opportunity to provide new and enhanced services to the consumer. However, like any new technological advancement, the shift to digital is not so easy. The telecommunications industry has to build new infrastructure, business models, relationships, and standards.

The advancement of DTV requires the collaborative efforts of businesses and organizations to push DTV initiatives and standards. There are numerous DTV standard bodies; the three described next are the most prominent contenders and represent the three competing models of digital broadcasting worldwide.

ADVANCED TELEVISION SYSTEMS COMMITTEE

The ATSC, formed by the FCC in 1987, is an advisory forum for "the technical and public policy issues regarding advanced television."[6]

[6] For more information on ATSC, visit their site at www.atsc.org.

Nationally adopted in 1995, the ATSC developed the ATSC DTV standard, a springboard of policies and technological specifications for broadcasters merging into digital technology. The ATSC DTV specifications include the implementation of the 8-VSB (vestigial sideband) modulation scheme, the main digital transmission method in use in the United States. ATSC's standards have also been embraced internationally by Canada, South Korea, Taiwan, and others.

DIGITAL VIDEO BROADCASTING

Located in Geneva, Switzerland, DVB is "a consortium of around 300 companies in the fields of Broadcasting, Manufacturing, Network Operation and Regulatory matters that have come together to establish common international standards for the move from analog to digital broadcasting."[7] DVB has adopted the COFDM (Coded Orthogonal Frequency Division Multiplexing) modulation scheme for digital transmission, the current standard for European countries (see *Tune In: COFDM vs. 8-VSB*).

DVB has also developed a common API (application program interface) called Multimedia Home Platform (DVB-MHP). Its main purposes include:

- Helping content developers create a unified interface between digital applications and the hardware that runs them.
- Extending and promoting DVB's existing open standards for broadcast and interactive services in all transmission networks, including satellite, cable, terrestrial, and microwave systems.

NHK LABORATORIES

NHK is Japan's prominent broadcast corporation. Out of the NHK was formed the NHK Science and Technical Research Laboratories, established in 1930; five years after NHK launched JapanUs, the first radio broadcasting service. Since then, the Laboratories have been engaged in comprehensive research relating to broadcast technologies and standards. The ISDB (Integrated Services Digital Broadcasting) system, centering on NHK's Hi-Vision technology, promotes "techniques for multiplexing and transmitting multiple types of information, new types of services and receivers, [a] total digital broadcasting system covering satellite, terrestrial broadcasting and cable."[8] Japan and other overseas countries have adopted the ISDB standard in their merge to digital transmission.

[7]For more information on DVB and DVB-MHP, visit their Web sites www.dvb.org and www.mhp.org.
[8]For more information on NHK and ISDB, visit their Web site at www.strl.nhk.or.jp.

Tune-In

COFDM vs. 8-VSB

Currently under debate in the United States are two main methods or modulation schemes of carrying digital information from the broadcaster to the viewer: COFDM (Coded Orthogonal Frequency Division Multiplexing) and 8-VSB (vestigial sideband). COFDM, sanctioned by the DVB standards committee, has been widely adopted in European and Asian countries.

ATSC's 8-VSB, developed in the United States, was endorsed as of January 2001 by the prominent NAB (National Association of Broadcasters) to be the standard in the United States and Canada. The controversy over which of these two modulation schemes will pave the way for the U.S. transition to digital has heated up immensely in the last year as more and more countries are deciding which digital standard to adopt. There are numerous factors in deciding which modulation scheme to choose, from the consideration of the time and expenditure of the build-out and the effectiveness of the signal over certain geographic areas and transmission types.

MORE CHOICES

The move to digital and the push to develop universal transmission standards comes down to one thing: more choices.

From a consumer standpoint, these choices arrive in many ways and are delivered through several DTV innovations: High Definition Television (HDTV), Multicasting and Interactive Television.

HDTV

If you don't own one already, head down to your local consumer electronics store and check out an HDTV. The first thing you'll notice is its price; ranging anywhere from $1,000 to $5,000, it can take a bite out of the pocketbook (this price, of course, is expected to level out as more individuals invest in the digital switchover). Nevertheless, one look at an HDTV's picture and sound quality, and the improvement over an analog box is clear. Using the same amount of spectrum as an NTSC television, HDTV can provide a higher resolution image, with a wider aspect ratio, and surround sound (Figure 2.4).

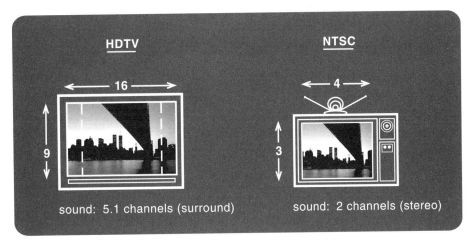

FIGURE 2.4 *HDTV vs. NTSC.*

Aspect Ratio

Televisions standard 4:3 aspect ratio derives from the film size of the Kinescope motion picture camera developed in Thomas Edison's Laboratories in 1889. A 4:3 aspect ratio produces a TV picture that is four units wide for every three units high. The NTSC adopted this aspect ratio as a standard in 1941, and the television picture has remained this size ever since.

In the 1950s, the rising star of television challenged the film industry, enticing the attentive eyes of moviegoers. To win back these wandering eyes, Hollywood introduced the expanded 16:9, widescreen format, offering the viewer a more naturally panoramic and visually stunning movie picture. This widescreen format became the movie standard, and is still in use today.

The wide-screen standard became a problem, of course, when viewing big screen movies on a TV equipped with the horizontal 4:3 picture ratio. To counter this dilemma, the TV industry devised two solutions. The most common is to crop the outer edges of the movie, or in other words, "format [it] to fit your TV." Unfortunately, this results in a cropped and sometimes misrepresented viewing of a director's or camera person's vision for the film. Alternatively is to rent a movie with letterboxing, in which the picture is scaled to fit into the 16:9 aspect ratio, leaving black space at the top and bottom of the TV screen. A leap beyond the formatted and letterbox solutions is HDTV. An HDTV system is designed to support the 16:9 aspect ratio, creating a movie watching experience with the same high quality and visual appeal as a Hollywood flick, but from the comforts of home.

Higher Resolution

In addition to a more horizontal and natural viewing experience, HDTV provides a higher resolution picture. *Resolution* refers to the amount of picture elements that run horizontally and vertically on a television display screen or computer monitor. Generally speaking, the more picture elements, or pixels in a given area, the clearer and more accurate the image. These pixels are, in essence, electronically drawn at a rate of 30 frames (or complete pictures) per second. The speed of this frame rate is directly proportional to the rate in which the human eye can perceive natural movement. Remember flipbooks? The faster you flipped the pages, the more lively and animated the character. Images flipping or scanning less than 20 frames per second are jerky and unstable to the eye. The average frame rate for film is 24 frames per second; for television, it is 30 frames per second.

The amount of circuitry required to quickly refresh a scanned image with a high enough resolution to see a clear and accurate picture is quite a task, such a task that no one bothered to improve the maximum resolution of the NTSC television set, 720 by 486 pixels, until digital technology came along. (Internationally, the PAL format is 768×576.) In terms of resolution, the increased bandwidth of a digitized signal offers two advantages. First, it allows the transfer of a larger number of pixels elements per scan (higher resolution). True HDTV systems produce resolutions up to 1920×1080. A second advantage is the use of progressive scanning. Traditional television sets use an interlaced scan method. To create one complete frame (525 lines) in the allotted 1/30 of a second (30 frames per second), information is divided into two fields, each scanning, and depositing pixels, at 1/60 of a second. Instead of dividing and scanning information every even/off field, progressive scanning scans one complete frame every 1/60 of a second, producing a more stable picture.

Surround Sound

HDTV also offers digital 5.1 sound, or as more commonly known, *surround sound*. The name is very descriptive—surrounding the listener with five channels of full-bandwidth audio and a narrower frequency, "bonus" component for extra impact sounds such as explosions and car crashes.

Surround sound can work with digital television systems because it is compressed. Currently, audio received by an HDTV system uses the lossy compression scheme, throwing away unrecoverable, redundant data.

MULTICASTING

As mentioned earlier, the advanced features of HDTV can be accessed using the same amount of spectrum as a traditional NTSC broadcast. Alternatively, this same spectrum, using the new digital technologies, can also be used to multicast. *Multicasting* is the ability of broadcasters to simultaneously transmit four or

more channels of Standard Definition Television (SDTV) using the same spectrum as one HDTV signal. SDTV will not match HDTV in sound and picture quality, but it is higher quality than traditional NTSC. The ability of broadcasters to send 4x more programming to the viewer in a single time slot allows for numerous programming possibilities. For example, a PBS documentary about meercats can correspond with the simultaneous download of additional, educational literature about meercats. Or, at 8 o'clock, the Fox station could run an episode of *The Simpsons* on Fox Channel 1, The *X-Files* on Fox Channel-2, and a live interactive game show on Fox Channel 3.

From a viewer standpoint, multicasting means more choices, many more choices. From a TV network standpoint, it means more chances to catch and sustain viewer eyeballs. For TV producers, filmmakers, and content developers it means a greater demand for their work to accommodate the increased programming line-up.

Tune-In

The Grand Alliance
When HDTV was first introduced in the United States by the Japanese, fierce competition incurred between consumer electronic manufacturers. Each wrestled to develop the first American HDTV system.

General Instrument won the prize in May 1990 with its all-digital, HDTV system.

Shortly thereafter came six other all-digital systems. This resulted in the ATSC recommendation for a competitive round, to evaluate whose system would bestow "marketability status." In response to this second round, the proponents decided to collaborate rather than compete.

Out of this decision arose the Digital HDTV Grand Alliance, members including AT&T (now Lucent Technologies), General Instrument, North American Philips, Massachusetts Institute of Technology, Thomson Consumer Electronics, the David Sarnoff Research Center (now Sarnoff Corporation), and Zenith Electronics Corporation. Together these companies developed the hardware technology and standards for the HDTV systems being used today.

Interactive Television

The luxury of the HDTV picture and the flexibility of multicasting are significant innovations to the DTV paradigm, but it is Interactive Television (ITV) that has most radically piqued the interest of the television industry, media, and public alike. As you will discover in the next chapter, ITV is defined by many types of services, from the ability of a viewer to record, pause, and rewind live programming, to accessing the Internet and real-time events.

In the ITV vision the ubiquitous TV set will take on a whole new face, transitioning from a dust-collecting device that you simply click on and watch to a humming home terminal networked to interactive technology that accesses customized and targeted programs and services.

The amount of available pipe space for a single digital channel (about 19.2 megabits per second) is a boom for broadcasters. It's a long-awaited opportunity to not only provide the viewer with high definition picture and surround sound, but to take television content to a whole new level: to provide content that is customized, dynamic, and interactive. However, full digital interactivity is still awakening, and right now most interactions we experience is through an analog solution, or a hybrid of analog and digital technologies (discussed in greater detail in Chapter 3, "Appendix B: ITV's Journey").

Open Concerns

In the United States, industries' concerns for the implementation of DTV are in constant discussion and review by all relevant players, including broadcasters, standard committees, the government, cable and satellite companies, and consumer electronic manufacturers. Such questions in consideration include: which DTV modulation scheme will be used? How do we encourage deployment of services? What will be the financial model for this deployment? How will proprietary and standard middleware developments be addressed? What will be the means of distributing this middleware content—set-top box, TV tuner cards, other? The evaluation, status, and outcome of these highly relevant questions are of a timely nature, and should be watched closely in the daily news and industry discussion threads (see "Appendix B: ITV Resource List").

Since consumers will inevitably drive the market, a main concern is the ability to "hook" and maintain these consumers by providing broad packages of programming, Internet, and interactive services that are reasonably priced and easy to access. To do this involves not only the exhausting task of technological restructuring of transmission types and methods, but a serious learning period. Industries traditionally from opposite sides of the fence must begin to collaborate and work together. This is evident by the joining of forces of long-standing

CHAPTER 2 TV NOW

media conglomerates with Internet newbies. Time Warner/AOL, MSNBC, and News Corporation with DirectTV are just a few newsworthy examples—keep an eye out for more. Moreover, the United States is continually learning from the already existing and successful DTV deployments in the UK and Europe, where many of the preceding questions have already been asked and answered.

PUBLIC AWARENESS

While the industry leaders are hacking out the details, the digital evolution from the public's standpoint is a slow progression. This is not to be a discouraging factor, but a historically expected one. It took 20 years, plenty of money, advertising, cajoling, and government mandating before Americans let go of their black-and-white tubes and reinvested in color. Even computers, which many of us now take for granted, are still considered a luxury in most American homes (but this is changing rapidly, as personal computers continue to drop in price and become easier and easier to use). The bottom line is that consumers are not adverse to new technology, just slow to adapt to it (Figure 2.5).

Fortunately for the TV industry, televisions are already an accepted and standard appliance in almost 100 percent of homes across the globe, so the shift to

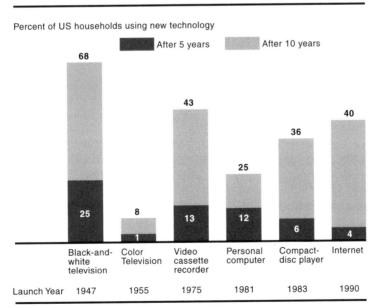

FIGURE 2.5 *Consumers adapt slowly to new technology.*

digital and the new services it can provide are more easily accessible. Strategy Analytics reports that in 1999, 34.4 million homes around the globe were watching digital TV, 77 percent using a DTH (direct-to-home) satellite service, 21 percent cable, and 2 percent terrestrial. The trend is happening. For the United States, the FCC has guaranteed its forthcoming, and like the Pied Piper, the digital TV industry is gaining followers.

Tune-In

A Connected Community

An intriguing and massive collaborative telecommunications project is underway in the Gulf of Finland, where plans are being developed to create, by 2010, an all wireless, all digital community called Helsinki Virtual Village (HVV). Spearheaded by Sonera, Finland's leading telecommunications company, and the city of Helsinki, the "ultra-connected" community will be a test ground for the technological and social effects of a fully networked environment (a reality version of the movie, *The Truman Show*). *Wired* magazine, March 2001, in the article "In Helsinki, Virtual Village..." describes HVV as including a "local area network and a wide range of services available through broadband fiber-optic cable and wireless links, that will be accessible anytime, anywhere. Users will be able to participate in HVV via any wireless handset, as well as by PC and digital TV."

CHAPTER SUMMARY

- In our moment in history, the telecommunications industry is making a dramatic shift from analog to digital technologies.
- There are three main types of television transmission: terrestrial, cable, and satellite.
- Transferring data through a digital signal is advantageous for three reasons: type of signal, speed of transfer, and consistency of signal.
- Numerous DTV standard bodies are not only developing technology specifications for DTV implementation, but promoting and encouraging the collaborative efforts of businesses and organizations aimed to move digitally forward.

CHAPTER 2 TV NOW

- Some specific DTV innovations have contributed significantly to the forward momentum of DTV: HDTV, Multicasting and ITV.
- What is ahead for DTV is a cautious but inescapable public awareness to accept and embrace digital services.

CHAPTER

ITV's Journey

IN THIS CHAPTER

- ITV as a Digital Playground
- In the Beginning
- Learning from the Past
- Service Check
- Getting to Know the Teams
- Getting Down to Business
- Chapter Summary

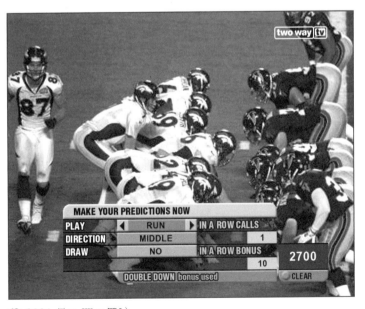

(© 2001. Two Way TV.)

The concept of Interactive Television (ITV) is not an easy one to pin down. It has taken many forms, spurred good and not-so good connotations, and has confused the public and supposed experts alike. Even its given title adds to the muddied waters, the word *interactive* having its own set of over-worked implications. Ask someone on the street what he or she thinks ITV is and you will get a variety of interesting answers—Doesn't that have something to do with, um, WebTV[1]?" or "You mean, watching television on my computer?" or simply " Huh?"

ITV AS A DIGITAL PLAYGROUND

For all intents and purposes, think of interactive television as a new environment in which to play—a digital playground. Janet H. Murray, Ph. D. and professor at Georgia Institute of Technology, describes interactive, digital environments quite succinctly in her book *Hamlet on the Holodeck*[2].

"Digital environments are procedural, participatory, spatial, and encyclopedic. The first two properties make up most of what we mean by the vaguely used word *interactive*; the remaining two properties help to make digital creations seem as explorable and extensive as the actual world, making up much of what we mean when we say that cyberspace is *immersive*."

Although Janet H. Murray's definition of digital environments is directed toward computer technology, it also pertains to ITV. We can use the four parts of her description—procedural, participatory, spatial, and encyclopedic—as a way to further define ITV.

The term *procedural* represents the concept of what can be called "smart TV". Instead of TV being what it has always been—a blockhead device that simply renders pictures—it can now inherit the brains of a computer. A brain that calculates and evaluates a programmatic set of rules and behaviors, evaluating, for example, how many times you've watched the television drama, *The Practice*, or storing and remembering your screen preferences—blue background with 20-point text. With added smarts, the TV can predict our programming preferences, inform us of the local weather 24 hours a day, record a week's worth of our favorite sit-coms, and perform and submit its own market analysis (see *Tune In: A Market Research Collaboration*).

[1]WebTV has been Microsoft's set-top box ITV solution, until recently, with the introduction of the company's UltimateTV service. For more information on UltimateTV, visit www.ultimatetv.com.

[2]*Hamlet on the Holodeck* by Janet H. Murray, originally published in 1997 by The Free Press, A Division of Simon and Schuster Inc.

CHAPTER 3 ITV'S JOURNEY

Tune-In

A Market Research Collaboration

In April 2001, Gemstar, a major proponent of ITV, and Nielsen Media Research announced a collaborative effort to measure the ITV advertising clickthroughs of Gemstar's *TV Guide* electronic programming guide (EPG). The *TV Guide* EPG service is available to millions of cable and satellite subscribers around the world. According to an article in Tracy Swedlow's *InteractiveTV Today* newsletter of April 11, 2001, "data collected through this international broadcast network will give Gemstar and Nielsen the largest and most dynamic picture of the ITV landscape."

Keep an eye out for what will be useful analysis from this arrangement.

Television being a participatory event, anything that induces behavior and makes us react, comes in degrees. Much of the time, television is completely unparticipatory—you turn it on and "veg out."

Other times, it is highly active and engaging, such as watching a sports event or a game show. Friends come over; you eat chips, and yell at the screen. For ITV the idea of participation can be further explored, creating more choices and greater degrees of activity, depending on viewer preference—from no activity to highly interactive, from asocial to very social. Allowing, for example, active TV watching with not just your friends in the living room, but with anyone in the same time zone. Imagine tuning in to a particular television channel and playing a video-game type application with someone across town (no more hooking up your Nintendo 64 or Sony Play Station with a couple of joysticks and a $40 game cartridge). In the UK, this global game playing is successfully happening, through such companies as Two Way TV, a company that runs its game-exclusive channel through digitized cable, satellite, and terrestrial signals covering a large majority of UK's TV watching audience. TV chat rooms, political polls, news surveys, and pick-your-own-ending storytelling scenarios are just a few of the interactive, highly participatory ITV services currently being offered.

Regarding the spatial property of a digital playground, an ITV application provides a television viewer the never-before option of a two-way communication stream. The ability to freely maneuver information through a TV device is a spatial function; information can be sent to you, and you can send information back. To communicate back (send an e-mail, submit a credit card number, answer a trivia question), although a participatory event, involves spatially

navigating to make selections, and to have the capability, just like the WWW, to move nonlinearly through those selections. To have a spatial experience is to be able to choose, for instance, to go left or right, up or down on the remote control, or in the case of Personal Video Recorders (PVRs) to pause, rewind, and fast forward, on a moment's whim, any television program or commercial.

Spatial can also refer to the option of shifting camera views of a TV show, creating for the viewer a more dimensional experience. Perhaps to have the capability during your favorite baseball game to switch, with a click of a button, from the view of the "catcher cam" to the press box.

With such a free flow of information, the final component of the digital environment is its endless capacity to provide an encyclopedic retrieval of data. In ITV Land, this means the opportunity to sift through archives of past episodes of the *Brady Bunch*, *Star Trek*, or *Seinfeld*, download them in megabyte chunks, and watch them whenever. Or to completely bypass the *Blockbuster* intermediary and purchase new release movies without waiting in line. Current set-top box solutions are also virtual libraries, such as Microsoft's UltimateTV, which holds up to 35 hours of digital video recordings.

No longer will TV be simply a "sitting on the bench" experience. It will contain a whole playing field of equipment, from monkey bars to swing sets. ITV has the potential to become the ultimate digital playground. It's gaining a brain (procedural), inducing reactions (participatory), offering navigational tools (spatial), and providing multiple program choices (encyclopedic). Put that all together with TV's immersive hypnotism and you have a new face of entertainment.

IN THE BEGINNING

The public awareness phase of what ITV is and can be is currently in full force. Hundreds of Web sites focus specifically on ITV, and it seems a new ITV-related book is published on an average of every three months (a lot, when previously there were few to none). TV commercials touting DirecTV, TiVo, and UltimateTV are popping up in primetime. ITV news and magazine articles are daily; top agenda reading for the who's who in telecommunication, TV, and Internet businesses around the world. Major broadcast networks, including ABC, CBS, PBS, and NBC are consistently launching innovative interactive programming and services, with data-packed Web sites.

This bustle of activity is a sure sign that the TV industry is on the road-pounding path of public awareness, technological refinement, and business maneuvering. (Sound familiar? TV has been on this path before, way back in its first growing years). But how did we get here? With all the hype it seems that this

ITV thing just recently spawned from the think-tank and went speeding down the media highway. In actuality, the idea of interactive elements combined with TV programming has been a kicked-around topic for some time.

About the same time that black-and-white TV was gaining popularity in the 1950s, a popular CBS children's program called *Winky Dink and You* introduced the first analog form of interactivity. Children equipped with a special Winky Dink kit, ordered through the mail, had the power to help the animated star, Winky Dink through trials and tribulations, such as how he might cross a river. From the kit a child would remove a clear plastic sheet, place it over the TV screen, and with a crayon, draw a bridge for Winky Dink to cross. Innovative, yes; interactive, yes; practical, well let's just say that many children skipped the plastic and drew directly on the screen.

After the Winky Dink fiasco, it wasn't until the 1970s, with the discovery of the Vertical Blanking Interval, that other interactive forays were gallantly attempted. A standard analog TV has a total of 525 scan lines. Only 486 out of the 525 are necessary to send video picture. The remaining lines it was discovered could be used to send emergency broadcasts and timing information for shows. These remaining lines are located as black strips at the top and bottom of the TV screen, an area called the Vertical Blanking Interval (VBI). In the 1970s, a specific unused portion of the VBI, Line 21, was regulated for open use, and U.S. broadcasters began to use Line 21 for delivery of closed captioning—the ability to transfer textual information for the hearing impaired. At this time, BBC (British Broadcasting Corporation) in the UK began using this open line to deliver CEEFAX teletext services to their viewers. Teletext was one of the first attempts at providing localized textual data, such as up-to-date news, weather, and sports, through the TV signal, and available anytime. The introduction of the HTML Web protocol led to further exploration of Line 21. With the development of special digital decoding software, via a set-top box or TV tuner card in a computer, HTML data, graphics, and links could be sent through the analog signal. The VBI discovery led to the growth of many businesses experimenting with new interactive possibilities. Most of the experiments, although seemingly unsuccessful, paved the way for today's digital TV evolution.

LEARNING FROM THE PAST

FIRST ATTEMPTS

One of the earliest and most well-known attempts to use the VBI signal to send interactive data was the QUBE project in 1977. Warner Communications (now Time Warner) with funding from American Express set out to attract new subscribers to their 36-channel cable service. An innovative set-top system called QUBE and developed by Pioneer was distributed to residents in the Columbus,

Ohio area. This box, a small computer with a chip and some memory, allowed for the distribution of two-way, responsive, interactive elements to the viewer. Such services, accessed by pushing a series of buttons, included current movie selections, game show participation, home shopping, and voting capabilities. QUBE also had the capability to perform market analysis about its use. Viewers were asked questions, such as which channel they are watching and what selections they have made, and the answers would be sent through QUBE and processed by a back-end mainframe computer. Considering that the personal computer had yet to be introduced, QUBE's level of interactivity and market analysis was incredibly innovative.

The QUBE experiment survived for a good seven years, but unfortunately it was ahead of its time. By 1984, under financial stress and rising competition for the in-home movie market (here enters video retailer, *Blockbuster*, and commercial-free HBO), QUBE ceased operation and discontinued service to its subscriber base of 40,000 homes.

QUBE is an important moment in ITV history, because its voyage into new territory provided perspective for future ITV initiatives.

One key lesson to be learned was how viewers responded to QUBE's interactive programming. With no development and design tools, or content standards to feed from, the programming producers were learning on instinct; budgeting as they went, and creating, with limited resources, projects they could only guess would hold public interest. One programming idea that did catch the eye of the public was Pay Per View (PPV). Viewers responded favorably to paying a small fee for the convenience of selecting and watching current movies from the comfort of their couch. This response, in turn, prompted the future development of numerous PPV services, and special programming channels such as *The Movie Channel*, *Music Television* (MTV), *QVC* shopping networks, and *Nickelodeon* (once known as *Pinwheel*).

Another important fall-out of the QUBE project was the high cost of the set-top box and its instability. Although innovative, the technically unsavvy public responded to the QUBE with hesitation (not unlike the uncertainty of the first black-and-white TVs). First, it was expensive; each box cost about $200 to manufacture, not to mention the 2 to 3 million dollars in equipment costs on the cable head end. Second, the underlying workings of the system lacked stability, resulting in a constant beta-test mode of its functionality and content delivery.

After its win-fall, the Warner-Amex QUBE project was considered by most a dismal failure; however, in hindsight, QUBE provides a wealth of lessons to be learned in the resurgence of today's ITV ventures. Technologically and economically, the QUBE box was a true test for the successful development of future set-top boxes.

After the QUBE's great effort, the 1980s offered little in the way of ITV development. GTE's *Main Street* was one of only a handful of projects during this

slow time for ITV advancements. Launched in Cerritos, California, *Main Street* was a set-top box type service, offering on-demand movies and access to the *Mobil Travel Guide*, *Groiler's Encyclopedia*, and *Money Manager* software. An important, repeated lesson, learned from the *Main Street* project was the discovery of the public's threshold for how much they were willing to pay for interactive services; the consensus being that most viewers would rather pay a small rental fee for the use of a set-top box, rather than pay for it outright, and would be willing to pay only a small, incremental fee for on-demand movies over renting a video at a local video store.

THE BOOM OF THE 1990S

The next big steps for ITV test runs happened in the 1990s, when technology as a whole was taking major leaps. Personal computers became mainstream, and suddenly, tuning in to a TV show didn't seem half as exciting as chatting, e-mailing, surfing, and browsing 24/7 on the World Wide Web. TV broadcasters with opposing feelings of pressure from and enlightenment for the personal computer and Internet revolution gathered up their experiences from the past and decided to make another push into the ITV arena. Too numerous to go into detail, the following sections are a brief listing of some of these ITV test projects within the last decade.

VIEWER-CONTROLLED TV (VCTV)

In 1992, TCI, AT&T, and US West conducted a trial of video-on-demand services, providing memory-equipped set-top boxes to approximately 300 test homes in Denver, Colorado. Using a remote control, consumers selected a movie from an updated feature list costing anywhere from $.99 to $3.99 per movie.

QUANTUM

Also introduced in 1992 was Time Warner's Quantum system, a video-on-demand service with a customer base of about 10,000 in Queens, New York. The set-top box, designed by Pioneer, contained a digital compression scheme offering more than 150 channels of information, with popular pay-per-view services taking up a third of the channels. Monthly subscription cost was $23.95.

VIACOM CABLE

Viacom Cable created a test site of 1000–3000 subscribers in Castro Valley, California, offering interactive programming through its privately owned networks including *MTV*, *VH1*, *Nickelodeon*, and *Showtime*. One prototype program called *Hands-On MTV* featured a shopping section where viewers purchased music discs and videos. The services were implemented through a set-top box system, similar to Quantum.

FULL-SERVICE NETWORK

After Quantum, in 1994, Time Warner took another large step into the ITV arena with its Full Service Network. Using newly developed digital technology, a larger, more efficiently transferable set of services was offered to a test group of 10,000 homes. Services included video-on-demand, educational resources, interactive video games, and Internet elements such as personal communication services and high-speed data transfer.

Contributors to the test included AT&T and US West to manage the network and data flow, IBM and Silicon Graphics to provide the computer server software and hardware, and Scientific Atlanta and Toshiba to develop and manufacture the set-top box converters.

LESSONS LEARNED

Lessons learned from these maverick ITV deployments can be summarized as follows

- Technology was expensive, and the system-based infrastructure was in constant "beta" test mode.
- Rich interactive content was limited, in part by technological barriers, but also for the lack of undeveloped tools and practices for designing interactive content.
- Audiences were slow to catch on, and were inexperienced with and reluctant to use and pay for new media.
- Audiences were receptive to pay-per-view and video-on-demand programming, as long as the price was right.

What was lacking in the valiant ITV deployments of yesterday is being fulfilled today. Propelled by the Internet revolution, these past challenges have become possible. Technologies that were once too expensive to implement are now cheaper and more efficient to use. The components to build a set-top box, for example, were initially hard to come by and very expensive. It wasn't until the 1990s, when the WWW was just a baby, that low-cost computer chips were designed to successfully compress and decode the large amounts of data used in reconstructing a video image.

Creating rich interactive content was also a challenge. The tools and resources for back-end development were makeshift at best, and the resources for graphical, front-end designs limited artistic freedom and consumer usability. Photoshop, the most well-known image manipulation software, was not introduced until 1990. In the same year debuted NewTek's Video Toaster, finally offering nonprofessional tools to create broadcast-quality television. Eventually, we got HTML, Java, Adobe System's Page Mill, and Macromedia's Dreamweaver. Moreover, amidst this software infiltration we got standards for digital content development, a set of rules to live by and enforced by such standard committees

as the WC3 (World Wide Web) consortium and our very own FCC. Today content and back-end development tools are varied and amazingly inexpensive, and the skilled workforce to use them is abundant. With a $900 computer and $300 worth of software, you can create a Web site equipped with video, sound, and animation, and post it to the world.

During all this change came the public's acceptance of new media, and the means to navigate through it. How we get our hands on digital technologies is as easy as a click of a mouse, and in most cases for a flat fee. $19.95 a month gets you the ability to talk with anyone in the world. With instant access, our reluctance to use digital technologies has waned, giving us a chance to experience and adapt. Think about it, the oddity of learning to use the touch-screen WYSIWYG interface of an ATM machine is no longer. For most of us, surfing the Internet, sending an e-mail, chatting on a cell phone, and configuring hand-held PDAs have become as rote as sleeping and eating.

Time and the explosive digital advancements in the last 10 years have made the lessons learned from past ITV deployments, well, a thing of the past. The landscape has dramatically changed for the technological and humanistic potential of ITV, moving from an idealistic experiment to a massive shift in television technology and viewing. In the words of Walt Disney's Chief, Michael Eisner[3], "Times have changed . . . The future of the Internet is content and interactive television and pay-per-view [programming]."

SERVICE CHECK

The types of ITV services available today are growing at a rapid rate. Many of them are available through a cable or satellite subscription that includes an installation of equipment to your analog TV. The equipment, a set-top box, decodes and stores digital video, and streams from a back-end channel (an Internet connection) Web-related information. Some services are also accessed directly through your computer with a TV tuner card, or by a computer and TV synched solution (more on this in Chapter 4, "The Experience of Enhanced TV"). Whatever the method, most services are coming into the home as a hybrid of analog and digital signals, but the transition to full digital signals received by fully digital equipment (i.e., a digital TV or HDTV) are becoming increasingly prevalent. Whatever the current method of transmission, the ultimate goal of interactive related services is the same: to provide content that engages viewers and offers them the power to personalize, customize, and, in return, make convenient their programming choices (see *Tune In: Interactivity in Comfort*).

[3]Quote taken from *Disney, in Retreat from Internet, to Abandon Go.com Portal Site,* by Saul Hansell, *New York Times*, Business Day, January 30, 2001.

Keeping in mind the endless possibilities of what interactive television can be, the following sections list some of the more common services offered today.

PPV AND VOD

Pay Per View (PPV) is one of the longest-running interactive services. To experience it, check yourself into a hotel room for a night, and for $4.95 a show you can watch, from a selected list, the latest in movies and adult entertainment. Even more convenient is the hybrid version of PPV, Video on Demand (VOD), where you can have 24/7 access to a video selection as large as your local *Blockbuster*, with the click of a remote and from the comfort of your couch. In addition, there, is NVOD (Near Video on Demand), a type of VOD with advanced back-end capabilities that enable an almost real-time feed of data from client-side digital video servers.

Companies currently in the PPV and VOD service sector include nCube, DIVA, Concurrent, and Intertainer.

PVR

Growing in popularity is the evolutionary upgrade to the VCR called the Personal Video Recorder (PVR), also referred to as a DVR (Digital Video Recorder). PVRs are hard-disk based devices costing between $400 and $700 (plus about $9.95 per month subscription fee) that can record up to 60+ hours of television programming, live or otherwise, and can pause, resume, rewind, replay, and skip them altogether (including commercials!). In a recent Forrester report, "Future Development in the Digital Media" by Raymond James, the U.S. PVR market was at 8.4 million in 2000 and is expected to rise to 52.95 million by 2005.

Companies offering PVR and DVR subscription services include TiVo, ReplayTV, UltimateTV, and DISHPlayer; their services running through standalone PVR/DVR systems manufactured by Panasonic, Philips and Sony, to name a few.

EPG

An Electronic Programming Guide (EPG) is essentially *TV Guide* magazine on a screen. As we know, the number of available TV channels, particularly to digital subscribers, is overwhelming and easily sends a viewer into the "infinite clicker trance," a state of pushing the remote channel button through a seemingly endless linear stream of stuff. EPGs are designed to alleviate this headache. Usually a free service with certain subscriptions, EPGs are navigation systems that allow you to browse through current and upcoming programs. An EPG works similarly to a Web browser, enabling a search function to find a program by date, time, genre, title, or channel. More advanced EPGs offer Web surfing, chats, and e-mail services (Figure 3.1).

CHAPTER 3 ITV'S JOURNEY

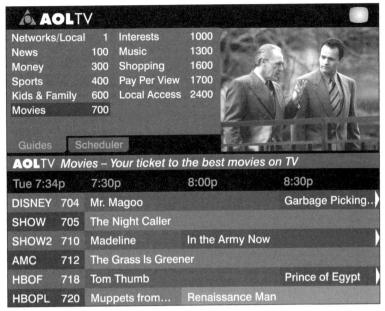

FIGURE 3.1 *An example EPG interface. (© 2001. Reprinted with permission from AOL.)*

Gemstar/*TV Guide* have managed to corner the market on EPGs, with their strict patent rights for the application's technology. Other companies, though, such as upstart iSurf TV, are successfully getting around the patent restrictions to create their own EPG services.

TELETEXT

Teletext, similar to close captioning, is a system that broadcasts textual information alongside the standard TV signal (VBI). Teletext services are most popular in the UK, where it was originally invented and implemented. A convenient amenity, teletext offers up-to-the minute news, sports, weather, financial, and entertainment information for most of the UK's TV viewing audience. The newest variety of teletext is completely digital, accessed through an STB or digital television system, and offers more efficient transfer of data and high-definition picture.

Teletext is implemented mainly in England with these services being offered through BBC's CEEFAX, Sky Five Text Ltd., and Teletext Ltd.

ENHANCED TV

Enhanced TV (ETV) is sometimes mistakenly used as a synonym for ITV, rather than a *type* of ITV. In its most generic definition, ETV is defined as the blending

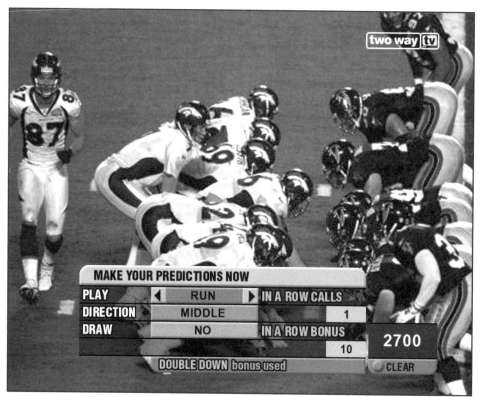

FIGURE 3.2 *An Enhanced TV screen shot of PlayLive Football. (© Copyright 2001. Photograph courtesy of ALLSPORT Ltd. Reprinted with permission from the Two Way TV.)*

together of TV picture with HTML, Web-like elements such as timed links, graphics, textual information, forms, and animations (Figure 3.2).

Content combined with these elements follows specific design and development standards, which are covered in Part Two of this book, along with further information on the planning and implementation of this content.

Enhanced content can be viewed through standard-compliant STB devices, a synchronized 2-screen (TV/computer) solution, or directly on a computer with a TV tuner card, enabling the viewing of TV broadcast channels.

Companies currently manufacturing Enhanced TV compliant STBs include Scientific-Atlanta, Pace Micro, and Motorola/General Electric, with platforms developed by such companies as Wink, WorldGate, Microsoft TV, AOLTV, and Liberate.

INTERNET ACCESS

Another interactive service important to mention, although not necessarily TV specific, is the ability to access the Internet and World Wide Web through your

TV set. Hooked up with a Web-compliant STB box, keyboard, remote, and Internet service you can browse Web pages, e-mail, chat, and send files directly from your TV.

Most companies that offer Enhanced TV content usually include Internet access as part of the package, such as Microsoft TV, Liberate, and AOLTV.

Proprietary ITV Services

To distinguish themselves in the market, more and more ITV service companies are creating proprietary interactive applications, many of them hybrids of the services listed previously, some of them completely innovative. Veon has created a service called HyperVideo, which they describe as "clickable video." Accessed through an Internet browser window using the Veon Player in conjunction with the Real System or Windows Media Players, you can click on various hot spots of a streaming video presentation, each link containing additional data, advertisements, and enhancements related to the show.[4] ACTV has created a software application for DTV called Individualized Television that enables TV programmers and advertisers to provide customized, demographically targeted content to their viewers.[5]

Tune-In

Interactivity in Comfort

La-Z-Boy® and WebTV® teamed up recently to design the Explorer E-cliner™, a chair that makes the "active" in "interactivity" a bit more palpable (Figure 3.3). An excerpt from a 2001 press release describes this joint venture between La-Z-Boy and Microsoft and their innovative product

"Our relationship with La-Z-Boy underscores our strategy to provide new ways to enrich the entertainment and information value of television by making it easy and comfortable for people," said Eric Estroff, director of channel marketing for WebTV Networks. "What could be more comfortable than a La-Z-Boy recliner?"

continued

[4]For more information about Veon, visit their Web site at www.veon.com, where you can download a 30-day free trial of their VeonStudio software for creating "clickable video."
[5]For further information on ACTV and to see examples of their projects, visit their site at www.actv.com.

Consumers who want to make "Explorer" their new workstation will appreciate the chair's other perks. The keyboard tray is perfectly suited to hold a laptop computer for comfortable word processing. The left arm also houses a 120-volt fused electrical outlet with surge protection, a high-speed DSL port and regular analog line, and an AC adapter for plugging in a laptop computer. The right arm contains a drink holder and storage space ideal for holding a remote control and *TV Guide*.

"We continually focus on adding new, innovative features to our recliners to enhance the La-Z-Boy comfort experience," says Kevin R. Wixted, director of marketing for La-Z-Boy. "This chair is the next step in our effort to be on the cutting edge of our industry without sacrificing our signature comfort."

La-Z-Boy was honored with a 2000 Pinnacle Award from the American Society of Furniture Designers for the outstanding design of "Explorer."

FIGURE 3.3 *The Microsoft® WebTV® Plus Recliner by La-Z-Boy.* (© Copyright 2001. Reprinted with permission from La-Z-Boy Incorporated.)

Getting to Know the Teams

As digital technology moves mainstream and more and more services are created and introduced to the general public, an increasing number of businesses are jumping on the opportunity bandwagon. Joining the ride is a mix of new-found businesses and old—manufactures and distributors, developers, designers, and producers. Many of them are offshoots of well-established Internet, television, and consumer electronic companies.

Breaking from comfortable molds of operation, these businesses are reinventing relationships and exploring uncharted territory, collaborating in ideas and assimilating resources. Two examples are the restructuring and relationship building of the $106-billion marriage of AOL/Time Warner[6] and the merger of Rupert Murdoch's global satellite business, Sky Global, with General Motor's Hughes Electronics unit, DirecTV. Large mergers such as these open important discussions concerning the forward progression of ITV, raising pertinent questions such as, will monopolies between cable, the Internet, and telephone companies hinder viable competition? Will the government safeguard a free market? Will emerging technologies remain open? Will standards be implemented? Will the rights to consumer privacy be maintained in this interconnected media environment? Answers to these questions are in current debate, but one thing is clear: the success of ITV is dependent on the continued brainstorming, solution making, and persistent risk taking of all who dare to be involved.

The players collaborating and competing for prominent position in this aspiring medium are many, making them hard to keep track of. Figure 3.4 is a visual aid of ITV-related business areas and example players. Expect this representation to grow and evolve.

Getting Down to Business

Without a doubt, the players involved in the ITV business have a lot to think about, not the least of which being profitability. Financial models of the TV and Internet industries of the past need to be, and are being, reevaluated.

The TV industry has grown out of a top-down, regulated economic structure—studios feeding off programming, networks feeding off advertising revenues, and broadcasters feeding it all to consumers.

[6]In January 2001, Internet giant America Online (AOL) and media titan Time Warner announced a $106 billion merger that has fast become the working model for a marriage of old and new media.

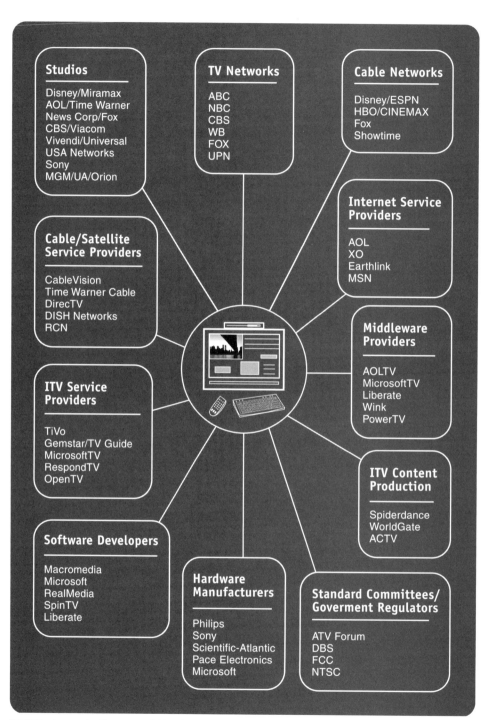

FIGURE 3.4 *A sample diagram of ITV players organized by business areas.*

Money is made from syndication revenues, advertising, and consumer's cable subscriptions. On the flip side is the Internet industry, in which financial models leave people scratching their heads, wondering "how is this company surviving?" Those that do survive are ISPs, offering Web services to consumers for flat fees, or point-of-sale Web sites and advertisers.

The mixing of both financial models is being put to the test with the current building of digital, broadband infrastructures. Many predict that the success of broadband technologies, and in result, the success of ITV applications, is dependent on the building of a pay-per-byte economic structure. This move leans toward the cable, pay-for-services TV structure introduced in the 1980s, which, of course, received much uproar from the consumer end, but eventually proved to be the most viable solution. For Internet die-hards, this model will be a big pill to swallow; no longer will the free exchange of information be free.

"Broadband will change the picture radically. Flat-rate billing isn't commercially viable in an era when some users consume 1000 times as much data as others," as stated by writer Charles Platt in a May 2001 *Wired* article[7]. "If you're downloading a million bits per second, the cost of those bits isn't trivial anymore; and when entertainment companies start peddling video online, pay-per-view, pay-per-byte, and pay-per-hour will be logical consequences."

Another profit-generating area predicted to change is in advertising.

As effective as TV is in branding awareness, it lacks point-of-sale interaction. There is no easy way, for example, to accurately monitor a viewer's response to commercials. Are we really running out and buying the Audi sports car or eating the Burger King Whopper because of what we saw on a TV screen? The closest TV can get to quantifying a viewer's response is by us dialing the 1-900 number off the Psychic Hotline ad, or purchasing that emerald ring from the Home Shopping Network (See *Tune-In: At-Home Shopping Spree*). For the Web world, click and buy is its bread and butter. Amazon.com, zones.com, and grocer.com have the power to design their virtual spaces to not just draw us in, but monitor our every move and guide us through our shopping experience. With ITV, the shopping circle will be complete—product branding, impulse buying, and targeted advertising realized in one, interactive session.

The outcome of the one-stop shopping experience could mean the end of the 30-second commercial. With interactivity comes the consumer's ability to access programming and data nonlinearly, such as the power with PVR owners who have the glorious option to skip through commercials, or tape and watch a show later. Viewers can redirect their attention during commercial breaks and log on to the Web, or access a show's interactive elements. With such diverted

[7]Quoted from "The Future Will Be Fast But Not Free," by Charles Platt, *Wired* magazine, May 2001.

attention spans, it is quite likely that advertisers will move back to the advertising model of the 1950s, in which the television show was the commercial. Remember such sponsored programming as *Texaco Star Theater* and the *Colgate Comedy Hour*? There is also the notion of a restricted commercialization scheme, giving people limited but targeted advertising, such as the "walled garden" approach where ITV subscribers have access to a controlled set of product-related Web sites and services. Whatever the means, through product placements, clickable graphic ads, exclusive interactive shopping malls, or ideas we've never thought of, the role of advertising is taking on a new dimension (Figure 3.5).

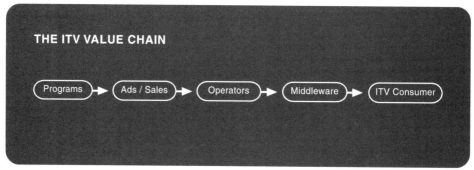

FIGURE 3.5 *ITV is in the process of creating new business models; for example, a profit-making value chain involving many companies and emphasizing a common thread of ITV initiatives across all industry players.*

 ## Tune-In

At-Home Shopping Spree
Shopping networks such as the Home Shopping Network, QVC, and NBC's ValueVision (soon to be renamed ShopNBC) are extending their appeal successfully through the Web. In the *New York Times* (April 2001), the article "TV-Web Link Succeeds in Shopping" by Bob Tedeschi explains how QVC is sending more viewers to their Web site and vice versa with special promotions and features. One example is a promotion called "61st Minute," during which QVC viewers are encouraged to go online immediately after a product showcase, where they find a continued pitch for the product. Regarding one such Webcast in February 2001,

CHAPTER 3 ITV'S JOURNEY 51

> W. Stephen Hamlin, vice president of iQVC, stated that "1000 people logged on, and 100 of them bought the featured goods. That's a smaller audience, obviously, but it's still a very good sell through." iQVC's online sales accounted for about 6 percent of QVC's 3.6 billion dollars' worth of sales in 2000.

CHAPTER SUMMARY

- ITV is a digital playground, an environment that is procedural, participatory, spatial, and encyclopedic.
- Many ITV deployments have been executed from the 1970s to today, the earlier deployments providing insights and "lessons learned" for later deployments.
- The Internet revolution and the essence of "time" have been the major contributing factors to alleviating the challenges of past ITV deployments.
- There are numerous ITV services including PPV programming, PRVs, EPGs, Teletext and Enhanced elements, Internet access, and cutting-edge, proprietary applications.
- The players involved in the ITV momentum are abundant and hard to keep track of.
- Financial models of the TV and Internet industries are being reevaluated to accommodate the ITV evolution, and could result in a subscription-based fee structure depending on the amount of ITV services consumed.
- Advertising models will also change—the 30-second commercial being replaced, perhaps, by product sponsorships and/or a "walled garden" approach.
- Collaboration between all ITV players is vital for the successful move to digital and ITV media.

Viewpoint

Do We Really Want Interactivity in Our Living Rooms?
With any emerging innovation comes an endless stream of questions, inquiries, and what-ifs; the ITV industry being no exception. Here, reprinted with permission from the [itvt- industry] unedited e-mail discussion thread, is a candid exchange between Malinowsky Bronislaw,

a digital TV user, and Craig Dalton, director of Business Development for Proteus, an interactive television solutions provider. The issues presented here revolve around the most fundamental premise of the existence of ITV—its purpose in our lives, and the answers to a most basic question—Do we really want interactivity in our living rooms?

MB: How many of you [ITV industry experts] subscribe to any DigitalTV operator? I was surprised by the fact that most of the people talking about the benefits of ITV simply don't have any kind of real experience from an user/viewer perspective. Professionals trying to convince other people about the differences between the TV and the Internet audiences, the 'lean forward' experience, the 'integration' of ITV with the living room, the 'impulse' shopping, the 'emotional' force behind TV, and other things alike, were talking from a mere 'theoretical' background, with no real experience about how you feel when you are in your living room, maybe tired after a long work day, maybe with a Gin Tonic in your hand, and watching some TV program, maybe a Football game... These are the real benchmarking conditions for ITV services, neither the demo rooms nor the labs.

CD: I couldn't agree with you more on this issue. It is critical that as industry professionals we "walk the walk as well as talk the talk." At Proteus our emerging market specialists do just that. Whether it is wireless devices or interactive televisions, we want to insure that our user interface designers and application engineers own the experience. From a personal perspective, I actively seek out "interactive" shows to watch. I attempt to disconnect myself from my "industry" side and experience shows on an emotional level. With that said, some of the current deployments work; others don't. I truly believe the ITV experience will add value to the television viewing experience, but for these compelling applications of technology to improve, both content creators and technologists must start living the ITV experience.

MB: Do you consider the TV viewing experience as an individual activity? The marketing material created around ITV tends to consider viewing TV as an individual activity. However, the TV is the center of a SOCIAL activity, as opposed to browsing the Internet, which is basically an individual action. I think the ITV community misses this very important point: watching TV has to be considered a social act, as you normally watch TV with somebody else, and, therefore, all the navigation process and switching activity among TV programs and interactive services will be affected by social interaction rules.

Chapter 3 ITV's Journey

CD: I not sure if I agree with your contention that all the marketing material created around ITV focuses on individual activities, but you bring up an interesting point. Is the TV experience a group (social) activity or an individual activity? I would put out there that it is both at one time or another. Applications need to reflect this reality. Often times, television is a group activity (think Super Bowl, game shows, etc.). Applications for this environment are inclusive and may require additional input devices (i.e., wireless devices) so that many people can interact with an application at once. TV and ITV can create an excellent communal experience. On the other hand, in many households TV viewing is an individual experience (sadly enough)—the kids may be watching *Pokemon*, while Mom is watching basketball and Dad is watching a movie. This is a reality in many homes and would dictate an entirely different set of appropriate ITV applications (potentially).

The beauty of Internet technologies is that we CAN deliver personalized ITV applications that meet the needs of a particular user group. I'm not going to hold my breath on responses to this suggestion given the current state of enhanced content, but we can theoretically make available different enhancements to the same show (can you say can of worms...). This is what we've learned from the Internet experience, why not bring it to ITV (leaving aside the complexity/cost issue for the purposes of an open discussion of the future)?

MB: I think that as soon as you start having real experience with live interactive services (at your home), you realize that viewing TV is a SOCIAL activity and that many of the services being proposed by the ITV community have simply no sense from a user/viewer perspective (such as surfing the Web).

CD: As above, I suggest we consider both the group and individual aspects of TV.

MB: The magic of the TV is due, among other reasons, to the immersive nature of the user experience. The emotional force behind TV relies on its immersive potential. You get engaged into the movie argument or into that important game of your favorite team. You are 'living' this experience with strong feelings.

Interactivity could 'break' this immersive illusion, creating a frustrating experience. Do you really want to buy this Omega watch, or just relax and enjoy the last James Bond movie? Probably you'd prefer to be part of a passive audience, enjoy your movie, and only afterwards, once you are in a different mindset, you will decide to buy the watch

from an Internet-Portal. Therefore, is Enhanced-TV and impulse selling something that makes sense in this context?

CD: ITV is going to give the viewer choices. You are correct in stating that the first time I see a movie or show I would want to become immersed and emotionally involved, but what about the second time? ITV has the potential to add value to the experience of second-run shows. If I've seen "A View to a Kill" ten times, the experience is a less involved than the first time. Perhaps I would be open to a well-designed commerce experience. Perhaps I would be willing to surf ITV optimized sites, write e-mails, send IMs while the screen is minimized. I think we need to consider the "lifetime" of entertainment properties and where enhancements might really add to the experience.

MB: I've been a Digital TV subscriber over the last couple of years. I'm very happy with my operator basically because of the quality of the TV programs: movies, sports, etc. This was the reason to become a subscriber. In addition to the TV programs, I also have access to a very good catalog of Interactive Services, including retail services, e-banking, games, etc., as well as some Enhanced-TV services. However, I would define my experience from an user/viewer perspective as "neutral." I simply don't use them, although they are available. They are somehow 'invisible' to me and the other members of my family, and they don't have any effect in my discussion of being a subscriber. Why? I don't feel in the mood to use Internet-like services once I sit in front of the TV: I just want to be entertained.

CD: Obviously different users are going to have different feelings regarding the television (as many do to the Web). As an industry we need to move forward in creating compelling, entertaining applications and enhancements so that ITV is more fun than regular TV. I don't think anyone would suggest that we "force" enhancements down our viewers' throats, but making them available creates freedom. For the last twenty years I've passively watched as the television networks have pushed programming at me. I, for one, am looking forward to the time when I can make my own decisions about how I want to be entertained through my television.

About Craig Dalton
Mr. Dalton has seven years of experience in sales and marketing management, as well as extensive experience building profitable business strategies. As Proteus' director of Business Development, his responsibilities include formulating market strategies, developing and

managing strategic relationships with partners and clients, and providing active management of ongoing sales opportunities. Mr. Dalton has been focused on the development of Proteus' wireless application and interactive television practices, developing strategic partnerships and educating clients on how to harness the power of emerging technologies. For more information about Proteus and their Unified Development approach, visit http://proteus.com/. (© Copyright 2001. Reprinted with permission from Craig Dalton and Proteus).

About Malinowsky Bronislaw
Malinowsky Bronislaw has 15+ years of experience in the software industry, 5+ years of experience in Internet projects, and 3+ years of experience in ITV and Media Streaming projects. Currently working in Europe as a Business Development manager, he has extensive experience in ITV business models and architecture, and a personal interest in ITV social culturalism and its impact. (© Copyright 2001. Reprinted with permission from Manislowsky Bronislaw.)

CHAPTER 4

The Experience of Enhanced TV

IN THIS CHAPTER

- Those Wandering Eyes
- The Experience
- Considering the Solutions
- Content Is Key
- Chapter Summary
- Timeline of Television and Internet Events

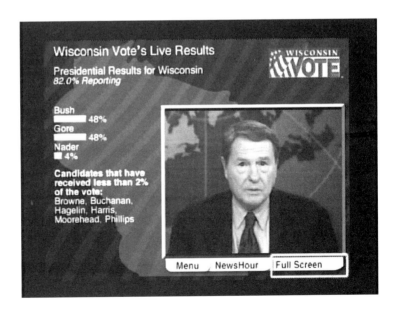

One way to further clarify and understand the current impact of ITV is to delve into a specific flavor of the medium—Enhanced TV (ETV). Considered the most dynamic and potentially compelling of ITV services, ETV works to unify Web and TV technologies. With the TV being the most popular entertainment appliance on the planet and the Internet poised as the Mercury of global information, ETV is the answer to the most begged question of the digital age: wouldn't it be great if all this media could just get together?

THOSE WANDERING EYES

As you discovered in earlier chapters, the growth of the Internet has had a profound impact on the revived ITV industry. The impact has put into question the future of home entertainment, and where the wandering eyes of the media consumer will go next. What screen, device, or platform are the majority of viewers gluing their eyes to now? And what kind of content are they watching? These are important questions to be answered by the TV and Internet industries alike, for their continued success is largely dependent, if not completely dependent, on the whims of the consumer.

A recent study from Cyber Dialogue[1] indicates that in the year 2000, 19 percent of adults online watch TV while online. This is compared to 14 percent in 1999. This phenomenon, the simultaneous viewing of TV and WWW content and called *telewebbing,* is an increasing activity that brings up a couple important points. First, telewebbing indicates that individuals are dividing their viewing time between two different devices, the TV and the PC. For the younger generation, this division of media input is becoming a way of life.

A completely natural activity gleaned while growing up during the Internet revolution, kids take what would have been four hours of watching Saturday morning cartoons and now spend part of that time on the computer. TV broadcasters have recognized this divided viewing and have spent millions to retain eyeballs, creating, for instance, an additional presence on the Internet. Want to learn more about your favorite cartoon character? Log on to www.cartoonnetwork.com. Want to know what's on PBS tonight? Log on to www.pbs.org. Need a leg up on the latest NBC Soap? Visit the Soap Station at www.nbci.com.

The second point is that telewebbing indicates the act of multitasking. By simultaneously viewing the tube and interacting with the Web, individuals are in pursuit of passive *and* active entertainment. An example realization of this

[1]Statistics were extracted from "The Business, Top News and Data from Entertainment and Media" of *Inside* magazine, February 6, 2001. For more information on *Inside* magazine and its coverage of the TV industry, visit www.inside.com/TV.

occurred during NBC's airing of the 1996 Olympics when, at 7 P.M., the station promoted its Web site, and promptly thereafter, 300,000 people logged on.[2]

Many broadcasters are now keen to multitask viewing, and encourage it.

TBS Superstation, a network of the AOL Time Warner Company, has an interactive program every Friday night called *Enhanced Dinner and a Movie*. While watching a flick on TV, you can log on to www.superstation.com and play a trivia game synched to the show, download a dinner recipe, and chat with other movie watchers (see *Viewpoint: Star Wars Goes Interactive*).

A viewer's motive to teleweb could also mean the simple ability to get more things done in a hectic lifestyle. During a commercial, for example, instead of running to the kitchen for a snack, you log on to your laptop, check e-mail, peruse your bank account, and perhaps pay a few bills.

When consumers are dividing and multitasking their time between the TV and the PC, it shows a definite twist in the traditional intake of media and entertainment.

However, the telewebbing audience is only part of the picture. A good half of American families are without a computer at home (let alone Internet access and at speeds worth logging on to). Nevertheless, their intake of entertainment has not waned. Computer or no computer, just about every home on the planet has a television set, or two, or three, being watched on average seven hours a day. For the ITV industry, this means potential all around. With the shift to digital transmission and the development of enhanced content, a new market can emerge and appeal to all entertainment junkies, including the already captive, but Internet-deprived population, and the wired telewebbers searching for a one-stop solution.

Tune-In

Nielsen Media's Convergence Lab

From their press release, dated January 11, 2001, Nielsen Media Research has set up what they call "the first 'Convergence Lab' in the U.S., an ongoing consumer research laboratory to electronically measure television viewing and Internet viewing as they occur in the same sample households." Starting with over 190 households, Nielsen Media will measure data in the following areas:

- Correlation, if any, between overall TV viewing and Internet surfing

continues

[2]Resource taken from the article "Human and Social Factors of iTV" by James Stewart, Research Center for Social Sciences, University of Edinburgh, Great Britain, August 1998.

> - Correlation, if any, between the types of programs watched on TV and content surfed on the Internet
> - Correlation, if any, between specific programming outlets or programs viewed and the likelihood of these viewers visiting related Web sites
> - Instances of simultaneous usage of the TV with the Internet
>
> For more information about the Convergence Lab and other television rating statistics, visit the Nielsen Media Research site at www.nielsenmedia.com.

THE EXPERIENCE

Working out the kinks of a one-stop solution, of a true assimilation of TV and Web elements, is not to be taken lightly (Figure 4.1). Creating enhanced content is a compelling and challenging task (as you will further discover in Parts Two and Three of this book). Let's start with what Enhanced TV is now and how it is experienced.

Admittedly, looking in a book at screen shots of Enhanced TV programs doesn't do the experience justice. They can provide a taste of a show's "design" sense, especially when the show is long off the air, but they do not justify what ITV really does—make us interact. It's similar to the feeling you get when you want to purchase a book on amazon.com, one that you've never actually flipped through the pages of, and all you have for reference is a thumbnail-sized photograph of the cover. Nothing compares to the true experience of engagement, of actually clicking a remote or typing in a keyboard command and, in return, receiving some interesting and useful information. Aside from attending the numerous ITV show booths at telecommunication trade shows across the world, there are currently three ways to experience the real deal: a set-top box solution (STB), a TV tuner card solution, or a 2-screen synched solution.

SET-TOP BOX SOLUTION (STB)

To view enhanced content on your analog TV set, you need an STB and a subscription to an interactive service provider. Also, optional, but highly recommended, would be a cable or digital satellite connection, since much of ITV programming is available through these networks (see *Viewpoint: Setting Up a Set-Top Box 101*). An STB device is a mediator between your outside signal

CHAPTER 4 THE EXPERIENCE OF ENHANCED TV 61

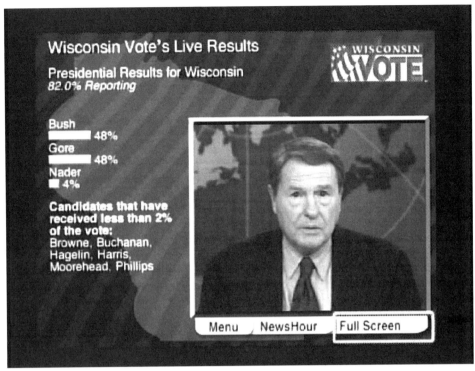

FIGURE 4.1 *An Enhanced TV screen shot from the Wisconsin Vote project, a localized broadcast of the 2000 Primary Elections in conjunction with the national broadcast of the News Hour with Jim Lehrer. (© Copyright 2001. Reprinted with permission from the University of Wisconsin-Extension, Wisconsin Public Television.)*

(cable, satellite, or terrestrial) and your TV set. It receives and decodes analog and digital data and works much like a pared-down computer with an operating system and memory. It also serves as an Internet terminal that can send and receive data from the Internet. An alternative to an external STB, although not as common (yet!) and fairly expensive, would be the purchase of a digital TV equipped with internal interactive capabilities.

TV TUNER CARD SOLUTION

An alternate solution to viewing enhanced content on your TV set is viewing it from your personal computer with a TV tuner card. Most TV tuner cards are based on the PCI capture-card technology, which merges video from external sources; hence, a TV signal (or camcorder or digital camera) with the normal display system of the computer (see *Tune-In: A PBS Test Run*).

Tune-In

A PBS Test Run

In February 2001, the Public Broadcasting Station (PBS) announced an experiment (one of many) to test-run interactive elements with Alan Alda's *Scientific American Frontiers* show. The enhancements will be available to a select 250 people in New York City, equipped with digital TV tuner cards in their personal computers. "We view this as a significant step forward in the path of personal television," Cindy Johanson, senior vice president of PBS Interactive said in a statement.[3]

[3]From CNET news article, "PBS viewers to experience a new wave in digital broadcasting" by Patricia Jacobus.

2-SCREEN SYNCHED SOLUTION

Another solution is the combo TV and computer screen viewing experience. While watching a television show, you simultaneously log on to your computer and interact with content that is synched to the show. With this method, both devices can do what they do best—the TV broadcasts the show and the PC gives it interactivity. Of course, to receive this type of enhanced content you will need a TV, preferably with cable, and a PC hooked up to the Internet (*see Viewpoint: Star Wars Goes Interactive*).

Viewpoint

Setting Up a Set-Top Box 101 (Author's Viewpoint)

During this writing, Microsoft's WebTV service was going through some changes. WebTV has been rebranded MSN TV, and Microsoft's UltimateTV service was introduced in the marketplace.[4]

Regardless of these changes the experience of setting up a WebTV STB, as presented here, is essentially the same for all types of STB solutions.

If you've never hooked up an STB, here's your chance to find out what it's like.

[4]For more information on Microsoft's UltimateTV, visit www.ultimatetv.com.

CHAPTER 4 THE EXPERIENCE OF ENHANCED TV

On a level of complexity (1 being no problem, 10 being forget about it), hooking up a WebTV unit is about a 6. This ranking, of course, is completely biased toward my own experience and minimal level of knowledge hooking up consumer electronics. If you spent a lot of time putting together Legos as a kid, the experience could be less difficult (and, hopefully, not more).

Expect to spend a good Sunday morning, like I did, to get all the pieces to fit. The process, which is a similar one for all STB setups, can be divided into three parts: connecting the system, navigating and signing up for service (in my instance, the WebTV Network) and accessing services. All I have to say here is read the operating manual carefully and purposefully. Resist the urge to skip to page 33, where "signing up for the WebTV Plus Network is as easy as filling out a short application form,[5]" or you'll end up on page 46, "Troubleshooting."

Part I, connecting the system, I could have just let a friend figure out, but that's too easy. Basically, the goal here is to get the STB, or what WebTV calls the Internet Terminal, to communicate properly with your TV and, in my case, the cable and VCR boxes. You must connect the unit to each of the following: your TV, an analog telephone line (for Internet access), an AC power outlet, and an antenna or cable (directly through your VCR or cable box). It's actually not very difficult once you manage to position yourself behind the TV set, and have ample room to pull out and plug in coaxial and A/C cables, while you examine the connect-the-dots diagrams on pages 8–12.

I successfully got through Part 1, my efforts rewarded when I was able to click the power button on the WebTV remote control and the TV and Internet Terminal came to life—no sparks, no smoke. I did, however, have to configure the remote control (and optional keyboard) to enable the switch between WebTV and regular TV viewing. If you don't do this, you're stuck in clicker limbo trying to figure out which of the four remote controls (TV, cable, VCR, and STB) is the one that actually gets you where you want to go.

Spend a few minutes trying to understand how the scroll up and down, return, up/down, and right/left arrow buttons work, and Part 2, signing up for interactive service and Internet access, is a snap. An onscreen display, similar to wizards on the Windows platform, sends you step by step through the subscription sign-up process. Although

[5]All operating information in this commentary was referenced from the Sony/WebTV *Internet Terminal Operating Instructions* manual that comes packaged with the WebTV Plus set-top box.

tedious, I highly recommend reading through the subscription agreement before committing to service. A part I found most interesting is section 4, Standards of Behavior, which states that "conduct on the WebTV Network service and throughout the Internet should conform to public standards of decency and decorum, right of quiet enjoyment and current 'netiquette' standards." I submit.

Part 3, accessing services, involves nothing more than a bout of patience. An STB box is essentially a computer, and, just like a computer, in order to provide customized and timely content its brain must be constantly updated. For my WebTV service, this initial updating process took about 30 minutes—enough time for me to eat lunch. I was then able to customize my WebTV home page, and set up my e-mail preferences (Figure 4.2). To view Enhanced TV programming, another bout of waiting occurred while WebTV accessed my cable service to download the day's local TV listings. Interestingly, most STBs will download local TV listings and new service upgrades in the middle of the night. I discovered this fact when my STB started humming and chunking information at 2 A.M.—perfectly convenient if your

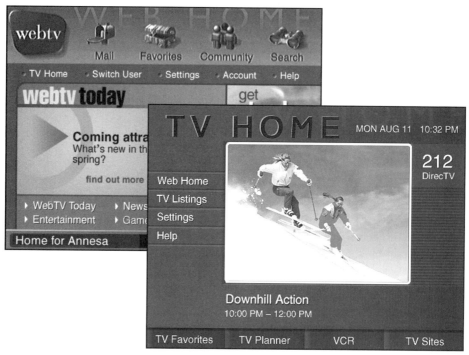

FIGURE 4.2 *The WebTV home site. (© Copyright 2001. Reprinted with permission from MicrosoftTV®)*

box is set up in another room and you can't hear it. I, on the other hand, live in a small apartment in Brooklyn, where my TV set, and hence the STB, are literally right next to my bed. Nevertheless, the idea here is that by first downloading as much information into the memory of the STB, the less wait time for you during the actual usage of the interactive services.

After some thought, I think setting up an STB is really about a 5 on the challenge scale, right up there with configuring the time on your VCR, or programming your palm pilot. It's quite simply a matter of reading the operating instructions, learning to navigate by buttons, and patiently maneuvering through onscreen step-by-step instructions. All that's next is to see what's on. . . and where did I put that remote?

CONSIDERING THE SOLUTIONS

Which enhanced viewing solution will ultimately corner the market is yet to be determined. Arguments sway both ways between the viewing of enhanced content on a TV versus a personal computer. Both are equally conflicting in their technological capabilities to combine video picture with graphic and text elements. TV is great for the viewing of one-way fast-moving film and video picture; the Web for two-way information transfer, e-commerce, text, and graphics. The economic structure of each is also a big issue. TV works on a highly regulated pay structure, depending on how much TV you want (standard to premium offerings), and where you are located (say, New York or New Guinea). The Internet, touted for its "free for all" business model, is based on a flat fee structure. For about $19.95 a month you can have access to a network stretching from one end of the Earth to the other. A final issue is the availability of TV and Internet capabilities to the consumer. The goal, of course, is to reach the widest market. As a means of sorting some of these issues out, the following sections discuss the various factors currently at stake in the implementation and use of the STB, TV Tuner Card, and 2-Screen solutions.

STB

The STB solution has been an answer to TV interactivity since the discovery of the VBI, the QUBE box being one of the first introduced to the mass market in 1977 (before the introduction of the personal computer!).

- Currently, the STB is the number-one way in which consumers receive ETV content. Strategy Analytics indicates that "during 1999, consumers [worldwide] installed over 17 million digital set-top boxes in order to access the new services. This year's global set-top box sales are forecast to

reach 28 million units, and by 2005, annual sales are expected to have reached nearly 92 million units."[6] These numbers are still relatively small compared to the overall TV viewing audience, but are growing.

- The STB solution for getting enhanced content to the viewer has the advantage of reaching the widest audience. Television sets have an over 95-percent saturation in American homes, compared to about 45 percent for computers.
- A current STB costs anywhere between $200–$500, not including the subscription to services, which can be an additional $9–$50 a month. Although this can become expensive, particularly if you throw in a digital TV system, the pricing model of installation and subscriptions fees is something that cable subscribers are accustomed to.
- STBs are considered a "less technical" solution and can reach audiences unaccustomed to using computers.
- STBs can offer additional interactive services other than enhanced content, such as PVR capabilities.
- An STB solution offers the big-screen visual advantage, since the viewing can occur on any size TV monitor, including new HDTV widescreen formats.
- Many STBs have the capability to download interactive elements overnight or before an interactive show begins, allowing for less "wait time" for enhancements (an experience most common for Web surfers, and a product of slow Internet connections). However, until faster back-end connections are available, the amount, complexity, and design of enhancements will be limited (see *Tune In: The Download Dilemma*).
- STB manufacturers and middleware companies are numerous and varied. Some work from a set of industry standards, and others create proprietary applications, which can result in difficulties on the content creator end—what platform do I design for?

TV TUNER CARDS

TV tuner cards have been around almost as long as set-top receiver boxes. A first attempt was with the introduction of the Mac TV—ring a bell? Mac TV was introduced in 1993, a limited addition of 10,000, with a cable-ready tuner card, CD-ROM drive and 32MHz processor.

- TV tuner cards cost anywhere from $40 to $150, are easy to install, and require no subscription fees. They do, however, require a powerful computer for proper functionality.

[6]Strategy Analytics statistics were taken from Carat's Interactive TV News, found at www.itvnews.com.

- The financial payback for the delivery of enhanced content over the Web will need to be considered.
- The TV tuner card solution could mean watching television on a 14-inch laptop screen, or most likely, an option to watching TV on a TV set, but perhaps not a substitution.
- TV tuner cards are currently not a standard component in most computer systems, lessening their overall ability to reach a large consumer base. However, the efforts to make it a standard, as CD-ROMS, modems, and DVD players are now, have not waned. According to a news brief from CNET News.com, March 2001, the TV tuner is expected to make an impact: "The worldwide market for both analog and digital TV tuner cards, which let people get television signals on their PCs, will grow from $473 million in 2000 to $1.8 billion in 2005, according to a new report from Cahners In-Stat Group. The increase will be driven by the delivery of services, such as e-commerce portals and pay-per-view programming, via satellite transmission. In-Stat forecasts that revenue for analog tuners will slow as the market for digital tuners takes off." (Richard Shim)

Tune-In

The Download Dilemma

No matter the method, there is one persistent problem with the capability to send and receive two-way, Web-related data: how fast it gets to us. For TV watchers, there's no such thing as "wait time." TV programming is based on a highly structured schedule: 9:00 A.M., "The Today Show"; 9:10 A.M., Post Cereal commercial; 10:00 A.M., "One Life to Live"; and so on, and so on. It's all very predictable. For Web users it's all very unpredictable. Information can be available day or night, but getting it in a timely manner is dependent on many factors: your Internet provider, Internet traffic, your connection speed, and your computer hardware. And one of the most file-intensive things you can do is attempt to download video—usually arriving postage stamp size and at playback speeds of about 12 fps (as compared to 30 fps for television). Obviously, a great desire for many is to get rid of analog and move to digital, and have the digital information arrive seamlessly. Slowly this is happening and there are great hopes for the future of DSL, cable, broadband, and streaming technologies. According to Jupiter Research, in the year 2000, 5 percent of U.S. households had some sort of broadband connection, and the amount is rising. This percentage might at first

continued

> seem pretty meager, but consider the fact that only one year earlier, a high-speed connection was considered a luxury in the workplace, let alone at home.

2-Screen

- Although it reaches a limited audience, the 2-Screen method can be considered an inexpensive "hybrid" solution for those individuals with a TV and PC in their homes. All you need is an Internet connection, and no extra equipment is required.
- Viewing from two screens can be double the fun, if you happen to have your computer and PC in the same room.
- Content design for the 2-Screen solution is more flexible, offering designers the use or advanced Web tools and greater screen real estate.
- While waiting for the digital TV transition, the 2-Screen solution offers an easier way for broadcasters to provide and test enhanced content programming (see *Tune-In: ABC Enhanced TV Traffic Statistics*)
- The 2-Screen solution is a "here and now" method of Enhanced TV delivery.
- It requires no extra hardware or software on the consumer end and alleviates the need for multiple system operators (MSOs).

Tune-In

ABC's Enhanced TV Traffic Statistics
For more information on ABC's 2-Screen solution for Enhanced TV delivery, visit their site and programming schedule at http://heavy.etv.go.com/etvHome/.

- Approximately 12 million viewers have experienced the Enhanced TV production of *Who Wants to Be a Millionaire* since its debut March 28, 2000, with an average connect time of 41 minutes.
- More than 3.4 million unique users experienced ABC's Enhanced TV for the 2000 football season, with an average connect time of 42 minutes.

CHAPTER 4 THE EXPERIENCE OF ENHANCED TV

> - Approximately 200,000 viewers participated in the Enhanced TV production of the *ABC News American Election Challenge* November 7, 2000, with an average connect time of 27 minutes.
> - More than 184,000 viewers experienced the Enhanced TV production of ABC's Primetime *Emmy Awards* telecast September 10, 2000, with an average connect time of 49 minutes.
> - More than 650,000 viewers experienced the Enhanced TV production of ABC's Super Bowl XXXIV telecast January 30, 2000, with an average connect time of 42 minutes.

AN ULTIMATE SOLUTION?

It's quite likely the ITV industry will support multiplatform delivery systems, with the STB, TV tuner card, and 2-Screen solutions each finding a secure place in niche markets, similar to the model of the massively profitable video game industry. Video games are developed for many platforms—CD-ROM, the Internet, and STB (e.g., Sony Play Station and Nintendo 64)—and are accessed by many systems—computer, TV, arcade machine, and hand-held device (e.g., Game Boy). Game development companies have created niche markets to profit in, and video game junkies are happy to have so many ways to get their thumbs on a trigger—to have options to shoot and kill on the system and price structure of their choice, be it $40 for a long-playing disc or $.50 for a short-playing video machine.

What can be disconcerting about a multiplatform delivery system is in development—each platform has different development standards and proprietary infrastructures. Moreover, for the budding ITV industry, the potential market share and profitability of each solution is still up in the air. A most grandiose idea would be the creation of a single platform that can be ported to many different devices, an ultimate solution. This has been the dream of many developers, and their applications. Take XML, for example, an all-in-one protocol with the power to be compatible with and support a variety of Internet applications. In addition, consider the Linux operating system, promising an "open and free" architecture unbound by the competitive likes of Windows. Among the hopeful are the future ITV content creators, Web designers and developers, calling out for a common set of design standards, in which 12-point text is 12-point text, regardless of what browser it is viewed from.

Viewpoint

***Star Wars* Goes Interactive (Author's Viewpoint)**
I've seen *Star Wars* about 10 times in my life, and still have a box of collector cards in the closet, and a crush on Hans Solo. I was 8 years old when the movie first came out. Every boy wanted a light saber, and every girl wanted Princess Leia's bagel hair. There was no force like it, until it went interactive.

On Friday nights, TBS Superstation, a cable network owned by the media conglomerate AOL/TimeWarner, presents a programming attraction called *Enhanced Dinner and a Movie*. This somewhat "out there" evening's entertainment includes at least three levels of viewer participation, depending on your mood. The minimal participation of course is to simply watch the movie (usually a family favorite). The next level of interactivity, if you choose to partake, involves cooking—yes, cooking. At breaks in the movie, two *Dinner and a Movie* hosts chat it up with an accomplished chef, who is preparing a meal to accompany the movie show. For *Star Wars* night, the menu included Obi-Wan Cannelloni with Darth (To)mater Sauce (no kidding). As the hosts and the chef banter on about a "pinch of this and a pinch of that," the real ingredient was in the product placements. Strategically positioned in the Martha Stewart kitchen was a healthy dose of advertising, subtle and not so subtle promotions of wine, kitchenware, and AOL 6.0 software. However, aside from this commercialized cooking class, and the comedic chitchat of hosts between Star Trooper invasions, this was not the real action.

The next level of participatory activity is what can truly be defined as enhanced television—a Web site synched with the entire event. At the start of the movie, viewers are prompted to not only put on their aprons and start boiling bouillon, but to power up a computer and log on to the *Enhanced Dinner and a Movie* Web site (www.TBSsuperstation.com). This is the part I was waiting for.

My computer is located in a different room than the TV, but close enough that I can hear the beep-beep of R2-D2. Logging on to TBS I navigated easily to the site of the evening, developed by Gold Pocket Interactive. The site, its interface partially designed in Flash, consisted of an image of various cooking paraphernalia with links to the evening's recipes and a list of trivia questions (Figure 6, color insert). The trivia component is a game, appropriately entitled Mind *Over Platter*. The trivia questions synch and relate to the current content of the movie. Quickly, who owned the Millennium Falcon before Hans

Solo won it in a sabacc game? You ponder the questions under the clock, and your answers are recorded and ranked among other online participants. During a TV break, an enhancement graphic opens at the bottom of the TV screen and announces the online participants' best scores.

However, the recipes, the trivia game, and the prizes you can win (a Panasonic TV/VCR or the *Dinner and a Movie Cookbook*) are still not the half of it. What really makes the experience is the chat feature.

I arrived early to the chat room and the party hadn't quite started. I mingled with two other Death Star die-hards named Sithmaster and Sirius.

SITHMASTER—anyone from ny
ANNESA—I'm from Brooklyn—have you been in this chat room before?
SITHMASTER—westchester

(I noticed here, a newbie to chat rooms, that I should be writing in lowercase, no punctuation, and not using my real name!)

ANNESA—do you all come here often?
SIRIUS—toronto, first time on this chat
ANNESA—me too, why are you here?
SITHMASTER—the only reason is stars is on
SIRIUS—to test my skills as a master of star wars
ANNESA—hmm, do like this interactive television thing?

(Might as well do a little research while I'm here…)

SIRIUS—love 15 days of bond
SITHMASTER—bond is the second best

(Cyber Bond, created by Spiderdance, was another of TBS Superstation's interactive adventures, now off the air.)

SIRIUS—has anyone tried these recipes?
SITHMASTER—my wife can't cook
SIRIUS—my roommate is a chef and so tries the recipes all the time.

(And the conversation continued…)

SIRIUS—I would love to own a light saber
SITHMASTER—too bright for the south bronx
SIRIUS—I'm from the country, it would help light the way to the barn.

(Mid-way through the movie the *Mind Over Platter* trivia scores were announced on TV, and more people began to log on.)

SURVIVORCHICK5—asking is elvis 1, elvis 2 , crazylegs here?

(some amazed by the experience…)

RYAN79—cool, my tv tuner card lets me watch tv while I chat at the same time.

(others cracking jokes….)

ENERGY E—i had chili for dinner and I have a lot of FORCE

The chatting went on throughout the movie and into the night; profound conversations of characters and events, an interactive *Star Wars* convention in a galaxy far, far away. Amazingly, through the wonders of technology, TBS Superstation's *Enhanced Dinner and a Movie* has become a global comradery of fans, a new venue for storytelling, a place to test your trivia mind, and an opportunity to impress loved ones with your cooking prowess. I went to bed dreaming of Hans Solo, and wondering what a far-out world we live in.

FIGURE 4.3 *Cathode Ray goes interactive with TBS SuperStation's* Enhanced Dinner and a Movie. *(© 2001 Turner Broadcasting System, Inc., An AOL Time Warner Co. All Rights Reserved.)*

CHAPTER 4 THE EXPERIENCE OF ENHANCED TV 73

CONTENT IS KEY

Right now, regardless of the platform, the success of ITV services and the businesses that create, manufacture, and sell them depends on one thing: content.

Content drives viewership; and over time, television viewers have grown particularly demanding. We require not just more content, but specialized content, with niche channels—*The Food Channel*, *The Weather Channel*, *The Home Shopping Channel*, and so on and so on—and varied content providing us with topical choices. For example, comedy. No longer is comedic entertainment defined by *I Love Lucy* or *The Honeymooners*. Every channel is a genre of programming in itself, and laugh potential is endless. Switch on the cable box and get a load of *Comedy Central*'s line-up—*Battlebots* and *Saturday Night Live*—or the *Cartoon Network*'s *PowerPuff Girls* and the *Flintstones*, or *The Disney Channel*'s *The Wonderful World of Disney*, the longest primetime series in history. If that's not enough, don't forget to visit their companion Web sites!

The potential for new forms of content is the allure of ITV, offering up not just more programming, but content that is easily accessible, targeted, varied, substantial, informative, responsive, and, of course, entertaining.

How this content is created is further explored in Part Two of this book, and examples of this content are presented in Part Three.

CHAPTER SUMMARY

- Studies indicate that more and more people are watching TV and interacting with the Web simultaneously, a phenomenon called *telewebbing*.
- Enhanced TV can be experienced in one of three ways: the STB solution, the TV Tuner Card solution, and the 2-Screen solution.
- Currently, each enhanced content delivery platform has its pluses and minuses, but chances are they will all find a niche in the ITV market.
- Compelling content is the key factor in the success of ITV applications, particularly enhanced content, which is explored in later sections.

Viewpoint

There's definitely a forward momentum in the exploration and implementation of ITV services, but it's important to not let the excitement stray from the purposes. Dan Silberberger, an online and interactive entertainment executive, brings the momentum down to earth by shar-

ing some insightful and hard-knock advice on the current status of the industry. This commentary was reprinted with permission from the [itvt- industry] discussion tread.

"What ITV needs are some hits. Unfortunately, television is a hit-driven business, and I don't see why that would change now. We can theorize, analyze, and hypothesize all we want, but what we need are some real-life examples of why ITV will improve our lives, or at least improve our leisure time. I feel that we won't see compelling ITV until a few things happen...

1. Programming needs to be devised with interactivity in mind from the beginning. Although it's often a baby-step in the right direction, I don't think that slapping generic functionality (such as chat or extra info) over existing programming will generate any hits. I also don't think that the ability to buy a star's shirt is as enticing as it's been hyped up to be.

 On the other hand, it would be great if a show could only be enjoyed to its full potential if at least some of its viewers interacted with it. The interactivity would be intrinsic to the programming. Only after this happens will we be able to answer the question, "why are we making ITV programming anyway?"

2. People from different disciplines need to conceptualize and produce ITV programming together. I don't know how it's done in Europe, but I don't think this collaboration happens much in the U.S. I've worked on ITV demos, as well as on plenty of web-based interactive entertainment projects. I think that usually either traditional entertainment folks impose their values and processes on digital media people or technology people impose theirs on traditional entertainment people. Both sides need to learn from each other and work together.

3. We need to study and learn from previous mistakes. ITV has been both touted and ridiculed since at least the late 80s. Web-based entertainment has had its share of problems too. There will be plenty of trials and errors moving forward, but let's not make the same mistakes our predecessors made.

4. There needs to be critical mass penetration of the technology, and there needs to be as few competing standards as possible. Nuff said.

5. We need more real artists in this business. Technology people and business people are great (I mean it), but they're not generally known for creating great user experiences.

6. Who's gonna pay for this stuff? Right now, the technology companies with vested interests are covering the costs, but that's not a sustainable revenue model. I've heard of a few creative ways to pay for it, but they all require some serious coordination and possibly even slight paradigm shifts. I guess this brings us back full-circle—television is a hit driven business that isn't exactly known for taking big financial risks. Most TV shows we see are fairly formulaic. The U.S. didn't even adopt "reality" shows until after we saw that they were hits in Europe. Until there's an ITV hit, I don't think it will be taken too seriously.

Regarding the personal vs. social television experience, I don't think that ITV is inherently one or the other. Neither is television though. I'd argue that over the years television has evolved from being something that the family experiences together in the living room, to something that each family member enjoys independently in their separate rooms. On a creative level, I'd say there's room for both personal and social ITV. I'd say there would be plenty of opportunities for both on a technological level too. Imagine if 5 people in a room each had their own plasma tablets which wirelessly communicated with the primary programming seen on a central television set. I also don't think that everything on TV needs to be interactive, or should every viewer needs to interact. There's enough bandwidth and resources for everyone to be happy.

That said, I still feel that the industry will pass these awkward growing pains and produce some hits. (© Copyright 2001. Reprinted with permission from Dan Silberberger.)

About Dan Silberberger
Dan Silberberger has focused on online and interactive entertainment since beginning his career. For his last employer, Pop.com, he led the company's interactive entertainment initiatives, and ensured that its original content was Web centric, exploratory, immersive, and community based.

Prior to Pop.com, Dan worked for numerous online entertainment companies, including DEN, Entertainment Asylum, and TheVisitor.com. Dan has also worked for professional services companies such as Razorfish and USWeb. While at Razorfish, Dan was a mentor for the AFI-Intel Enhanced TV Workshop and helped E! Entertainment create an ATVEF-compliant ITV demo of the show *Talk Soup*.

He continues to study media theory and believes that art, culture, and technology are inseparable—a basis for his professional work.

Timeline of Television and Internet Events

By decade, here is a rundown of milestones discussed in Part One and leading up to ITV today.

1880s

(1884) Paul Nipkow develops the Nipkow disk, a mechanical spinning disk that can transmit, receive, and send images.

1890s

(1896) Guglielmo Marconi introduces wireless telephony, the birth of the radio.

1900s

(1906) German engineer Max Dieckmann files a patent for the invention of a rudimentary fax machine, transmitting a picture by means of the cathode ray tube (CRT).

(1908) Allan A. Campbell Swinton proposes a method of using the CRT for scanning and receiving of images, an idea that eventually lead the CRT to be the underlying component of analog TV.

1920s

(1922) Approximately 25,000 radios were being sold in the United States each month.

(1925) John Logie Baird introduces his Televisor, considered the first working television device.

(1926) NBC (National Broadcasting Company) is formed, grown out of partnership with RCA (Radio Corporation of America).

(1927) CBS (Columbia Broadcasting System) is formed.

(1928) Philo T. Farnsworth, age 21, introduces his Image Dissector, an electronic version of the TV featuring the CRT.

1930s

(1933) Russian born Vladimir Zworykin announces his Iconoscope, an electronic version of the TV, and in direct competition with Farnsworth's Image Dissector.

(1934) The Communications Act of 1934 marks the establishment of the FCC (Federal Communications Commission), which begins mandates for a standardized analog TV system.

(1939) David Sarnoff, senior vice president of RCA, markets the first home electronic TV.

1940s

(1940) FCC establishes the NTSC (National Television Standards Committee).
(1943) ABC (American Broadcasting Company) is formed.

1950s

The booming years of TV; *I Love Lucy*, among other sit-coms, become ever popular.
CBS's *Winky Dink and You* kids' show gains popularity with its special Winky Dink interactive kit.

(1954) David Sarnoff of RCA debuts the first color TV, broadcasting in Technicolor the Tournament of Roses Parade in Pasadena, California.

In this year only 5000 color sets are sold at $1,000 a piece.
(1957) United States forms the ARPA (Advanced Research Projects Agency) to research cutting-edge technology that would specifically benefit the military and American people.

1960s

(1969) ARPA forms the ARPANET, a fully funded think tank exploring Internet-specific technologies, such as packet switching.

1970s

An unused portion of the television signal is discovered, called the VBI (Vertical Blanking Interval); its Line 21 is used for closed captioning and teletext services.

(1976) Apple Computer, Inc. introduces the first personal computer, sold as a kit (assembly required).
(1977) The QUBE project is initiated, the first U.S. attempt at publicly deploying interactive services via a set-top box system.

1980s

Personal computers are used mainly by businesses and educational institutions, costing anywhere from $3,000 to $7,000 each.

Cable TV and the remote control were introduced. The public reluctantly began to pay for premium programming services.

(1983) ARPA runs its network completely on the TCP/IP protocol.

(1986) The National Science Foundation sets up its own Internet (NFSNET) with a backbone of five supercomputer centers. By the end of the year, 10,000 hosts were online.

(1987) Japan's public television network, NHK, demonstrates in Washington their high-definition television set (HDTV) known by the acronym MUSE.

(1987) The FCC forms the ATSC (Advanced Television Standards Committee).

1990s

A boom of Interactive TV deployments begins, with the combined efforts of companies such as TCI, AT&T, Time Warner, and Viacom Cable.

(1990) NewTek's Video Toaster, providing tools to create broadcast-quality television, is introduced.

(1992) Swiss physicist Tim Berners Lee introduces the World Wide Web (WWW) based on HTML (HyperText Markup Language).

(1993) Estimated growth rate of hosts online is said to be 340,000 percent.

(1993) The Grand Alliance is formed, a team of businesses that collaborated to create the U.S. approved HDTV system.

(1994) MPEG-2 becomes the standard codec for digital television.

(1994) Apple Computer introduces the MacTV, a limited-edition computer equipped with a cable-ready TV tuner card.

(1996) The Telecommunications Act of 1996 is issued, outlining the FCC's standards for DTV and requiring all U.S. TV networks to convert to digital signals by 2006, or an 85-percent consumer penetration of DTV, whichever comes first.

(1996) Philips and Sony Corp's WebTV set-top box links TVs to the Web for the first time.

(1998) Microsoft introduces WebTV for Windows 98.

(1999) Approximately 34.4 million homes worldwide are watching digital TV.

Chapter 4 The Experience of Enhanced TV

2000s

AOL and Time Warner announce a $163 billion merger, the largest to date. Close to 100 percent of American families own a television set (or two), and over 45 percent own a computer.

The rest is in the making....

Sources for Timeline:
- *Tube, the Invention of Television*, David E. Fisher and Marshall Jon Fisher, Harvest Books, 1996.
- *Digital New York*, Sep/Oct 2000 issue, Digital New York, Inc.
- *Using the Internet*, Jerry Honeycutt, et al., Que Corporation, 1998.

PART II

Development

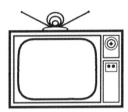

CHAPTER 5

Content Is Key

IN THIS CHAPTER

- The Importance of Eyeballs
- Trial and Error
- Feedback and Evaluation
- Educate the Viewer
- Chapter Summary

Part Two is about developing for Enhanced TV content. It's designed to guide the TV producer and Web developer through the process of conceptualization and implementation of an interactive program. In this chapter, you will gather a bit of insight into why compelling content is important for the success of ITV, and through examples, understand its process of trial and error between consumer, designer, and developer.

THE IMPORTANCE OF EYEBALLS

"... there is a lot of drama and cage rattling being done around ITV as if one day it's all going to change when we wake up. Part of that, I theorize, is that the Internet got big rather quietly, and a lot of people missed the prime freshening of that cash cow. Now, ITV is inheriting the cash cow throne, so everyone is running to be the winner. Win.Win.Win. Best OS. Best set-top. Most advances! Win! In the long run, all that matters is good content on intuitive technology, because that is the recipe for eyeballs, and eyeballs are money."

—Rob Davis, Executive Producer, Spiderdance.

The bonus-round question on the ITV game show is always the same: how can I make money doing this ITV thing? If the answer was obvious, the million-dollar prize would already be won. While contestants strategically position themselves to hit the "I got it!" button, the reality of the ITV game depends on one major factor: consumers. Without consumers on the playing field, nothing will happen.

Even the Telecommunications Act of 1996 adheres to the importance of a wide consumer acceptance of the DTV evolution. Clearly, the Act defines how broadcasters must "go digital" by 2006 or when DTV penetration reaches 85 percent of the market, whichever comes first. Truthfully, both events must happen simultaneously—without one, you don't have the other. Both broadcasters and consumers must come together to get digital TV, and hence ITV, off the ground. In short, if you, your neighbor, and your relatives in Timbuktu aren't using a digital TV service of some sort within the next few years, the forward potential of ITV could move at a snail's pace.

However, as a consumer, what will prompt your move and adherence to DTV? What will put you in the 85 percentile? What will justify the purchase of a HDTV, a set-top box, or even a PC-TV tuner card? And once you find yourself with a new-fangled, all-in-one ultimate entertainment system, and at the right price, what exactly will you encounter when you turn the thing on? Will it be worth watching? Will it be worth the switch? Will it keep you coming back for more?

These are the questions that consumers are asking, wondering about, and raising eyebrows in skepticism over. What exactly am I going to get with DTV

CHAPTER 5 CONTENT IS KEY

and ITV that I don't already have? *Get* being the optimal word; *get* meaning content.

As a TV producer or Web developer, here's where you fit in—like a rock stuck between risk and reward. To make money in this industry, you have to reach the consumers, and to reach consumers, you have to make content.

It's the old chicken-and-egg scenario. What came first, the chicken or the egg? What comes first, the content or the consumer? For current contestants, Web developers, and TV producers on the ITV quiz show and heading toward the million-dollar bonus round, the choice is clear: make content.

The reason why TV watching is so popular is because there's usually something on we want to watch, a plethora of programming initiated in the cable evolution of the 1980s. When the cable installer arrives at our doorstep with black box under his or her arm, we anticipate the bombardment of program choices. We have no qualms with the $40 installation and $20 monthly subscription fees, as long as we can revel in our favorite program. The money is worth it to get our fix of high-production value programming, *The Sopranos, Sex and the City*. Bring it on.

The role of the TV producer and developer for a new genre of programming—the digitized, interactive version—is to, literally, bring it on. To convince the consumer to buy into our idea, to overcome the chicken-and-egg financial quandary, is to take the innovative mixture of TV and Web and create some compelling new content—content that's varied and interesting, targeted and enjoyable; content that stimulates the formula of supply and demand.

As we know, this worked for the World Wide Web. Think about it, the real reason why online activity rushed into the public mainstream was not because we dumped billions of dollars into its infrastructure, but because Joe told Sally and Sally told Steve that they just saw the most "killer," new animated Web site. "You gotta check it out! There's nothing like it."

Yes, *there's nothing like word of mouth to start a wild fire*. What shook and moved the Web was compelling content, content that started out as nothing but linear, scrollable text moving at nth-bits per second. Eventually, it grew into what it is today, a cornucopia of data exchange, delighting the senses of touch, sight, sound, and in some specially equipped computers, smell and taste[1]—all as accessible as a click of a mouse.

The WWW is the most timely and prominent example of how content became the momentum, the snowballing formula, for the Internet boom. How this momentum progressed parallels what is happening with ITV content creation right now—a necessary process to effectively reach the consumer, a cycle of trial and error, feedback, and evaluation.

[1] Interested in an odorous Web experience? Visit TriSenx at www.trisenx.com or AromaJet at www.aromajet.com.

Tune-In

The Battle for the All-in-One Gadget

Just in case you're wondering whether there will be enough opportunity, enough platforms and devices to create content for, the following is a short list of companies currently jostling for a piece of the all-in-one digital entertainment pie. This short list was compiled from an April 2001 Associated Press article entitled "The Battle for Digital Living Rooms."

- Rearden Steel Technologies, owned by Steve Perlman, entrepreneur behind WebTV, receives $67 million in first-round founding for an as yet undisclosed digital home entertainment product.
- Hewlett-Packard Co. and Real Networks Inc. announced a joint venture to create products that will "let consumers obtain digital entertainment via the Internet and experience it on their living room stereos and televisions."
- Noka, Inc. "plans to start selling a so-called home infotainment center called Media Terminal." The Media Terminal is a set-top box solution that will receive DTV, VOD, play MP3 files, connect to a digital camera, and offers Internet access.
- Microsoft recently launches UltimateTV, combining WebTV with DVR capabilities, and DirecTV satellite service.
- Motorola Corp. and Scientific-Atlanta Inc., top manufacturers for current set-top box solutions, are introducing this year (2001) a more advanced set-top box system, featuring everything from DVR to interactive TV, e-mail, VOD, and high-speed Internet access.
- SONICblue, Inc., formerly a graphics chip maker called S3, acquired DVR pioneer Replay TV Inc. and plans to move fully into the digital entertainment medium. "We want to let people have audio, video, and information in their homes and we want it all to work together," said Andy Wolfe, SONICblue's chief technology officer. "We are now poised to develop that all-in-one device, but there's clearly a lot to be done first."

TRIAL AND ERROR

There are endless resources on how to make compelling content for the Web; the most dynamic Web sites equipped with e-commerce databases, chat features, and Flash animation. Just about every college and university across the planet offers some degree in Web/multimedia design and development. Books and online references are plentiful, boasting what fonts and color palettes to use, the difference between a GIF and a JPEG, and what buttons, nav bars, and drop-down menus are most user friendly. In addition are hundreds of discussion threads to peruse and trade shows to visit, loaded with such advice as what software to use, how to deal with browser incompatibility, and whether it's best to build a site in tables or framesets, HTML or Flash. Where did all these techniques, tips and tricks, and do's and don'ts of Web site creation come from? How did this consensus of content creation evolve? As with anything, out of a process of trial and error.

At first, the means to create Web content was hit or miss. For the developers of the very first Web sites, the discovery of the <blink> and <marquee> tags was a revelation in visual appeal. The ability to blink and marquee hexadecimal-colored text, bright yellow, Times New Roman against a tiled background was wonderfully different. It was new, it was possible, and it was another way to present textual information without printing it on plain old paper with plain old black ink. There were no rules, no standards of appearance; it was just another canvas to explore.

This initial stage of creatively challenged Web design arrived out of what David Siegel in his book *Creating Killer Web Sites*[2] calls a first-generation site, a linear site with bare-bones functionality, and designed by technical people. Second-generation sites according to David Siegel are sites in which the design "continues to be menu, icon, and technology driven. These sites tend to follow the homepage model, in which the first page you see is encrusted with icons and 3-D graphical representations of buttons, windows, and pictures." It wasn't until third-generation site design that designers and artists started mixing with the left brainers, and began to struggle to mold the technology, to push around <table> and tags in an attempt to produce eye candy, the glue that holds the viewer (Figure 5.1). As David Siegel points out, "the third-generation site is wrought with design, not technological competence." Terms like *layout*, *color space*, and *image correction* gleaned from desktop and print publishing began to describe the Web designers' process, their methods, their new outlet. At this time, a greater demand for WYSIWYG development tools and standards grew,

[2]*Creating Killer Web Sites, The Art of Third Generation Site Design*, David Siegel, Hayden Books, 1997.

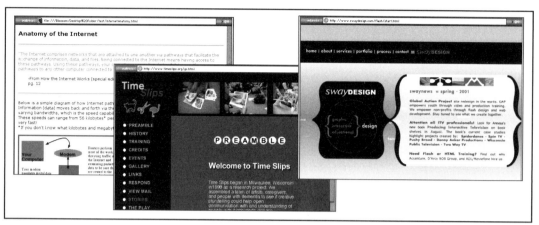

FIGURE 5.1 Three sample Web page layouts, left to right, from simple to complex. Web site design went through many phases of trial and error, similar to the process that ITV content design and development is experiencing today.

and produced the third- and now forth-generation sites—sites with an emphasis on design that push the user into an exciting and enticing visual experience, not unlike a well executed and alluring 30-second TV commercial.

To propel each generation of fresh Web design, Web developers and designers valiantly exposed their masterpieces to the world at the risk of unsatisfactory feedback, feedback that made them stronger, and helped them define what will work better next time; a natural cycle known all too well by ITV players, particularly the contributors to the *Projects* section of this book. Any one of them would tell you, that to be a successful ITV content creator is to be unafraid of trial and error.

Imagine the process of trial and error as a three-person Frisbee toss. Playing on the field you have the programmer/developer, who throws the Frisbee across to the designer/artist, who, in turn, throws the Frisbee to the client/consumer. They play around and around in this triangle, the Frisbee representing a tossing out of beta test tools, protocols, and interface designs. Some Frisbees are caught and thrown back for further development, some catch the wind and sail smoothly, and some become lost in the embankment (Figure 5.2).

Still others come back in different forms; for example, VRML (Virtual Reality Markup Language). Remember those real-time 3D spaces where you could become your own avatar and chat with others in a fully mobile, made-up hyperworld? VRML was (is) a truly sophisticated use of technology, designed by heavy-headed animators. Unfortunately, VRML never quite won the hearts of the user. In the long run, plain old chat rooms and instant messaging have proven easier to navigate, easier to access, and easier to sell. However, VRML and 3D on the Web hasn't gone away; new innovations are regularly announced into

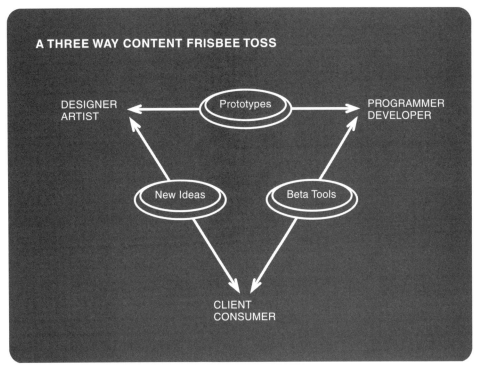

FIGURE 5.2 *The process of trial and error acts like a three-way content Frisbee toss among designer, developer, and consumer.*

the market, such as Adobe Atmosphere[3], a Web-authoring tool for virtual 3D worlds. The manufacturers of these products hold out and wait. They continue to toss the trial-and-error Frisbee, biding time until content is produced from their products that catches the wandering eyes of the online surfer, content produced with a perfect mix of design and functionality and with the spark necessary to spread like wild fire through the Internet community. (A spark similar to the one ready to ignite on the ITV content scene.)

Just like in the game of Frisbee, you win some and you lose some. The process of content codification is a continual cycle with many tools, navigation schemes, and design concepts proving unsuccessful when placed in the hands of the consumer. However, the point is to just get the ideas out there, to have a starting point from which to continue to learn and build. The consumer is your best critic, and will more than likely determine your eventual success.

[3]For more information on Adobe Atmosphere visit, http://www.adobe.com/products/atmosphere/main.html.

FEEDBACK AND EVALUATION

As you will discover in Chapter 7, "The Process," part of the process of implementing a successful ITV show is feedback and evaluation. Since the discussion here is about the importance of content and the consumer, this is a good time to bring up the feedback part of the picture. Feedback and evaluation are very important parts to the trial-and-error process, and of getting into the hands of consumers the kind of content they want.

For the U.S. television industry, the most common way of understanding TV viewers' watching habits, what they do and don't like, has been through the efforts of Nielsen Media Research, Inc. Since the inception of the television set, Nielsen Media has conducted TV, and now online, systematic studies within the homes of television watchers everywhere. Being a "Nielsen Family" used to typify you as the all-American household, although this doesn't seem to be the case anymore. Interestingly, in the span of writing this book, Nielsen Media (who had no idea I was writing this book) asked me to be a part of two studies, one that evaluated my Internet usage, and the other my TV usage. The Internet study, as you might imagine, was conducted over the Internet. I simply logged on, spent about 45 minutes answering all sorts of questions, like what type of sites I enjoy, and how many hours I spend online, etc., etc., and then I pressed the Submit button and went on my merry way. In contrast, the Nielsen TV Ratings study was as untechnical as I imagine it would have been in 1959. In the mail, I received the official *TV Viewing Diary*, on the cover an image of a typical American family with mom, dad, sister, brother, and cat happily sitting in front of the TV. Inside were detailed instructions on how to fill out the seven-day calendar, a toll-free number if you had questions, and information on when to stick the diary in the mail and send it back. Filling out the diary was a lengthy, daily process, involving the archaic method of handwriting in ink pen. I'm almost certain my answers skewed their study, since I was, ironically, too busy writing this book to watch TV during my assigned week.

Nevertheless, the point here is to provide an example of how we evaluate and receive feedback from a viewing audience. The efforts of Nielsen Media are an undisputed resource of evaluation and feedback for the TV industry. Television programming, whether it stays or goes, is determined by its ratings. However, as thorough as a market study may be, the very nature of TV technology makes the task challenging. Truthfully, advertisers really have no "instant" way of knowing if the millions of dollars of commercials they produce really impact a viewer's buying decision. Do they simply implant a branding name and look, or can a commercial *really* send a person out the door for a Burger King shake and fries? From the viewer's standpoint there is no easy way to get your feedback heard as well. Dialing the long distance telephone number on infomercials

and psychic outlines provides the only means of spontaneous content reaction. Wouldn't it be great if you had the opportunity to instantaneously send your comments, opinions, and gripes directly to the TV producer of CBS's *Survivor* show, for instance, or your local news station?

Unlike TV, the two-way nature of data exchange over the Internet makes market research, consumer feedback, and content analysis almost too easy. Web advertisers and e-commerce sites have the ability to monitor every move of the Web user. They know precisely how many times you visited their site, and what pages you lingered on the most. Also, for most businesses on the Internet, providing instant-gripe forums are the norm, even expected. If you don't like the images, copy, or navigation of someone's site, you just e-mail the Webmaster—a URL usually found at the bottom of every page. Some companies are known to stick their reputation on the line by actively asking their viewers what they like and don't like about their site, and even, in the case of Amazon.com, go as far as to have users vote on their next site redesign. Whether a conscience act or not, a Web surfer is constantly sending feedback to its solicitors.

The feedback and evaluation relationship between consumer and client is a vital necessity in the quest for creating compelling content. Luckily for Enhanced TV content creators, the luxury of blending two-way data exchange with TV makes the ability of obtaining instant and viable feedback from your viewer very possible. Most set-top box platform providers include a back-end system of monitoring the consumers' use of their boxes, how many times they click through enhancements, what sites they visit, and how long they stay interactive. Companies creating content for the 2-screen solution have it even easier; for example, TBS Superstation and ABC's Enhanced TV programming[4], which routinely sends out e-mail opinion surveys about their interactive programming. Moreover, Spiderdance has built a monitoring system right into its sync-to-broadcast software. A more direct approach to getting feedback is to organize specific feedback sessions, perhaps before a show is aired. Simply gather a sampling of your intended audience in a room, show them your stuff, and let them have at it. This approach has proven endlessly useful for content creators, as you'll discover in the case studies in Part Three.

EDUCATE THE VIEWER

An important aspect in the trial-and-error process and in the goal of receiving the most valuable feedback from your viewers is to educate them on what they are seeing. What can be really tricky about presenting a more dimensional form

[4]For more information on ABC's Enhanced TV, visit http://heavy.etv.go.com /etvHome/mil/. For more information on TBS Superstation's enhanced programming, visit www.TBSsuperstation.com.

of entertainment, such as Enhanced TV, is trying to get people to understand not only what they are looking at, but how to use it and why it can be useful, beneficial, or more enjoyable for them. This brings us back to a Web example, in which the Internet provider's goal is making life on the Web as easy as turning on a light switch.

Remember how learning to navigate through your computer interface used to be a matter of typing in long strings of code? Now we've got WYSIWYG browser tools with big, readable icons. What's AOL's tagline, "the easiest just got easier." Meanwhile, majorities of TV watchers are completely unaccustomed to the Web's link and click navigation, and have remained in the safe haven of accessing entertainment through remote control. If you ever tried navigating the Web with a remote control, pretty much how all STB applications perform, you will understand the challenge in trying to ease the transition from normal TV watching to interactive TV watching. In addition, as you might imagine, for ITV content creators the job of educating a user on Web navigation synced with TV is necessary to facilitate the next most important step: having them watch, not fight, with their show. For a great example on how an organization is educating its audiences about ITV, visit PBS's digital television site at http://www.pbs.org/digitaltv, and check out "A Cringely Crash Course" by high-tech know-it-all Robert X. Cringely. Without a doubt, almost all companies providing interactive services are making great efforts to publicly get the word out, and to make the understanding of this nascent medium and what it can provide as clear and as easy to access as possible.

Chapter Summary

- The success of ITV depends on consumer acceptance of the new technology.
- The role of the ITV content producer is to create compelling content that will drive the consumer into the ITV market.
- The success of the WWW is a prime example of how good content can propel a new type of media into the mainstream, and represents the necessary process to effectively reach the consumer: a cycle of trial and error, feedback, and evaluation.
- To be a successful ITV content creator is to be unafraid of trial and error.
- Feedback and evaluation are important parts to the trial-and-error process, and of getting into the hands of the consumer the kind of content they want.
- Part of presenting innovative ITV content to the viewer is to ensure that they understand not only what they are looking at, but how to use it and why it can be useful, beneficial, or more enjoyable for them.

Chapter 5 Content Is Key

Viewpoint

Bob Mariano, Steeplechase Media, Inc.
Bob Mariano, executive vice president of Marketing at Steeplechase Media, has been an active participant in the ITV industry since heading up the marketing efforts for one of the first interactive deployments, Warner's QUBE project in Columbus, Ohio. I met Mr. Mariano at an ETV seminar hosted by Thelen, Reid, and Priest in New York, and asked if he would share some of his interactive television wisdom.

What is needed in order to make interactive TV an art?
 "If Interactive TV is to become the "new television," the best producers have to have the opportunity to produce lots of it. Only then will the form of adding enhancements and interactive opportunities for the audience of a TV show go beyond the current special effects stage.
 All techniques based on new technology have started as special effects. Sound added to pictures, the zoom lens, the crane shot were all clumsily used when first introduced. But only after artists, writers, and directors got to experiment a lot did the craft emerge and allow the full effective use of these new tools.
 Also, the new more active audience that has grown up with TV and now finds it, for the most part, too slow, must have many opportunities to experience these new forms of presentation. Opportunities to hone their skills as participants and help grow this new potential grammar that will be the future of TV.
 Of course, in order for producers to be able to make a critical mass of this new programming available, interactive TV will have to grow into a business. This will be both the challenge and opportunity for the entire broadcast community, involving all broadcasters, cable operators, advertisers, as well as many hardware and software companies."
(© Copyright 2001. Reprinted with permission from Steeplechase Media, Inc.)

About Steeplechase Media, Inc.
Through its expertise, experience, and relationships, Steeplechase Media, Inc. is developing the next generation of interactive broadband services. The company has been operating for over five years with revenues of almost $2 million for year 2000. Almost all of its first three years were spent as a laboratory for ITV theories, business models, and production tool development, on behalf of Microsoft. Steeplechase is well known for pioneering the field of enhanced television by

collaborating with companies like Paramount Television to make television shows such as *Judge Judy* interactive. The Steeplechase team has also been instrumental in the interactive productions of *Bay Watch*, *FX*, *Pacific Blue*, and *Moesha*.

CHAPTER

Diving In

IN THIS CHAPTER

- Starting with Cake Mix
- Considerations in Creating an Enhanced TV Show
- Things to Consider Quick List
- Keep All Doors Open
- Chapter Summary

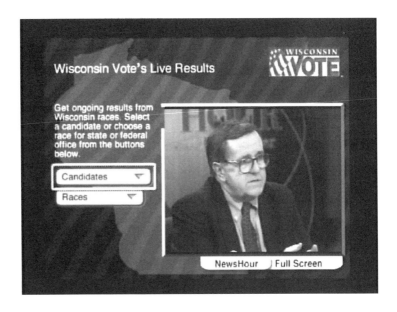

If you are this far in the book, chances are you are seriously considering taking the plunge into producing some interactive content. This chapter helps you decide what type of interactivity you might like to dive into, offering a guide of "things to consider" when creating an Enhanced TV show.

STARTING WITH CAKE MIX

If creating content for a medium not fully developed and then throwing it out to the wolves to test its validity and staying power seems a bit daunting . . . well, that's because it is. However, rest assured that you are not the first visionary to feel this way. Consider Walt Disney, for example. Before him, character animation was a rudimentary art. He had no textbooks or videotapes to reference, no predefined vocabularies, no codified techniques for production. Therefore, Walt, to bring his 2D drawings to life and to the world, developed his own rules and vocabulary, made his own methods of storytelling, trained his own team of animators, discovered his own genre of entertainment and, through all the trial and error made billions in the process.

Another starting-from-scratch example is game developers. Their seemingly far-fetched dream of big business revolved around the ability to render media in real-time, to conquer the wrath of pixels, first in the form of *Pong* and *Pac Man* and, later, in the three-dimensional worlds of *Doom* and *Quake*. Now, the video game industry is the most profitable media entertainment business next to Hollywood, and it all started with a couple of really smart programmers designing new systems of storytelling with nothing more than luck.

Lucky for you, you will not need to start from scratch. As Enhanced TV content builders, we have the pre-made ingredients of the TV and Web industries, a *Betty Crocker* cake mix, just waiting to be stirred and molded into its own thing. At first, initial attempts at enhanced content creation might seem clunky, a tacking-on, rather than a seamless blending of TV and Web elements. These attempts should not be frowned upon, but celebrated as a beginning step to new innovations; all new ideas come from old ones. Consider TV, for example; when it was first turned on most viewers witnessed visual versions of radio. For the first time, they saw radio personalities and televised music concerts, personalities and live concerts that in the end would have been better off heard rather than seen (this was before MTV, of course). In addition during this, yes, trial-and-error period, TV producers began to conclude that certain patterns and colors tended to crawl when reproduced on the TV screen, and that striped clothing and bright red backdrops were definite no-nos. Eventually, things began to click, design rules of broadcasts were implemented, and programming formats, such as the one-hour drama and the half-hour sitcom, were instituted. Using these now well established formats and standards along with those issued-in by

the Web, a predefined content starting mix is already at hand. Now, it's just up to you to define what type of content to bake, how it's best mixed together, and if what you make is worth consuming.

CONSIDERATIONS IN CREATING AN ENHANCED TV SHOW

In the initial stages of deciding what type of ITV show you might like to delve into, it's helpful to have some foundation guidelines. The following sections discuss things to consider when creating an Enhanced TV show. Use these considerations relative to your particular set of circumstances.

PURPOSE

To have a purpose for your project seems like such an obvious consideration, but in actuality it's a concept quite often overlooked by the excitement of wanting to try something new and different. Remember this mantra: "the show is IT!" And whatever "IT" is must be a seamless experience for the viewer; the interactivity *enhances* the show, does not deter from it, and the show warrants the elements and benefits from them.

There is a hilarious *Saturday Night Live* skit that epitomizes the idea of a problem arising from the lack of having a purpose. The skit goes like this: An actor is playing a news anchor, a full-screen shot of him sitting behind the typical news desk. As he discusses various news items, graphic overlays start to cover his screen space—snippets of videos, sports statistics, weather icons, and so forth. These elements begin to crowd the TV's screen real estate, and the news anchor starts to duck over, under, and around them to keep eye contact with the camera. Eventually, all you see of him is his mouth, talking to you through endless layers of colorfully animated, yet gratuitous screen graphics. What makes you laugh during this skit is knowing how true this overworking of information and visual stimuli can be. How often we encounter media that gets to a point of uselessness, or has no point at all, and defeats its purpose of functionality and interest. A lack of purpose in a product can result in what Tom Kelly in his book *The Art of Innovation* calls "feature creep." He explains, "... if a goal is fuzzy, you can be sure that feature creep isn't far behind.... Remember how the original VCR was absurdly difficult to program? Nobody bothered to separate the unnecessary features from the critical ones, let alone create a user-friendly interface. If you find yourself struggling with a manual, you're likely a victim of featuritis."[1]

So, consider your purpose. Why create something interactive? Will it do what it's intended to do, enhance the show, or will it deter from it, and frustrate a viewer's experience?

[1] *The Art of Innovation, Lessons in Creativity from IDEO, America's Leading Design Firm*, Tom Kelley, Doubleday, 2001.

SHOW TYPES

Part of clarifying your purpose is to have a clear understanding of what type of show you intend to create. Not all shows are meant be interactive. Sometimes, the very nature of their topic or format for delivery doesn't mesh with the qualities of interactivity. The following is a sample list of programming genres suitable for interactivity, with examples included.

Documentaries. Although documentary film-making is a carefully planned art, usually producing works with very specific, linearly defined visions, incorporating interactive elements into or after the program can be the means to provide supplementary information to the documentary's topic.

Example: A documentary film attempts to educate and inform, and/or takes viewers through an experience that sticks with them long after the movie is over. For many film-makers, the ultimate success of a documentary is the ability to sustain what filmmaker Danny Anker calls its "afterlife... the post broadcast life that targets the audience. The outreach materials that will go to a middle school, for instance, along with the program."[2] Or, as is common practice now, to supplement the film with a corresponding Web site, a continuously available and updated resource. Just one more option to add life to a film would be TV enhancements. In some cases, as with Anker Productions and PushyBroad's, *Music From the Inside Out* project highlighted in Part Three of this book, the implementation of interactivity within a documentary provided direct and instant learning to the targeted audience. Instead of post-broadcast interaction, there opens up the possibility of during-show or right-after show interaction.

Educational. An educational show, such as a children's learning program, is rife with interactive possibilities, providing a visceral and spontaneous learning experience for the viewer.

Examples: Children are the perfect audience, malleable to technology, eager for it. TV stations such as the Cartoon Network have learned this fact all too well, with most of their cartoon characters touting their own Web sites, willing and waiting to greet their fans. (Go to www.cartoonnetwork.com and click on your favorite characters to see their own Web sites!) It's just a matter of time before shows such as *Bugs Bunny* and *Batman* offer this same type of interactivity. Or, for kicks, how about a truly digital version of *Winky Dink and You*[3]? Instead of

[2]Danny Anker is a TV producer and documentary film-maker whose interactive project, in collaboration with PushyBroad, *Music From the Inside Out*, is highlighted in Part III: Projects.

drawing the rope to help Winky Dink climb down the mountain, you would click the remote through a selection of choices—rope, ladder, pipe—what would be the best prop for Winky Dink to get down the mountain? For a listing of innovative past and present educational ITV initiatives, visit the Corporation for Public Broadcasting site at www.cpb.org/tv/digital, and the Teachers and Learners section of the Public Broadcasting Service (PBS) site at www.pbs.org/digitaltv/teach2.html. Also check out the *PBS and TWIN Entertainment* Tune-In.

Tune-In

> **Press Release (May 2001)—PBS and TWIN Entertainment to Produce Educational Interactive TV Games Based on PBS KIDS Programs**
>
> PBS and enhanced interactive TV company TWIN Entertainment, Inc. have agreed to produce educational, fully interactive TV games based upon PBS KIDS programs and designed to run across leading interactive TV platforms such as Liberate, OpenTV, and Microsoft TV.
>
> *ZOOM*, the daily kid-powered television series that challenges young people to "turn off the TV and do it" will be the initial PBS KIDS program adapted under the agreement into an interactive TV, on-demand trivia quiz-game called *ZOOMnoodle*. *ZOOMnoodle* will be offered to viewers as a free game. *ZOOMnoodle* will engage kids with word games, riddles, fill-in-the-blanks, and more. Powered by TWIN Entertainment's powerful, interactive TV platforms, the game will test knowledge, provide feedback, elaborate on facts, and encourage players to succeed—within timed rounds. Each episode of *ZOOMnoodle* will draw upon the *ZOOM* curriculum, developed by leading educators and advisors to engage kids with different themes such as weather, music, or books.

Sports. A most obvious genre of entertainment worthy of interactivity is, of course, sports. ESPN, NBC, CBS, and Showtime are just a few of the networks that have ventured into interactive sports programming. Sports fans

[3]*Winky Dink and You* was a popular CBS children's show in the 1950s, considered the earliest TV show to explore television interactivity. See Chapter 3, "ITV's Journey."

love data—stats, player bios, game plays—and what better way to get it than at the push of a click-happy thumb during time-outs? (See Figure 6.1.)

Example: ESPN.com has introduced 2-screen synch applications for some of its sports fans; for example, ABC/ESPN's "Enhanced TV" Orange Bowl Game in January 2001. The synced site featured, among other goodies, dynamic polls about players, automatic statistics about specific teams, drill-downs on specific players, and advertisements for team Web sites and Ford sport utility vehicles.

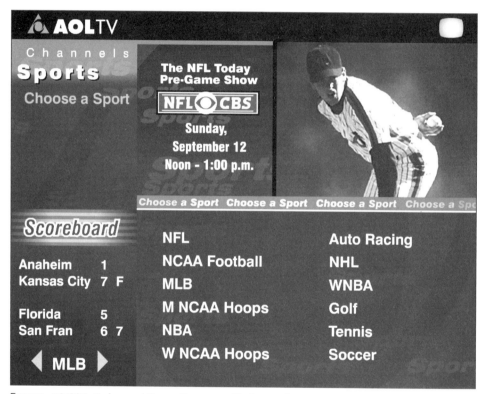

FIGURE 6.1 *AOLTV's Enhanced Sports Program. (© Copyright 2001. Reprinted with permission from AOL.)*

Games. Another great genre just itching to be enhanced is game shows; they already have the built-in element of participation.

Examples: Spiderdance has mastered a complete front-end and back-end software application to implement and administer interactive game playing through the 2-screen synch solution. Get a behind-the-scenes look at Spiderdance and the making of the MTV's *webRIOT* game show

in Part Three of this book. Another example of ITV game play is ABC's Enhanced TV presentation of the ever popular show *Who Wants to Be a Millionaire* and includes options to play along with the TV contestants, and compete for prizes with other online players. Complete networks, such as The Game Show Network have also entered the arena by hiring ITV content providers such as ACTV, Spiderdance, and Mixed Signals to create enhanced versions of their preexisting game shows, as well as the creation of new shows with interactivity in mind from the beginning (Figure 6.2).

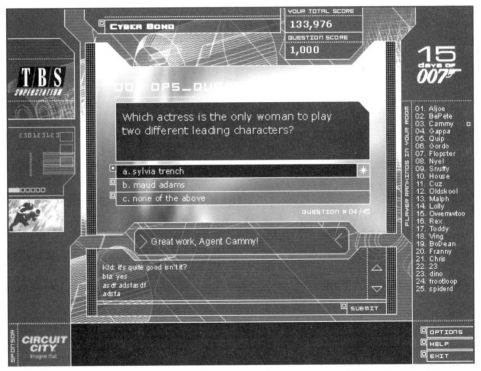

FIGURE 6.2 *TBS Superstation's Cyber Bond Interactive Game Program. (© Copyright 2001. Reprinted with permission from Spiderdance, Inc.)*

Shopping, E-Commerce, and Advertising. Initiating the impulse to buy can be part of any show's interactivity, a clickable banner ad or a link to an online shopping site, or, it can be the sole impetus of a program, an infomercial, or a complete shopping channel. The possibilities here are endless.

Example: All in good fun, Two Way TV and Cadbury Trebor Bassett teamed up at Easter time, April 2001 to promote Cadbury Time Out

chocolate bars during Two Way TV's interactive games. According to their press release, chocoholics on the NTL and Telewest digital networks were able to enjoy special edition Two Way TV/Time Out games, including an Easter egg hunt, and winners won hundreds of Time Out bars.

News and Weather. News-type shows that can be localized and continually updated are prime targets for interactivity.

Example: The Weather Channel, for instance, has been one of the longest running interactive shows, allowing a viewer to access up-to-date weather reports any time of the day. Teletext, popular in the UK, is also a 24-hour interactive news and weather service where viewers, with a click of a remote control, can access an interface with choices to view regional news headlines, sports data, and weather reports. Opinion polls and political election results can also go interactive, as in the Wisconsin Vote project highlighted in Part Three of this book (Figure 6.3).

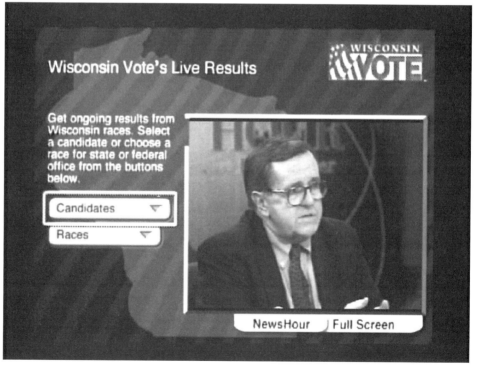

FIGURE 6.3 *Enhanced version of* The NewsHour *with Jim Lehrer. (© Copyright 2001. Reprinted with permission from the University of Wisconsin-Extension, Wisconsin Public Television.)*

Talk Shows. Weekly, daily, and nightly talk shows are possible candidates for interactivity. Elements from these shows, such as real-time audience participation and timely topic discussions, beg for the innovative inclusion of enhancements.

Example: "Further embracing their ongoing partnership for original ITV content development (and it's a good idea, too), network broadcaster, NBC and ITV services developer and broadcaster Wink are planning more enhanced television programs in the years ahead," according to Tracy Swedlow's Interactive TV Today. Working within the talk show format, NBC and Wink will add enhancement treatments to the ever-popular, late-night comedy sketch shows Saturday Night Live and The Tonight Show with Jay Leno. Viewers can, among many options, access additional information on the guests, get tickets for upcoming shows, and buy merchandise.

Dramas and Sitcoms. Character-driven shows can take many different forms with added interactivity.

Examples: In 1999, Showtime teamed up with HyperTV to create a 2-screen synchronous program of Showtime's ever-popular cult drama *Stargate SG-1*. The goal of the project was to use enhancements to create a new type of narrative in which the viewer became a part of the drama, a character within the characters. In essence, viewers had the ability to play a video game synced to the show. The game transformed you, the viewer, into a member of the Stargate fleet, allowing you to man the Stargate computer, travel with characters in their control vehicles, or examine weaponry and prepare for battle.

It's quite possible that an idea you have for an interactive show is in a genre of entertainment never before considered. Perhaps it doesn't fit neatly in any category, and that's okay. At this flexible moment in the ITV game, any avant-garde approach to storytelling is always open for consideration.

Tune-In

Pick Your Ending
Although more a gimmick than a full-blown interactive experience, NBC tried a narrative twist with an episode of its sitcom *Just Shoot Me*.

continued

> This twist was the option of having viewers vote for which ending they would like to have for the show. Logging on to nbci.com, viewers could choose from three different endings. The online polls stayed open until midway through the actual show; the votes were tallied and the pre-recorded ending aired. In a *New York Daily News Online* article, March 28, 2001, writer David Bianculli makes an interesting point about the *Just Shoot Me* pick-your-ending-episode, stating:
>
> "So what's the real motive here? Is it a) giving viewers a new way to relate to their favorite TV shows, b) getting more free media attention than they would otherwise generate, or c) concocting a reason to lure computer-savvy viewers (and consumers) to their network Web sites?" Perhaps it's a bit of all three.

ENHANCEMENT ELEMENTS

One of the best ways to get your mind going on what's possible in the world of interactive enhancements is to start browsing the Internet. Check out what Web sites work and don't work, what interesting tools and applications are available, and how they function for you, the user.

In addition, do the leg work to find out what ITV content producers are producing—how are they effectively or ineffectively using interactive elements, and how could you take the same technology used for those elements and bend and mold it to fit your vision. In your investigation, though, keep in mind that what's considered an "enhancement element" is not so easily defined, and should not merely be restricted by what others have done before. Depending on your purpose, the level of enhancements you use can be as simple or as rich as you choose to make them. To help in your formulation of what can and might be possible for your show, enhancements for interactive television can be grouped into three general areas: Internet links, constant elements, and synchronous elements.[4]

Internet Links. Part of ITV is the option for viewers to access the Internet directly and instantly while they watch a show, or to log on later for additional information. Including direct links to the Internet from your

[4]Enhancement area names, formats, and descriptions have been extracted from the Developing Interactive Television manual, Microsoft Corp. for their Microsoft TV Planning and Implementation seminar.

program might be beneficial; perhaps to send the viewer to a Web site specifically designed to supplement your show or a contributing sponsor. Keep in mind that an Internet link allows the viewer to go away from your show, so be sure "when" you want to make this option available.

Constant Elements. Constant elements are accessible any time; made available throughout a particular show or any given time slot. Example constant elements might be a drop-down menu of the latest news headlines and weather reports, local or national, updated and viewable throughout the day or an evening news broadcast. It can be as simple as a "go back to full screen" button for STB users moving between interactive and full viewing mode, or a Help button to access information on how to use an interactive service. Constant elements are consistently timed into a broadcast, but do not necessarily need to be "synched" to a particular moment or action in a show.

Synchronous Elements. The most compelling and challenging of interactive enhancements are those elements that attempt to synch precisely with what's happening in the video or audio portion of a program. Interactive game show applications depend greatly on synched elements—the timing of quiz show questions, the answer and respond feedback of the home viewer versus the show contestant, is a prominent example. The challenge of implementing synched elements depends largely on the format of the show. A live show, for example, involves real-time triggering of events, whereas in a pre-recorded show, synched elements can be planned, encoded, and tested ahead of time. Synched enhancements are really *any* type of enhancements, constant and Internet links included, but with the added dimension of time.

SHOW FORMATS

Show formats, here, are described as the way in which a television program is presented. They are divided into two categories: taped and live. These categories can be further specified into two areas: scripted and unscripted. Which show format you use will present different design considerations and challenges.

Taped Shows

A taped, scripted show is the least complex show format for the implementation of interactivity. All elements and timing can be prepared, encoded, and, importantly, tested with the broadcast ahead of time. Example show types might be dramas, sitcoms, and educational.

Taped, unscripted shows—such as talk shows, game shows, and documentaries—are pre-recorded shows, but a script is not used during the show's

production. In this format, interactive elements are usually developed and revised as the show is being taped, or added in later.

Live Shows

A live, scripted show is aired live but produced based on a script, such as the *Academy Awards*. Since a general idea of the script is known ahead of time, a selection of interactive elements can be prepared beforehand and inserted into the broadcast as it airs.

A live, unscripted show is broadcast in real time, and for interactivity can be the most challenging; involving the implementation of data in a unknown, timed environment. Graphic and textual interactive elements, such as constant elements and Internet links, can be prepared ahead of time. Others are triggered in during the show, usually by a programmer standing by during the broadcast. Such live, interactive elements might include a posting of Tino Martinez's bio after he scores a home run for the Yankees, or posting up viewer poll results of who might win the World Series. As you might imagine, live events are challenging for one main reason: they are difficult to test and troubleshoot.

PROTOTYPES, TEMPLATES, AND THE FULL DEAL

The type of show and format you choose leads to another consideration: its reusability. By *reusability*, we mean how much you can benefit from your time, money, and efforts. Don't hesitate to ponder on what would be the best way to most efficiently create your project—is it necessary to have a prototype produced ahead of time, or will your first airing be your prototype? Will this show be aired more than once, and can its interactive structure be used again for similar programs?

THE DELIVERY MECHANISM

Another area to fully investigate in your ITV project considerations is what platform to use. For example, will it be a 2-screen show, or presented on a STB solution? And which STB? This will be your most limiting factor in what can and cannot be done in your personal constraints of budget and technological staff. Currently, there are many different platforms on which to present your ITV work, each of them, unfortunately at this time, with their own set of proprietary features and deployment initiatives. Some of the top platform pacers and their specifications are discussed in Chapter 8, "The Creative Tool Set." The determining factors for finding just the right delivery mechanism depend on your answers to the following:

> What platform will best suit the show I have in mind, and the audience I'm trying to reach? What platform will best reach that audience? What size audience must I reach to make this project worth my while?

What's my budget? Do I have the money and resources to produce content for more than one platform?

THINGS TO CONSIDER QUICK LIST

- **Purpose**. The show is IT! Know the purpose behind why interactivity will best suit your show.
- **Show type**. Consider what type of show you want to enhance. Show types include documentaries, educational shows, games, sports, news and weather shows, shopping and e-commerce, dramas and sitcoms.
- **Enhancement types**. Consider what type of enhancement elements you would use, including Internet links, constant elements, and synchronous elements.
- **Show format**. Think of your show format, whether taped or live, scripted or unscripted.
- **Reusability**. Consider how your show can be utilized and reutilized to its fullest.
- **Delivery platform**. Choose what platform on which to present your show by considering your audience, budget, time, and resources.

KEEP ALL DOORS OPEN

Imagine two doors, one painted red, the other blue. You enter the blue door, and sitting around a table is a group of executive types, each with a clean legal pad of paper and pen in hand, drinking Evian, and looking at you with a smile. "Come in, come in," they say. "Sit down and tell us about your project. Before you start, though, let us be clear that the technology for what you want to do right now is just not there. And our deadline is very soon. And our budget is limited. But, go ahead and tell us your idea anyway."

After that meeting, feeling somewhat apprehensive, a bit overwhelmed, a bit skeptical about your whole idea, you enter through the red door. Inside, chatting around a table is a group of creative types, each with a big, fat magic marker in hand, and a large roll of butcher paper stuck to the wall. They gulp down soda pop, and gesture wildly to you to come on in. "Hey, good to have you join us. Take a chair, and give us the scoop on your project. Don't hold back. Don't worry about whether it's possible, or about time, or money. Just tell us how it is, what you see in your mind's eye, what motivates you to do this project. Here, scribble it down, sketch your ideas with this purple marker."

If you've taken on the challenge of doing anything innovative, you've probably found yourself behind both types of doors—a blue door that when opened

contains the voice of practicality and reason, and a red door that when opened holds the voice of motivation and optimism. Both voices are necessary in the pursuit of an idea, and their doors should remain open throughout the process. You will consistently enter and exit one door and then the other, listening to the voices at the appropriate stages of the process, eventually finding a balance and resulting in a product—a product of your own voice.

The metaphor of the doors is a lesson in mindset, of learning to listen to the right voices at the right time in the creative process—a mental formula seemingly ever present in the numerous ITV content creators I spoke with for this book. This is a mindset necessary to go beyond creating projects of a hybrid sort, of only thinking of the "tacking-on" of Web elements to TV video for the sake of doing it, and avoiding the real opportunity to remain open about how these new elements can be used and presented to their fullest and most beneficial capacity for now and into the future.

Chapter Summary

- While many visionaries had to create their content from scratch, ITV innovators are lucky to have pre-tested TV and Web resources as foundation ingredients for their creations.
- Before diving into the specifics of developing an Enhanced TV show, it's important to consider the following: the show's purpose, type, and format, the enhancement types, the show's reusability, and its platform of delivery.
- A more mental consideration in the attempt to create content for a medium not fully developed is listening to the voices of practicality and reason, motivation and optimism. Out of this you develop a mindset in which your options remain open, while your task is firmly in hand.

Viewpoint

Author Interview with Louis Barbash, Project Development Officer at the Corporation for Public Broadcasting (CPB)

About CPB

CPB, a private nonprofit corporation created by Congress in 1967, is a leader in public broadcasting's transition to digital educational and programming services for the American people. The corporation is public broadcasting's largest single source of funds for analog and digital program development and production. CPB also funds more than 1000 local public radio and television stations across the country.

CHAPTER 6 DIVING IN

Louis, tell me about your role at CPB and how you got involved with interactive television?

I came to CPB, having formerly been in law, politics, and TV production, to review proposals for TV programs. At the time I came in early 1998, CPB was just starting up its digital initiatives. Since I didn't have the backlog of previously funded projects to manage, I had time to do various things that needed to be done in connection with the startup of CPB's digital initiatives. I learned from what I saw and what I was involved in, until digital—ITV and the Web—became my primary focus.

I understand that CPB is a significant financial contributor for projects that use digital technologies to enhance educational programming. Tell me a bit about the past and current initiatives CPB has supported for the growth of this emerging medium.

CPB has had two initiatives, one called DTV 2003 and the other New Voices, New Media. We've funded a variety of educational Web sites and ITV prototypes. One of them, an ITV prototype based on the PBS series *Science Odyssey*, can be seen on the Web at http://etvcookbook.org/test/prototypes.html. We also funded a DVD-based ITV prototype based on the PBS math series, *The Eddie Files*. In a broad sense, we regard everything we do as educational, whether to students in a formal educational situation or to viewers at home.

Describe for me a particularly interesting project that CPB funded that best highlights the use of advanced digital TV technologies and the blending of web and TV elements.

We funded a DVD-based ITV prototype based on the program *Black Press: Soldiers Without Swords*. The primary component is an interactive version of the program itself, in which the viewer can branch to narrative-based enhancements produced in the same style as the program itself for a seamless experience. Other components of the prototype involve typical DVD and Web elements such as the modern perspectives on the historical story, front pages from black newspapers, and interviews with the producer and composer. This prototype has attracted great interest because it's one of the first interactive TV projects that actually *looks* like a TV show rather than looking like a Web site.

Based on your experience, what type of feedback, if any, have you received from the general public and television viewing audience about the innovative programs CPB has supported?

Too early to tell. For all intents and purposes, there is no large-audience ITV platform, nor do most audiences now go on the Web to be entertained. And it's just as well: even in public television, and infinitely more in the commercial space, this genre of interactive TV or interactive media (including the Web), is still figuring out how to make compelling content with digital technologies. We're kind of at the stage now of trying different things, doing more of what works and leaving behind what doesn't. The public just isn't tuned in to the idea of interactivity yet. To a large extent, they'll be drawn to interactivity more and more as the approaches become better and better.

There is a lot of hype about ITV right now, a daily topic in technology news. Hype seems to come and go for the ITV industry. In your perspective do you think the hype is now vindicated?

No! Not close! The hype has been driven primarily by tech types, fixated on cool applications or on gold at the end of e-commerce or IPO rainbows. Broadcast TV and telephones, to pick two communications media, are not fabulously successful because of cutting-edge technology or elegant business models. They're successful because they provide programs and services that people want and they're easy—user friendly. ITV won't succeed until content creators understand, "It's the audience, stupid."

What are your predictions for the next years of ITV?

No predictions. David Liroff, VP and CTO of WGBH, the premier on-line PBS station says, "Anybody who says he knows how this will turn out doesn't know what he's talking about." Look not for big breakthroughs but little insights, little advances, signs that content creators are creating things that people want to interact with and are easy.

What recommendations can you give the reader of this book on how he/she can learn more about and become involved with this incubatory medium of ITV?

Start on the Web. ITV doesn't exist as a mass medium, so there are few ways to develop one's skills in it with real audiences, which is the only true test. But Web-based interactivity does play to real audiences and is a great place to learn how to produce interactive media.

For more information on CPB and its digital television ventures, visit its site at www.cpb.org/tv/digital/. (© Copyright 2001. Reprinted with permission from Louis Barbash.)

CHAPTER 7
The Process

IN THIS CHAPTER

- A Process Outline
- Fitting It All Together
- ITV Production Role Quick List
- ITV Equipment Quick List
- Chapter Summary

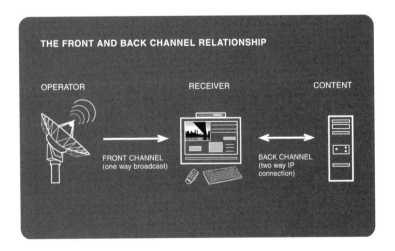

Nothing but experiencing the real thing can give you a true idea of the process of producing an interactive show. However, to get you on the right track for your initial project(s), this chapter provides you with the next best thing, a generalized process outline assembled from discussions with the ITV content creators highlighted in this book. Also included is an important detailed section on the production and testing phases of the process, the core of any Enhanced TV project, with explanations of how the content, timing, and delivery pieces of the process fit together.

Depending on what side of the fence you stand, the TV producer versus the interactive developer, the process can vary slightly. An important thing to consider is your previous knowledge of content production, how a show or a Web site effectively comes together. However, do not let it stifle your openness toward more suitable and collaborative process solutions. After all, you can't expect to be a master of something that's just beginning to emerge.

A Process Outline

James Bond just received word from Miss Moneypenny that his mission is to apprehend a Russian spy running loose somewhere in South America. He heads down to the basement of the British Secret Service to confer with Major Boothroyd, otherwise known as "Q," on the logistics of the operation. "Q" has all the answers, all the equipment necessary to get the job done—pens that shoot poison, and cuff-link size surveillance cameras. 007 wastes not a moment's time to master "Q"s gadgets. He then heads into action, prepared, with his effervescent charm, to tackle the best of unforeseen plot twists.

Your task in planning an ITV project is not unlike the process James Bond goes through when getting ready for action. You prepare for your mission by conferring with the best in the business, assembling a plan, and mastering, or, at least understanding, all the gadgets suitable for the task. Your assignment breaks down as follows: Planning, Pre-Production, Production, Testing, Show Launch, and Evaluation. Although this process seems less alluring than a James Bond mission, it's no less heroic.

Planning Phase
 1. Brainstorm Ideas

 Don't skip this step. Gather a group from all sides of the task, propose the topic of an enhanced show, and let the flow of ideas begin. Write down *every idea* on a big piece of butcher paper, no matter how crazy or unreasonable; number them and ponder them, one by one.

 ". . . you can deliver more value, create more energy, and foster more innovation through better brainstorming," expresses Tom Kelley, in his

book, *The Art of Innovation*, a great resource for learning how to stimulate great ideas, and make the most of them.[1]

2. Review "Things to Consider" List

In the previous chapter is a listing of things to consider when coming up with an Enhanced TV idea, including such issues for discussion as show purpose, type and format, enhancement types, reusability, and delivery platform. Review these considerations as you begin to hone in on your interactive project.

3. Discuss Budget

Budgets vary, and depend on many factors. Some of these factors will be stipulated by your funding resources: will the funding for the project come from one source or several sources, a sponsor perhaps, or a collaborative financial relationship between a television production station, an interactive design firm, and a set-top box manufacturer?

Another variable might be talent and equipment resources. Do you already have an inhouse Web and design team, or will you need to hire specialized talent?

With your specific variables in mind, you can then begin to put some numbers down on paper. Keep in mind that an Enhanced TV project consists of two separate content parts: the show production and the interactivity production. Figure out the cost of each part and you'll have a good, base-level budget. Of course, the trick is to know what type of show you're creating and what kind of interactivity you want—stuff considered in the previous step of this process outline. The budget phase is where the combined, past experiences of budget making from a TV producer and Web developer can truly be beneficial.

(Note for reference: In New York City, May 2001, I attended an ETV seminar presented by Thelen, Reid, and Priest, LLP. The unofficial consensus from a panel of well-known ITV content innovators at the seminar was that the average production budget for an ITV show can be anywhere between 5 and 10 percent above the original show cost.)

4. Discuss Project Timeline

The project timeline, its deadlines and milestones, is highly dependent on the intended air date of the show. Since you will be working with emerging technologies, be sure to leave plenty of room for learning and testing.

5. Create Technical/Creative Brief

A technical and creative brief outlines in the greatest detail the scope of the project, basically clarifying everything discussed in steps 1–4. This brief

[1] *The Art of Innovation, Lessons in Creativity from IDEO, America's Leading Design Firm*, Tom Kelley, Doubleday, 2001.

is important if you plan to solicit funds for the project, and it serves as the basis for the contractual and legal obligations of all parties involved.

6. Approval of Project Specifications

Of course, all parties involved must approve first-round ideas, budgets, and deadlines before taking the next steps. Allocate a project manager to ease the communication flow of this approval process.

PRE-PRODUCTION PHASE

1. Develop the Interactive Team

At minimum your interactive team should include:

- The TV producer
- The content producers (including a graphic artist and developer)
- An administration assistant to monitor schedules and content distribution
- A project manager to be the liaison, communication link, between the TV producer and interactive content developers and designers.

(Also see the ITV Production Role Quick List at the end of this chapter.)

2. Set Up the ITV Content Production Studio

See Equipment Quick List and diagram at the end of this chapter.

3. Create a Storyboard and Flow Chart of Interactivity

Outline in detail the timing and navigational structure of all elements.

4. Design 2–3 Prototype Interfaces

To get a feel for how the show and interactive elements will blend together, create a couple of design layouts. Often times the "look and feel" of the enhancements is determined by the preexisting nature of the show (see Chapter 12, "The Wisconsin Vote Project" for an example). However, sometimes the show is designed with interactivity in mind from the beginning, and the visual appeal of the two components can be seamlessly built together.

5. Review and Revise Storyboards, Flow Charts, and Prototypes

Review for consistency of design and structure the storyboards, flow charts, and prototypes, and revise if necessary.

6. Final Approval

Before heading into the time- and money-consuming core of the process, the Production phase, be sure that finalized storyboards, flow charts, and design prototypes are obtained from all pertinent team members.

PRODUCTION PHASE

1. Assemble Content

Gather and prepare content—images, photographs, copy, sound, and database elements. Integrate media and code for front-end elements.

Note: Not indicated in this Production phase is the building of a back-end database structure that might be necessary for some show formats; for example, game shows in which there is real-time feedback from viewers, or polling applications. Many of these database structures can be made available through middleware software developers. Some are developed specifically for a particular show; for an example, see the webRIOT project in Chapter 13, "Spiderdance.".

2. Implement Timing

Encode triggers and/or synch content with enhancement elements and network operations protocol.

Further details of the Production phase are covered in Chapters 8 and 9.

TESTING

1. Alpha Test Components

Depending on show format and the chosen delivery platform, this testing phase can vary in length and implementation. If your platform, for example, is a set-top box, synch enhancements to a beta video of the show and view on the specific box. Many platform and middleware providers include simulation software for the viewing and testing of the TV object with the enhancements on the computer screen; this is useful for quick feedback for the designer or developer, but should not be the sole testing mechanism.

2. Beta Test Components, and then Do It Again

If possible, test triggers and links through a live broadcast feed to ensure accurate timing.

SHOW LAUNCH

Here's where all your hard work pays off.

During show time, it's a good idea to have a technician on hand to be sure that operations run smoothly. Also provide viewers with contact information, so they can request technical help and send in feedback.

EVALUATION

After the launch, and even beforehand, set up focus groups of project team members and outside viewers to evaluate the show—the technical pitfalls, ease of use, overall enjoyment, and so forth. Spend the valuable time to review and discuss the project as a whole, its successes and weaknesses.

FITTING IT ALL TOGETHER

The Production phase of the preceding process guide seems brief and insignificant, a simple mission statement from Miss Moneypenny—assemble content, implement timing. Of course, there's much more to it. The Production phase is the very core of transforming your theoretical idea into the real, tangible product. It's the part of the process in which the action, the hard work, really begins, and like Bond, James Bond, you must come prepared for battle.

The action-packed implementation of Web content with a TV broadcast is a melding of many heroes, a team equipped with the many required disciplines and skills to get the job done. Although each team member will have his or her own set of "Q" gadgets to work from, the overall success of a project requires a thorough understanding by all team members of how ITV content is handled and coordinated in the TV broadcast arena. This involves an understanding of how all the pieces will eventually fit together, the Web and video production cycle, and the transmission and delivery process—what this section is all about.

MISSION POSSIBLE

What's unique about creating for ITV is its structure of development.

You can think of this development cycle as broken down into four main areas: content creation, linking and timing of the content, testing of the content, and delivery of the content. As a way of explaining how these areas fit together let's work with an example. Suppose your task is to create interactivity for a marathon broadcast of James Bond movies, and the code name for the project is "Mission Possible." During a brainstorm session it is decided that the show will air on a set-top box platform. Based on the technological standards and limitations for the specific set-top box and the one-screen TV viewing experience (specifics of these standards and limitations are discussed in Chapter 8), decisions for what type of enhancements are clarified. The enhancements will be made available to the viewer in two ways:

- As a Web site of Bond trivia, character profiles, etc., which viewers could link to *between* Bond movies. The Web site will continue to be posted even after the Bond marathon.
- As constant elements, such as backstage photos of a particular film or bios of the actors, synched and available to the viewer *during* the specific Bond movies.

CONTENT CREATION

There are two parts to content creation for ITV: the video source and the interactive Web source. Depending on the type of show format you are using, the cycle for when these two sources are created varies.

Chapter 7 The Process

If the show is "made for interactivity," both content parts must be developed simultaneously, and daily collaboration between the TV producer and the interactive content developer is crucial. In the case of Mission Possible, the shows, a back-to-back airing of James Bond movies, have already been created and so the task is solely focused on how the interactive elements will seamlessly blend with the preexisting format. For the content developers, this involves deciding how to organize the content, its navigation structure, and the formatting and coding of the content to be compatible with the TV. Hardware and equipment used for this process includes what makes up a Web site production studio—a personal computer with Web development software, such as Macromedia Flash or Dreamweaver for HTML coding, and Adobe Photoshop and Image Ready for design and image manipulation.

Note that most multiple system operators (MSOs) for STB applications—such as Liberate, AOLTV, Wink, and WorldGate—provide WYSIWYG software that enables the designer to easily design for TV, as well as simulate the look of a video picture within a Web page for quick testing. However, as mentioned earlier, these helper solutions are usually platform dependent. Software development company SpinTV has created a cross-platform testing suite. As an extension to Macromedia's Dreamweaver Web authoring tool, the SpinTV software allows you to test ITV content against many STB standards currently deployed in the United States (see Chapter 11, "SpinTV").

Linking and Timing of Content

The linking and timing of the video source with the Web source is where things get interesting—it's the logistic side of the whole concept of Enhanced TV, the virtual interlocking and synchronization of the two mediums. The precise linking and timing of the two sources will depend on the enhancement elements used, Internet links, constant or synchronous elements, and the format, live or taped. Mission Possible is a good starter example for linking and timing for one main reason: the show is already taped and the precise syncing of elements can be encoded and tested ahead of time.

This process starts with the content developer creating a list, a schematic view of links, outlining when and how the interactive elements will get to the viewer. For example, a link that comes up every 10 minutes during the Bond marathon will give the viewer the option to click on it and open a schedule of Bond movie titles and airing times.

Once this list of links is defined, the next step is to encode the links as triggers into the video. Again, how this is accomplished varies, depending on the platform used and the method of transmission, analog or digital or a combination of both. For Mission Possible, the platform is a set-top box, which, in most instances at this time, involves encoding the triggers into the VBI, analog signal of the broadcast. It's the same process used for closed-captioning and teletext

services. Although you can do this inhouse, in many cases it is done by a third-party vendor using, most commonly, the following equipment to execute the process:

- Two videotape decks for source and destination tapes
- A Norpak analog encoder (www.norpak.ca)
- A PC computer with Mixed Signals TV Link Creator Software (www.mixedsignals.com)

TESTING OF CONTENT

By far, testing is the most important thing you can do in the preparation for a seamless interactive show experience. As any Web or software developer knows, there is no way around testing. Unlike the old reliable TV, computers and how they handle data can vary from system to system, and screen to screen.

As mentioned before, most MSOs offer specific WYSIWYG software applications enabling the content provider some means of viewing TV/Web integrated design and testing of the link and trigger process. However, these software applications are only specific to the platform they support and are simply simulations for the real deal. No simulation software can match or replace the testing of the actual show.

To accurately test the Mission Possible interactivity requires a television set and its corresponding STB box. Since the show is not live, an encoded standard videotape of the show can be obtained and tested inhouse. In addition, if possible, the show should be tested with a live feed; for example, an actual broadcast during the off-peak hours of the station on which you plan to air the show.

Tune-In

The Trigger Dilemma

One complication with the ability of MSOs and content providers to insert interactive TV trigger information in the VBI of an analog signal is whether those triggers are acceptable to the network(s) airing the show.

While closed-captioning and program ratings are carried on this signal for regulatory reasons, Enhanced and Interactive TV services are carried specifically for commercial reasons. Because of this, there are no set regulations on who is responsible for the preservation of ITV trigger information, leaving the option open for networks to freely strip triggers out of unaffiliated content providers. At this time to ensure their triggers are preserved and accurately

> monitored, content provider companies are making specific deals with the networks that air their shows.
>
> Although there are no clear-cut answers between broadcast networks and the content providers on how to easily deal with this issue, companies such as Norpak are offering trigger control tools. Norpak, the largest distributor of data transmission systems and interactive online information systems in the United States and most of the world, recently created a new tool, announced in April 2001, called WHAK-it. WHAK-it, according to Norpak's Web site, enables the broadcasting content provider, MSO, or network "to filter and/or replace embedded interactive TV data in real time, based on pre-determined rules established by the administrator."
>
> Applications include management of ITV content, including Interactive TV trigger blocking, substitution and modification, control of outgoing VBI data, localization of national ITV data, and substitution with local ITV data.
>
> When used to its advantage, tools such as WHAK-it offer ITV content to be localized and tailored to individual demographics as the technology improves, and open the option for more dynamic content. For more information on Norpak visit their site at www.norpak.ca.

DELIVERY OF CONTENT

The show is in hand and ready to roll, with the triggers synced and the Web elements complete. The final piece of the puzzle is how the show is made accessible to the audience, how the interactivity is delivered to and from the home. To understand this is to understand the difference between a front channel and a back channel.

Fundamentally, we know a TV show is carried through a video signal by terrestrial (air), cable, or satellite transmission. The signal can be either analog or digital, and the flow of information is always unidirectional, a one-to-many relationship from the broadcaster to the receiver.

This unidirectional path is called the front channel. On the receiving end is the option for a back channel, in the form of an Internet connection, that allows for two-way communication. The back channel is how the viewer interacts with content coming from the front channel; for example, to chat with others, purchase merchandise, fill out a form, or send an e-mail. Whether you're delivering content by STB, 2-screen, or with a PC /TV tuner card, the front- and back-channel

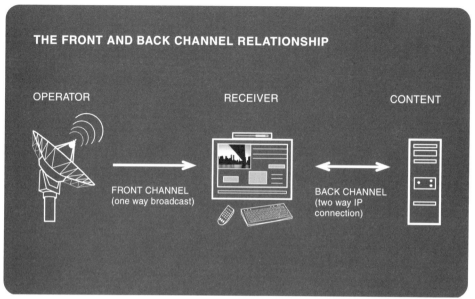

FIGURE 7.1 *The front- and back-channel relationship.*

relationship is necessary, in some form or another, for one-way video and two-way data to truly work together (Figure 7.1).

In the case of Mission Possible, our platform is an STB. If the STB being used is ATVEF [2] compliant, the display of content would be based on one, or a combination, of two methods: Transport A and Transport B. Transport A works in the analog space using Line 21 of the VBI. Triggers and video are pushed to the viewer by the forward, front channel, and all corresponding Web-like data is received and returned by the back channel. For example, during a Bond movie an interactive trigger icon is presented to the viewer—"click here for more on Roger Moore." The trigger contains a URL, a path to the corresponding data being hosted on the back-end Web server. The viewer clicks on the link, sending the message to the Web server and executing the download of the requested Roger Moore information. At this time in the United States, Transport A is the most popular enhanced-content transmission method for the STB environment. As technology progresses and improves, Transport B will be the more viable choice. Transport B offers the capability to deliver both triggers *and* data by the forward path where the return path is optional. These two methods with

[2]ATVEF stands for Advanced Television Enhancement Forum, and is the main standards body in North America for enhanced content specifications.

detailed diagrams and their ATVEF specifications are discussed further in Chapter 9, "Timing and Delivery."

ITV Production Role Quick List

If you remember from Chapter 3, "ITV's Journey," there was a sample diagram of ITV players organized by business areas. As an ITV content developer you will no doubt run into and associate with someone from just about every one of those businesses. However, within your own space you have the task of creating another team of players—a production team, the hired guns that get the job done. Following is a sample rundown of an ITV production team; keep in mind that this is a list of roles, not people. Quite possibly, one talented person will administer two or three roles, or many persons may be needed for one role. Some of these people will be inhouse, some will need to be contracted out.

Note: not included in this sample list is the staffing, the crew, necessary to produce the actual show portion of the content. Presented here are only the roles associated with the administration and production of the interactive component.

- TV Producer
- TV Associate Producer
- Project/Operations Manager
- Art Director
- Writer/Researcher
- HTML Developer/ Programmer
- Graphic Artist

ITV Equipment Quick List

For your reference, here is a sample of equipment, hardware, and software needed for the production of interactive show components (see also Figure 7.2).

For Content Creation
- Mac or PC computers with Web development software
- Web server (ISP) to host content

For Testing
- STB (if delivering by STB)
- Television set

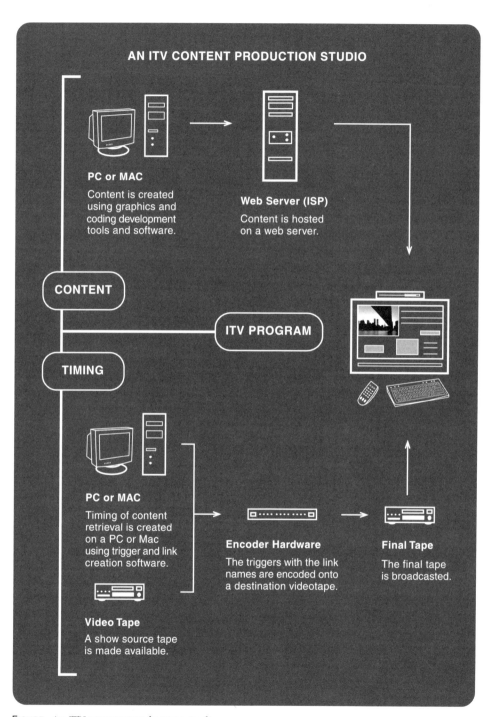

FIGURE 7.2 *An ITV content production studio.*

FOR TIMING
- Mac or PC with link/trigger creation software
- Encoder
- Tape machines for source and destination tapes

CHAPTER SUMMARY

- Although the best processes are learned from doing, a Process Outline can be a guideline for first-time ITV projects.
- There are six parts to the Process Outline: Planning Phase, Pre-Production Phase, Production Phase, Testing, Show Launch, and Evaluation.
- The Production phase of the development process is the core of the work. Understanding how the pieces of this phase come together—the content, testing, timing, and delivery—is vital for the success of any ITV project.

CHAPTER 8

The Creative Tool Set

IN THIS CHAPTER

- Content Standards
- ITV Content Pacers
- Design Guidelines
- Design Guidelines Quick List
- Chapter Summary

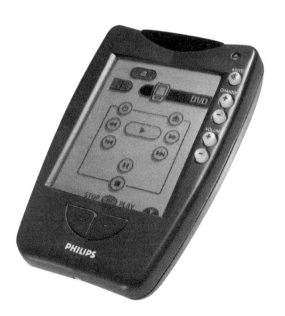

Presented in the last chapter was an overview of specific areas related to the production of Enhanced TV content: creation, testing, timing, and delivery. This chapter hones in on content creation, provides a tool set, is packed with information on standards, middleware providers, and protocols, and presents design guidelines for the making of PC and TV mixed-media content. The creative tool set provides the trusty know-how behind the first stage of the Enhanced TV Production phase: developing content.

CONTENT STANDARDS

Developing for Enhanced TV is very similar to developing for the Web; you design for a specific platform using a pre-set of protocols. For Web developers, these protocols (HTML, JavaScript, CSS, etc.) stem from a body of standards endorsed by the W3 Consortium[1] and allow for the creation of Web sites that are accessible by the most fundamental of computer systems. Aside from the use of these "common denominator" standards, specific browsers and software also offer the Web developer an opportunity to push the envelope and create above and beyond the standard base.

The ability to push the design envelope is both good and bad; while it promotes the influx of new and competitive ideas, designers have to create for many types of platforms. Internet browser wars are a prime example; the ongoing rivalry between Microsoft's Internet Explorer, Netscape, and AOL. These free enterprise battles are the agony of the Web designer, who, in order to reach the largest audience attempts to create a Web site that is cross-browser friendly. Although there are standards in place, the Web developer's task for cross compatibility is not an easy one. Depending on which platform and browser a Web site is viewed, its design, layout, color, and functionality can have varying results. For example, an HTML tag indicating the font size "3" will look smaller on Internet Explorer viewed on a Macintosh than on a PC Windows system. While this situation is far from ideal, it does encourage a competitive edge, encouraging new innovations, such as the use of Shockwave and Flash technologies. Currently not endorsed by the W3, the use of Shockwave and Flash vector-based software has become incredibly popular, producing sites with streamlined sound, animation, and interactive elements that have never been possible with straight HTML. Eventually, these revolutionary technologies will become standard fare, but until then, ambitious Web designers are creating two versions of their sites—one using Flash and the other coded in HTML—to guarantee accessibility to all users.

[1]The World Wide Web Consortium found at www.w3.org.

CHAPTER 8 THE CREATIVE TOOL SET

Designing for TV/PC combined programs is not much different; the foundation protocols for the creation of enhancements are the same as for the creation of Web sites, and the industry is a mix of platforms, each with its own set of "above-and-beyond" design tools. The only real difference lies in STB applications, in which you have the added complication of designing and delivery for TV. Television, of course, also has its own set of standards and methods of transmission, long established and strictly adhered to by all parties involved. In the United States, the NTSC standards have represented the code of conduct for more than 50 years. Within TV Land, there are no qualms about a show's compatibility; a show produced to NTSC standards will be compatible for all television sets and broadcast stations throughout North America. The same goes for European countries where the code of conduct is PAL, and its standards are similarly enforced.

ITV is in a unique position; its development cycles depend on two sets of standards: the continually congealing ways of the Internet, and the well-established, no-if-ands-or-buts-about-it rules of TV. As you progress through this chapter, you will begin to see how these standards and protocols are defining the way in which ITV content is designed and implemented. However, be warned; as a Web designer, learning these development methods might seem a step back from your expansive Web tool set, a re-learning of fundamentals, but with TV in mind. You will encounter plenty of challenges, however, and have many new questions—how do you blend video with easily navigational elements? How do you design an interface that can be viewed from 12 feet away or 12 inches away depending on the screen, TV or PC? For the TV producer, the challenges and questions might be different; understanding the functionality of two-way data exchange and Web-specific issues such as information load time, linking and URL schemes, and table and frameset layout structures.

OPEN STANDARDS

As you might imagine, the emergence of open standards for both back-end and front-end ITV applications is of utmost importance. Open standards enable content developers from all sides of the fence—STB, or 2-Screen synch developers—to port their applications to different operating systems. Ideally, open standards offer option to deliver, for example, one program over many platform devices and in tandem with each successive upgrade to digital and ITV technologies. Moreover, adopting industry standards stimulates competitive pricing from multiple software and hardware suppliers, and overall reduces ITV deployment costs, making, for example, the slick Philips Cybertube, the Hitachi Widescreen, or Sony FD Trinitron available at a more consumer-friendly price.

Content standard bodies are working hard to secure open middleware standards. Which specific standards will be secured in the marketplace have yet to be determined, an endless debate in ITV news and discussion groups. At present, the two prominent content standards bodies are DVB's Multimedia Home

Platform (DVB-MHP) and the specifications endorsed by ATSC's Advanced Television Enhancement Forum (ATVEF). DVB-MHP is the current candidate for the European regions; ATVEF throughout North America.

PROCEDURAL VS. DECLARATIVE CONTENT

The fundamental premise, the underlying development approach of each of these standards, is what sets them apart and fuels most of the debate among ITV players. One issue that refuses to be compartmentalized is the relational difference between a procedural versus declarative approach to content compatibility. These two approaches overlap consistently in the DVB-MHP and ATVEF specifications, and make the defining of standards impossibly fuzzy.

The term *procedural* exemplifies the intrinsic power of the computer, and the computer's ability to process, calculate, and contextualize complex behaviors or scripts (a series of instructions and rules). Computer video games are built on procedural functionality. Specifically for ITV, the use of Sun Microsystems' Java (DVB-J) is considered a procedural, coded environment and is fully supported by MHP.

The term *declarative* describes the use of a computer simply as a display mechanism, a means to present static information. The declarative format is defined by front-end protocols such as HTML or JavaScript, in which a line of code represents a "given" instruction; for example, `` and `function goFull()`. These commands declare an event and action, like spoken words—"go get the image called image.gif" and "return to full screen mode."

Just as procedural and declarative approaches have found their places and purposes on the Internet, hopefully a consensus will emerge in which they can also co-exist in the ITV space,—declarative offering the authoring tools for easy, front-end enhancement interactivity, such as basic navigational structures, input forms, and image and textural layouts, and procedural providing the dynamic and database-driven underpinnings of more complex ITV applications, such as e-commerce and real-time gaming applications. As Bill Sheppard, lead business development manager of Digital TV at Sun Microsystems, put it in a heated [itvt] industry discussion thread, "The future of ITV absolutely should be a mix of declarative and procedural models. Let's just make sure both of these are always available to content providers."

MULTIMEDIA HOME PLATFORM (DVB-MHP)

The Multimedia Home Platform, developed by the Digital Video Broadcasting (DVB) project, is an open application programming interface (API) for the creation and broadcast of interactive television programming. Currently, MHP is the main API solution for interactive deployments throughout Europe. In July 2000, the specification was endorsed by the European Telecommunications Standards Institute (ETSI), and has been the essential standard for OpenTV, Europe's most

prominent digital and interactive TV middleware provider. The following features exemplify the MHP:

- The goal of MHP is to provide an open resource for providers to create digital, interactive content and broadcast applications that will function independently of the delivery platform, whether a set-top box, integrated TV set, or multimedia PC. And theoretically, without alteration, these applications can be broadcast on any network.
- The core of the MHP specification is Sun Microsystems' Java virtual machine (DVB-J), a procedural-based programming format.
- MHP promotes a horizontal market model, stimulating competition down the line, from content and application providers, to programs and services, to broadcasters, receivers, and transmission networks in hopes to offer the customer the most varied and economical ITV services possible.

For more information on DVB-MHP, visit Digital Video Broadcasting at www.dvb.org, and Multimedia Home Platform at www.mhp.org.

ATVEF

The best way to describe ATVEF is to take it from the source:

"The Advanced Television Enhancement Forum (ATVEF)," as presented in their Enhanced Content Specification paper[2], "is a cross-industry group formed to specify a single public standard for delivering interactive television experiences that can be authored once using a variety of tools and deployed to a variety of television, set-top, and PC-based receivers."

The ATVEF group is a consortium of broadcast and cable networks, consumer electronics companies, television transport operators, and technology companies.

The specifications outlined by ATVEF have fast become the foundation standards for Enhance TV development in North America, particularly for STB content, and will be referred to often in this chapter and the next.

In short, the ATVEF specifications for enhanced television programming aim to address, promote, and utilize the following:

- The ATVEF specifications use existing Internet technologies for content creation, including the use of IP, HTML, SAP/SDP, URIs, ECMAScript, DOM, CSS, and MIME/ HTTP (these protocols are looked into further in this chapter and the next).
- The ATVEF specifications deliver Enhanced TV programming over both analog and digital video systems using terrestrial (air), cable, satellite, and Internet networks, and have the capability to bridge analog and digital data

[2]The full ATVEF Enhanced Content Specification can be downloaded from their site at www.atvef.com/library/spec.html.

between networks. This cross-pollination of delivery methods is achieved through the creation of transport-independent content and the use of IP as a reference binding, a definition of how ATVEF runs on a given network.
- Both one-way broadcast and two-way video systems are supported by the ATVEF specifications.
- The ATVEF specifications are designed to be compatible with international standards for both analog and digital video systems.

Note

As part of the continuing efforts of ATSC and ATVEF to implement the most effective and up-to-date standards for Enhanced TV implementation, a standards subcommittee has been formed to promote the Digital Applications Software Environment (DASE). The DASE standard promotes a higher level of functionality than ATVEF and requires a more powerful Enhanced TV receiver, including a Java runtime engine. For more information on DASE, visit www.dase.nist.gov.

While the specifications and standards outlined by DVB-MHP and ATVEF encourage cross-platform content creation, the shifting technologies of the nascent ITV medium are ever present. Consequently, enhanced content is made for a very specific audience, on a very specific platform. The "write once, publish to all" ideal has yet to be fully realized; the hope to author once and view on any device, whether TV, PC, STB, or an up-and-coming wireless gizmo. However, despite the future ideal and the semantics of developing for many platforms, the foundation tools and technology are in hand. There is no necessity to wait, to explore, experiment, build, and produce today.

Tune-In

The ATV Forum, Furthering the ITV Momentum
I asked Cindy Kelly, now former executive director of the ATV Forum, if she would share in her words the mission of the ATV Forum, a non-profit, open forum of worldwide electronic media companies, such as Nielsen Media Research, Filter Media, Respond TV, MSNBC, Norpak Corporation, Spiderdance, SpinTV, and Two Way TV, to name a few.

"The level of industry collaboration provided by the Advanced Television (ATV) Forum is the best response to this climate of fierce competition, overshadowing the technical advancements in

> ITV. With the current absence of rigid technical standards, industry consensus on standard working practices and other challenges to deployment is absolutely necessary.
>
> Over the last 50 years, television has not changed nearly as much as its audience has changed. Television needs to become a consistent source of entertainment and information for viewers where they get value for the time and money they've invested. Viewers' expectations have evolved, and so have the many alternatives for entertainment. For television to become relevant again, interactive services that are truly valuable to consumers must be developed, and the value chain that exists in delivering these services must be recognized.
>
> The ATV Forum addresses the need for the industry to work together to find these solutions, and identifies the requirements of nurturing the market before competing for market share. A sustainable business model that rewards all the stakeholders must be built before any company will reap the benefits of its investment in ITV. By enabling participation and cooperation across the technology, television, content, and broadcasting communities, the Advanced Television Forum is set to drive interactive television."
>
> For more information on the ATV Forum, visit their site at www.atvforum.org.

ITV Content Pacers

ITV content pacers, STB and 2-Screen solution providers, distinguish themselves with proprietary specifications, software, and software development kits (SDK); specific features that are best learned by pouring through their technical white papers, or, if available, joining their developer forums. Competitively, these providers benefit to stand apart, yet fundamentally they adhere to two basic principles: the use of ATVEF specifications as a foundation, a starting point, for content creation (or in the case of OpenTV, the DVB-MHP specifications), and the promotion of "thin client" applications, developing services that work well on all types of hardware systems without a great deal of memory or processing power on the client, consumer end.

STB Solution Providers

STB middleware providers through platform or software applications aim to create the most marketable solutions for ITV content delivery within a set-top box,

receiver environment. To review, a set-top box works very much like a pared-down computer, and serves as modulator, a translator between the broadcasting and receiving equipment. There are numerous STB manufacturers (Motorola and Scientific-Atlanta, to name two) and versions of STBs, (DCT-5000, Explorer 8000, etc.) that, just like computers, are upgraded regularly. The middleware of a set-top box is an operating system (usually based on Windows CE or Java), defining and executing the look, feel, and functionality of the content we see, just as Windows or MacOS defines our computer desktop preferences. Middleware services can be based on procedural (e.g., Java) or declarative (HTML/JavaScript) virtual engines, or a combination of both. For the technically challenged, think of middleware, and the STB it's housed in, as the peanut butter that holds together the bread of the broadcasting and receiving devices.

For your reference, included next is a listing of some of the top STB middleware providers and information on their development programs, services, and tools.

AOLTV

Corporate site: www.aoltv.com
Developer information:

The AOLTV StyleGuide provides front-end content providers the direction needed to produce AOLTV-specific interactive interfaces. Visit: http://webmaster.info.aol.com and choose the AOLTV StyleGuide link.

In addition to these resources, AOLTV offers a Certified Developers' Program. For more information, contact the AOL main number at (703) 265-0110 and ask for the AOLTV Business Development Group. You will be asked to submit samples of your work to be reviewed by an AOLTV team.

Canal +

Corporate and developer information: www.canalplus-technologies.com

Liberate

Corporate site: www.liberate.com
Developer information:

Information on Liberate's developer partner program, POPTV, and developer resources can be found at http://partners.liberate.com/overview/poptvprogram.html.

MicrosoftTV

Corporate sites:
www.microsoft.com/tv
www.ultimatetv.com

www.webtv.net
Developer information:
 Microsoft offers a couple of resources for their interactive and Enhanced TV developers:
 Visit www.microsoft.com/tv/content/default.asp for more information on their Content Developer Program.
 Visit http://developer.webtv.net for information and design guidelines for WebTV-specific content creation.

OpenTV

Corporate site: www.opentv.com
Developer information:
 OpenTV offers an extensive developer program, OpenAdvantage.
 For more information, visit the site: www.opentv.com/services/developers.

Wink

Corporate site: www.wink.com
Developer information: www.wink.com/contents/tech_studio.shtml

WorldGate

Corporate site: www.wgate.com
Developer information:
 For more information on WorldGate's Certified Developers Program, contact directly Bud Breheney, vice president, Media Services WorldGate at 215-354-5363, bbreheney@wgate.com.

2-SCREEN SYNCH SOLUTION PROVIDERS

Probably the most "here and now" solution for Enhanced TV applications is 2-Screen delivery. To recap, this is the experience of viewing interactivity from your PC while in synch with a TV show watched from your television set. This solution negates the need for an intermediary device, and its audience is as accessible as the availability of an Internet connection. When designing for 2-Screen, you're designing content to be viewed via the WWW, opening the opportunity to use the current, rich media tools available in making today's Web sites. The latest technologies—DHTML, Flash, Shockwave, and so forth—while limited in use in the STB space, are readily available and acceptable in the 2-Screen world. (Most STB environments, for example, support Flash 3.0, although the current version is 5.0.)

 Currently, most of the under-the-hood functionality of 2-Screen environments is based on proprietary, patented systems. To create content for 2-Screen is to

work within the auspices of those companies that develop the systems, or build your own back-end program.

This is unlike STB development, in which testing your content, for example, can be as easy as running down to your nearest consumer electronics store and purchasing a box off the shelf. Fortunately, however, and the impetus of this chapter, the front-end, declarative building blocks and timing mechanisms of enhanced content is generally the same for both STB and 2-Screen. There are only a handful of 2-Screen solution leaders currently in the United States; URLs for the prominent three are provided here:

ACTV/HyperTV
www.actv.com
Gold Pocket Interactive
www.goldpocketinteractive.com
Spiderdance
www.spiderdance.com

Design Guidelines

While it's easy to find oneself in the thick of trying to understand the proprietary components of ITV platform and service providers, don't let the specifics get you down—at least not yet. It's true, designing enhanced content requires a certain amount of discipline and understanding of Web development technologies, but a quick study of established ATVEF design guidelines and strategies is a good place to start.

Know the Foundation Standards

As described in the ATVEF Enhanced Content Specification for Content Level 1.0,[3] "The ATVEF content specification provides content creators with a reliable definition of mandatory content support on all compliant receivers." The mandatory profile for enhanced content formats consists of the following existing Web standards:

- HTML 4.0
- ECMAScript *
- Level 0 Document Object Model (DOM 0)*
- CSS v.1

*ECMAScript plus DOM 0 is equivalent to JavaScript 1.1

[3]The full ATVEF Enhanced Content Specification can be downloaded from their site at www.atvef.com/library/spec.html.

HTML

HTML (HyperText Markup Language) is the cross-platform publishing standard for Web pages used to display text, graphics, and other Web-specific technologies. Derived from the international Standard Generalized Markup Language (SGML), HTML has since grown out of many versions to its current standard of 4.01. HTML is a language of commands written in ASCII (plain text) format.

To start composing in HTML, all you need is a text editor, such as Notepad for Windows or SimpleText for Mac, or for the typing-faint-of-heart, you can use one of the many off-the-shelf HTML WYSIWYG editors currently available (Macromedia Dreamweaver, Microsoft Front Page, Adobe GoLive, etc.).

HTML is comprised of tags, simple lines of instruction surrounded by brackets; for example, ` click here to go home ` creates a link that sends you to a home page. Learning a little HTML can go a long way in your enhanced content development training. The resources are plentiful; for starters, pick up a book or learn online (try www.webmonkey.com).

Note

Dynamic HTML (DHTML), a combination of HTML, cascading style sheets (CSS), and scripts, is an expanded application program interface (API) for HTML. Used by Web designers to add animation to their Web sites, DHTML is currently not supported by ATVEF, although some ITV content vendors support minimal levels of the API.

For more information on HTML 4.0, visit www.w3.org/TR/REC-html40.

ECMAScript and DOM 0

Although usually listed as separate technologies, together ECMAScript and DOM 0 are most commonly known as JavaScript 1.1. JavaScript extends the functionality of HTML with the use of scripts, a set of instructions that informs a program how to do a particular action.

JavaScript is not a complex programming language, per se, as JAVA or C++, but rather a simple language of short, compacted, and well-defined commands used by Web developers to implement basic functions such as browser detects, roll-over buttons, and form validation.

Example JavaScript:

```
<script language="JavaScript">
function showTime() {
    myDate = new Date()
    myHours = myDate.getHours()
        if (myHours >12) {
```

```
        myHours -=12
        }

document.forms[0].elements[0].value = myHours + ":" +
myDate.getMinutes() + ":" +
    myDate.getSeconds()
    setTimeout("showTime()", 1*1000)

    }
</script>
```

For more information on ECMAScript: www.ecma.ch
For DOM 0: www.w3.org/DOM
For JavaScript: www.javascript.com

CSS

Cascading Style Sheets, or CSS, is a powerful way to further specify the look and feel of HTML content. Written in HTML, CSS allows Web designers to author stylistic, across-the-board attributes (as in font, color, and object positioning) to their Web pages.

For example:

```
<div style="position:absolute;top:8;left:14"></div>
```

specifies the placement of an object 8 pixels from the top and 14 pixels from the left of a page.

Or:

```
<STYLE>
H1 {font-family:Verdana, Helvetica, Sans Serif;color:blue}
</STYLE>
```

Indicates an inline page style for a single page, specifying the page's headline font as Verdana, Helvetica, or some sans serif font in the color blue.

For more information on CSS: www.w3.org/pub/WWW/TR/REC-CSS1

UNDERSTAND SCREEN RESOLUTION

To ensure the proper size and look for your interactive TV interface, you must know the resolution at which your work will be displayed. Grasping the concept of screen resolution can be tricky, yet it is unavoidable in designing for digital media. First, how resolution relates to different display devices (in our case, the computer and the TV) can vary. Second, the term *resolution* can encompass two definitions:

Chapter 8 The Creative Tool Set

- Resolution can refer to the overall dimensions, width and height, of a screen or image display measured in pixels. An average Web page, for example, has a resolution of 640 × 480 or 800 × 600, depending on the intended browser and monitor size. An average area for a STB interface design is 560 × 420.
- Resolution can also be used to describe the clarity, sharpness, or quality of a screen image. Computers can display much sharper and clearer images than a standard television can.

Resolution of a computer screen is adjustable. For example, try this: Open the Monitor Options panel on your computer. For the Mac, this is found under the Apple Menu>Control Panels>Monitors; for Windows, choose Start> Settings> Control Panels>Display>Settings. Select and view each of the available monitor sizes. If you choose, for example, 640 × 480, your desktop elements become bigger and less sharp, whereas if you choose 1024 × 768, your desktop elements become visibly sharper and more defined (Figures 8.1 and 8.2). In short, the display dimensions and visible clarity, the resolution, of a computer screen is flexible, limited only by its hardware circuitry.

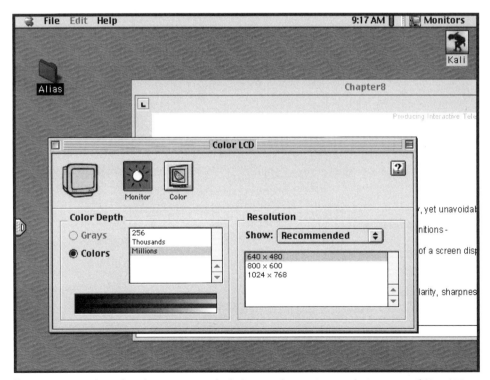

FIGURE 8.1 Screen shot of author's Macintosh desktop with monitor resolution set at 640 × 480. Images appear larger and less clear.

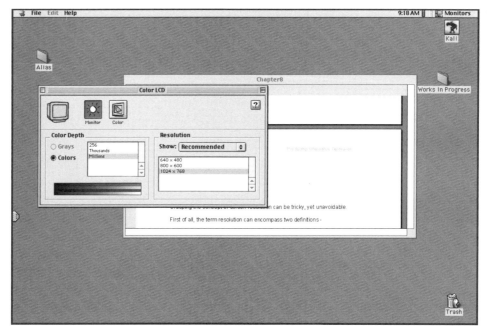

FIGURE 8.2 *Screen shot of author's Macintosh desktop with monitor resolution set at 1024 × 768. Images appear smaller and clearer.*

In contrast, a standard television's resolution is limited by the signal it receives. The picture resolution of NTSC analog televisions is always 640 × 480 (internationally, the PAL format is 768 × 576.) The 640 × 480 mandate ensures that a program is properly aired and within its allocated signal, a usual 6 MHz of spectrum. A horizontal resolution of 640 pixels yields the 525 scan lines necessary to transmit a TV signal (483 lines for the viewable picture, and 42 lines reserved for the VBI). This standard resolution also matches the 4:3 (width to height) aspect ratio most commonly used to encode video.

Note

An exception to this match is if the pixels rendering the final image are not rectangular, as is the norm for NTSC televisions. HDTVs, for example, do not use standard pixel ratios; they render square pixels, like computers. In designing for these systems, the aspect ratio will be slightly different and must be accounted for in your design.

To design for standard TV is to design for a set 640 × 480 space, but to make allowance for overscanning and action safe areas. Overscanning is a TV-specific

phenomenon, in which, depending on the television, 10–20 percent of a television image is frequently lost. Broadcasters are wise to this, and shoot their shows expecting to loose some information on the outer edges of the screen. STB platform and middleware providers realize this as well, and require developers creating for their environments to stay within certain resolution guidelines. Subtracting the reserved pixels for AOL-specific interface elements, the AOLTV design area, for example, is 585 × 386. MicrosoftTV uses a 528 × 388 pixel area, WebTV is 544 × 378.

Pictures rendered on standard television screens are not nearly as crisp as what you see on computer monitors (unless, of course, you're sporting a new HDTV). There are several technology issues as to why this is; a main one is the artifact of interlacing. While even-odd interlacing and the refresh scan rate of 60 frames per second alleviates the problem of "flicker," it results in a characteristically blurry effect on an image display, particularly when viewed from a close distance.

Keep in mind the following when dealing with resolution in your TV-displayed interactive design -

- Design for the resolution area of the platform you are using.
- To combat "blurring," watch your text and color selections (stay tuned, more details on this coming up).

CENTER STAGE THE TV OBJECT

The most important subject of your Enhanced TV show is, of course, the show. Therefore, the most prominent part of your Enhanced TV design is the TV Object, the spot where the show resides. Enhanced TV HTML pages specify the placement of a TV Object with the "*tv:*" unified resource identifier, which is further explored in the Chapter 10 Hands-On lessons. For now, know the following:

- Make the TV object as large as possible.
- Use the 4:3 aspect ratio for the TV Object to avoid distortion of the video picture. (To determine this, take the width desired for the object size and multiply it by .75 to get the height.)

DESIGN FROM A DISTANCE

TV is generally viewed from 12 feet away (or at least that's what mom recommends). Therefore, create content that can be viewed from a distance.

- Optimum font sizes for TV are between 16–20 points.
 Normal text, 16 or 18 point = HTML size 2 or 3.
 Headlines, 20 point = HTML size 4.
- Avoid fine detail. Strokes or underlines can become indiscernible, and watch out for embedded, graphical text elements and hypertext links that can be visually lost when created too small.

- Use sans serif fonts instead of serif fonts. Studies indicate that sans serif fonts, such as Arial or Helvetica, are easier to read on screen.

CONSIDER COLOR

Choosing visually appealing combinations of color is an art in itself, and probably one of the most time-consuming aspects to consider in your overall design. While this section doesn't have the capacity to get into the "art of color," it does, however, provide an overview of TV color spaces, and useful suggestions on using color effectively in the TV viewing environment.

For reference it's good to know that the reproduction of TV color involves the use of three different color spaces: RGB, YUV, and HSB.

RGB

Color is reproduced to TV and computer screens using the red, green, and blue (RGB) color space. How this works is the essential CRT (cathode ray tube) blasts red, green, and blue electron-filled light to the glowing phosphors on the back of the screen. The intensity of each of the blasts and how the colors mix together and deposit as pixels to the screen discern the millions of colors and shapes we see. The RGB color space is also referred to as additive color; when 100 percent of red, green, and blue light is added together, the brightest color of the spectrum is created—white. Intense combinations of some RGB values can cause blooming effects, and an uneven distortion of color, on standard TV systems.

YUV

A TV's video signal and how it transmits an image depends on a type of color space called YUV. The YUV color space is made up of two components, luminance (Y) and chrominance (U & V), and distinguishes whether a TV is built for a color or black-and-white picture display. The use of this color space is actually left over from the transition days of black-and-white systems to color. Color TV systems display both luminance and chrominance, black-and-white just luminance. Certain luminance values combined with RGB colors can cause blurred, anti-aliased effects around edges of text and images.

HSB

TV color can also be defined as levels of a third color space: HSB—Hue, Saturation, and Brightness. Out of the three components, saturation values are the most considered in Enhanced TV design. Saturation determines the "purity," the "richness" of color. Like all information coming to a TV set, color is represented in the video signal as an electronic wave. Colors with high saturation are represented by a high-frequency (amplitude) wave, and low-saturation colors are represented by a low-frequency wave. Not to get too technical here, but when there are many high-frequency waves—hence, high saturated colors—

rapidly transitioning between low-frequency, low-saturated colors, the TV's scanning mechanism can't keep up, resulting in a less clear representation of color. What occurs visually is a crawling and bleeding of color.

Tips on Color
- Always test your work on a television set.
- Avoid the use of full white or full red backgrounds. Highly intense colors covering large portions of the screen produce hot spots in the color, causing what is called a "bowing" or "blooming" visual imparity.
- As has been proven in the designing of Web pages, consider darker backgrounds with light-colored text; it's easier on the eyes to read, and avoids color distortion.
- Avoid "chroma-crawl," an artifact that occurs when two high-contrast (high chrominance) colors are placed next to each other. The edges, the transition from light to dark between colored areas, causes images and text to look fuzzy. Text is particularly vulnerable, with letters consisting entirely of edges demanding legibility.
- Avoid moiré patterns, the use of patterns that overlap each other with alternating dark and light areas.
- Above all, use NTSC safe colors to counteract many of the problems discussed. The NTSC color palette consists of colors that are specifically suitable for TV viewing, colors with correct saturation and luminance values. Video safe colors fall between 0–255 in the RGB space, colors that do not fall too close on either extreme of the range. Some image manipulation software programs, such as Adobe Photoshop, have NTSC filter utilities, offering the designer an effective way to adjust colors to the NTSC specifications.

WATCH NAVIGATION

How a viewer navigates through a program's interactivity can make or break his or her experience. Thoroughly flow-chart or storyboard the movement patterns a viewer might take to go from full-screen mode to a Web page or between Web pages. Here are some suggestions on navigation design:

- Keep navigation simple and intuitive.
- Always test on the actual platform for your show.
- A remote control or keyboard is used for navigation on a TV screen. The experience of using these devices and how they highlight linkable material is quite different from the click and drag motion of a computer mouse. Don't assume a viewer has the experience to move through interactive material. Create simple user interfaces that can be navigated successfully by the non-technically and technically savvy alike.

- Avoid scrollable information. There are many reasons for this. One, can you imagine your viewer scrolling away from the video portion of your show? Probably not, which is why most ITV services restrict the use of scrolling in interactive mode. Two, scrolling on a TV works differently than scrolling on a computer, and can hinder the ease of navigation. The scrolling action on a TV Web browser is a page-by-page shift of information up and down, rather than a smooth line by line scroll. Scrollable functionality is best utilized when a TV viewer surfs the Internet or needs to read long blocks of text (Figures 8.3 and 8.4).

FIGURE 8.3 *Sample ITV navigation buttons on a remote control. Scrolling is executed by a click of the up or down buttons.*

FIGURE 8.4 *Navigation made easy. Philips Pronto, a cutting-edge variation of the remote control, allows you to program and navigate all your entertainment devices. (© Copyright 2001. Reprinted with permission from Philips Consumer Electronics.)*

MINIMIZE LOAD TIMES

When dealing with mass amounts of information being pushed through a wire, you're bound to encounter data jams. We've all been there, surfing the Internet, and suddenly the connection chokes, and we wait, watching the infamous progress bar ease slowly across the screen, like a car sitting on the Los Angeles freeway. At this moment, we do one of two things: we wait patiently, or we take the nearest exit and get off. A viewer of interactive content might have this same

reflective, and, often frustrating moment if you don't consider load time. Creating a successful interactive experience is about designing content that looks good, is simple to navigate through, and loads in a snap. The successful combination of all three is no easy task. The rules of optimization for creating Web pages for TV are essentially the same as those for creating Web pages for a PC. Here are a select, important few:

- Rule of thumb: The entire content on a page should be no larger than 30K, that's 30 kilobytes of information. In the scheme of possibilities, this is not much to work with, but if you learn to optimize you'll be amazed at what can be done with so little.
- Master the fine art of image compression. GIF, JPEG, and PNG are the most common graphic Web formats. Each of them inherently uses some sort of compression to keep load time down. Depending on your images, which format and compression scheme to use varies. By mastering different image optimization formulas you can find the best ways to maintain the visual quality of your image and have it load fast. Programs such as Macromedia Fireworks or Adobe Image Ready are designed specifically for preparing graphics for the Web, and, hence, the ITV space.
- Avoid the use of animations. They tend to eat up file space since they are comprised of many images, frames, flipping one after another. If you are considering animation, look into using Macromedia's Flash or Shockwave. These technologies create less file-intensive animations using vector versus bitmap (GIF-formatted) images. Flash and Shockwave, however, are not ATVEF-compliant formats, are supported by some middleware programs, and currently only up to version Flash 3.0.
- Consider constructing your HTML pages using framesets, avoiding the necessity for the screen to redraw and reload consistent elements each time a viewer selects a different page.

DESIGN GUIDELINES QUICK LIST

- Know the Foundation Standards
- Understand Screen Resolution
- Center Stage the TV Object
- Design from a Distance
- Consider Color
- Watch Navigation
- Minimize Load Times

Chapter Summary

- This chapter was all about building the creative tool set for the first stage of the Enhanced TV production phase: developing content.
- Developing for Enhanced TV is very similar to developing for the Web; you design for a specific platform using a pre-set of standards.
- ITV's development cycles depend on the preexisting standards of the Internet and TV industries.
- ITV content standards bodies are working hard to secure open middleware standards. Two prominent content standard organizations are DVB's Multimedia Home Platform (DVB-MHP) and ATSC's Advanced Television Enhancement Forum (ATVEF).
- The future of Enhanced TV content creation is a mix of procedural and declarative programming models.
- ITV content pacers include STB and 2-Screen synch providers. Most of them encourage content development based on the ATVEF or DVB-MHP specifications and promote "thin client" applications.
- There is a lot to learn in designing and developing PC/TV content for the many ITV platforms and services currently available; however, a study of consistent Enhanced TV design guidelines can set you in the right direction (see Design Guidelines Quick List for overview).

CHAPTER

Timing and Delivery

IN THIS CHAPTER

- Chapter Explanation
- A Common Binding
- Transport A, the Here and Now Method (Return-Path Data via Triggers)
- Transport B, the Emerging Method (Broadcast Data via IP)
- Chapter Summary

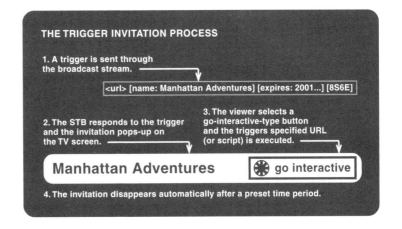

It's late and you've had a long day. You just finished watching the 10:00 p.m. news and next up is Jay Leno. He does his usual schtick, a comedic bantering of news-oriented antics. You're tired and your defenses are down, but Leno's perfectly timed performance induces you to laugh.

What makes Jay Leno so funny? Or David Letterman? Conan O'Brien?

Each of them has mastered the skill of a well-executed joke, a combination of tightly scripted, topical substance, perfectly timed, and impeccably delivered. A well-executed ITV program requires the same combination of talents—substantial content, timing, and delivery-synched to perfection. Design-conscience content development was explored in the last chapter; now we learn to finish off the skit, a study into Enhanced TV timing and delivery techniques.

Chapter Explanation

For most just venturing into ITV content creation, even for the experienced Web developer, the learning of how to synchronize and deliver Web pages with TV programming will be a new and challenging experience.

This chapter further investigates the properties of the ATVEF delivery methods, Transport A and Transport B. Transport A is the most commonly used delivery method, sending out triggers (links) through the VBI of a broadcast and pulling data, the HTML pages with their supporting graphics, from a back channel. In contrast, Transport B offers the capability of delivering both triggers *and* data by the forward channel, and the return path is optional.

To sanely explain the characteristics of each delivery method, this chapter is divided into three parts:

- **A Common Binding**: An explanation of Internet Protocol (IP) as the reference binding for the implementation of ATVEF-compliant, transport-independent content.
- **Transport A, the Here and Now Method**: An overview of Transport A, and the specifics of its well-established delivery process, including the publishing of content to a Web server, preparation, sequencing and encoding of triggers.
- **Transport B, the Emerging Method**: An in-depth overview of Transport B, also called data broadcasting, and its promise of "true interactivity" in the wake of the digital TV evolution.

A Common Binding

The delivery methods of Transport A and Transport B maintain ATVEF's goal to create a transport-independent content format. This format allows data to run on

both analog and digital video systems and supports transmission across terrestrial, cable, satellite, and Internet systems. To accomplish this format, Transport A and Transport B use Internet Protocol (IP) as a reference binding, the glue defining how a content specification, such as ATVEF, runs on a given network. A standard ATVEF binding ensures an interoperable relationship between a network's broadcast specifications and the ATVEF specifications. Although not covered here, there are specific bindings for each video standard, including, among others, NTSC, PAL, and DVB. The ATVEF IP bindings are supported by most networks and allow for simultaneous broadcasting of both Transport A and Transport B delivery methods, offering a network, for example, an easier transition from analog to digital broadcasting.

WHAT'S IP?

Internet Protocol (IP) is the universal protocol for delivery of data resources, the translator of information from one computer system to another. On the infamous two-way cyber highway, IP works with TCP (Transmission Control Protocol) to assemble data into efficient, transferable chunks. IP is the traffic cop, accurately directing endless streams of TCP-encoded data packets. Each packet contains an IP address, a map of destination directions, identifying the client and the host. The address can be expressed as an easily identifiable DNS (Domain Name Systems) address:

```
terry@crescentdrive.com
```

or, as a class number:

```
124.124.55.0
```

IP is the technology used for the on-demand, two-way feed of Internet media we've grown to depend on, allowing you, for example, to send your buddy an MP3 file from your iMac to his Sony Vaio, or access the latest movie trailer at 4 A.M. The typical functionality of IP is characterized as a unicast exchange of information, a one-to-one communication between recipients. Currently, this is the method used in Transport A, when receiving enhancements through the return-path. The information is delivered each time a user requests it. In the TV broadcast space of Transport B, IP has much more potential, allowing for a one-to-many communication model, where information can be sent to many individuals at once (this is called IP Multicast, and is discussed later in this chapter).

TRANSPORT A, THE HERE AND NOW METHOD (RETURN-PATH DATA VIA TRIGGERS)

Currently, Transport A is the most commonly used transport method for ITV delivery. An analog-based solution, Transport A is sometimes called the "link and pull" method—it sends out links (triggers) along the unidirectional front path and pulls data from a required return path.

Triggers, sometimes called TV Links or Broadcast Data Links, contain the timing and syncing instructions and the URLs (Uniform Resource Locators) of requested Internet data (trigger specifics are covered further into this chapter). As previously discussed, these triggers are encoded into Line 21 of the VBI signal, the same signal used for closed-captioning, subtitling or teletext, and sent via satellite, terrestrial, or cable.

The triggers are sent through the front channel, and if the viewer requests the interactivity, the triggers execute the call to the back channel. The back channel then pulls the requested Web page enhancements and gets them to the viewer by analog (telephone) or digital cable (DSL, etc.) using IP technologies. See Figure 9.1 for a visual representation of Transport A.

CONTENT PUBLISHING AND DELIVERY

Before moving into the specifics of triggers, it's important to understand how data is made available for the trigger to get. The contents, the actual HTML pages and supporting graphics, of an enhanced show are published to a Web server via the File Transfer Protocol (FTP). For experienced Web developers, the process of transferring files to a Web server is a snap, a quick-step process, particularly if using one of the many shareware FTP utilities such as CuteFTP for Windows or Fetch for Macintosh (Figure 9.2).[1]

Once transferred, HTML pages become part of an elaborate filing system administered by the HyperText Transmission Protocol (HTTP), the universal communication system between Web servers. On the server, the data waits until requested by the viewer of your Enhanced TV program. Once requested, the data is compacted into packets and sent along the international IP freeway.

ALL ABOUT TRIGGERS

Triggers are the synchronization component of your Enhanced TV show.

They are real time events occurring before or during a show's interactive mode and can be triggered automatically or with user confirmation. Triggers most commonly:

[1] For a list of FTP shareware software programs for both Macintosh and PC visit www.tucows.com

CHAPTER 9 TIMING AND DELIVERY

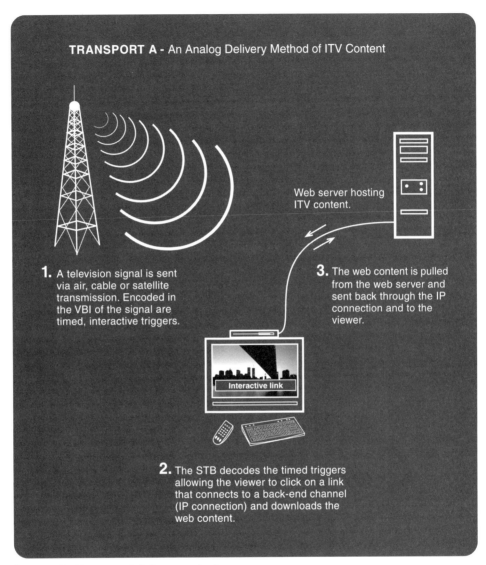

FIGURE 9.1 *The Transport A delivery method.*

- Invite the viewer "to go interactive" (requires user confirmation)
- Introduce new interactive elements during a show (can be automatic or user confirmed)
- Initiate the viewer out of interactive mode and back to full screen at the end of the show (a recommended, and usually required automatic trigger)

Trigger links that invite a user to go interactive contain a URL, among other data, that specifies the location of the Web elements. Trigger links made

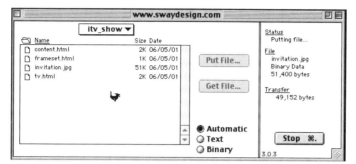

FIGURE 9.2 *Loading HTML pages using the Macintosh Fetch program.*

available during a show are executed through JavaScript functions. These scripts can perform such dynamic actions as changing the value of a stock quote, making a trivia question visible at a certain time, or returning a viewer to full-screen viewing mode.

The trigger process involves three parts: creating triggers, sequencing triggers, and encoding triggers.

Creating Triggers

ATVEF-compliant triggers are created using the syntax specifications of EIA-746 A, a standardization of the Electronic Industries Association (EIA).

The following are some examples of valid trigger links.
An invitation example:

```
<http://www.itvshow.com/go.html>[tve:1][n:Learn More!]
[e:20100101T2359][10E3]
```

A script example:

```
<http://www.itvshow.com/go.html>
[s:frame.src="http://www.itvshow.com/more.html"][e:20100101T2359]
[C2A9]
```

Another valid script example:

```
<http://www.itvshow.com/go.html>[s:goFull()][e:20100101T2359]
[8D6E]
```

Triggers are easy to generate with trigger creation software, such as the proprietary tools provided by STB middleware providers, or with Mixed Signals TV Link Creator software. Figure 9.3 shows a trigger generated in the WebTV

FIGURE *The Interactive TV Link Generator is for creating Enhanced TV triggers and is part of*
9.3 *the WebTV Viewer simulation utility.*

Viewer, a simulation software for the testing of ITV content to be delivered on the WebTV platform.[2]

The Anatomy of a Trigger

The general attributes for triggers contain a required URL, attribute/value pairs, and a required checksum:

 <URL> [attribute1:value1],[attribute2:value2]…[checksum]

Depending on the trigger's task, a trigger link can include six parts: URL, name, tve, script, expires, and checksum (Figure 9.4).

<URL>

Example: http://www.itvshow.com/go.html

[2]MicrosoftTV provides many resources for their ITV content developers as part of their Content Developer Program. To register to be a member see www.microsoft.com/tv/content. For WebTV visit http://developer.webtv.net.

THE TRIGGER INVITATION PROCESS

1. A trigger is sent through the broadcast stream.

 `<url> [name: Manhattan Adventures] [expires: 2001...] [8S6E]`

2. The STB responds to the trigger and the invitation pops-up on the TV screen.

3. The viewer selects a go-interactive-type button and the triggers specified URL (or script) is executed.

 Manhattan Adventures ✸ go interactive

4. The invitation disappears automatically after a preset time period.

FIGURE 9.4 *A visual breakdown of the trigger receiving process.*

The Uniform Resource Locator (URL) specifies the exact location of the interactive elements to be downloaded. ATVEF's level-1 content specification supports two URL schemes: HTTP and LID.

The HTTP header scheme indicates an absolute URL path; for example, http://www.swaydesign.com . This absolute path is used in the URL of your trigger invitation when you want your interactive page to be searched for and loaded "on-demand." Each time this URL is encountered in an interactive session, a virtual search party will first look for the requested page on the receiver's local cache file. If unavailable, it heads out into the highly populated world of your Web server and locates the requested HTML page from there.

Sometimes content delivered by a one-way broadcast (i.e., use of the VBI transmission method) is not necessarily available on demand, as HTTP or FTP requested data. For example, many interactive services pre-cache interactive content to a viewer's STB. The EPG listings for the next day's shows, for example, could be loaded at midnight to the localized memory compartment of the viewer's STB. To locate such content, a unique, relative path structure is used and identified by a LID (Local Identifier) header scheme. An LID supplies a location-independent name and is used for cross-referencing within content, such as hyperlinks, or to pre-cache content to a receiving device.

An example LID used for Transport A triggers is as follows:

```
<lid://myshow.com/interactive1.html>
```

This particular LID looks for the "interactive.html," and indicates to the local receiver to look for this directory structure and its cached content. This request

is necessary, for example, to reinitiate a trigger invitation for those viewers who might have missed it the first time around.

[name:string]
Example: [n: My Interactive Show]

The name attribute of a trigger indicates the readable text that is viewed as part of a trigger invitation, providing the name of the show or an instruction to the viewer—"Learn More!". A trigger without a [name] attribute is used to activate a script on the current page, if the URL attribute is the same, and the expiration time is still valid.

[expires:time]
Example: [e: yyyymmddThhmmss]

The expiration attribute indicates the date and time for when a link is no longer valid. The first four characters (yyyy) specify the year, the next four (mmdd) are the month and day, and time is separated out by a "T" and written in hours, minutes, and seconds (hhmmss). The expire attribute

```
[e:20100101T2359]
```

would be January 1, 2010 at 11:59 (no seconds) P.M.

[script:string]
Example: [s:frame.src="http://www.itvshow.com/more.html"]

A script attribute indicates a script fragment to execute within the context of an HTML page. The page must contain the trigger function and the trigger receiver object (see next section).

[tve:string]
Example: [tve:1.0] or [v:1]

The TVE attribute notifies a receiver that the content specified in the trigger is conformant to the ATVEF content specification level.

[checksum]
Example: [8D6E]

The checksum is an automatically defined attribute that detects data corruption. Each trigger has a unique checksum that can be tracked and verified.

The Trigger Receiver Object

A trigger receiver object within a TV enhancement page indicates that the page is ready to receive a script trigger instruction. The trigger receiver object is indicated within an <object> HTML tag.

Here's an example:

```
<OBJECT TYPE="application/tve-trigger" ID="objReceiverObj">
```

Sequencing Triggers

Once you've defined each of the triggers and the trigger receiver objects for your show, the next step is to place them in a sequence list. A trigger sequence list indicates the exact timing of the trigger in conjunction with the broadcast. Depending on your show type, triggers can be inserted into the broadcast on-the-fly, or sequenced and encoded beforehand. Just like creating trigger links, trigger sequencing is done using proprietary software tools (Figure 9.5), or with Mixed Signals TV Link Creator software.

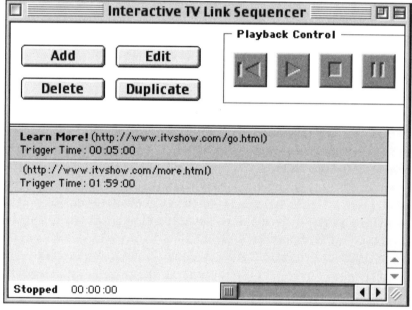

FIGURE 9.5 *The WebTV Viewer Interactive TV Link Sequencer, a simulation utility for synchronization of triggers.*

Encoding Triggers

The final step in the synchronization process is to encode the triggers and their timed sequences into the video portion of the show. As mentioned in the Process in Chapter 7, you can do this inhouse, but in many cases it is executed by a third-party vendor using, most commonly, the following equipment:

- Two videotape decks for source and destination tapes
- A Norpak analog encoder (www.norpak.ca)
- A PC computer with Mixed Signals TV Link Creator Software (www.mixedsignals.com)

Ms. Manners on Trigger Etiquette

Currently, broadcast networks and receivers have different policies and limitations for the implementation of broadcast data triggers. Therefore, it's important to set up relationships with each of the network operators who will be airing your show, and learn their policies on trigger insertions.

Other delivery-related issues to discuss with the networks include how the show's synched elements will be monitored during the show, and how the interactivity will work in relation to other scheduled programming. For example, will the viewer have the option to stay in interactive mode during commercial breaks? Will the viewer be bumped out of interactive mode between shows? Also, plan for the anticipated flow of HTML requests right after a trigger announcement. It's likely that your show will be so popular that everyone "goes interactive," requesting the HTML data at the same time. If not properly prepared, this sudden burst of requests could bring the Internet superhighway to a grinding halt. Another consideration is the validity and path structure of the URLs that trigger the announcements; it's important they are accurate (test, test, and retest), not only for the initial showing, but also for future re-broadcasts of the show. The what, when, and where of triggers should be thoroughly pre-planned with your network, and your content prepared accordingly.

ATVEF Trigger Recommendations

- Never exceed 25 percent of the total bandwidth in Line 21 of the VBI. Keep your trigger titles and attributes small and compact.
- Invitation links should not be sent sooner than three minutes into a show to avoid interference with data from a previous show.
- An automatic trigger should send your viewer back to full-screen mode at the show's completion.

Transport B, the Emerging Method (Broadcast Data via IP)

While Transport A loads its interactivity from a back channel, Transport B, also called data broadcasting, offers the capability to deliver both triggers *and* data by the forward channel. Transport B alleviates the necessity for an Internet

connection to deliver data, instead delivering the interactivity within the initial broadcast. An Internet connection as a return path, however, might be desired if the viewer wants the capability, for example, to send form information, purchase items, or surf the Web.

Sometimes referred to as a "true broadcast," Transport B data and triggers are sent to a receiver using compact IP packets. In theory, Transport B packets can be sent through analog or digital video signals.

Through analog, the enhanced content is sent along as IP over the VBI, usually requiring up to three lines of VBI for successful transmission. IP over VBI, however, is not the preferred mode of analog ITV delivery.

The reasons for this are larger than the scope of this book, but are attributed to long-standing regulations for how the VBI space should be used and preserved. There are hundreds of broadcasters and affiliate stations, all with various agreements about VBI usage making it difficult to implement the bindings required for IP over VBI.

Transport A remains the most common analog solution for ITV content delivery at this time.

Where Transport B will eventually excel is in digital transmission. However, in order for Transport B to truly hit home, and cash in on its promise of "instant interactivity," among other rewards, two things need to happen: TV networks must bust-a-move and fully transition to digital transmission infrastructures; and the glory of broadband, to open the capacity for large amounts of consumer data consumption, must come to light (Figure 9.6).

There are numerous advantages for the emerging Transport B method. Most exciting is the use of Internet Protocol Multicast (IP Multicast).

IP MULTICAST

IP Multicast offers a one-to-many delivery of data, and allows TV broadcasters the following new options:

- The use of multiple channels on a single data signal. For example, the Fox network can broadcast two episodes of *The Simpsons* and an interactive version of *The X Files* in the same 11 o'clock time slot.
- The ability to send and cache locally vast amounts of data—such as software updates, documentation, educational material, and so forth—quickly and to many viewers at one time.
- The easy scheduling of different data feeds at different times, since each channel is identified by a specific address. Also, the means to differentiate between data providers and monitor their bandwidth and data usage.

In result, IP Multicast promises the consumer a more seamless, instantaneous, and varied ITV experience.

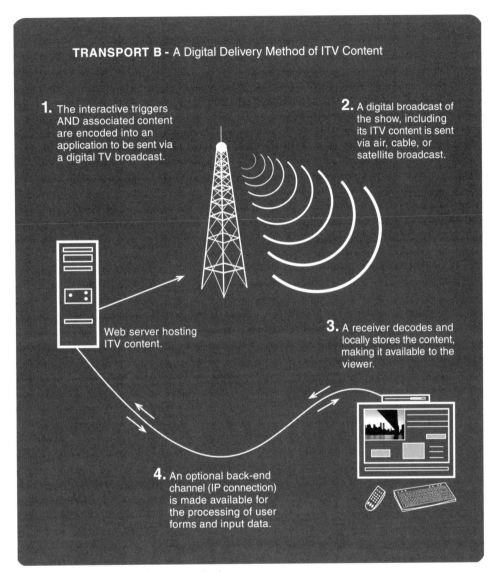

FIGURE 9.6 *The Transport B delivery method.*

IP MULTICAST DELIVERY OVERVIEW

There are three parts to an IP Multicast – the announcement, the content, and the triggers.

Announcements

Announcements describe the location of triggers and data streams (the files that provide content) for a particular enhancement. The announcement applies to whatever program or channel a viewer is tuned in to. How announcements are created are based on a combination of two Internet standards: SAP (Session Announcement Protocol) and SDP (Session Description Protocol). A series of textual and numeric instructions, an announcement includes the program's assigned session identifier, the enhancement title, the IP address and port on which triggers will be sent, bandwidth and peak storage sizes for incoming data, and the start and finish time for the enhancement.

Content

The content, the actual HTML pages of an IP Multicast, are compressed and delivered in UDP/IP packets (User Datagram Protocol/ Internet Protocol). The packets are announced to an address using the Unidirectional Hypertext Transfer Protocol (UHTTP), and sent to the interactive cache on the client end.

Triggers

Triggers, very similar to those used in the Transport A method, are used to instigate data that was previously sent. They can either present an invitation to go interactive or execute a script function. Just like IP Multicast content, triggers are sent in lightweight, compact UDP/IP packets.

CHAPTER SUMMARY

- The ATVEF delivery methods of Transport A and Transport B use IP as a reference binding, the glue defining how a content specification runs on a given network.
- Transport A is the most commonly used delivery method, sending out triggers (links) through the VBI of a broadcast and pulling data, the HTML pages with their supporting graphics, from a back channel.
- Transport B offers the capability of delivering both triggers *and* data by the forward channel, and the return path is optional.
- Triggers are the synchronization component of your Enhanced TV show.
- The what, when, and where of triggers should be thoroughly pre-planned with your network, and your content prepared accordingly.
- An exciting possibility of Transport B is the implementation of IP Multicast, a one-to-many delivery system of data with many advantages for the broadcaster and the ITV content viewer.

- In order for Transport B to be fully realized in the ITV delivery environment, TV broadcasters must fully transition to digital transmission infrastructures, and broadband IP must become accessible to the consumer mainstream.

CHAPTER 10

Hands-On

Editor's Note: This book went to press prior to the tragic events of September 11, 2001, and no disrespect is intended by the inclusion of the project within this chapter.

IN THIS CHAPTER

- Part 1: Napkin Sketch Assignment
- Part 2: Constructing a Design
- Part 3: Building the Interface Functionality
- Chapter Summary
- Top 12 Suggestions for ITV Developers

This chapter is a three-part practical guide to help you make a TV/Web-compatible interface design and prototype. The first part is a brainstorming task to stimulate ideas and excitement for your project. Part Two dives into Adobe Photoshop and presents some practical approaches to creating a TV-specific Web design. Finally, using Macromedia Dreamweaver, Part Three is an HTML dissection of an ITV frameset and overlay interface, currently the two most common front-end development structures for STB applications.

Note

No prior knowledge of graphic or Web design is necessary to move through these lessons and grasp a general understanding of the material. However, a basic understanding of HTML helps, and to fully execute your own Enhanced TV pages requires an intermediate level of Web development experience.

1: Napkin Sketch Assignment

TUTORIAL

When I teach seminars and courses in Web and ITV design, I encourage my students to step away from their computers, office cubicles, and technical tools when formulating their ideas. As is so often the case, our best ideas come to light when we are not bogged down by the stress of work and everyday life. The epiphanies that come to us, for example, after a glass of wine at dinner; a clairvoyant moment where you're searching for a pen and paper to jot down your fleeting idea before it passes into the night. With any luck you scribble your idea on a cocktail napkin, usually the only available writing surface at a dinner table. This moment I call "napkin sketching."

When ruminating over the design functionality of your ITV show, put yourself in the "napkin sketch" space. Have available lots of paper and some colored writing utensils (I prefer the 96 pack of Crayola crayons). Give yourself some guidelines to hone in on your ideas. A recommendation is to review and adhere to the design considerations covered in Chapter 8, "The Creative Tool Set."

Also keep these two questions in mind when determining the "look and feel"—the colors, fonts, textures, and navigational elements—of your idea:

- What is my show's type and purpose (educational and fun, pure entertainment, character driven, etc.)?
- Who is my audience (kids, adults, young, old…)?

When you really start cooking with your brainstorm, create a series of three or four sketches graphically depicting the navigation between pages, and how

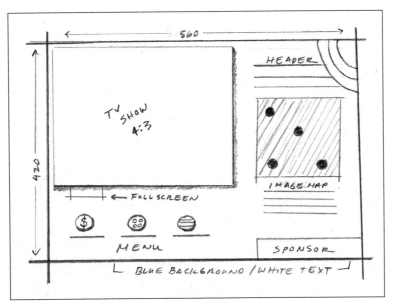

FIGURE *Author's example napkin sketch for the design used in this hands-on lesson.*
10.1

the enhancements used—linked, constant, synchronous—will deter or benefit the overall design. Use your sketches as a reference for the continued development of the project (Figure 10.1).

Don't worry too much about the actual implementation of the design quite yet. This will be further defined in the coding phase, and in the ultimate moment when you test your prototype on the chosen platform.

PART 2: CONSTRUCTING A DESIGN

TUTORIAL

In this lesson, you will learn the following in ITV specific design:

- Setting up the proper design area dimensions for TV
- Creating a safe border area
- How to select and apply NTSC safe colors
- Define the "look" of a frameset (picture-in-picture) ITV layout
- Positioning a "for placement only" TV Object in the proper 4:3 aspect ratio
- Creating easily readable text elements
- Creating a full screen graphic
- Testing for NTSC safe colors

LESSON SETUP

For this tutorial, you will need Adobe Photoshop, and some familiarity with working with graphics programs. Photoshop and Image Ready (which comes packaged with Photoshop versions 5.5 and later) are two programs you definitely should consider for your digital design tool box. The combination of both programs is all you'll need to manipulate and prepare digital imagery for both print and Web design. You can download a free trial of Photoshop/Image Ready from www.adobe.com. In the free trial, however, you will not be able to save your changes, but for purposes of learning this might suit you. If you don't have access to Photoshop, you can view a JPEG of the final template created in this tutorial on the CD-ROM—lessons/part2/demos/design1d.jpg. For a completed Photoshop version with all the layers, see lessons/part2/demos/design1d.psd. Both of these files can be used as references for this lesson (Figure 10.2).

ON THE CD

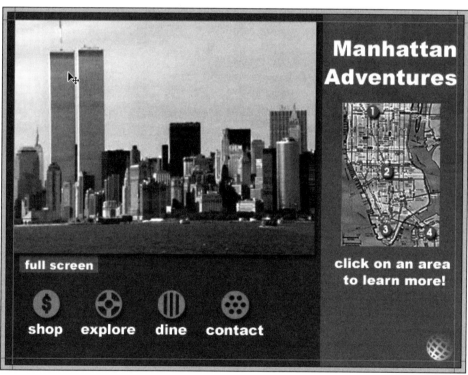

FIGURE 10.2 *Hands-On ITV tutorial design, created in Photoshop.*

ON THE CD

The files for this tutorial are found on the companion CD-ROM, in the lessons/part2 folder. Copy the complete lessons folder to your computer desktop for easy accessibility.

Design Dimensions

The first thing to be defined in our design is its file dimensions, its resolution (a concept covered in detail in Chapter 8). Depending on which platform you will use, the dimensions will vary. The TV screen real estate can be thought of as divided into three resolution areas:

- **Full-screen resolution.** For NTSC, this is 640 × 480, a 4:3 aspect ratio.
- **Viewable area.** This takes into consideration overscanning and safe borders. For the WebTV and Liberate boxes, for example, the viewable area is 560 × 420. Most ITV browser applications automatically size an ITV program to fit within the safe areas.
- **Usable area.** This is the area minus the space taken up by a specific platform's browser interface. This number varies for each middleware application. Designers are encouraged to read the screen dimension guidelines from the specific provider. For example, AOL TV's usable design area is 585 × 386; for WebTV, it's 544 × 378.

For purposes of this assignment, this design will be constructed using the viewable size area of 560 × 420.

Setting Up the File

1. Open Photoshop. Choose File>Preferences>Units & Rulers, and under Rulers choose Pixels. Click OK (Figure 10.3).

FIGURE 10.3 *Photoshop Units and Ruler Preferences.*

2. Choose File>New, and set the width and height to 560 × 420, resolution to 72, and mode to RGB Color. Call the file *design1* and click OK.

3. Choose File>Save As and save the file in Photoshop format in your lessons folder as design1.psd.

4. For demonstration, let's create an 8-pixel title safe area around the documents.

Note

The use of 8 pixels is arbitrary; eventually, you will create guides based on the guidelines of the platform you will use.

Choose View>Show Rulers. The ruler around the edge of the document should be in pixel dimensions.

5. Select Window>Show Info. Choose the Move Tool (V) in the Tool Box. Watching the Info palette, drag out guides from the horizontal and vertical Ruler edges to create an 8-pixel border frame (Figure 10.4).

FIGURE 10.4 *The X, Y of the Info palette to position guides.*

Based on the 560 × 420 document size, the guides should be as follows:

Right, x-dimension = 8 pixels
Left, x-dimension = 552
Top, y-dimension = 8 pixels
Bottom, y-dimension = 412

FIGURE 10.5 *The Foreground color swatch and the corresponding Color palette.*

CHOOSE THE BACKGROUND COLORS

1. Double-click on the Foreground color swatch in the tool box (Figure 10.5) and put in the following RGB colors:
R = 51, B = 51, G= 102 or type in the hexadecimal Web-safe color of #333366. Click OK.

Note

This color, as all that are in this lesson, is within the NTSC-safe, Web-safe, and printable color palettes, and aims to be aesthetically pleasing to the perceptual color space of the human eye.

2. Choose Edit>Fill to fill the selected document with the dark blue, foreground color.

DEFINING THE FRAMESET "LOOK"

This design will eventually be reconstructed into two HTML frames (see Part Three). Let's define the look of these frames by color. The left side will contain

the TV object and will have the dark blue background. The right side will contain the dynamically updated information and will be a medium blue—let's define the color of this side.

1. Double-click on the Rectangular Marquee Tool (M) in the tool box to bring up its options, and choose Style>Fixed Size (Figure 10.6).
 Enter the following fixed size: 172 W, 420 H.

FIGURE 10.6 *The Rectangular Marquee tool and its corresponding options box.*

2. Click and drop this fixed selection along the right side of the document. (Note: a selection in Photoshop looks like a dotted line of crawling ants.)

3. Create a new layer in the Layers palette (Window>Show Layers, if not already visible) and call it *rightframe* (Figure 10.7). Label the other background layer *leftframe* (to do this, double-click on the Layer icon and enter in a new name in the options box).

4. Double-click on the Foreground color swatch in the tool box and put in the hexadecimal color #666699, or R=102, B=102, G=153.

5. With the rightframe layer selected in the Layers Window, go to Edit>Fill and fill the selected area with the medium-blue color. Select>Deselect to view.

6. Choose File>Save and save your file!

POSITIONING THE TV OBJECT

For placement purposes, it's a good idea to include a screen still of your show (or an image of what it will be like) in your design template. In the "real world," of course, this image will be replaced by the video footage. It's imperative that

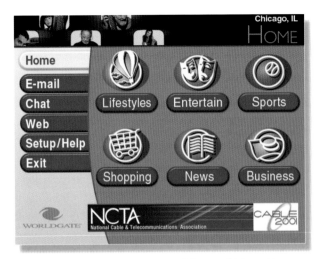

Color Plate 1 Sample image of the WorldGate ITV user interface. (© Copyright WorldGate 2001.)

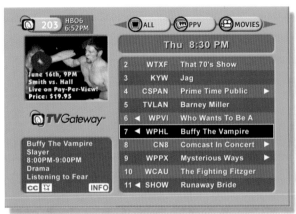

Color Plate 2 Sample image of the WorldGate electronic programming guide. (© Copyright WorldGate 2001.)

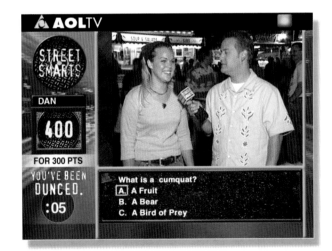

Color Plate 3 A picture-in-picture Enhanced TV interface on the AOLTV platform. (© Copyright 2001. Reprinted with permission from AOL.)

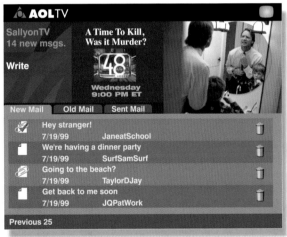

Color Plate 4 AOLTV's ITV e-mail service. (© Copyright 2001. Reprinted with permission from AOL.)

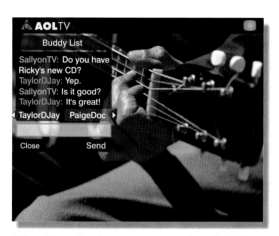

Color Plate 5 A transparent overlay of AOLTV's Instant Messenger ITV service. (© Copyright 2001. Reprinted with permission from AOL).

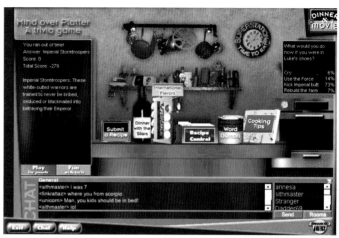

Color Plate 6 Screen shot of TBS Superstation's Enhanced Dinner and a Movie 2-screen interactive program. (© Copyright 2001 Turner Broadcasting Systems, Inc., An AOL Time Warner Co. All Rights Reserved.)

Color Plate 7 Enhanced TV case study design for SpinTV's NASA interactive prototype. (© Copyright 2001. Reprinted with permission from SpinTV, Inc.)

Color Plate 8 Enhanced TV case study design for SpinTV's Animation Station interactive prototype. (© Copyright 2001. Reprinted with permission from SpinTV, Inc.)

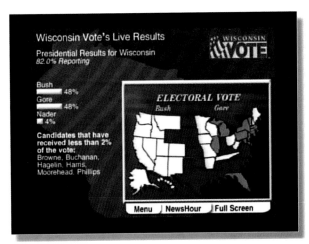

Color Plate 9 An Enhanced TV screen shot from the Wisconsin Vote *project, a localized broadcast of the 2000 Primary Elections in conjunction with the national broadcast of* The NewsHour *with Jim Lehrer. Presented on the Microsoft WebTV platform. (© Copyright 2001. Reprinted with permission from the University of Wisconsin-Extension, Wisconsin Public Television.)*

Color Plate 10 *A selection from the* Music from the Inside Out *ITV prototype, presented on the Liberate platform. (© Copyright 2001. Reprinted with permission from Anker Productions, Inc.)*

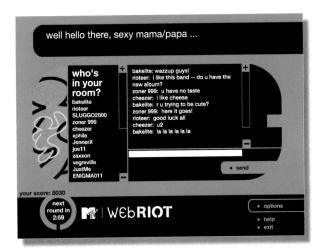

Color Plate 11 *The chat feature of MTV's webRIOT, an award-winning, 2-screen interactive program. (© Copyright 2001. Reprinted with permission from Spiderdance.)*

Color Plate 12 *The synched-to-broadcast game feature of MTV's webRIOT. (© Copyright 2001. Reprinted with permission from Spiderdance.)*

Color Plate 13 *An Enhanced TV interface for Discovery Channel's Extreme Rides. (© Copyright 2001. Reprinted with permission from the American Film Institute.)*

Color Plate 14 *Game interactivity based on the television program 15–1 produced by Regent Productions for Channel 4. (© Copyright 2001. Reprinted with permission from Two Way TV.)*

Color Plate 15 *A screen shot of Showtime's Interactive Boxing program. (SET Pay Per View boxing event, courtesy of Showtime Networks Inc. © 2000 Showtime Networks Inc. All rights reserved.)*

CHAPTER 10 HANDS-ON

FIGURE 10.7 *Creating and naming a new layer.*

the video be the focus of the stage, as this design dictates. To further highlight the TV Object of this design, it will also include a subtle drop shadow element.

1. Create a new layer in the Layers palette, and call it TV frame.
2. Create a fixed marquee selection of 372 W and 279 H, and place it in the upper-left corner snug to the edge of the guides.
3. Fill the selected area with a gray color (the exact color doesn't really matter, since we won't actually see this box, only its shadow—next step).
4. Choose Layer>Effects>Drop Shadow and assign the effect. Click OK.

Note

FYI: If you need to modify an effect later, simply double-click on the effect icon on the layer of the object you want to adjust. If you want to copy and paste an effect, right-click (PC) or command-click (Mac) over the icon for its options (Figure 10.8).

5. Select>Deselect and save the file.
6. Choose File>Open and open the city327.jpg in the lessons/part2/images folder. This image has a resolution of 327 × 279, adhering to the necessary 4:3 ratio.

FIGURE 10.8 *Copying a Layer Effect.*

Note

For use on your own, included in the images folder is a city560.jpg that you may crop down to your liking. To adhere to the 4:3 ratio, simply choose Image>Image Size and enter your desired pixel dimension width in the options box (Figure 10.9). If "constrain proportions" is checked, it will automatically update the height to the proper ratio. To determine a 4:3 ratio from scratch, simply determine your desired width amount and multiple it by .75 to get the height dimension (e.g., $640 \times .75 = 480$).

FIGURE 10.9 *Setting the 4:3 pixel ratio of the city560.jpg.*

7. Select the complete image—Select>All and with the Move Tool click and drag the image to your design1.psd. This will copy the image to your design file and create its own layer.

 Alternatively, you can Select>All, choose Edit>Copy, move to your design file, and then Edit>Paste.

8. Double-click on the new layer and rename it TV image.

9. Position the image over the TV frame in the upper left corner of the document.

10. Close the city372.jpg file (you're done with this image).

ADDING A BACKGROUND ELEMENT

1. Choose File>Open and open the target.psd found in the images folder. Select and copy the image to your design document, and rename the layer "target".

2. Place the target image in the upper-right corner.

Note

If you're familiar with Photoshop try experimenting with some Layer blends on the target layer. In the demo file, the Multiply blend is used (Figure 10.10).

3. Close the target.psd and the design1.psd file. Save.

FIGURE *Adjusting Layer blends.*

INSERTING THE IMAGE MAPS

The navigational elements in this design will be links within two image maps, the main menu and the Manhattan map. The far, lower-right corner will be reserved for sponsor logos and ads—let's add this element as well.

Remember, for visual reference refer to Figure 10.2.

1. Open the menu.tif found in the images folder. Select and drag and copy to your file. Place in the lower-left corner of the template. Call its layer *menu*.

2. Open the map.gif, select and copy to your file, and place it in the center of the rightframe bar. Call its layer *map*.

3. Finally, open the logo.tif, select and copy to the file. Place in the lower right, bumped to the edge of the 8-pixel border (Figure 10.11). Call its layer *logo*.

4. Close the menu.tif, map.gif, and logo.tif files and save the design1.psd.

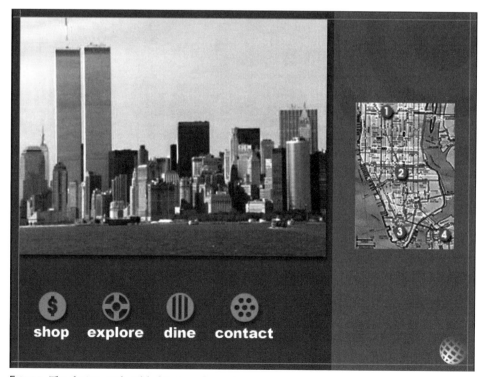

FIGURE 10.11 *The design with added image elements.*

ADDING TEXT

Let's include three textual sections: a header, "Manhattan Adventures" which will eventually be in HTML text; a "click here" request, also to be in HTML; and a "sponsored by:" line, which will become a graphic image including the spherical logo.

1. Select the Type Tool (T) in the tool box. Click anywhere on the document to open the text options. In the dialog box, type in "Manhattan Adventures".

 Select white for the font color, and Arial Black for the font type (Figure 10.12).
 Font size = 24, Leading = 30, Tracking = 8
 Click OK to close the Type tool box.

FIGURE 10.12 *The Type Tool option box.*

Note

In this design, a common, sans-serif font is used: Arial, Bold. Well-spaced fonts that are light on dark backgrounds are easier to read from far distances, as is the case when watching TV.

2. Position the text in the upper-right corner of the design above the map image.

Note

To edit text in Photoshop double-click the Text icon in the Layers window on the layer of text you want to edit.

3. Create another line of text below the map, something like "click on an area and learn more!" to encourage the user to select one of the numbers on the map and view further information in that frame.

4. Finally create a line of "sponsored by:" text and place in front of the spherical logo in the lower-right corner. Arial, Bold Italic, 16 pt., hexadecimal red color: #993333.
Refer to Figure 10.2 for visual reference.

THE FULL-SCREEN LINK

A most important element to include in your interface is the full-screen button; this will be the visual/textual indicator for the viewer to go back to regular TV viewing if desired. It should be placed prominently on the page and near the TV Object. On your own, create the full-screen text and colored background box. Save your file.

TEST FOR NTSC SAFE COLORS

Photoshop has a filter designed to convert colors to the NTSC palette. While this is a great tool to get a sense of how colors might or might not work in your design, be warned, it doesn't replace a true test of the project on its designated viewing platform. Also, computer monitors individually have different brightness and contrast settings, so what you see will not be exactly what you get.

1. To use the NTSC filter, you must flatten your file. First, preserve your original file by saving it under a different name. Second, in the Layers options menu, choose Flatten Image to merge all the layers. (The Layers Options menu is a drop-down menu found under the arrow in the upper-right corner of the Layers palette.) Choose Filter>Video>NTSC colors to convert the document's color to NTSC safe. You should not see much of an adjustment, since we used NTSC safe colors from the start.

2. Save your file. You're done with this design.

3. For comparison, open the file part2/demos/ntsc_test2.psd. This is a version of the file with a questionable color palette; apply the NTSC filter to see the change (Figure 10.13).

CHAPTER 10 HANDS-ON 175

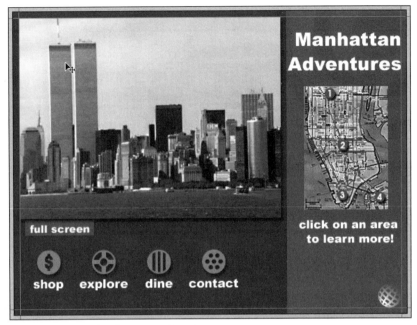

FIGURE *The completed ITV interface design.*
10.13

PART 3: BUILDING THE INTERFACE FUNCTIONALITY

TUTORIAL

For the integration of Web on TV, the two basic, front-end development layouts are framesets and overlays (for real-world visuals of both these structures, see the center color section of this book). Which structure you might use depends on your content—how much there is, and how visually you might choose to present it in relation to the TV image. Using Dreamweaver, this lesson is a dissection of the coding and functionality of both the overlay and frameset (embedded picture) Enhanced TV layout options.

Overlays are interactive elements that lay over a full screen television picture. Overlays are an ideal approach for presenting small amounts of information to the viewer, such as scrolling statistics, polling information, and simple instructions. While some interactive services support transparent-type overlay backgrounds, keep in mind that overlays have the limitation of obscuring a TV picture.

The embedded TV picture method forces a smaller TV image, but doesn't obscure the picture. This method is usually created using HTML framesets, which offers the advantage of presenting more and varied information.

In this lesson, you will learn the following ITV-specific HTML properties, as well as a bit about Dreamweaver:

- The ATVEF-compliant code for TV placement in an overlay structure
- The ATVEF-compliant code for TV placement in a frameset structure
- The use of CSS for positioning page elements
- What's a z-index
- The difference between graphic vs. HTML text
- Sample protocol to send a viewer back to full-screen mode
- The use of the Trigger Receiver object

LESSON SETUP

From the CD make a copy of the lessons folder, if not already done, to your desktop. Keep all files and filenames intact to ensure the proper linking of all elements and images.

ON THE CD

For this lesson, please install the Macromedia Dreamweaver 4.0 trial software included on the companion CD-ROM. Dreamweaver is one of the more popular HTML WYSIWYG tools being used by Web developers today. It is also rapidly becoming a helper tool for cross-platform ITV designs. In its most recent version, 4.0, WebTV and Microsoft TV screen size templates have been added, and Dreamweaver ITV extension tools are readily becoming available, such as those provided by SpinTV—see the next chapter for details.

Alternatively, if you are familiar with HTML and prefer not to use Dreamweaver to examine the code, it can also be viewed in any text editor, such as SimpleText on the Mac or Notepad for Windows.

MOCK DEMONSTRATION OF ITV

Before we delve into the source code of the overlay and frameset example screen pages, let's get a feel for how these pages might function for the viewer. Since we don't have an STB and television set available at our fingertips, a mock demonstration of how these pages are used in an Enhanced TV environment is on the CD-ROM and can be viewed from a Web browser.

1. Open a browser, preferably a newer version of Internet Explorer or Netscape.

2. Choose File>Open File or File>Open, and browse for invitation_ov.html found in lessons/part3/overlay.

 This page is intended for visual example only. It's a representation of full-screen mode when a trigger appears inviting the viewer to "go interactive." The "go interactive" invitation link can vary in appearance depending on the ITV services and platform used. It might include a channel logo for example, or appear above, rather than below the TV viewing area.

Click on the "go interactive" button to take you to the ITV overlay (Figure 10.14). That's all for this example.

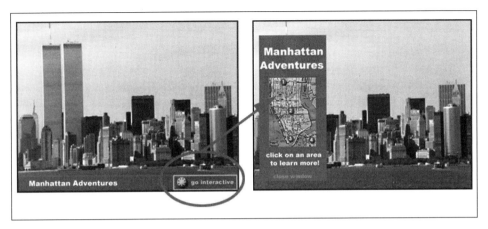

FIGURE *From invitation to overlay interactivity.*
10.14

3. Open invitation_fr.html found in lessons/part3/frames for an example of an invitation calling an enhanced frameset layout (Figure 10.15).

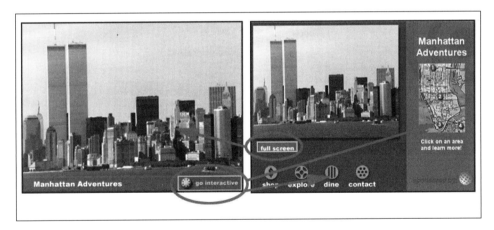

FIGURE *From invitation to frameset-based interactivity.*
10.15

Although not "hot," the menu items and map numbers in the framesets would be additional navigational elements, and when chosen would open more information within the framesets. Also indicated here is the option to go back to full-screen mode.

Note

Items that are "hot," or clickable in interactive viewing, are usually indicated by a yellow box as the user clicks the up/down/right/left menu buttons on the remote or keyboard. For a visual representation of this type of functionality, see the Wisconsin Vote demonstration on the CD-ROM.

DEFINING A SITE IN DREAMWEAVER

In order to examine the ITV-specific source code of the overlay and frameset files in Dreamweaver, we need to define a site. This is so Dreamweaver knows how to link and update image and source files.

1. Open Dreamweaver and choose Site>New Site. Under Site name put ITV Show, and then browse for the Local Root Folder—lessons—that you copied to your desktop earlier (Figure 10.16). Click once on the lessons folder to select it (do not go inside of the folder) and click Choose. Be sure the "Enable Cache" option is selected. Click OK.

 Dreamweaver asks to create the initial site cache;—click OK again.

FIGURE 10.16 *Defining a Site in Dreamweaver.*

2. A site map window for ITV Show will pop up, here is where you can navigate to find the pages you want to view (if you need to find this site map window again for any reason, simply choose Site>Open Site>ITV Show).

3. In the site map, open up the folder part3/overlay and double-click on the overlay.html. This is the same document you just viewed in the mock demo, but now it's in Dreamweaver, where it can be edited and tweaked.

VIEWING THE ITV OVERLAY CODE

1. There are several ways to view the code in Dreamweaver. A quick way is to choose the Show Code View or Show Code and Design View icons in

FIGURE 10.17 *The Show Code and Design View.*

the upper-left corner of the interface. Its icon is two brackets (< >), the tags that define all HTML instructions (Figure 10.17). Click the icon that views the code and the design in the same window, and fully open the window to view the HTML code.

2. There's no room is this book to cover the basics of HTML (although this is a prerequisite for ITV development), so let's just take a look at the part that's TV related. Provided are two variations of code: the code necessary to view this page in a Web browser (for demonstration purposes), and the code to prepare this page for STB viewing. The TV-specific viewing code is within comment tags starting with < !— and ending with — >. Browsers ignore comment tags, so you can use them to create notes for yourself or other developers within the source code.

THE IMPORTANT "TV:" SYNTAX

1. In this example, ATVEF code that defines the placement of a TV Object on a page—the actual instruction to insert the TV video into a specified space—is as follows:

```
<TD width=560 height=420 style="background: url (tv:)">
     Here is the content that is overlaid on top of the TV picture
     inside this table cell.
</TD>
```

This code, of course, varies slightly depending on whether the TV placement is within a background of a table structure or used as a background for the whole

page. If it is a background element for the whole page, the syntax would be as follows:

```
<body style= "background: url (tv:)">
```

As you can notice, the "tv:" attribute is the key—you must have the "tv:" attribute somewhere in your page in order for the TV portion of the interactivity to be inserted in the page correctly.

2. Close overlay.html

ANOTHER WAY TO INTEGRATE TV WITH WEB PAGES

1. Open overlay2.html in Dreamweaver. To do this, double-click on the page in the Site window of ITV show, or choose File>Open and browse for it on your desktop. View the source code.

2. In the code, notice the Object Data comment tag—here is another way to get that "tv:" object into the page.

```
<OBJECT DATA="tv:" width="100%" height="100%">
```

Also, you can simply use the tag:

```
<IMG SRC="tv:" width="640" height="480">
```

THE USE OF CASCADING STYLE SHEETS

Using Cascading Style Sheets (CSS), as discussed in Chapter 8, is an easy way to define the positioning of an object or apply consistent styles (font, image attributes, etc.) to elements on a page or multiple pages. Let's examine how CSS can be used to position the overlay element.

1. View the Code of the overlay2.html document. This overlay is created using CSS, noticeable by the <DIV style> tags. You can define the absolute position of your overlay image by simply adjusting the top and left pixel numbers of the code. Look closely at the syntax for the Manhattan Adventures overlay (note: to easily verify the code for the placement of the overlay, click on the image in the scene, and the code will highlight in the view code window). Currently, it looks like this:

```
<DIV style="position:absolute; left:20; top:20; width:164; height:261; z-index:1">
<IMG src="images/overlay_img.jpg" width="172" height="370">
</DIV>
```

2. For example, typing directly in the code window, change the left and top attributes to 50 and 50 pixels. Press F5 on your keyboard to refresh the view. To test directly in a browser, select F12 or File>Preview in Browser.

Note

To edit the default browser setting in Dreamweaver, choose File>Preview in Browser>Edit Browser List. I recommend using the most up-to-date version of a browser, such as Internet Explorer or Netscape, for viewing.

```
<DIV style="position:absolute; left:50; top:50; width:164; height:261; z-index:1">
<IMG src="images/overlay_img.jpg" width="172" height="370"></DIV>
```

Extra credit: try positioning the image to the upper-right corner, or lower corner.

THE Z-INDEX ATTRIBUTE

The z-index attribute of the overlay image source code defines the graphical layering of elements above and below each other.

All objects that define a coordinate system are positioned by default with a z-index of 0. Elements can be positioned above or below this coordinate plane; a negative z-index sends an object below, a positive number above. For example, an image at index –1 is below an image at 0, which is below an image at level 1 or 2 or 3…

Elements whose z-index values are not implicitly defined are assigned a z-index according to their source order in the document. An element defined later in a document will be positioned above elements defined earlier in the document

To illustrate this, send the TV object city560.jpg in front of the overlay_img.jpg in the overlay2.html. Change the z-index of the TV Object to any number above 1 (the current index of the overlay). Press F12 to view in a browser. Once you have an idea of how this positioning works, return the TV object's z-index back to 1 (its original state).

IMAGE WIDTH AND HEIGHT

To ensure a quicker download of images, it's best to define an absolute scale, a height and width in pixels, of each image, as indicated for the overlay_img.gif.

```
<IMG src="images/overlay_img.jpg" width="172" height="370">
```

For the TV Object, however, you might choose to use a relative scaling, a height and width based on percentage, to move proportionally in relation to other elements on the page.

```
<OBJECT DATA="tv:" width="100%" height="100%">
```

Note

Most STB applications automatically resize images that are wider than 560 pixels, unless the image is used as a background. Also automatic, if necessary, is the 4:3 ratio sizing of a TV Object within its allotted area of the document.

CSS Absolute and Relative Positioning

Absolute and relative scaling in CSS syntax is the same concept as using absolute and relative scaling for an tag, as discussed earlier. In our example, `position:absolute` defines an absolute top and left pixel amount, removing the item from the flow of other objects on the page. `Position:relative` will also define a documents area, but keep it within the document flow.

```
<DIV style="position:absolute; left:20; top:20; width:164; height:261;
z-index:1">
```

Close the overlay2.html; we are done dissecting this page.

Viewing the Frameset Source Code

1. Open the frameset.html in the lessons/part3/frames. (Remember, you can also access this page by double-clicking on the document in the ITV Show Site window.) This frameset defines the space for two frames; the left side holds the tv.html, the right holds content.html.

2. Choose View>Visual Aids>Hide All to hide any visible helper icons on the page.

3. Let's view the frameset code for each of the three pages shown. The easiest way to do this is to use the Frame window; choose Window>Frames.

 While clicking on the tvFrame and contentFrame indicators in the Frame window, view your selection in the source code window (you might need to turn on the Show Code and Design View icon).

 To select the complete frameset, click on the outer border of the Frame window (Figure 10.18).

CHAPTER 10 HANDS-ON

FIGURE 10.18 *Selecting the frameset in the Frame Window.*

4. To select and modify the actual pages positioned in each of the frames, simply click on an element in the document; for example, click on the TV Object image (the photo of Manhattan) and the code for tv.html will be made available in the source code window.

THE FULL-SCREEN LINK

1. Click on the full-screen image and view the source code. Examine the comment for the full.gif image, a new ITV specific syntax.

```
<A HREF="tv:" TARGET="_parent" SELECTED>
<img src="images/fullscr.gif" width=98 height=21 alt="" border="0"></a>
```

The syntax in this comment is an example of how to indicate the link back to full-screen mode on the fullscr.gif in the TV viewing environment.

Although not an ATVEF-specified syntax, this code also identifies the full-screen button as the starting selection for the viewer's navigation of all page links, indicated by the word SELECTED. In the TV environment, this full-screen link might be highlighted in yellow when selected.

IMAGE MAPS

While not functioning in this example, image maps and/or rollover links are often used in Enhanced TV programs. When using image maps, it is recommended to keep the hotspots, links, rectangular.

1. To see the rectangular, image-map hot spots in this example, choose View>Visual Aids and uncheck all. They will be highlighted in blue on the design (Figure 10.19).

FIGURE 10.19 *Highlighted rectangular, image-map hot spots in Dreamweaver.*

2. Select one of the blue boxes and choose Windows>Properties to see the properties of the image map (Figure 10.20).

FIGURE 10.20 *The Image Map Properties window.*

HTML TEXT VS. GRAPHICAL TEXT

1. Select the "click on an area and learn more" text and notice its syntax in the code viewing window:

```
<FONT size="4" face="Arial, Helvetica, sans-serif"><B><FONT color=
  "#FFFFFF">Click on an area<BR> and learn more!</FONT></B></FONT>
```

2. This text is defined as HTML text, not as a graphic image. HTML text loads faster than graphical text, but be aware of your size and font selections. HTML text of size 3 and 4 is recommended, equivalent to an 18–20 point sizing on a TV screen.

TRIGGER RECEIVER OBJECT

The last syntax to be dissected here is the trigger receiver object, an instruction that waits to execute a defined JavaScript. The script will be executed when its corresponding trigger link is encountered during an enhanced program. We learned about creating trigger links for invitations and scripts and how they are sequenced in Chapter 9.

A receiver object actually has two parts: the script, usually defined in the <head> of the document, and the receiver object instruction. The following is a sample instantiation, indicated in comment tags in the content.html (the right side of the frameset).

The script (this example sends the viewer automatically back to full screen mode):

```
<script language="javascript">
    function goFull(){
        window.top.location.href="tv:"
    }
</script>
```

and the receiver object:

```
<OBJECT TYPE="application/tve-trigger" ID="objReceiverObj">
```

Note

If a page consists of multiple frames, such as our example, only one frame may contain a receiver object.

CHAPTER SUMMARY

- Napkin sketching is a condition where your best ITV show ideas can come to fruition—a creative space to think away from the office, the computer, the stresses of life.

- Once your ideas are formulated, construct an interface design in a graphics program, such as Adobe Photoshop.
- There are two types of development structures for placing Web elements within a TV environment: overlays and framesets (embedded picture format). Both of these structures can be built using a WYSIWYG editor, such as Macromedia Dreamweaver.
- Overlays are interactive elements that lay over a full-screen television picture. Overlays are ideal for presenting small amounts of information to the viewer, such as scrolling statistics, polling information, and simple instructions.
- The embedded TV picture method, while it forces a smaller TV image, doesn't obscure the picture. This method is usually created using HTML framesets, which offers the advantage of presenting more and varied information.

TOP 12 SUGGESTIONS FOR ITV DEVELOPERS

These highly recommended suggestions, listed in no particular order, come straight from the source, compiled from discussions with industry experts highlighted in this book.

ROB DAVIS, EXECUTIVE PRODUCER, SPIDERDANCE

1. Design tomorrow's experience for yesterday's box. Why? New entertainment is what the public clamors for, and yesterday's box and its inherent technology have the wide deployment base you need for success.

2. For software centric people: respect deadlines. In TV, there is no such thing as a delayed release date; your deadlines are firm.

3. For TV-centric people: get ready for user testing and usability testing on your ITV app that you don't normally need for passive TV shows.

4. Work to design a seamless experience between TV and PC viewing, such as creating matching colors schemes and parallel screen transitions.

5. Over-proofread your work; typos are not acceptable in TV.

 A disconnect with TV and Web people, the philosophy, is that TV producers will user test, focus group a show, but never technical test a TV show. They know it works. So, there's something to get used to, to be comfortable with the fact that you have to beta test, and proof TV shows, ongoing, throughout operations.

6. Thoroughly think about the user experience. For example, if you give viewers a clickable ad banner, they're going to use it. Do you want them to do that? Are you sure? It's all about control. The screen is yours, no matter what platform you're on. There is nothing clickable unless you make it so. There's no functionality unless you build it. So make sure all the functionality enhances the TV experience. The first thing that takes away the experience will be what starts to sink your project—whether from a user perspective or a business perspective.

ERIC BANGERTER, ITV DEVELOPER, UNIVERSITY OF WISCONSIN-EXTENSION

7. Buy a delivery box that you can test on, and choose one platform—don't try to develop for all the boxes right out of the gates.

8. Don't be afraid to try new things. Audiences are new to ITV, so they do not have any expectations.

9. Assign a full-time point person to organize the project and make final decisions about the content.

DANNY ANKER, PRODUCER/DIRECTOR, ANKER PRODUCTIONS

10. You have to continually ask "why?" Does the interactivity add to and support the content presented? Does it detract from it? Is it simply a game? Or are you experiencing something new by interacting that is related to what's happening on the television?

ANNA MARIE PIERSIMONI, ASSOCIATE DIRECTOR, NEW MEDIA VENTURES, AFI

11. TV producers need to embrace the medium to get past the fear of it and fully contribute. They need to get "underwhelmed" by the technology and steer the true direction of the product. It is an educational process and cannot be learned "overnight."

SCOTT AND BRIAN LILLIG, FOUNDERS OF SPINTV

12. An innovator should start by getting familiar with the different platforms that exist in today's market. A good mindset would be to develop for what works today, because one can get very confused when entering the ITV space because of the overlap in many ITV company business models.
 Education and understanding of the market is key.

PART III

Projects

CHAPTER 11

SpinTV

IN THIS CHAPTER

- Words from Brian and Scott Lillig of SpinTV
- Overview of the SpinTV Studio Suite
- Using the TV Embed Feature
- Sample Enhanced TV Content Interfaces

We'll kick off the Projects section with SpinTV, representing the perfect segue from conceptual development processes to real-world implementation. SpinTV made a big splash at NAB[1] 2001 when they debuted their pre-release of the SpinTV Studio Suite, a set of ITV-specific extensions for Macromedia Dreamweaver used to create ITV layouts that aid in production automation and team efficiency.

In this chapter, SpinTV founders Brian Lillig and Scott Lillig discuss their company, their tools, and their ITV visions. Also included is an overview of the SpinTV Studio Suite, a tutorial highlighting one of the ITV Dreamweaver extensions, and project images. Provided on the book's CD-ROM is a fully functional pre-release version of the SpinTV Studio Suite extensions, currently for PCs running Windows 98/NT/2000. The advanced suite of tools is expected to be available in December 2001, and the Mac version to be released in the second quarter of 2002.

ON THE CD

WORDS FROM BRIAN AND SCOTT LILLIG OF SPINTV

First, share a bit about your backgrounds and how you ended up with a company with such a fun name as SpinTV.

In the mid-nineties, Scott was just returning from a two-year tour with Planet Hollywood Multimedia-France. Brian had just finished a position with the United Video Satellite Group (now TV Guide) and luckily, both ended up in Dallas at the same time the Internet was beginning to commercialize.

After about one year of massive Internet growth and building on personal experiences in Web technologies, we revisited some of our earlier predictions within several emerging growth sectors and found ourselves right on target. We decided it was prime time for both of us to pull together and start on the pioneering trail.

We obviously knew each other well enough to know our own strengths and weaknesses, and after several strategic meetings we were confident enough that we had what it took to spin the existing technologies together into broadband solutions for the World Wide Web. So, we launched our own company and SpinDev Broadband Media was born.

Spending roughly two years developing solutions for many of the top companies in the industry, we started seeing the term *gold rush fever* take on new meanings and many agencies jumping into the dotcom arena.

During the peak of the "dotcom," we went back to our long-term predictions and began focusing on global media development and solutions. While living in Europe, Scott had experienced first hand a somewhat different ap-

[1] The National Association of Broadcasters, www.nab.org.

proach to the Internet through interactive television that was similar to the all too familiar North American WebTV service.

We delved deep into extensive research, focusing on taking advantage of today's existing television broadcasting systems and devices and combining them with the force of the Internet, and found out there was an industry already starting to evolve in this sector. With what we discovered, we decided it was time to separate ourselves from the "dotcom" pack and take on something that would take us into the future, and then the day came for the announcing of the new company focus and name change, on Feb. 1st 2000, SpinTV was official.

I understand the driving force of SpinTV is to create ITV development software tools that can be used across many ITV delivery systems. Explain why your tools are unique and receiving national attention.

The earlier days of SpinTV consisted on focusing the majority of our business resources primarily on services for developing enhanced content and applications for various North American set-top box environments. In the process we ran into every pothole you can imagine working in a new and evolving industry, due not only from too many competing and immature standards, but a lack of ITV-specific tools to streamline the production process and integrate with today's existing systems. It was obvious that interactive television content production was still premature for primetime television and was used mainly for testing and analysis research through smaller controlled ITV deployments at the time.

During this early phase we discovered that most of the content development process required extensive partnering arrangements in several areas such as set-top box middleware providers, cable companies, third-party providers, and advertisers. Also, a growing demand to piece together a solution that adheres to the many set-top specifications and deployable to the widest available audience not only for the television but the PC as well, using tools that had not been originally targeted or tested for this type of convergence production development.

We finally took a step back and realized the challenges others would have to face trying to enter or even test the waters in the ITV market. These challenges included a lack of ITV-specific tools, definitive open standards, along with a growing tension between Web development teams and television programmers trying to understand one another's systems, production methods and business models. After more research and surveys in the ITV industry, we realized the strong potential and demand for a product that could be used today; plug in to the most widely used tools and not have to spend a lot of time learning another standalone application or unique skill set.

We decided then the best strategy for SpinTV is to be known as the bridge in the industry by building from our experiences and applying our newly acquired skills to produce tools based on open technologies. Technologies that would integrate with today's existing authoring tools, and legacy systems streamlining the production process for ITV development and deployment.

The first version of the SpinTV Studio Suite targets an application that works today on many devices, especially the Television and PC's Web browser. One of our strongest partners, Macromedia has already been recognized as a neutral company in the Web developing industry and currently has one of the largest and loyal developer bases globally. Macromedia not only has built one of the most popular WYSIWYG authoring suites in the world, but also one of the most extensible. This is considered one of the unique key points in our product strategy—to break down the barriers in ITV production by building an ITV suite of generators or also known as wizards that plug in to the existing Macromedia suite, allowing developers to prototype, build, and test new Web content or pre-existing content on multiple set-top browser environments locally on a PC.

Another unique point is the target audience for our products, the non-commercial as well as the commercial Web developer, agencies providing multiscreen solutions, and, of course, the ITV-specific industry. Today it seems you're either TV or you're Web, and this attitude is still lingering in the ITV industry. We believe that these conventional and non-conventional models have to blend immediately starting with tools that can produce for the lowest common denominator, such as analog and 3.0 browsers and are able to grow into the latest digital multimedia technologies.

What technologies, business models, concepts do you see driving the industry forward or holding it back?

My crystal ball tells me there is a lot of work to do before ITV becomes widely deployed. The technologies are out there, they now need to be connected or integrated together to build a production and distribution infrastructure. The space is not government regulated; therefore, plenty of opportunity exists. Consolidation will drive the force of ITV becoming reality with technologies becoming stronger as the standards bear being set in stone. As broadband deployment becomes more widespread, the demand for ITV will become stronger.

It is just about time for the creative community to see the light and do what they do best with what works today and into tomorrow. The creative community is forced to build successful business models that surround content to deploy synchronized interactive content applications to multiple devices and platforms.

From your experience, what advice would you give to innovators interested in getting into ITV content development? Where should they start, what would be a good mindset, and why should they do it?

An innovator should start by getting familiar with the different platforms that exist in today's market. A good mindset would be to develop for what works today, because one can get very confused when entering the ITV space because of the overlap in many ITV company business models.

Education and understanding of the market is key. Currently, there is a lot out there to disseminate. Many standards, specifications, manufacturers, and developers define the industry, and a good understanding of the market landscape is an invaluable must. Having a complete understanding of the ITV landscape should give you a good idea of the needs of the industry. By focusing on what is needed, you are able to tap into the life's blood of ITV. As with any business focus, you assess the landscape, define what is needed in the industry, and become the first ones to deliver, a first to market philosophy. As with any business venture or project, the obvious mindset should be a positive one. Sometimes all the details and information may seem overwhelming, so it's good to take things slow sometimes to really get a global understanding of what you are trying to accomplish in the industry. Why should you do it? Any great task ahead provides a sense of accomplishment when completed. But as we know in the technology world, nothing is really ever completed. The technology evolves and changes faster now than ever, and to be part of those changes provides a profound feeling of being part of the big solution. You are able to give back to society a little of what you think society should be. You shape the way people interact with the world. © Copyright 2001. Reprinted with permission from SpinTV, Inc.

OVERVIEW OF THE SPINTV STUDIO SUITE

SpinTV has developed the SpinTV Studio Suite for Interactive Television (ITV) production. The suite consists of extensions created for the most widely used development tools in the world: Macromedia Dreamweaver, and Macromedia Dreamweaver Ultradev, and provides these extensions:

- Promote "write once, publish many"—developing content one time for many different ITV platforms, such as WebTV Plus, AOLTV, and Liberate.
- Minimize production time—no need to learn a whole new software application.
- Create quality control standards for ITV development.

FIGURE 11.1 *Selecting the TV Embed area on the document. (© Copyright 2001. Reprinted with permission from SpinTV, Inc.)*

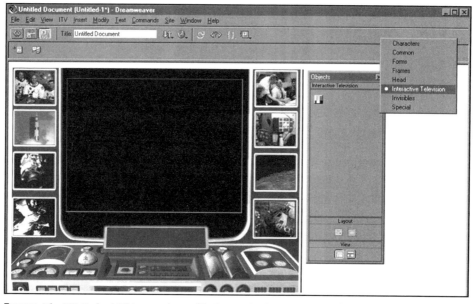

FIGURE 11.2 *The TV Embed Objects palette. (© Copyright 2001. Reprinted with permission from SpinTV, Inc.)*

CHAPTER 11 SPINTV

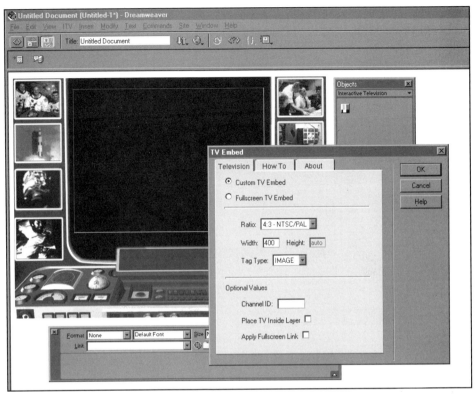

FIGURE 11.3 *Entering the properties for the TV Object. (© Copyright 2001. Reprinted with permission from SpinTV, Inc.)*

4. The TV Object is now inserted on the page and can be modified as necessary using the Properties Inspector (Figure 11.4).

5. The TV Object is now ready to receive the TV broadcast signal (Figure 11.5).

Note

The page must be uploaded to a server and accessed from a TV connected to a set-top box.

To explore on your own, a trial version of Macromedia Dreamweaver 4.0 and the pre-release version of the SpinTV Studio Suite (for Windows platform only) are available on the book's CD-ROM.

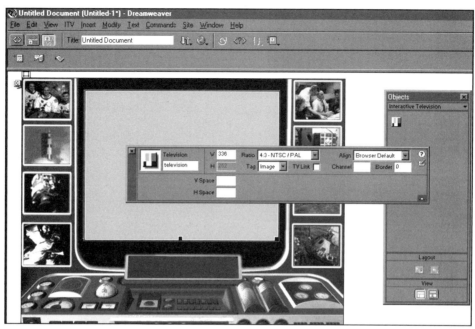

FIGURE 11.4 *The TV Object Properties window. (© Copyright 2001. Reprinted with permission from SpinTV, Inc.)*

FIGURE 11.5 *That's it! (© Copyright 2001. Reprinted with permission from SpinTV, Inc.)*

Sample Enhanced TV Content Interfaces

In this section is a sampling of enhanced content interface designs, courtesy of SpinTV. The first two images, and the images used in the TV Embed demonstration in the preceding section are taken from their NASA-Apollo 13: Houston We Have a Problem case study. (See also color screen shots in the book's insert.)

About the NASA Case Study

This particular case study was aimed at NASA's most historic and heroic space incident during Apollo 13's mission. With the wildly acclaimed movie of the same name, SpinTV thought they would revise NASA's archived movie short to include additional information and images during that harrowing mission. The design approach was to try and make the viewers feel as if they were at a control panel. This control panel acted as the main interface to delve deeper into the Apollo 13 mission details. Being a relatively short program, 28 minutes and 30 seconds, SpinTV focused on the major issues during the space flight: Crew, Launch, Problem, Supplies, Control, Scrubber, Burn, and Splashdown.

To allow the viewer the choice to engage the enhancements, SpinTV supplied eight prompting triggers throughout the program. Each trigger covered one of the detailed topics that pertained to what the viewer was watching at that moment in the program. If the viewers chose to dig a little deeper in the story, all they had to do was press their remote control button twice, once to accept the invitation trigger and once to engage that section of detail pertaining to the story. Very simple and very easy to navigate, this is one of the major rules of thumb when building ITV program enhancements.

In building the enhancements, SpinTV had worked with the online assets that NASA has just recently made available to the public via the Internet Web site. They searched through literally hundreds of documents pertaining to the mission's details, boiled down the most important aspects of the information, and then edited it for ease of consumption by the viewer. Unfortunately, SpinTV did not get to work with NASA or the producers of the program directly since this was a period piece. Produced in the sixties, they re-purposed the content with ITV enhancements to allow a new experience for any viewer who may have seen it before. Ideally, they would have worked with the writers, producers, and directors from the conception of the program to truly create an integrated ITV program (Figures 11.6-11.10).

FIGURE 11.6 *From SpinTV's NASA ITV case study. This particular screen shot shows a detail within the ITV program enhancement. Prior to this screen, a viewer has the option to delve deeper into the informational aspect of the program. The TV object has been reduced to focus more on the content. Notice the big and easily readable text and navigation buttons. (© Copyright 2001. Reprinted with permission from SpinTV, Inc.)*

FIGURE 11.7 *Also from the NASA ITV case study. This screenshot also demonstrates the focus of attention to informational content and the ability to access it easily. Large fonts and simple navigation. (© Copyright 2001. Reprinted with permission from SpinTV, Inc.)*

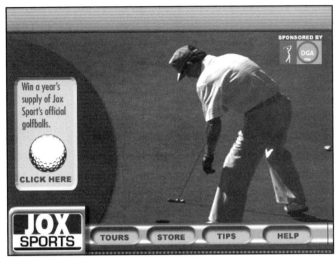

FIGURE 11.8 *Here is a case study for sports-related interactivity during a program. Simple navigation and easy-to-read graphics enhance the action the viewer is watching. (© Copyright 2001. Reprinted with permission from SpinTV, Inc.)*

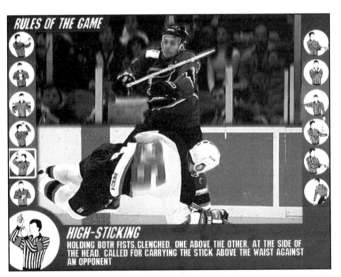

FIGURE 11.9 *A popular enhancement type; the rules for any sport at the fingertips of a viewer is priceless. (© Copyright 2001. Reprinted with permission from SpinTV, Inc.)*

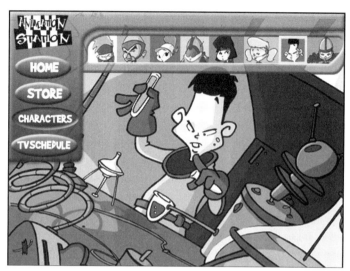

FIGURE 11.10 *A SpinTV ITV case study. Saturday morning cartoons are no longer a passive experience. (© Copyright 2001. Reprinted with permission from SpinTV, Inc.)*

For more information on SpinTV, visit their site at www.spin.tv.

CHAPTER 12
The Wisconsin Vote Project

IN THIS CHAPTER

- A Collaboration
- First Run—the Wisconsin Gardener
- The Wisconsin Vote Project
- Author Interview with Eric Bangerter

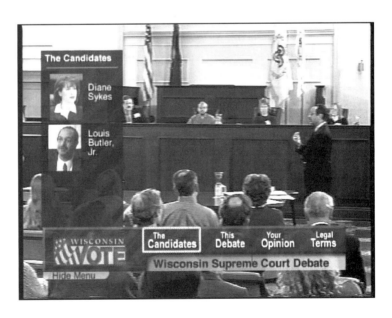

A Collaboration

In 1999, the electronic publishing department of the University of Wisconsin-Extension and Wisconsin Public Television (WPT) joined forces to create the Interactive Television Project; a research and development program for the deployment and study of Enhanced TV programming. Since then, the two publicly funded organizations have collaborated on over six ITV projects, resulting in over 50 enhanced shows, all of which have successfully gone live throughout most of Wisconsin. Eric Bangerter, originally hired by the University of Wisconsin-Extension to create online materials for the University's many outreach programs, was the media department's lone Web guru when the ITV Project first began. I asked Eric how his relationship with Wisconsin Public Television evolved.

"At the WPT station they had a Mixed Signal encoder that could send data via the line 21 VBI signal, and they wanted to try sending data out this method. They asked us to get involved; the synergy being the combined talents of their TV production experience and the Web background of our department."

The relationship began and Eric's department grew by two people—the whole of the group consisting of Eric as a manager and projects liaison, graphic designer Kevin Graeme and Web programmer Deanna Schneider. For WPT, the group consisted of an associate producer and depending on the project, a full producer and various advisors.

First Run—The Wisconsin Gardener

The newly formed team's first project (and still ongoing) was creating enhancements for the regularly scheduled WPT program *Wisconsin Gardener* (Figure 12.1). Viewers equipped with a WebTV box have the option of receiving three different enhancements related to the show.

- Textual descriptions of particular plants and insects, including the spelling of their scientific names.
- Polls with such questions as, "to what extent do you organically garden?"
- An option to have sent via e-mail a gardening newsletter, an additional text resource on the shows topics, including information on classes available and Web sites at the University of Wisconsin-Extension to further the gardening habit.

After some initial trial and error, the process of adding interactivity to the *Wisconsin Gardener* show is now fully automated, working from a database-driven template that makes updating and assigning enhancement triggers easy and with virtually no additional manpower needed.

CHAPTER 12 THE WISCONSIN VOTE PROJECT

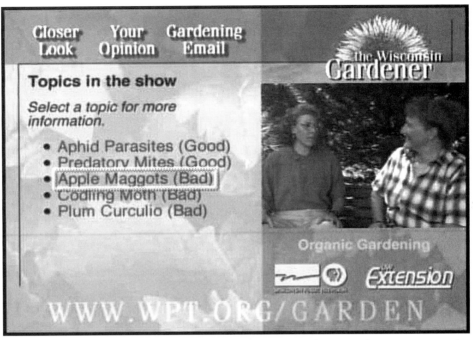

FIGURE 12.1 *The Wisconsin Gardener WebTV enhanced program. (© Copyright 2001. Reprinted with permission from the University of Wisconsin-Extension, Wisconsin Public Television.)*

THE WISCONSIN VOTE PROJECT

To date, the group's most successful assignment is *Wisconsin Vote*, a comprehensive project of over eight hours of interactive content and a corresponding Web site. *Wisconsin Vote* can be detailed in four different areas: a special interactive episode of WPT's *We the People* show, enhanced programming for the Wisconsin primaries held in September 2000 and the final election in November, the creation of enhancements for a number of episodes of WPT's *WeekEnd* show, and a Wisconsin Vote Web site.

First was the implementation of enhancements for WPT's *We the People*, a special edition political show that included coverage of the Supreme Court justice debates, held in March 2000. The enhancements, viewable through WebTV, were overlaid elements atop the full-screen show and included a Quiz, information on the candidates, an opinion poll, and definitions of legal terms (Figures 12.2–12.4).

Next was the implementation of live interactivity of Wisconsin's primary election returns in September 2000. The interactive returns, made available to

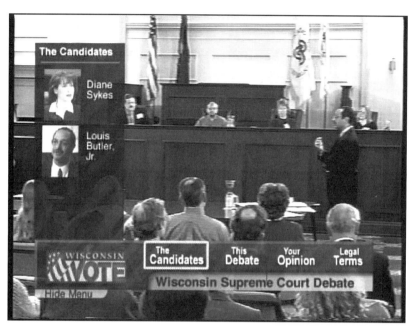

FIGURE 12.2 *An interactive overlay of The Candidates in the We the People, Wisconsin Supreme Court Debate. (© Copyright 2001. Reprinted with permission from the University of Wisconsin-Extension, Wisconsin Public Television.)*

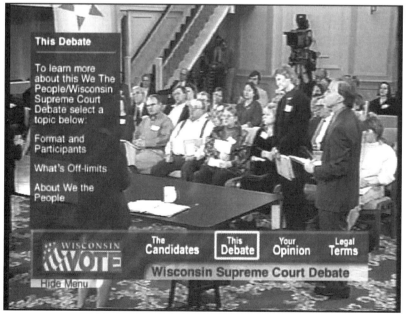

FIGURE 12.3 *An interactive overlay of This Debate topics. (© Copyright 2001. Reprinted with permission from the University of Wisconsin-Extension, Wisconsin Public Television.)*

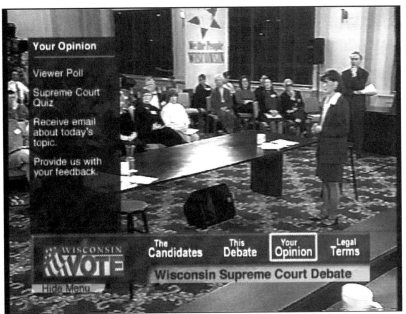

FIGURE 12.4 An interactive overlay of Your Opinion topics. (© Copyright 2001. Reprinted with permission from the University of Wisconsin-Extension, Wisconsin Public Television.)

WebTV viewers, ran during normal WPT programming and were continuously updated in five-minute intervals. It functioned like this: A trigger announced the interactivity, you clicked to "go-interactive," a drop-down menu was made available, and from there you could choose to view the results by candidate or by race. Once finished, you could opt to stay in interactive mode and watch the regular programming in a picture-within-picture format, or return to full-screen viewing. What was advantageous and innovative about these instant enhancements was the option given to viewers of not needing to be distracted by the endless run of election results scrolling at the bottom of their televisions.

This instant update method of delivering enhancements was also made available during the November 7th election in conjunction with the ATVEF-compliant ITV broadcast of *The NewsHour* with Jim Lehrer. In Wisconsin, viewers of *The NewsHour* election coverage received a special "go interactive" invitation on the show that connected them to the localized ITV election coverage.

"As far as we know, this is the first time two interactive applications have been linked together. Technically speaking, the linking of the two pages was relatively easy—the communication and partnership was the valuable thing to come of it." explains Eric.

ON THE CD

For a visual, click-by-click representation of the enhancements for this uniquely local and national ITV broadcast, see Figures 12.5–12.10 and the Flash interactive demo on the CD.

In addition was the creation of enhancements for numerous episodes of the WPT's local news and public affairs show *WeekEnd*. Using what they learned from the *Wisconsin Gardener* show, the team created an easily updateable template, allowing them to simply plug in the weekly enhancement graphics and data.

Finally was the creation of the Wisconsin Vote Web site, an online source for up-to-date information on the Wisconsin political arena. A bare-bones version of the site was completed for the Supreme Court Justice debates in April 2000, and then finished before the November elections. The site acts to supplement the interactive elements of Wisconsin Vote programs, and includes current schedules of upcoming political events, additional literature, audio clips of various debates and discussions, and a database of candidates and polls. Made to be viewable on all browsers, the site's back-end code and front-end "look and feel" stems from development and design of the interactive program elements, and the same database for information on candidates and news is used for both the Web site and the ITV components. During the election in October and November, the site received over 1 million hits, prompted by the on-air promotion of the site. "We don't usually get this kind of reaction from Web sites we develop, this was pretty exciting for us," explains Eric. The site can be found at www.wisconsinvote.org .

AUTHOR INTERVIEW WITH ERIC BANGERTER, INTERACTIVE PROJECT MANAGER FOR THE INTERACTIVE TELEVISION PROJECT

Eric, how long did it take to coordinate and create the enhancements for the Wisconsin Vote broadcasts?

The TV world works with a fast turnaround. With a team of about five people—two managers and three production artists—we created the September 2000 primary election enhancements in about one month, and the *WeekEnd* show template in about one month. Overall it was about three months of work.

What was your estimated budget for the project's TV enhancements?

I will answer that in terms of time. I guess it took about 100 hours per person to create enhancements, most of it learning time. In TV, everything is set; in Web development, nothing is set. I'd say, 100 hours per person for 8 hours of interactive TV content. The developers spent more time than the producers.

From a design standpoint, what challenges (pitfalls) did you encounter in your content creation?

FIGURE 12.5 *To access interactivity, you select via remote control the WebTV "go interactive" invitation found in the upper-right corner of* The NewsHour *with Jim Lehrer program. (© Copyright 2001. Reprinted with permission from the University of Wisconsin-Extension, Wisconsin Public Television.)*

FIGURE 12.6 *The invitation triggers a link that accesses the Wisconsin Vote content and downloads it to your television set. (© Copyright 2001. Reprinted with permission from the University of Wisconsin-Extension, Wisconsin Public Television.)*

FIGURE 12.7 *A drop-down menu is made available to choose which local race results you would like to see. (© Copyright 2001. Reprinted with permission from the University of Wisconsin-Extension, Wisconsin Public Television.)*

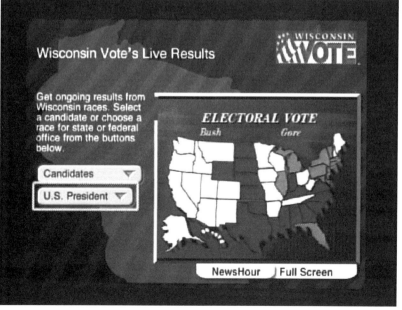

FIGURE 12.8 *The option to see the national Presidential results is also made available. (© Copyright 2001. Reprinted with permission from the University of Wisconsin-Extension, Wisconsin Public Television.)*

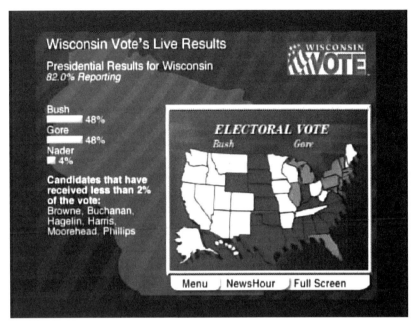

FIGURE 12.9 *Shown here are the Presidential results for Wisconsin. (© Copyright 2001. Reprinted with permission from the University of Wisconsin-Extension, Wisconsin Public Television.)*

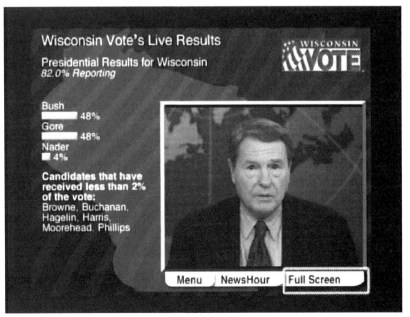

FIGURE 12.10 *The option to go back to "full screen" is always made available. (© Copyright 2001. Reprinted with permission from the University of Wisconsin-Extension, Wisconsin Public Television.)*

Keep navigation issues friendly and create usable interfaces. We created a specific Wisconsin Vote look, a logo that's identifiable and based on a current identity.

Your department at UW-Extension and the WPT have managed to create a seemingly productive and successful relationship. Tell me how it was working together on the Wisconsin Vote project?

At first it was frustrating, and you hoped to go beyond the 'you do your thing, we ours' type of attitude. Over all, communication is the hardest part. The word *programming*, for example, has a completely different meaning to Web developers than to producers. The best thing we did was to assign a full-time point person—someone who organized and made final decisions about the content. This also helped alleviate 'scope creep.' It's important to nail down your project, hammer out its definition, and plan a realistic turnaround for the work. This can be difficult because you have the 'learning as you go' problem, the not knowing how long something is going to take. It's not easy to predict.

You taught the Microsoft TV Interactive Television seminar, as I did. From your experience with the Wisconsin Vote project, what do you tell your seminar students when they ask such questions as "how will creating an ITV program benefit my company and viewership?"

First, try to get a grant for the project, a good possibility since you're trying something new. An ITV project could lead to national exposure for your organization; for us, it was the association with the PBS *NewsHour* show. It's good to jump in and start battling through partnerships, make mistakes and get ready for the real move to ITV. Unlike many in the Web world, such as us, who found themselves always playing 'catch-up.' As for attracting new audiences, our viewership was already defined by the nature of a pre-existing show, WPT's *WeekEnd* program, and available to those with a WebTV box. But, by its 'cool' nature, ITV can bring in younger people, as indicated in our focus groups.

Tell me a bit about your upcoming projects and what's in store for the University of Wisconsin-Extension and WPT.

The thing I am looking forward to is moving back into a research and development mode. We just finished doing 10 interactive shows for *Wisconsin Stories*, a history program, and 13 shows for *Whole Child*, a show for childcare providers on child development. We did very little learning from a technical standpoint doing those projects. However, we did learn to work in a true 'production environment.' Now we are going to move to the Microsoft

TV platform and possibly the AOL TV platform. This means we may be able to do more with Flash and other more processor intensive technologies. We are also moving very quickly to the world of digital television. We are going to be working with data broadcasting companies to learn how to do interactive television where the majority of data comes encoded in the broadcast itself and not through a modem. We think our experience over the last two years puts us ahead of a lot of other broadcasters in this area because we only have to solve the technical challenges and not the ITV production ones.

What practical advice can you give to developers interested in creating enhanced content?

Buy a delivery box that you can test on, and choose one platform—don't try to develop for all the boxes right out of the gates. Get a rough edit of the show and try static tests through a dial up from the set top box. To create our links we use Mixed Signals software, and encoded the data in the text line 2 of Line 21 of the encoder. Don't be afraid to try new things. Audiences are new to ITV so they do not have any expectations. For a long time we did not try to see much of what others were doing in ITV so we could try new things. That forced us to be creative and solve problems for ourselves rather than being able to defer to what others had done.

Share with me your thoughts about the future of ITV, and what you think will be the essential advantages of being able to move from an analog solution of content delivery to a digital solution.

First of all, digital is going to happen. But, the 'walled garden' approach is not; this is the use of a Web portal to provide generalized information branded around a particular show or network—that's what the Web can already provide—ITV needs to be more than that. Also, I think PVRs will drive interest, and prices will run their course. Once PVR and ITV technology come together, viewers will want it. Digital will also allow for multicasting, where the directors cut can be on channel one and other camera angles on channel two, three and four. And, obviously, with the ability to broadcast data at incredible speeds the ITV industry has the chance to really take off. I see viewers coming home from work or waking up to find movies, TV shows and Web sites waiting to be viewed and while watching their favorite shows they'll be downloading related interactive information. (© Copyright 2001. Reprinted with permission from the University of Wisconsin-Extension, Wisconsin Public Television.)

For more information on the Wisconsin Vote project and other projects in the works for the University of Wisconsin-Extension, and Wisconsin Public Television visit the following online sources:

Interactive Television Project
http://itv.wpt.org

University of Wisconsin-Extension
www1.uwex.edu

Wisconsin Public Television
www.wpt.org

Wisconsin Vote
www.wisconsinvote.org

Contact for Eric Bangerter
Eric.Bangerter@ces.uwex.edu

CHAPTER 13

Spiderdance

IN THIS CHAPTER

- About Spiderdance
- Author Interview with Tracy Fullerton
- Author Interview with Rob Davis

Wanna dance? Spiderdance that is. As their promotional/dance video proclaims, with Spiderdance there's no waiting for interactivity, and it takes only three steps. Step 1—Turn on Your TV, Step 2—Log on to the Internet, Step 3—Play. No doubt Spiderdance is into promoting the fun of interactivity, as I discovered in my conversations with Spiderdance's Tracy Fullerton, president, and Rob Davis, executive producer.

In this chapter, Tracy provides an overview of Spiderdance as a company, its sync-to-broadcast technology, Spiderdance's content creation process as it relates to their award-winning project with MTV, webRIOT, and her insight into the future. Rob delves deeper into the Spiderdance philosophy, provides an inside scoop on the making of webRIOT, and shares his thoughts on the state of the ITV industry as a whole.

About Spiderdance at www.spiderdance.com

Spiderdance bridges the gap between television and the Internet, providing the infrastructure and tools necessary to fully synchronize online content with on-air broadcasts, turning any TV show into an interactive experience.

Spiderdance and MTV made television history on November 29, 1999 with the launch of webRIOT, the first television show designed from the ground up for interactivity. With tens of millions of games served over two seasons, webRIOT became a national sensation, breaking new ground for interactive TV and setting the bar for all subsequent convergence programming.

After webRIOT, Spiderdance went on to develop Inquizition for Sony's Game Show Network, History IQ for A&E's History Channel and Cyber Bond for Turner's TBS Superstation.

Author Interview with Tracy Fullerton, President of Spiderdance

Briefly describe your company, Spiderdance. How and why you got started. Where did your name come from?

"Spiderdancing" is an internal slang term our team has always used to describe the synergistic moment when creative innovation meets technical achievement. It refers to that exciting moment in a brainstorming meeting when everyone leaps to their feet, starts frantically drawing on the whiteboard, and waving their arms around trying to express their ideas. When we started Spiderdance, we wanted to emphasize the wonderful possibilities that exist in

the marriage of creative concepts and technology, and so we named the company "Spiderdance."

Steve Hoffman (CEO), Mike Gresh (CTO), Naomi Kokubo (COO), and I formed Spiderdance in 1998. Mike and I had worked together previously on a large-scale multi-user game for The Microsoft Network. Steve and Naomi were running a successful CD-ROM game company at the time. Everything starts with an idea, and our idea was to develop a system for fusing technology with content and help to redefine how people watch TV today. We gave birth to our company in the virtual world, with the four founders separated by distance and time zone, calling three different zip codes home. We worked for almost a year over the Internet and telephone to develop the core ideas and software necessary to synchronize online shows with television broadcasts.

Talk to me about your sync-to-broadcast technology. What is it, and how does it differ from other interactive TV delivery platforms?

Spiderdance's TruSync™ Interactive television system bridges the gap between television and the Internet. Over 44 million Americans currently surf the Web on their online PCs while watching television. Our TruSync technology allows broadcasters to offer synchronized interactive programming to all of these millions of viewers today without waiting for set-top boxes to finally arrive in viewers' homes.

Our infrastructure can handle millions of simultaneous users, and delivers frame-accurate interactive programming, advertising, e-commerce, sports, news, polling, game shows, and live events. Because of the open design of our system, the interactive programs deployed on our system can be made available on Internet-enabled wireless devices, set-top boxes, Web tablets and other Internet-enabled devices as well when these become more widely available to consumers.

Spiderdance has won many awards and recognition for its ITV projects, such as History IQ for The History Channel, *Inquizition for Sony's* Game Show Network, *and webRIOT for* MTV. *Describe for me one of these projects, and what was unique about it.*

Spiderdance made television history on November 29, 1999 with the launch of MTV's webRIOT, the first television show designed from the ground up as an interactive experience. Each day, tens of thousands of online contestants could compete in real time against four on-air players. Players logged on and tested their knowledge of music trivia. The top ten online players saw their names appear in the broadcast and won a chance for some kickin' prizes. On-air, we would cut away to an at-home "player of the day"

to see how it was going for him or her. With over 1 million registered users and tens of millions of games played, webRIOT became a national sensation, breaking new ground for interactive TV and setting the bar for all subsequent convergence programming (Figures 13.1–13.4).

What was your role is this project? Describe for me your experience working collaboratively with the show's producers? How did you and the producers work together to communicate each of your visions for such an innovative project?

webRIOT was a joint effort between MTV Networks, MTV Online, Spiderdance, and First Television (the on-air production company). I was the producer for Spiderdance. I managed the development of the sync-to-broadcast component (Figure 13.5). Our production and engineering teams worked very closely with MTV's executive producer of Convergence, Rob Davis, to define the features and flow and to manage our production of the online component. We communicated with MTV and the other team members via a weekly conference call in which everyone participated. Because of the cutting-edge nature of the program, communication was especially critical when designing and testing the game play.

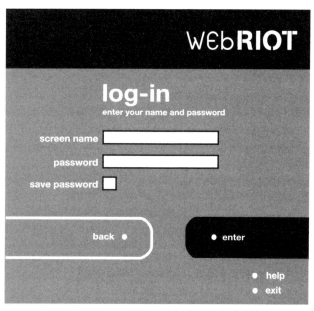

FIGURE 13.1 *Log in to play webRIOT. (© Copyright 2001. Reprinted with permission from Spiderdance.)*

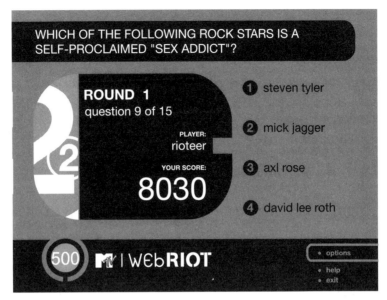

FIGURE 13.2 *The webRIOT game interface. (© Copyright 2001. Reprinted with permission from Spiderdance.)*

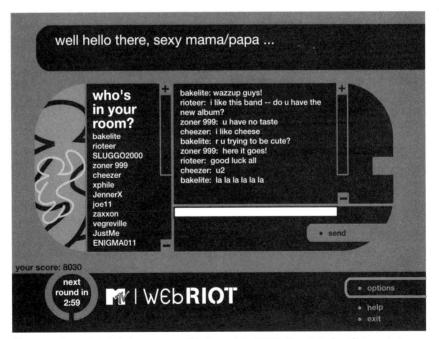

FIGURE 13.3 *The webRIOT chat screen. (© Copyright 2001. Reprinted with permission from Spiderdance.)*

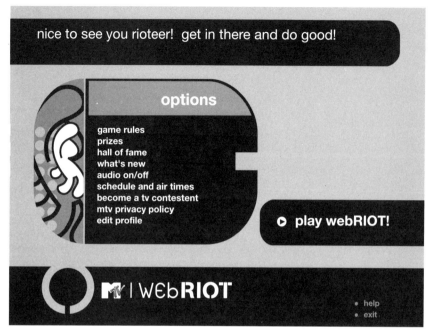

FIGURE 13.4 *The webRIOT options screen. (© Copyright 2001. Reprinted with permission from Spiderdance.)*

What were the main things you had to consider in producing the show?

When we produced webRIOT, this type of live, massively multi-user convergence programming had never been done before and no one was sure quite where the pitfalls would be. Spiderdance had already spent a lot of time trying to anticipate issues in designing the technology infrastructure, but we knew that there were bound to be unexpected issues along the way. We knew that the most important thing was to make sure that the players experienced a flawless integration between the television show and the online game, and that the experience was as stable and usable as turning on your television.

List for me in a brief timeline format the process of the shows creation.

DEVELOPMENT PHASE
Scoping: 1–2 weeks

- Brainstorm creative meetings with show producers to define flow for the online show and lock down of features

- Clarification of advertising-related functionality for the application
- Creative/Technical Strategy Brief complete that includes clarification of:
 —Technical interface between the online component and the broadcast network operations equipment, including cueing tools
 —Plan for gathering user profile data during registration process
 —Assessment of interface with third-party ad servers
- Approval on Scoping Phase Deliverables

Design: 2–4 weeks

- Flowchart and wireframes for the online experience developed and finalized
- Look and Feel boards complete for online component
 —3–4 preliminary style boards
 —Graphical revisions on the chosen look and feel
 —Finalize look and feel
- Design board for all screens in final look and feel
- Design specification complete
- Approval on Design Phase Deliverables

EXECUTION PHASE

Production: 3–6 weeks

- Produce art, animation, and sound assets as per design specification
- Program features
- Draft QA plan
- Write sync-to-broadcast scripts for first four weeks of show
- Integrate media and code for online component
- Begin pre-Alpha testing of all show components
- Test syncing execution between online component and network operations equipment
- Achieve Alpha milestone for online component
- Approval on Production Deliverables

Testing Phase: 4 weeks

- Alpha testing of all components
- Beta testing of all components
- Sync-to-Broadcast Testing via live test broadcasts
- Approval on Testing Deliverables

Launch

- Launch Show

ADMINISTRATION PHASE
- Maintain game/monitor cueing all network feeds:
 —Enter question data and timecode cues into the Spiderdance Script Generator
 —Schedule and monitor the online airings
 —Provide a technician to be available during live broadcasts
 —Respond to any issues that arise in the shows
 —Provide backups
 —Provide e-mail technical support for individual users via support@spiderdance.com

From a technical standpoint, describe for me what standards you decided to go with for this particular project.

We used the Spiderdance TruSync system for the backend and developed a custom C++ application for the downloadable client.

From a design standpoint, what challenges (pitfalls) did you encounter in your content creation?

Because we wanted webRIOT to be a completely integrated experience, we choose to make the online graphics look exactly like the on-air graphics. This meant that players could look from their TV to their PC and instantaneously know how to play along. This was a design challenge because it meant that every time a change was made to the on-air graphics, we had to respond in the online graphics. In the end, this is one of the best features of the application as it achieved our goal of having instantly recognizable interface to the game.

From a technical standpoint, what challenges (pitfalls) did you encounter in your content creation?

From a technical point of view, the production broke new ground in almost every aspect of its design. The greatest challenge of these was in achieving the kind of frame-accurate synchronization that the game play demanded. The precisely timed nature of the questions, combined with the matching graphics on PC and TV, made it such that it was very easy for the human eye to notice even a small inaccuracy in the timing of the experience. Our technology was carefully developed to display frame-accurately on all systems, regardless of processor power, connection speed, or Internet latency.

Talk to me about the airing of the program. Was the show well received by the viewing audience? What is the feedback you received from the viewing audience? Name its main success, and where it could have been improved.

The show was extremely well received in terms of both on-air ratings and online usage. Feedback from the users was incredibly positive. As mentioned

previously, over 1 million people registered to play, an extremely large community by online standards. Because we had a 24/7 version of the game available, these people could come in at any time and practice, chat, get to know each other, etc. Ultimately, the experience had very few usage issues. We did learn some key lessons, which we have since incorporated into future programs. These included letting users chat during the game play, showing them each other's scores in a leader board, etc. These types of community-focused additions have really added to the experiences we deliver.

In your opinion, share your thoughts on the future progress of ITV. What in your experience has led you to these thoughts and predictions?

To comment on the future of ITV is really to comment on the future of television as a whole. From a cultural standpoint, I think that people are demanding more from television. Not more channels, but more community, more influence, more personal involvement, more specificity, more programming that relates to their lives. In short, I think that people want some of the qualities they are finding on the Internet to apply to their television viewing. I think this because of the "organic convergence" that viewers are creating by watching television and surfing the Web on their online PCs at the same time. Clearly, these two experiences are somewhat complementary for a large number of people. As designers of new forms of media, it's important to look at how people use media naturally, what makes sense to them, what they are already doing with or without new technologies.

What do you think you will be the dominating factors to overcome in the forward progress of the ITV medium?

The largest factor that needs to be overcome is the business model for ITV. By this I mean determining the value and benefits of ITV programming and to whom that value is delivered. If we look at the model for television, we can clearly see the values created. Traditional broadcast television is valuable to advertisers; cable television is valuable to both advertisers and subscribers. Television programming and brands are valuable to their owners as licensed properties.

The value of ITV to these and various other parties is not clear. This needs to be determined and proven, with measurable results, in order for ITV to become a real business opportunity and not just a technological novelty.

What recommendations can you give to the reader of this book on how he or she can learn more about and become involved with this incubatory medium of ITV?

I recommend a very "hands-on" approach to learning about ITV. There is already too much talk about this subject in proportion to actual production

going on. The best way to learn more about developing for ITV is to do it. It is going to take producers and networks that are willing to stick their necks out and develop shows that benefit from interactivity, in fact could not be done without interactivity. It is going to take good, solid marketing to get those shows seen by the right audiences. It is going to take intelligent advertising models to create real returns on those innovative shows. In short, it is going to take a lot of people, industrywide, committed to the concept of ITV to make it happen. (© Copyright 2001. Reprinted with permission from Spiderdance.)

About Tracy Fullerton, President

Tracy Fullerton brings Spiderdance veteran creative vision and leadership. As a founding member of R/GA Interactive, Tracy served as producer and creative director, providing strategic development and management for the firm's most advanced projects for clients, including Intel, AdAge, Ticketmaster, Compaq, and Warner Bros. The highlight of Tracy's tenure at R/GA is her work leading Microsoft Network's 1996 landmark, NetWits, which defined the genre of mass-participation online game shows. R/GA also tapped Tracy for the creative director role on both Multiplayer Wheel of Fortune Online and Jeopardy! Online for Sony Online Entertainment. Tracy came to R/GA from Interfilm, Inc., the pioneer interactive filmmaker. In partnership with Sony New Media, Interfilm released three interactive films nationwide. Tracy played a key role in Interfilm's transformation from a small team into a publicly traded interactive production studio. Tracy's work has received numerous industry honors, including several New Media Invision awards, best Family/Board Game from the Academy of Interactive Arts & Sciences, ID Magazine's Interactive Design Review, Communication Arts Interactive Design Annual, the Bandies 2000, the Digital Coast 2000 Awards, and Time Magazine's Best of the Web. She is a graduate of the USC School of Cinema, where she currently teaches interactive game design.

AUTHOR INTERVIEW WITH ROB DAVIS, EXECUTIVE PRODUCER OF SPIDERDANCE

First of all, Rob, explain the Spiderdance TruSync system. Exactly how does it work?

TruSync™ is a three-tier software system. Of course, there is an element of hardware dependency, but the nuts and bolts are really in the software. The three tiers to the system are the end-user client, the back-end communications application that hooks into a timing mechanism, and the data collection and tracking system.

The middle portion is the core of the system where all the interactivity comes together. Mike Gresh, CTO and founder of Spiderdance, invented the software-based method of keeping a home user's machine in synchronization with a server without having any special hardware on the home end.

The reason TruSync works as well as it does is the way the communication model works; the server is in full control of both the pulling out and receiving of data so all the hard work is done on our end, leaving the user's machine dedicated to the entertainment experience. Unlike a push-based system, we have worked hard to minimize problems that may occur when you ask the home computer or set-top box to do too much.

It's all about control. Mike's system is about managing every type of event that we can possibly control, including bandwidth irregularities, and that's solely because we want to make sure that the user experience is the same no matter what speed computer a user is on. Another nice thing about TruSync is that pretty much any IP-centric device will work with our system (set-tops, wireless units, tablets, etc.); each one might have different variations of the synchronization mechanisms, but the philosophy of management and control remains the same.

Rob, what are the stumbling blocks for Web developers, designers interested in getting into ITV, and what's to overcome them?

From my experience, there are two major stumbling blocks, both of which I think can be worked around. The first is to lift some of the mystery and create design philosophies and tools that leverage experienced Web developer talents and streamline application of those skills to ITV environments. That's a smart step since the talent pool exists today. It's important to relate technical tasks to the Web and gaming worlds, and to consider how Web developers are used to working.

The other stumbling block, and the one I think causes the most head spinning, is looking past the notion that tomorrow's set-top box is the ultimate ITV solution. Experienced interactive designers hit a wall when entering the ITV world and find people developing for cable boxes that are basically computers that wouldn't have been state-of-the-art 15 years ago. If you are a 25-year-old, really hot Shockwave, Flash developer, what are you going to think when you have to actually unlearn what you know? What do you do when you're asked to do the latest and greatest thing in HTML 3.2 and Flash 3? This is a total disconnect for the left-brain thinker and an illogical regression for right brainers.

Another difficult adjustment for a programmer who wants to work in the set-top box/television space, besides having to learn the legacy versions of the software, cannot be avoided; he or she must learn a whole new construct of development, a whole new color palette, and the rest of the established

NTSC standards that guide TV production in North America. While the HTML code for set-top box development is similar as for the Web, there are a lot of other issues that you must take into consideration. This is where the two worlds begin to meld, and there is no closure to be found until the industries follow the paths that the pioneers blaze.

In short, here's my advice to developers:

Relate the tasks to your current expertise, and come in to ITV with an open mind… an open mind that's ready to accept that TV has mature, time-proven standards and practices in place that you cannot change. Of course, some of the same thought process needs to be brought from the traditional TV side, as well. If you want to get into ITV at this point in time, you have to just jump off the ledge!

Let's move on and talk about webRIOT. Briefly tell me about your role on the project. What did you do?

I was the executive producer of Convergence for MTV Networks when webRIOT was just a gleam in our eyes, working with Alex Maghen, at that time VP of Online Development at MTVN, who had been a part of AT&T's interactive group back in the early nineties where he got the taste for ITV. Alex came to me in November of 1998 with an idea to create a game show where viewers played along at home while they watched. I thought this was great, and I started mentally preparing a list of set-top OS companies to experiment with. But, Alex had a catch… the viewer had to be able to play in perfect sync with no additional hardware in the home other than a PC and a modem. And this wasn't an experiment, it was an A-level MTV project. I was thinking, you got to be kidding… there's nothing anything close to this out there. We went ahead and wrote the RFP.

There were exactly two companies to express interest in helping us develop this game application—Spiderdance, and a company that was planning on middle-manning Spiderdance to us. Spiderdance got the gig.

In February 1999 MTV agreed on a deal with Spiderdance that gave them four months to prove that all tiers of the TruSync system would work. If it did we would green light the project. I never considered what we would do if it didn't work…

MTV Music Development team created a sample pilot of the show with a fairly mature vision for what we wanted the show to be. It was a five-minute prototype of three videos cut back to back with questions overlaid in the style they thought the show was going to be—music videos, with trivia questions during it. This is the material Spiderdance had to develop against to prove the system. It was the beginning of two very different cultures (interactive and TV development) having to work together, and I was the person in the middle.

As the interactive executive producer on the project, I had daily hands-on contact with webRIOT, making sure that we were all going to be happy with the results at each benchmark, and striving to uphold the level of quality and brand-building that makes MTV a consistent success.

Midway through the four-month development period, Brian Graden, the head of programming at MTV, asked us to debut what we were working on at the Television Critics Association conference in Pasadena. Deep in the luxurious Ritz-Carlton hotel, the summer TCA event hosts hundreds of TV critics in a lavish spectacle where networks introduce their Fall line-up of shows, bringing in reels, cast members, and other glitterati in an attempt to woo the press.

We all wanted to do it, but it turned the pressure up.

TV critics have a reputation, largely unfair, at TCA for not always being the happiest people in the world. They come to TCA with their cannons loaded ready to shoot holes in the networks' million-dollar programs. That added to the nerves as we set up the room with a kind of M.A.S.H. unit LAN supporting 27 laptops on which the critics would play, in sync, to a huge screen at the front of the room showing our short pilot reel. We were the talk of the show that morning as the critics saw the immense undertaking transform. The synchronization engine wasn't finished yet, so to start the demo, Tracy [Fullerton, president and founder of Spiderdance] had to actually click on an Enter key on a laptop located in the back of the room. In short, the laptops and the show ran flawlessly, and 200 critics rewarded us with an ovation punctuated by hooting and hollering. We learned later that a response such as that had never happened in the history of TCA. From that moment we all had the confidence to move forward with webRIOT, and in June of 99 the show went into production.

How many people were actually involved with this project?

For the most part, there were 10–15 people focused on the show; five of us at MTV, another five at Spiderdance, and Mack & Bradley Anderson's production team at First Television. Of course, there was the irrepressible Ahmet Zappa, too. He's great fun.

How long did webRIOT run?

We produced 135 episodes, with each airing at least three times over the course of late 1999 and 2000.

Did you create a template to work from? Did the show eventually become a routine-type task?

Oh yes, absolutely.

How long did it take to get into this routine?

Planning for the first couple of shows had its ups and downs as we learned the system. The system was designed so that all MTV had to do was enter in the data for each show... the questions and the correct answers, points, etc. In all honesty, the hardest part after the initial development of the software was completed was getting the design of the show firmly set in our template. We wanted the colors to match on screens, TV and PC. This was hairy, trying to match the NTSC palettes that MTV used. Once we got the show look defined, however, we let the TV artwork guide what the Web artwork would be.

How many people ran the routine operations? And describe the process.

After the first two weeks of airing we settled into a routine of two people running the show on a day-to-day basis. The finished air-ready tapes would come in, and my producers would fire up the Spiderdance software and enter all the data. Then they would watch the shows locally in our studio and check everything to make sure all the sync points and content were exactly right. Remember, this was TV, so typos and errors somewhat accepted on the Internet were not acceptable with anything connected to webRIOT.

Our goal was to enter data and visually proof the show twice in a four-hour period. We achieved that and more. During the airing of the show, our live producer would babysit the software and manually contribute to the experience via messaging to players and other communications tools.

Tell me exactly how it worked during the show?

We set up direct data feed between the network operations center in Long Island and the MTV Online offices in Times Square. A trigger would come through the line, indicating that the show had started. Spiderdance's software listened for this trigger coming off the data pipe, and we knew exactly if everything was synched up. If for some reason the data pipe failed, we had a manual override.

It was really a three-person operation each show. One person to enter in the data beforehand, one person to do the live production, and whoever was on duty at the TV operation center running the tapes and making sure our return feed of online high scores made it to the Chyron machine and was displayed on-air. That on-air display of home users' scores really stood out with the audience.

A funny side story... I talked to you about how much we want control and that's valuable to us. Well, during one show, we lost the automatic triggers because a dump truck ran into a telephone pole in Long Island and took out our data line. There's the real dirt behind the most interactive TV show in history!

On the subject of control and avoiding mishaps, what was your testing process like?

We did extensive on-air technical testing, at four in the morning, a month before the launch date that taught us a lot about how the system was going to work under real-world conditions. We pulled a lot of all-nighters on this project. But we didn't care—we were on top of the world trying to pull off something that had never been done before.

What would be the best route for a TV production company to get the tools necessary, the hardware and software, for the creation of an ITV show? Should they hire an outside company, or invest in their own equipment?

I think the answer is yes, you either have to hire a company that knows what its doing, or build an inhouse studio. Nobody really has a WYSIWYG tool set to put these things together. I know people are working on developing them and I think that might serve some scenarios very well, but I don't know what the future of that is, because that's not how you make television. Every TV show is going to be different. Look at *Weakest Link* and *Who Wants to be a Millionaire*. They're game shows that appear similar, but they're not—the scores aren't computed the same way, the rounds and gameplay are totally different. You can cut-and-paste good game design, so I always see a need for specialists in this field. Each show is unique and will need some sort of customized programming and back-end environment.

What type of feedback did you get from the user end of webRIOT?

There were two classifications for feedback that we tracked for the event—feedback about the show itself (entertainment and aesthetic related questions), and technical operation feedback. Most of the time we would get questions from people who needed help with basic PC functionality—installing software, etc. and asking, "um, where's the Mac version?"

I think the majority of our feedback leaned more toward comments about the show—likes and dislikes and not so much about the technology. This made us quite happy. Because if all the e-mails were about the technology we would have known that something wasn't quite right, that the experience was disconnected.

Was all your feedback through e-mails? Did you send out a questionnaire to the users? Did you pursue active type of feedback?

No, but we did get some phone calls in addition to the e-mails. And, we did do a lot of usability testing and focus groups ahead of time. I'll tell you the moment that I knew that webRIOT was going to fly. Throughout all the milestones we had, the one moment that sticks out in my mind was watching the first focus group, a group of teenage women. After the third or fourth

question playing along with the pilot, their eyes were on the TV and their hands were on the keyboard. They weren't looking at the PC all the time, and I thought, "alright, it works! It's still about the TV."

What did you know you had done right from the focus group's feedback?

Matching the colors, matching the interfaces of the PC and TV as much as possible, was key. It helped them make the jump into believability and say, "alright, this really is working together." Also, tight synchronization is absolutely essential. During the testing I was operating the sync controls, and if I let the sync stray too far then we could see that the reactions weren't as positive, that there was confusion.

What are the next new things for Spiderdance?

Our primary goal is to increase our hours on-air and develop the best interactive entertainment possible. We need to work within the confines of the TV industry calendar, so we spend much of the Spring planning and waiting to see which shows get green lit and will continue to go interactive during the Fall. We generally receive an upfront development cost and then on-going operations costs—so the longer the show runs, it's just like a network—it's good for us revenue-wise.

In addition, our guys in the NJ-based Spiderdance development team are making constant updates to the TruSync system. We are constantly improving scalability. We know we can handle a million users, which is the industry's current magic number, but we want to keep improving. Also in development is our Mac client. I keep hearing that the number of Mac users is dwindling, but a solid 5–9% of TV/ Web site users seem to be Mac clients. Truthfully the Macintosh is a smarter second platform for ITV right now than an STB. There are more of them deployed. (© Copyright 2001. Reprinted with permission from Spiderdance.)

(Check out Rob's suggestions for ITV content developers in the "Top 12 Suggestions for ITV Developers" list found at the end of Chapter 10.)

About Rob Davis, Executive Producer

Rob Davis is Spiderdance's East Coast creative lead, and developed the first convergence programming on four major networks: MTV (*webRIOT*), History Channel (*History IQ*), VH1 (Behind the Music t-commerce), and Nickelodeon (*Laverne and Shirley*). As the first person to hold the title of executive producer of Convergence at MTV Networks, Rob oversaw the development of *webRIOT* and laid the groundwork for *DFX* and *Control Freak* while also launching the *VH1* and *Work* online radio station. Immediately prior to joining MTV, Rob was chief of Gannett's *IN Jersey* online news service. Rob's television production ca-

reer boasts credits from NBC, the NBA, PBS, and *This Week in Baseball*. Rob holds an MS from the S.I. Newhouse School of Public Communication at Syracuse University and is a member of their alumni hall of fame. Rob is an elected member of the Advanced Television Forum board of directors, a founding advisor of the iMIX industry conference, and a member of the Academy of Television Arts and Sciences. He is currently supporting an effort to preserve Marconi's first commercial radio installation as a museum to the Information Age. Rob works out of the Manasquan, New Jersey office. *Reprinted with permission.*

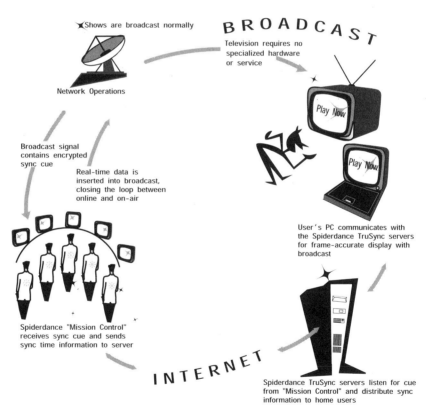

FIGURE 13.5 *Diagram of the Spiderdance Sync-to-Broadcast system. (© Copyright 2001. Reprinted with permission from Spiderdance.)*

CHAPTER

14

Music from the Inside Out

IN THIS CHAPTER
- Carolyn Carmines and Nancy Saslow Talk Shop
- A Conversation with Danny Anker
- The Ensemble Interactive Sequence
- About PushyBroad

"Royal March" for miniature orchestra by Stravinsky

One of the most innovative projects to recently come out of the AFI Enhanced TV workshop[1] is the interactive TV prototype for Music from the Inside Out, a PBS cinema-verite film series that explores music and music-making through the eyes of the 105 members of The Philadelphia Orchestra. The productive core in the making of the enhanced TV prototype was Danny Anker from Anker Productions and Carolyn Carmines and Nancy Saslow of PushyBroad. Danny is the producer/director of Music from the Inside Out, and PushyBroad, who serves on the advisory board for the AFI Enhanced TV Workshop, supplied the developer/designer expertise for the project.

Next, Carolyn Carmines and Nancy Saslow, co-founders of PushyBroad, describe the project and technologies used followed by an in-depth interview with Danny Anker, and screen shots of the production.

CAROLYN CARMINES AND NANCY SASLOW TALK SHOP

Describe your collaborative project with Danny Anker.

Music from the Inside Out is a prototype that was created for the 2000 AFI/Intel Enhanced TV Workshop [now, AFI Enhanced TV Workshop]. This innovative PBS series features the 105 members of The Philadelphia Orchestra in an exploration of the world of music outside the concert hall. The project adopts a fresh approach to music education—rather than teaching music theory or history, it attempts to make the abstract in music more accessible, by exploring the connections between an artist's everyday life and the creative process.

Anker Productions, working with PushyBroad, Liberate Technologies RoundPeg, Team Audio and Beatnik have created a working prototype that showcases cross-platform interactivity. New material was conceived, shot, and edited especially for the prototype to create a fulfilling linear experience as well as an interactive experience, for both ETV and Broadband online. Enhancements include a "karaoke" feature that allows viewers to literally "play along at home," and a segment where the musicians are joined by a group of students in an enhanced exploration of natural sounds. Viewers can also follow along with the score, isolate a player's performance, learn more about the instruments in the piece, and get more information about the music itself.

[1] The American Film Institute's Enhanced TV Workshop is an R&D mentorship program that brings together TV producers and ITV content developers who want to learn, explore, and produce in the Enhanced TV environment. For more on the AFI- Enhanced TV Workshop, see Chapter 15.

TV optimized Web pages also allow for more exploration of the construction of a new hall for the Orchestra.

From a technical standpoint, describe what platform and standards you decided to go with for this particular project.

The Liberate CT-500, ATVEF-compliant application was used because it supported the type of interactivity we wanted to offer in the program and Liberate is a mentor in the AFI program.

Liberate CT-500 supported a 16x9 TV aspect ratio where other set-top boxes only offered a 4x3 aspect ratio. This was particularly important to this project since the show was shot in letterbox. Since the show was based on music, we chose the CT-500 because it supported a wide array of interactive sound features:

- Beatnik sound technology
- Embedded wav files
- Mapping keys on the keyboard to wav files used in the karaoke section using "onmousedown" sounds on interactive buttons within Flash 3

It was important that the CT-500 supported ATVEF triggers because that gave us the opportunity to do contextual enhancements and allowed us to synch up the content of a frameset with the running video.

Even though Liberate supported Dreamweaver extensions, it didn't end up being very important since most of the presentation was created with Flash 3 or hand-coded HTML.

The software used for encoding the program was Mixed Signals' DV2000 encoder and Mixed Signals' TV Link Creator.

From a design/development standpoint, what challenges (pitfalls) did you encounter in your content creation?

The answers for design and technology are very much intertwined ... because what you design has to work on the technology, and sometimes, well, it just doesn't. We were pushing the envelope from a development standpoint, so not everything we hoped would work or did as exactly as we would have liked.

Once we got the karaoke section working on the box, we tried to incorporate it into our frameset architecture. The sounds stopped working. After spending a day experimenting with all of Flash's wav compression methods without success, we tried putting the frameset in an outer frameset. As if by magic, that did the trick. The drawback we found with Flash 3 within the CT-500 is that it doesn't allow communication with JavaScript or certain actionscript functionalities and that sounds don't work inside a regular frameset,

only inside a nested frameset. (© *Copyright 2001. Reprinted with permission from PushyBroad.*)

A CONVERSATION WITH DANNY ANKER

Danny, share a bit about your background.

I've produced a wide variety of public television programs and films, most recently the historical documentary *Scottsboro: An American Tragedy.* But much of my work has involved music. I've been an amateur musician all my life, and I majored in music as an undergraduate at Harvard. I got into television in the mid-eighties because of my music background, starting first at the *Great Performances* series at WNET in New York, and then a bit later I was producer of the PBS broadcasts from the Metropolitan Opera and several documentaries about classical musicians.

I also was one of the producers of a series of programs for kids with Wynton Marsalis, *Marsalis on Music,* which was sort of a 90's follow up to the Leonard Bernstein Young People's series. And while the Marsalis series was considered a success, it still adhered to the Bernstein model from 40 years ago—one host, standing before an audience or classroom, speaking about the fundamentals of music.

That's how the idea for *Music from the Inside Out* came about. I wanted to do something different that presented music and ideas about music in a provocative way. *Music from the Inside Out* doesn't have a host. We follow the 100 players of a symphony orchestra in their lives in and outside of the concert hall and portray music and the musical experience as something that is constantly affected and refined by everyday life. Our series is not about teaching the fundamentals of music, but about seeing music in a broader sense, acknowledging its mystery and magic, and finding the connections between music and other aspects of our lives. The premise is sort of a constructivist approach—What does the world look like through the eyes of musicians? What do musicians think and feel as they play music? How do they listen to music? Information about music becomes, in a sense, secondary, to the musical experience itself.

Any television project today needs to have a Web site thought out in advance, and so early on I began to envision a rather large, ambitious Web site to accompany the series. Someone at PBS Interactive suggested I apply to the AFI Enhanced TV workshop, which I did knowing very little about ITV.

How would interactivity benefit the Music from the Inside Out *project?*

The first question that always comes up when pitching a project is "who is your audience?" This a very difficult thing to answer when it comes to music programs, because unlike other subjects where you'd target adults or high school kids with one approach, middle school with another, and very young kids with another, music really has just two audiences—those who are knowledgeable about music, and those who aren't. You speak about music to a 10-year-old who's not musically literate pretty much the same way you'd speak to a 90-year-old.

So the television audience for this project is quite broad, defined as a family viewing audience. However, interactivity is a way to target segments of this audience. I found, as we began developing our prototype, that it naturally skewed much younger than anything else I was developing for the series. Kids and teachers who have seen the prototype have been enthusiastic. And so I think the interactivity allows us to target and reach kids with music in a way that linear television can't do.

Discuss the process of brainstorming. What was it like collaborating with Carolyn and Nancy of PushyBroad, located in San Francisco, while you're stationed in New York?

Our plan from the beginning was that the prototype would work as a linear narrative, and that interactivity would always be a choice. Therefore, much of my work was first to create a piece that worked linearly, but also allowed for the layer of interactivity on top.

I edited in New York for a few weeks, while we talked by phone about interactive ideas, and planned how they would integrate within certain shots. I'd send tapes to San Francisco, and they'd e-mail me storyboards and design elements. Then I scheduled a shoot with BOTH interactivity and non-interactivity in mind.

I also worked early on with musicians in the orchestra to plan one of the segments—the "groove" sequence—in which the audience at home plays along with the musicians. The piece of music played had to be written especially for the piece. In the sequence, the members of the orchestra's percussion section create a groove—four interlocking beats—and teach it to a group of about 50 kids using four kinds of percussion instruments: bells, shakers, high drums, and low drums, each with its own part. The scene itself, the kids learning the groove, is quite charming on its own.

But in addition, the viewer can also choose one or more of the four instruments and play along at home.

The audience at AFI surprised us with an ovation after we presented the Groove section demonstrated on the Liberate box. I think this was because it actually worked. It makes you want to grab your keyboard and play along, and by doing so you become engaged in the action and begin to understand

in a visceral way the idea of "groove" being presented. One of the most valuable contributions from my partners at PushyBroad was that from the beginning they insisted that we create a working prototype, rather than a canned demo. I think their persistence on this point was invaluable.

Coming from the TV world, what were some sticking points in your collaboration?

We had a good working relationship. Nancy Saslow has an extensive background as a television producer and understood much of what I was doing. One battle we did have, though, was about "time"—my instincts were to let an idea develop before inviting your audience to reach for the remote to interact. The ITV folks were always pushing to introduce the interactivity sooner. This probably will be less of an issue when we're past the prototype phase.

One lesson I learned is that it's just as important to be frame-accurate with the interactive dimension as with every other aspect. The interactivity has to be post-produced—you need just the right fade up or fade down of each element, the appropriate audio mix, the right layering of the interface, etc. There also has to be some kind of learning curve. With this type of synchronous real-time enhancement, you only get one shot at it. So, if you make it too complex or unintelligible, the person figures out the interactivity just as it disappears.

Also you have to continually ask "why?" Does the interactivity add to and support the content presented? Does it detract from it? Is it simply a game? Or are you experiencing something new by interacting that is related to what's happening on the television? It's quite complex.

What is your expert testimony about the ITV medium now that you've received such attention for the work you've done?

I would consider myself a reformed skeptic of ITV, though still slightly cynical. Not every content should be interactive.

Not every audience wants to interact. My project, I feel, was ripe for interactivity, and will reach a specific demographic that may be interested to experience the project in an interactive way. Also, the subject matter—music—is really about interactivity. Musicians naturally interact with each other, they interact with their audience. So making the program interactive is really just broadening this interactivity to reach people at home.

I also think the best use of ITV will be when content creators begin ITV projects from scratch; creating an interactive drama, or a documentary project, and designing it from the beginning with ITV in mind. I think there

needs to be developed new models for ITV that don't simply apply a Web interface to a television program, like so much of what's been done thus far.

What are your next plans?

My present plan is that the *Music from the Inside Out* series will consist of three programs—only the third will utilize interactivity. It will be a special interactive program with synchronous enhancements on a set-top box, like we did with the prototype. The interactivity for me is only one small part of a larger project, and may be most successful as part of its afterlife—distributed as a DVD or some other format that can be used by teachers. I'm not sure how many households will have the technology to actually interact with the broadcast. But I am intrigued enough with ITV to possibly try to develop another project specifically with interactivity in mind.(© *Copyright 2001. Reprinted with permission from Anker Productions, Inc.*)

Contact information for Danny Anker, Anker Productions, Inc.
APIFilms@aol.com, telephone: 212-645-2205.

THE ENSEMBLE INTERACTIVE SEQUENCE

The Ensemble interactive section of *Music from the Inside Out*, as other pieces of the program, were shot and produced with interactivity in mind from the beginning. The enhanced elements were created in Macromedia's Flash, hand-coded, and the show delivered on the Liberate CT-500 ATVEF-compliant platform.

Figures 14.1 through 14.4 are four visuals from the Ensemble interactive sequence. To access interactivity, a participant selects from four choices on the circular menu to the right—score, cams, music, and more.

ABOUT PUSHYBROAD

PushyBroad (for pushed and broadband content), is a convergence production and design studio. They provide one-stop shopping for content and design across all media. Partnering with traditional media and production companies, PushyBroad develops content for interactive/enhanced TV, broadband, narrowband, and wireless. PushyBroad also creates original programming for television, as well as for distribution across any, or all of those platforms. PushyBroad's hybrid creative and technical teams are veterans of broadcast and cable, Internet, multimedia and interactive. They come from film, television, commercial

FIGURE 14.1 *The "Score" interactivity displays in time exactly what the trombone is playing. At anytime, you can change which instrument's score you want to see. (© Copyright 2001. Reprinted with permission from Anker Productions, Inc.)*

FIGURE 14.2 *The "Cams" selection slices the screen in half; here you see the violinist on the right screen (MPEG2), and the director's cut—the show on the left. You can interactively select any of the instruments, like the trombone, and on the right side be presented with specific information about that instrument and the musician. (© Copyright 2001. Reprinted with permission from Anker Productions, Inc.)*

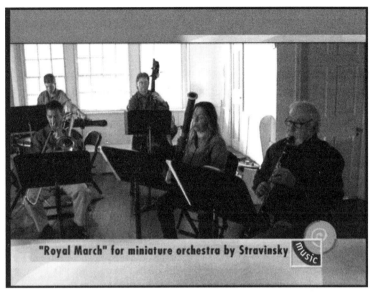

FIGURE 14.3 *By selecting "Music," viewers can also get some limited information on the music itself. This enhancement gives the basics on the piece being played, and can be accessed at anytime during the ensemble segment. (© Copyright 2001. Reprinted with permission from Anker Productions, Inc.)*

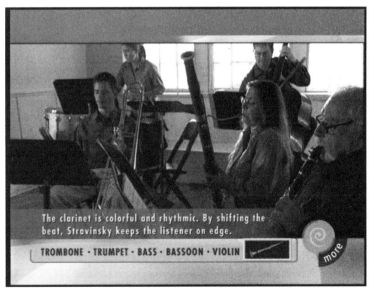

FIGURE 14.4 *By selecting "More," you can receive more information about the role of each instrument in the "Royal March." Here, for example, we can find out how Stravinsky used the clarinet in this piece. And you can get that perspective from any of the instruments displayed on the menu. (© Copyright 2001. Reprinted with permission from Anker Productions, Inc.)*

production, location-based entertainment, music, set-top box development, CD-ROM, and the Web. PushyBroad has completed projects for clients such as Discovery, MacNeil/Lehrer Productions, JP Kids, Transcast, Tech TV, PanAmSat, Hughes, Women.Future, Levi Strauss & Co., and Americast. For contact information, visit www.pushybroad.com.

CHAPTER 15
AFI Enhanced TV Workshop

IN THIS CHAPTER

- A Conversation with Anna Marie Piersimoni, Associate Director, New Media Ventures, AFI, formerly Director, AFI Enhanced TV Workshop

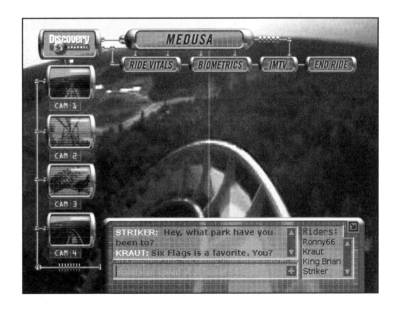

A Conversation with Anna Marie Piersimoni

Briefly describe the AFI Enhanced TV Workshop—its beginnings, its purpose, its goals.

(Note: The AFI Enhanced TV Workshop began with seed funding from Intel Corporation as part of an overall commitment of support from Intel Corporation for the American Film Institute, which included The AFI FEST and The California Digital Arts Workshop. It has since secured funding from new sources, including the Corporation for Public Broadcasting and Microsoft Corporation, and is now named the AFI Enhanced TV Workshop.)

You know, it seems it was just three short years ago that people were asking, "Exactly what is Enhanced TV?" Is it simply video + data? Is it on a TV or a PC? 2-Screen or single? Lean forward? Lean back? Push or Pull? While many of these questions were being argued from convention hall floors to boardrooms, the American Film Institute asked another question, "Why bother?" In fact, we even actually kind of referred to this program as the "Why bother? workshop." Well, here are some of the reasons we decided to bother.

When interactive TV was first introduced in the mid 70s, it was hailed as the innovation that would revolutionize the medium—and subsequently went bust, time and time again. But this time was different. This time, there was the Federal mandate that all TV broadcasts be digital by 2006.

The impact of the digital revolution continues to offer challenges and opportunities to both for-profit and not-for-profit organizations in the entertainment community. AFI is no exception. AFI programs teach and celebrate an art form that is created and delivered through technologies. As the moving image art form has evolved from cinema to television, video, cable, and now to new media, so too has AFI sought to evolve its programs and professional support to reflect the changes in technology.

Likewise, Intel Corporation was developing its digital strategy for television technology and was interested in expanding its reach into the Hollywood community and created a Content Group within the company with this as a large part of its mission. It was obvious that a new model must be forged to allow video services to be "enhanced" with data services and that this could only be done by a true partnership of art and technology—one that allows the creative development of the medium to occur simultaneously and, in fact, alongside the technological development.

Spearheaded by Nick DeMartino, currently AFI's Director, New Media Ventures, we created a special hands-on R&D environment for television professionals. It is based on a tried and true customized "apprenticeship" curriculum that the American Film Institute has developed over a long history of

nurturing professional development. In all of these efforts, we strongly believe that creativity cannot be taught—only nurtured. One learns by doing. The AFI Enhanced TV Workshop was thus designed to directly help the television professional not only to learn about various platforms, tools and technologies, but to master the creative, conceptual, production and technical challenges in migrating their traditional linear, broadcast properties to this new convergent medium.

Now, the workshop exists as a juried selection program: approximately eight producers are chosen each year to participate. They must be seasoned professionals with a TV show on the air or with an air commitment. They attend a three-day orientation session during which they are exposed to a wide variety of state-of-the art production and application examples and mingle with top innovators in the field, many of whom are on our advisory board. Some of these production and technology innovators have agreed to mentor the producers and are "matched" with them shortly after orientation to form Prototype Production teams. These teams then collaborate over a period of 3–4 months to create process, share the information, set up additional learning experiences for all—seminars, critiques and essentially, "executive produce" the prototypes. The insistence of seasoned producers with programs on the air insures that there is compelling original content to work with and provides a "familiar" content in which to observe and study the evolving "context."

The AFI Enhanced TV Workshop brings together TV producers and ITV developers in a collaborative effort to develop an interactive television project. Describe for me your thoughts on the importance of collaboration in this new medium.

I believe that nothing truly creative really operates in a vacuum. Film and television as industry and as an art form borrow from the theater arts a highly collaborative methodology, as do many forms of scientific inquiry. In the case of the ETV workshop, the focus on hands-on production of prototypes allows creative professionals and technologists to experiment together with the actual crafting of this new form of television. To imagine how something will look and feel and function and then to try it out practically and see what sticks, what needs "tweaking," and what may have been an impossible idea to begin with. Regardless of platform, this initial stage of conceptualizing and "modeling" is critical to even comprehend why a particular platform or tool should be used. And, it's essential to allow the technology sector to know what may improve the tools they are building to accommodate various types of content. It's really akin to architecture, it's a building process in which the materials and tools of the model are used to lay out the plan for the real thing and suggest the materials and methods best suited for

the function and design. These initial collaborative individual projects, coupled with a broader collaboration through presentation and demonstrations to the industry at large creates a "community of practice" from which we all benefit.

What are the main reasons a TV producer participates in your program?

First, you must remember that the industry has a keen and often painful memory of other technology changes from talkies to home video.

So, this is an opportunity to stay at the "top of their" game, as Harley Tat, producer of Blind Date puts it. Producers are keenly aware of the sea change taking place in their medium and feel an urgency to not be left out.

Second, many producers are realizing that this is a way to extend the value of their property. Enhancements provide different uses and ways to view their programs, and breathe new life into something that cost them a lot of heart, sweat, and dollars, which might have had only one or two airings and then sat on a shelf.

Third, and most important to me, many producers become completely enthralled and motivated by the possibilities of telling their stories and expressing their art in new and different ways. These are the true pioneers of the medium as they literally experiment with breaking the story line, inviting "audience" participation, dynamic character development and personalized plot elements, shifting POV, etc.

Can you describe for me a particular AFI Enhanced TV Workshop project that represents how interactive television storytelling can change and/or enhance more traditional storytelling genres, such as regular television programming, books, and movies?

Discovery Channel's Extreme Rides is an ongoing primetime series, appealing to roller coaster enthusiasts. The show highlights their unique features, design, engineering, world records, and the enthusiasts who love them! The program was perfect for ETV development because of its compelling content (and lots of it)—exciting visuals, great characters, specialized information, and an established, targeted community of fans. In its ETV form, Extreme Rides 2001 allows for more and richer information coupled with a viewer controlled experience that provides a deeper immersion in the subject matter (Figure 15.1).

This includes allowing viewers to jump out of the narrative broadcast and ride any coaster they choose, from any chosen POV, with the option of watching others ride, while chatting with their community of coaster lovers. Additionally, viewers can compete in coaster trivia contests to win season passes to their favorite parks, view behind-the-scenes interviews and historic newsreel footage, buy Extreme Rides merchandise, and even build their own

CHAPTER 15 AFI ENHANCED TV WORKSHOP

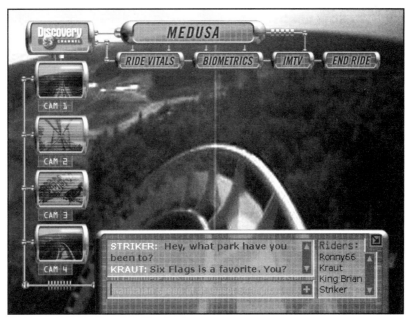

FIGURE 15.1 *Enhanced interface design for Discovery Channel's* Extreme Rides. *(© Copyright 2001. Reprinted with permission from the American Film Institute.)*

3D coaster, which they can test and post on the Web for community feedback. The project was scaled to reflect different levels of immersion as divided into three interface architecture categories or "buckets": the first, a broadcast experience, the second, a post-broadcast for broadband PC, and third, a sync-to-broadcast experience involving two-screens, a TV and a PC.

What were the three main challenges in producing Extreme Rides?

To answer this, I consulted with the producer of the program, Kiku Lani Iwata, since she was the most immersed in both the original property and the ETV prototypes.

 a) Learning curve—Changing the producer mindset to expand the range of production possibilities, learning about various applications and platforms, and evaluating which ones make sense for the particular show.
 b) Teamwork—Coordinating between the network, production company, producer, graphic artist, ETV designers and programmers.
 c) Scalability—Deciding on how much interactivity to allow at various levels, setting limits to make critical creative choices, essentially, how to keep it "FUN."

And Kiku adds:

> d) Explaining to colleagues what interactive television is all about (this is not really a challenge, but a funny fact that's reality).

How was the project successful?

Critical reception was extremely positive from ITV/ETV industry leaders, and also from those at Discovery Channel network. Discovery is actively pursuing development of interactive programs and Kiku is one of the producers they look to—which makes it a success for AFI in terms of professional development as well.

What was learned from the project?

Aaron Sugarman, mentor from Agency.com on this project, puts it best: "Forget what you know—think beyond traditional TV concepts. And—DON'T forget what you know—the producer's knowledge about the show is valuable during development and production."

Traditional TV producers really care about their audience and know how to keep them entertained. They are the closest to their property and know what feels best and looks best. They already know how to make creative choices. But they need to embrace the medium to get past the fear of it and fully contribute. They need to get "underwhelmed" by the technology and steer the true direction of the product. It is an educational process and cannot be learned "overnight."

Anna Marie, you had another ETV project you wanted to share. Tell me about The Eddie Files.

The Eddie Files was a Peabody Award-winning series, produced by Rob Mikuriya and FASE Production, centering on a middle-school aged child named Eddie who documented his world and organized his archive to reflect what he was exploring and learning about, particularly in terms of his future. The Eddie Files is a unique blend of drama, comedy, and documentary designed to help kids make the connection between school learning and real living. The show was ideally suited for enhancement because the narrative line was already driven by a series of inter-situational blocks that built upon each other to tell the story and convey information (Figures 15.2–15.3). For example, while Eddie was dog sitting, the creature got away from him. Since it was a school day, he enlisted a young adult to find the dog. As his friend searched the city, the story would cut back to Eddie learning about how to calculate the speed of light and sound. When the dog got on a subway train, the show could cut to a short piece on the technology of the subway system. A lot of cutting, but in no way was the linear story line lost. It was completely accessible

CHAPTER 15 AFI ENHANCED TV WORKSHOP

FIGURE 15.2 The Eddie Files. (© Copyright 2001. Reprinted with permission from the American Film Institute.)

FIGURE 15.3 The Eddie Files. (© Copyright 2001. Reprinted with permission from the American Film Institute.)

and entertaining. Upcoming generations of viewers are already attuned to watching stories this way—and now with their PC turned on as well!

Yet, the main challenge in this prototype remained keeping the story flow while allowing interactivity. To this end, the producer and mentors designed a charming series of clickable animated files that corresponded to character or plot points and would pop on screen and off according to the presence of the character on screen or a turn in the script. Another challenge this producer pinpointed was the difference in language, the need to translate terms from one field, say software development, that have different meanings when applied to the television production world and vice versa. I consider the project a success because it caused a sea change in the thinking of the producer, who developed a concept that the story itself has a life outside of one particular medium and was actually an "environment" that could exist across many media and platforms. He did in fact receive additional funding to further develop the project and has since then developed the project to incorporate DVD technology with localized station market and educational elements.

As we all know the technology and standards for creating content in this emerging medium is ever-evolving—how do you see the AFI Enhanced TV Workshop changing in the next year? In five years?

While the adoption of standards is still an evolving issue, it's been proven time and again that content leads hardware and platforms. I believe a combination of compelling content and personal convenience is what will finally fuel real market development. The collaboration we've been developing between distributors, applications developers, and TV producers will drive it.

The AFI ETV Workshop, going into its fourth year, is the most prestigious enhanced TV R&D environment in existence. One of our goals this year is to bring together an even more diverse roster of industry segments to weigh in on the development of TV programming—advertisers and agencies, talent representatives, as well as deeper involvement of cable and satellite operators.

In the next year, the spectrum of disciplines needed to create enhanced TV—MSOs, networks, middleware, interactive content developers, interactive/broadcast designers, etc.—will bring both broad and very specific contributions to the conception and execution of an enhanced TV prototype.

This year, AFI envisions moving to a two-tier system—produce the prototypes as we have in the past, and permit sponsors the right to take the prototypes to the next stage, subject to the willingness of the participant and the provision of additional resources. At that point, AFI may continue to be the appropriate executive producer to implement the next stage of production. Or, it may move outside the AFI's purview, and become "productized" with a commercial vendor and the funder. The shifting layers of production sched-

ules and training modules of this tiered approach will eventually transform the "workshop" experience into a "laboratory" experience, creating an atmosphere of year-round research and development across numerous technological platforms with constant review and dialogue.

In the longer view, new ways of reaching viewers will prove to be the killer apps of this medium. Business-as-usual is giving way to ever more personalization, intimacy, and interaction with our viewers. Just as cable TV and home video seemed like new media at their inception, so will the new forms of television we call "enhanced" become commonplace on our TV screens ... and our PC screens, and our wireless handheld devices—in fact, we may just end up calling it "TV."

The AFI has a long-standing commitment to professional development as part of its overall mission to advance the art of the moving image. Just as this new medium may become the norm, the special customized workshop experience may evolve into a more standardized curriculum designed to teach the creative process of telling stories via moving picture and sound, and could even become a more mainstream educational component of AFI. Plus, the educational functionality of this new medium itself may also serve as a teaching tool. Certainly, it will play a large part in our future plans to develop distance learning and e-courses based on AFI models, as well as new programs in screen education and literacy aimed at future generations of potential storytellers. (© Copyright 2001. Reprinted with permission from the American Film Institute.)

For more information on the AFI Enhanced TV Workshop, visit the training section of the American Film Institute site at www.afionline.org.

CHAPTER 16

Two Way TV

IN THIS CHAPTER

- Interview with Heidi Bruckland

INTERVIEW WITH HEIDI BRUCKLAND

To add a bit of international perspective to the Projects portion of this book, I contacted Heidi Bruckland, marketing representative at Two Way TV, a world leader in interactive TV games, and asked if she could drum up some answers for the following questions.

First of all, elaborate on Two Way TV, its beginnings and influence in the ITV market in the UK and abroad.

Two Way TV was set up in 1992 with the specific vision to bring "play along" interactivity to live broadcast programmes such as quiz shows and sports events. It developed its own proprietary analogue system that required the consumer to buy a Two Way TV set-top-box and handsets.

The principle was (and still is) to enable family and friends to interact with their favourite programmes, compete and score points against the on-screen contestants as well as others playing in the home or elsewhere on the network.

Commercial trials were run in homes in the mid-1990s and the results showed a significant uplift in the size of the audience. Viewers who ordinarily would have avoided a particular general knowledge challenge found themselves turning to it simply because of the play-along element. Once they started an interactive game they would also stay for the full length of the programme to see how they fared and check their scores against other players.

This type of interactivity has come to be known as "enhanced" television, or ETV, and describes the marriage of an existing broadcast programme with an interactive overlay.

The Two Way TV trial did not lead to a full market roll-out because "digital" was pipped, imminently, to replace analogue. Two Way TV took a strategic decision to wait for digital network deployments that could run TWTV interactivity and would mean that Two Way TV no longer needed to supply boxes and handsets.

While waiting to launch its ETV programmes and games in digital form, Two Way TV took the opportunity to create a channel of interactive games based on classic formats that include word puzzles, trivia challenges, and arcade-style games. Also, the mechanisms for collating scores, handling "pay-per-play" payments and billing customers.

In the UK, the Two Way TV channel of interactive games runs on digital cable networks across the country and will soon have an equivalent on UK digital terrestrial platform, ONdigital. A satellite presence is also anticipated.

Countries such as the US, Australia, Israel, and parts of Europe are deploying the Two Way TV channel, presented for their indigenous

audiences. This gives Two Way TV a foothold in these territories and on these platforms which, in turn, will lead to the introduction of ETV programming.

At conferences, exhibitions, and in the specialist press, Two Way TV is constantly referred to as leaders in the interactive field, an organisation that understands the type of content consumers respond to and has the technology and infrastructure to deliver that.

What are your main objectives in this new interactive space?

From the outset, the company's objective has always been to deliver ETV programming to the widest possible audience. Digital broadcasting services have been the goal of broadcasters around the world, and the past two years have seen widespread introduction of such networks and services. Two Way TV expects to see its ETV technology and content re-emerge before the end of 2001.

Other objectives are to establish wider presence on satellite networks and continue to see TWTV interactive services spread across Europe.

Simultaneously, it is expected that the production community itself will begin to produce a much larger number of programmes where interactivity is integral to the core idea. Two Way TV is in talks with a number of companies about creating interactive programmes, particularly where voting by the audience is a strong element of the proposal, from the ground up.

How do viewers receive your content? How large is your viewership?

Not only does Two Way TV's technology deliver an interactive games channel, but it can also overlay existing TV shows and entire channels to make them interactive.

So who gets it?

In the UK, the Two Way TV channel is available to over 900,000 digital cable users on the NTL and Telewest digital networks. The channel will also launch to a further 1 million subscribers on the UK's only digital terrestrial service ONdigital/ITVdigital summer 2001.

Two Way TV has offices in the US, Two Way TV Australia runs on the Austar satellite service, and the channel will be launching in Israel and Portugal later this year.

And how do they get it?

It works using Two Way TV's Central Computer System (CCS) technology together with a set of Windows NT based tools. The CCS manages and schedules the delivery of all content over the broadcast networks and handles all the information coming the other way such as scores and payment details.

In addition to the CCS, the Two Way TV 'Engine' is a platform-specific plug-in that manages all the remote control clicks and viewer responses, in effect allowing the viewer to 'talk back' to Two Way TV. Players can view their scores instantaneously and access leaderboards, playing against friends, family, their next door neighbour, or anyone else on the network. It also delivers the live data feed to run and synchronise applications in real time over TV shows.

From a technological standpoint, what platforms do you use to create your interactive content? Do you adhere to industry standards of content development, such as DVB- MHP and ATVEF?

The Two Way TV channel is already running on digital cable, satellite, and terrestrial networks worldwide. The technology can also work on broadband Internet systems and WebTV-type set-top-boxes, but more importantly, can deliver live interactivity to multiple networks and platforms simultaneously.

In order to make this possible, Two Way TV has developed close working relationships with all the major middleware platforms that enable interactivity to take place. These include HTML and JavaScript Internet-based platforms such as the Liberate TV Navigator and the Microsoft TV package. Two Way TV also uses the OpenTV platform over the Austar digital network in Australia and MediaHighway when it launches on ONdigital.

Two Way TV is also involved in the major industry forums and standard bodies that have been set up to speed the commercial deployment of interactivity on all platforms throughout the world. These include ATVEF (The Advanced TV Forum) in the US and DVB (Digital Video Broadcasting) in Europe.

Describe one of your most successful projects to date.

We created a pilot programme for an ETV travel series, called *Away Games*. This takes the principle of ETV a step further in that, instead of on-screen presenters and contestants being oblivious to the home audience, this programme directs its whole attention towards the person sitting in an armchair on the other side of the camera.

Two presenters set off on a trip to Paris to describe and inform all about the French capital, its clubs, culture, and quirks. At the same time, they are setting questions for the viewers to answer as they follow the programme, enabling them to rack up points as they go along.

There are questions with multiple-choice answers, questions that the presenters ask each other, or may even appear independently. Players use the number buttons on their controls to select the answer they think is correct.

At the end, viewers can vote on which city they want the presenters to visit next and, if they've scored enough points, may even have won a trip to the city they've just been learning about.

Away Games was produced with Workhouse, a production company. Workhouse provided its programme-making skills which dovetailed with Two Way TV's interactive expertise.

The key was to plan how both halves would end up as a whole well before any production started. With this type of programme, for example, the producer would have to ensure there was enough footage of a particular scene in the edit for the viewers at home to read three possible answers to a question and click the relevant button on their handset.

Away Games went first to Paris for the pilot show and a series has yet to be commissioned by a broadcaster. Its success lies in its demonstration of the advanced principles of an interactive programme, one that draws in and involves the viewer who, at the same time, is playing a point-scoring game.

How successful is the use of advertising in your interactive content, such as the Cadbury campaign?

Major confectioner Cadbury Trebor Bassett took part in an advertising promotion on Two Way TV during the Easter period. Specifically, Two Way TV players were able to take part in an Easter egg hunt around the channel and then complete a tie-breaker extolling the benefits of Cadbury's chocolate and Two Way TV game playing.

The campaign brought two winners two years' supply of chocolate bars. Players clicking through to Cadbury's Web site from the Two Way TV channel during the time of the campaign was around 25 percent, an incredibly high figure in marketing terms.

Once ETV is fully deployed on networks, Two Way TV expects to see a surge in mainstream advertising—commercials, for instance—where a narrow interactive response mechanism runs along the bottom of the ad.

In trial work with a kitchen manufacturer, a panel was added asking questions like "are you thinking of changing your kitchen in the next six months?" or "do you want a brochure?" To answer, all the viewers had to do was press one of the coloured buttons on their handset. The manufacturer could then deal with this data during the following few days rather than needing a call centre to handle this incoming information.

The golden rule, as ever, is to keep it simple. If the transactional process for a television viewer is more involved than just making a phone call, then it will fail.

The UK is the leader in digital TV conversion and one of the top innovators of new ITV and enhanced content. What has contributed to this forward leap

into this technology? In your perspective, what do you think needs to happen in the United States to push forward the necessary interest in ITV and make it truly successful and profitable.

In the UK, digital TV penetration has already reached 30% and the government is attempting to set a date to switch off all analogue signals by 2006.

Interactive can mean Internet access, e-mail, and t-commerce, but it is games that have proved the biggest hit in the UK.

The rapid deployment of digital TV in the UK owes much to a relatively new cable infrastructure compared to the US and the fact that there are only two main cable operators in the UK compared to the hundreds that exist in the US. This, along with the popularity of satellite in the UK and Europe, has sped digital conversion and therefore the introduction of ITV services.

On the content, broadcasters in the UK are beginning to experiment with interactivity and are asking for "projects" rather than mere programmes. For example, the BBC will not commission any new programmes that do not have an element of interactivity with the proposal.

However, industry researchers estimate that some four to six million US homes will be interacting with their TV sets via cable or satellite connections by the end of this year. Once US cable franchises begin to work towards a common set of specifications, the rollout of digital will speed up and no doubt overtake Europe.

What are your predictions for the upcoming years of ITV?

Currently there is a whole range of options under the heading of television interactivity, ranging from surfing the Net to buying goods that appear on screen.

Games, as highlighted, have turned out to be far more popular than anyone could have predicted (Figure 16.1). In research, when asked, interviewees would not admit to wanting to play games on their television. In practice, they do. This is because "games" suggests inane, fiddly video games played by kids. Two Way TV's top game appeals to adults and is a challenging word puzzle, where the player has to form words from a constantly changing grid of letters, all inside 20 minutes.

Once you understand how electronic interactivity can reinvigorate the humblest of forms, so the ideas begin to flow.

Two Way TV shares the view that interactivity will become commonplace among certain programme genres such as light entertainment, particularly game shows, and sports events.

Its system of enabling the audience to answer the same questions at the same time as the studio contestants is set to become a big audience vote winner (Figure 16.2). Just as in sports, being able to express predictions of how

CHAPTER 16 TWO WAY TV 261

FIGURE *Picnic Antics interactive game. (© Copyright 2001. Reprinted with permission from*
16.1 *Two Way TV.)*

the event will play out, will become a compelling and wide spread addition to the television viewing experience (Figure 16.3).

At the same time the production community at large is desperate to be the first to create and see broadcast a show built from the ground up as an interactive event. Any proposal that includes a voting element or where the audience can in some way be allowed to influence outcome is ripe for button-pressing interactivity.

To date, reality shows have demonstrated the role an Internet Web site can play in driving the audience to a broadcast series. The merger of these two halves, the interactive with the programme, on the television, is the clear path for interactive integration.

The viewers do not have to get out of their chairs and dial a premium phone line or go and look up a Web site on the PC in the backroom. It's all there, accessible by them through the remote control handset in their hand. As a matter of course.

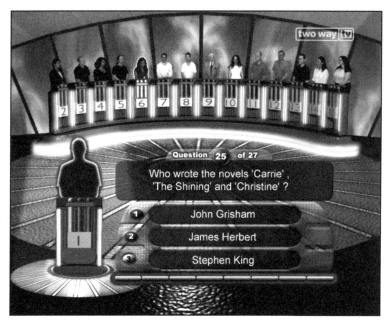

FIGURE 16.2 *Interactivity based on the television program 15 – 1 produced by Regent Productions for Channel 4. (© Copyright 2001. Reprinted with permission from Two Way TV.)*

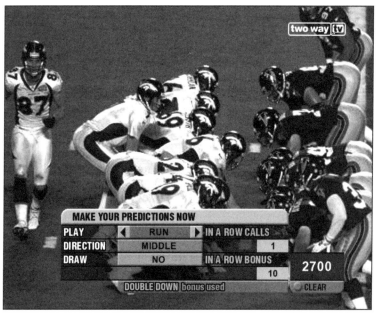

FIGURE 16.3 *PlayLive Football interactive sports. (© Copyright 2001. Photograph courtesy of ALLSPORT Ltd.)*

CHAPTER 16 TWO WAY TV

What recommendations can you give the reader of this book on how he or she can learn more about and become involved with this nascent medium of ITV?

Check out the following sites for statistics and platform information.

Statistics:
 www.oftel.org
 www.datamonitor.com
 www.durlacher.com
 www.forrester.com

Platforms:
 www.liberate.com
 www.opentv.com
 www.microsoft.com
 www.canalplus.fr

(© Copyright 2001. Reprinted with permission from Two Way TV.)

For more information on Two Way TV, visit online at www.twowaytv.com.

CHAPTER 17

Showtime Networks

IN THIS CHAPTER

- Author Interview with David Preisman

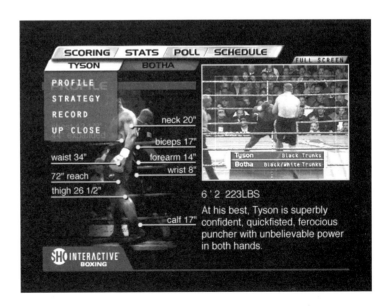

For the Projects finale is Showtime Networks, a company that has consistently been on the forefront of ITV innovation and content development. David Preisman, director of Interactive Television at Showtime, speaks candidly about his background in the digital technology field, his role at Showtime, the company's place in the ITV arena, and his experience "producing interactive television"—summing up nicely what this book is all about.

Author Interview with David Preisman, Director of Interactive Television, Showtime Networks

David, how did you get involved with Showtime Networks, your background, and experience?

Someone recently asked what I wanted to do when I was younger. I said, "exactly what I'm doing now." I've always been interested in broadcasting, design, and computers. After spending most of my teen years at my high school radio station, and at a local station on Long Island, I realized that I really loved production. In '85 or '86 I saw MacPaint on a computer at school. I could actually create graphics using a computer! I immediately started to play with the Mac at school for my home video and radio projects.

I attended SUNY Oswego, majoring in Broadcasting with a minor in Art. My professors didn't know what to do with me. I finished all of the school's audio & video production classes in my sophomore year and I was spending a lot of my free time at the college TV station, heading up the on-air promo production. I heard that the technology education department had Color Macs and I immediately ran over to the other side of campus to see it for myself. The brand new Mac IIs were for students learning to become technology teachers (aka: shop class), but I managed to get into the class after talking to the professor. I remember seeing an early version of Photoshop running a filter on a photograph. I was totally blown away and really couldn't believe what I was seeing.

It didn't take long before I was a teacher's assistant with access to the computers. I must have read every manual cover to cover two or three times.

Again I ran out of classes to take, but I managed to convince both the Technology and Communications departments to let me do independent study classes. I remember spending a full semester animating, one frame at a time by capturing stills into a Mac, touching them up in Photoshop, and editing it back to 3/4" video, frame by frame. Today, I could probably do the same thing in After Effects in a few minutes. But I loved every minute of it.

Chapter 17 Showtime Networks

After college I spent a few years teaching teenagers video production and animation at a youth center called Levels on Long Island. We got a VideoToaster and the kids produced an award-winning public access TV show. In my spare time, I worked as a graphic designer and I started editing video on the Media 100 and building Web sites for the few companies that knew about the Internet.

I hooked up with Showtime in the mid 90's. Showtime was way ahead of the pack in digital video. They were offlining using early versions of Premiere. There was a real pioneering hands-on spirit that appealed to me.

I worked as a Post Production Video Editor, and after a few years, they let me start producing promos and animation. I was also doing a lot of experimenting with databases and automated solutions for our inhouse production systems, which is key to pulling off ITV these days.

Showtime was also involved in New Media early on. We were one of the first companies to do enhanced broadcasting with Wink, and also do 2-Screen interactive with Online Scoring for our boxing matches. My current boss heard about the work I was doing in Creative Services, and I switched over to the company's New Media group, where I've been ever since.

Showtime has been and continues to be a leader in the forward progression of the ITV medium, why?

Showtime understands that ITV can add value for its subscribers. As a premium television network, our subscribers expect more from us and we need to deliver. Additionally, since we are a premium television service, we don't have many of the same issues that an ad-supported network does.

Showtime was involved early on with TiVo, Replay, Wink, WorldGate, and HyperTV. We do a lot of production inhouse, both traditional video postproduction and new media, which is unusual in the industry. I really think this empowers the staff. Because everything is so hands-on, most of the company has a better understanding of the work that's involved. I think this makes us really efficient with a much smaller staff. I also think that Showtime understands the potential of digital technology. We were an early leader in both HDTV and Dolby Digital Surround Sound.

What is Showtime's main objective, main impetus, in creating content for the ITV space? What types of content are you creating? For what audience? And why?

Today, while the business models of ITV still aren't clear, we're concentrating on enhancing the consumer experience, which is a great environment in which to work. How do we create applications that make Showtime and our other channels, better, more entertaining? Since we're a premium service,

if we can retain subscribers longer because of our ITV initiatives, it translates into money for the company. We're also developing ITV applications to acquire new subscribers.

We're very active in the ITV and SVOD space, developing a variety of applications for our different programs and services. One of the most important things about enhanced TV is that the enhancement really has to fit the program. It shouldn't compete with it. No one wants interactive ER where you can control the EKG machine. There are, of course, the logical genres that are inherently interactive. In the past, the only way you could interact was to yell at your television screen. Game shows are the most obvious. Then there's sports, news, documentaries, and information, like weather. The challenge for us is that besides boxing, we primarily air movies and original dramatic series. Some dramatic series can be successfully enhanced. We did some really innovative work on the sci-fi program *Stargate SG-1*.

The big question for us is, how do you enhance movies? Does our demographic really want a highly interactive experience when they're watching a movie on Showtime? I don't think everyone does. So I think we came up with a really innovative idea that does work for movies. We make Showtime more like a DVD. Consumers love the extra stuff that you get on DVDs and we have an application that's running 24 hours a day, 7 days a week that provides a similar experience. The next time you're watching a movie and you want to know an actor's name, or you're wondering what other movies he or she has been in, you click the remote and enter our 24/7 interactive application. This ultimate movie guide contains program information, a summary, cast lists, bios, filmographies, behind the scenes trivia, a network schedule, and a listing of the next scheduled airing if you tuned in late. You can also set e-mail reminders and send a friend a Showtime TV Postcard™ right from your TV. We think that having this application running 24 hours a day, 7 days a week is a great "passive" enhancement, which works really well with our programming. It's there anytime you want it.

From a technological standpoint, what platforms do you use to create Showtime interactive content?

As you know, we're in the very early days of Interactive TV, which makes development a real challenge. There are many different platforms out there. We want to reach as many Showtime subscribers as possible, so we need to support the technologies that are being deployed. Some of the platforms have developer kits with special software and documentation, which is really challenging. Some of the software is buggy and the documentation can be limited or inaccurate.

Our apps are written for almost all of the major platforms out there.

We're developing for the ATVEF-compliant boxes, which would include Liberate and the Microsoft products. We're also developing for WorldGate, Wink, sync-to-tv on the PC, and for new emerging devices. Almost all of these work differently, with different authoring tools, different color palettes and screen sizes. Many of these platforms have different systems for the lower-end set-top boxes, so if we want to reach the largest audience today, we have to write the application many different times. The key for us is to make sure that we build things in a very smart, efficient way, so we can manage to port our apps to all of the different platforms.

We like to create automated solutions, often building our own tools for admining the process. I'm fortunate to work with a very talented technical team that helps us pull it off.

Describe a particularly successful Showtime ITV project.

I'm really proud of the work we've done on Interactive Boxing. I think we really pushed the limits of what the current set-top boxes are capable of.

We came up with a nice balance between an active and passive ITV experience. A Showtime Championship Boxing event is comprised of a couple of undercard fights that lead up to a headliner at the end. All of the sports apps that I've ever seen either present the enhancement as an overlay, which doesn't leave you a lot of space for content, or as a picture in picture, and who wants to watch an entire sporting event in a little picture window? We created a pretty cool animated interface that allows the view to toggle back and forth between both modes.

When the action is intense, the enhancement appears as a semitransparent overlay that matches the look of the traditional on-air graphics. The viewer can vote round by round on this interactive scorecard and the nice part is, the on-air talent frequently talks about the online scoring results. There's your payoff. We were the first to do online scoring on the Web, and it's been very popular with our viewers.

When the viewer wants more information, perhaps between rounds or matches, he or she can hit the zoom button and enter a picture in picture mode, which is loaded with everything a boxing fan could ever want. The interface is very easy to navigate, but it also has a lot of robust content, including a complete fight history for both fighters, tons of stats, bios, and a poll. We also included a lot of animation, which is missing from most of the apps out there today. I think by letting the viewers control how much interactivity they want and when, we've successfully created a compelling end-user experience. The content also changes during the event, so it can hold the viewers' attention throughout the program.

What was your role in this project? Describe for me your experience working collaboratively with the Show's producers? How did you and the producers work together to communicate each of your visions for such an innovative project?

Fortunately, Showtime has a great boxing department, and they were very enthusiastic about the idea when we initially pitched it to them. I've been working closely with them to make sure that our vision for the application is in sync with their larger vision for the on-air program and the Boxing franchise. We've had a Showtime boxing Web site for many years, so everyone was already familiar with the idea of enhancing the experience.

My role varies from project to project. Boxing is a big one for us, so I've been thinking about it for a good year before any work began. I usually try to get my ideas down on paper, and being a visual person, I usually mock up some of my ideas in Photoshop. Sometimes I do design work and basic programming; it really depends. In this instance, I worked with a designer and a programmer who were able to take my ideas to the next level. I usually try to get others psyched up for the project, and most of the time, my enthusiasm spills over.

What were the main things you had to consider in producing Interactive Boxing?

We spent a lot of time working out the information architecture. We nailed down all of the content, but the challenge was in organizing it into logical sections. We wanted to include a lot of substance, while keeping the file size small.

It was also essential that the user interface was easy to use without any instructions. We can't assume that our participants have ever touched a computer. Many of them have never used an ITV app before, so it needed to be highly intuitive.

David, discuss a bit about the creation process for Interactive Boxing.

To start, I did a lot of research. I looked at boxing Web sites, magazines, and with my TiVo, I recorded boxing matches off of every other network that covers the sport. I like to do a lot of research. What are the most important stats? How are they effectively communicated? I found that most of the boxing stuff online and in print was pretty gritty and the design often looked like the stuff you see in the *Pennysaver*. I wanted to combine as much of the valuable information as possible, but present it in a fun, graphical way. I think I really nailed it on the Profile page, where we list the physical attributes of a fighter by pointing to his or her body (Figure 17.1).

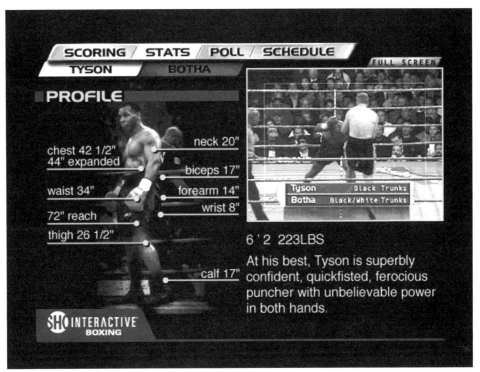

FIGURE 17.1 *Showtime's Interactive Boxing application presents statistics in a unique visual fashion. (SET Pay Per View boxing event, courtesy of Showtime Networks Inc.) (© Copyright 2000. Showtime Networks Inc. All rights reserved.)*

Interactive Boxing also needed to be plotted out over time. Some of the elements span the entire event, some change from fight to fight, some round by round; others are totally interactive and they change on-the-fly.

I made a lot of charts (Figure 17.2).

Boxing is pretty complicated and we do a lot of fights on Showtime, so we spent a lot of time coming up with the back-end system that would enable us to really pull this off on a regular basis, with limited manpower. This added a lot of time to the development, but it will definitely pay off in the long run.

Name the main success of the show.

I think we learned a lot about some of the advanced capabilities of the different platforms. I think we also learned a lot about interface, letting the user control the level of interactivity. In terms of viewer feedback and testing, it's too soon to tell.

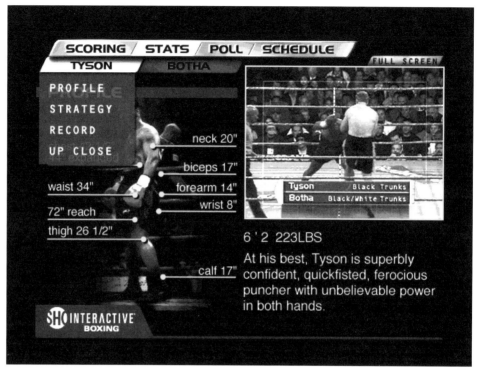

FIGURE 17.2 *Clicking on a fighter's name brings up a semitransparent pop-up menu. (SET Pay Per View boxing event, courtesy of Showtime Networks Inc.) (© Copyright 2000. Showtime Networks Inc. All rights reserved.)*

Name one of the challenges (pitfalls) of the show.

The biggest challenge for Boxing is that sometimes it's broadcast live and the sport is often unpredictable. Live is scary. My background is in postproduction, where you can tweak over and over until you get it perfect. With a live event, we don't have the same margin for error.

Many people I have talked to about ITV are under the impression that a lot of what's out there in the way of ITV content and implementation is mainly theoretical. That the experts involved are not really working from experience as a "user" of this new content. What are your thoughts on this impression? Are you, personally an avid user of television content? As a user, how has this new content changed your perspective on television watching?

I agree that a lot of the ITV out there today misses the mark. But if you look at the early days of TV, the first shows were radio and vaudeville per-

formances shot with a single camera. It took them years to figure out what inherently worked with this new medium. We didn't get the mini series until the 70's. That's what I love about ITV. We might be the first ones ever to enhance a program a certain way. The good ideas are still to come.

I try to be an active Interactive TV user. I've checked out almost all of the enhanced shows that are on the air and I use my TiVo every day. I think PVRs are going to have a major effect on how we watch TV.

Unfortunately, for enhanced TV, many of the systems out there today still rely on a phone line with a 56k modem as the return path. This really hampers the experience. When most TVs have high-speed access to rich interactive content, there will be a lot more success stories. In the meantime, we're all trying to figure out what works and what doesn't, so we're ready when the boxes are in millions of homes.

The idea of interactive elements infused with TV programming has been kicked around for a while, why do you think it's making such a prominent comeback?

I don't think this is another fad, or it's like some of the early ITV trials in the past. I think Interactive TV services are coming and many of them are going to succeed. Not all of the ITV services that the engineers come up with will win over consumers, but over time, many of them will, and TV as we know it will be changed forever. It's different this time around because we've learned so much in the last couple of years. Digital TV penetration is exploding, and look at the PC and the success of the Internet. The prices of chips and hard drives have dropped to the point where the boxes can be cost effective. Technology has come a long way the last couple of years. I believe that the successful ITV systems will leverage the technologies that are already out there. In the early trials, they had to build everything from scratch. Think about it. ITV isn't that difficult. We just need to take the pieces that are already out there and put them together. We have great interactivity on the PC. We have great-looking video on the TV, and we have more and more high-speed Internet accesses. How can it fail?

What are your predictions for the upcoming years of ITV?

I think deployments will continue to be slow until we reach this magic point, where the average consumer knows about it and needs to have it.

Look at cell phones. Where did that come from? They've been around forever, but it seems like overnight, everybody got one. I think the successful ITV services will be built into cable and satellite receivers as well as TVs. No more black boxes that consumers have to wire together (Figure 17.3).

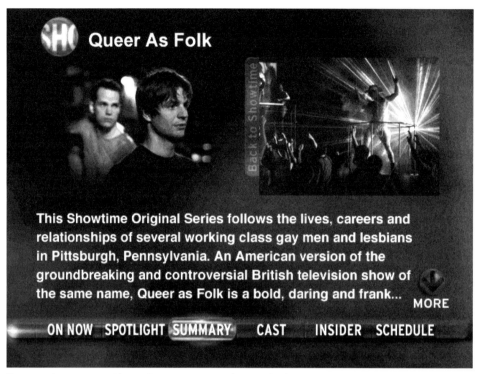

FIGURE 17.3 *Showtime's 24/7 application as seen during the hit series* Queer As Folk. *(© Copyright 2000. Courtesy of Showtime Networks, Inc. © Warner Bros.)*

I think integrated PVRs will be really big. Showtime is very active in PVRs and SVOD, and I think both of these will have a bright future. I'm not too sure about interactive banking, Web surfing, and other information services on the TV. The line between the PC and the TV will continue to blur, until the only difference will be the size of the screen. People like to sit close to a bank statement, and they want to enjoy a movie on a big screen while watching with friends and family. That's not to say that some basic easy-to-use information services won't have a place on the TV.

I think they will, but it's not going to be the main reason people watch TV. It'll be really interesting when there's wide distribution of ITV and HDTV. It will give us so many more options with the larger screen real estate and higher resolution.

I think the enhanced TV space that extends the traditional entertainment of TV as we know it will be a big winner. The programming will always be the main focus. Also, I think that wireless will be big. Interactive TV on the PDA is not that far away.

What recommendations can you give the reader of this book on how he or she can learn more about and become involved with this incubatory medium of ITV?

There are actually a lot of resources on the Web. Some of the middleware providers have great Web sites with areas for developers. With a basic PC, a really inexpensive basic Web site and a set-top box, you can get started. You can go out and buy a standalone box, or you can see if your cable or satellite provider offers ITV capable boxes. Make sure to find out what system it is, as some of them have proprietary authoring systems with really expensive authoring tools.

It's a good idea to also have a fundamental knowledge of Photoshop, Flash, HTML, and JavaScript. There are a ton of resources out there for all of these. Spend a lot of time checking out the apps that are on the air today, and get started creating your own. (© Copyright 2000. Reprinted with permission from Showtime Networks Inc. All rights reserved.)

APPENDIX A

Acronyms Alert

A quick reference guide for ITV-related acronyms in this book.

ABC American Broadcasting Company
AOLTV America Online Television
API Application Programming Interface
ARPA Advanced Research Projects Agency
ATSC Advanced Television Standards Committee
ATVEF Advanced Television Enhancement Forum
BBC British Broadcasting Company
CBS Columbia Broadcasting System
COFDM Coded Orthogonal Frequency Division Multiplexing
CPU Central Processing Unit
CRT Cathode Ray Tube
CSS Cascading Style Sheets
DASE Digital Applications Software Environment
DBS Digital Broadcasting System
DNS Domain Name System
DOM Document Object Model
DSL Digital Subscriber Line
DTV Digital Television
DVB Digital Video Broadcasting

DVB-MHP Digital Video Broadcasting—Multimedia Home Platform
EIA Electronic Industries Alliance
EPG Electronic Programming Guide
ETSI European Telecommunications Standards Institute
ETV Enhanced Television
FCC Federal Communications Commission
FTP File Transfer Protocol
GIF Graphics Interchange Format
HDTV High Definition Television
HSV Hue, Saturation, Value
HTML HyperText Markup Language
HTTP HyperText Transfer Protocol
IP Internet Protocol
ISP Internet Service Provider
ITV Interactive Television
JPEG Joint Photographic Experts Group
LID Local Identifier
MMDS Multipoint Microwave Distribution Services
MPEG Moving Pictures Experts Group
MSO Multiple System Operator
MSTV Microsoft TV
MTV Music Television
NAB National Association of Broadcasters
NBC National Broadcasting Company
NHK Nippon Hoso Kyokai (Japan's public broadcasting corporation)
NSFNET National Science Foundation Internet
NTSC National Television Standards Committee
NVOD Near Video On Demand
PAL Phase Alteration Line
PBS Public Broadcasting Service
PDA Personal Data Assistant
PPV Pay-Per-View

Appendix A

PVR Personal Video Recorder (also DVR, Digital Video Recorder)
RCA Radio Corporation of America
RGB Red, Green, Blue
SAP/SDP Session Announcement Protocol/Session Description Protocol
SDK Software Development Kit
SDTV Standard Definition Television
STB Set-Top Box
TCP/IP Transmission Control Protocol/Internet Protocol
UDP User Datagram Protocol
UHF Ultra-High Frequency
UHTTP Unidirectional HyperText Transfer Protocol
URL Uniform Resource Locator
VBI Vertical Blanking Interval
VOD Video On-Demand
8-VSB 8 Vestigial Side-Band
W3C World Wide Web Consortium
VRML Virtual Reality Markup Language
WWW World Wide Web
WYSIWYG What You See Is What You Get
XML Extensible Markup Language
YUV Luminance (Y) and Chrominance (UV)

APPENDIX B
ITV Resource List

A list of selected resources for further ITV study. Also found at www.swaydesign.com/itvbook.

CONTENT DEVELOPMENT AND EDUCATION

ATVEF Enhanced Content Specification
www.atvef.com/library/spec.html

AFI Enhanced TV Workshop
www.afionline.org

W3 Television and the Web
www.w3.org/TV

Ruel.Net Set-Top Page
www.ruel.net/top/box.developer.htm

Digital Television.com
www.digitaltelevision.com

Public Television Service
www.pbs.org/digitaltv

COMPANY-SPECIFIC DEVELOPER SITES

AOLTV
http://webmaster.info.aol.com

Canal +
www.canalplus-technologies.com

Liberate
www.liberate.com

OpenTV
www.opentv.com/services/developers

WebTV and MSTV
www.developer.webtv.net
www.microsoft.com/tv/content/default.asp

Web/HTML Guides

NCSA, A Beginner's Guide to HTML
http://archive.ncsa.uiuc.edu/General/Internet/WWW/HTMLPrimerAll.html

Web Monkey, A Web Developers Resource
http://hotwired.lycos.com/webmonkey

Shareware and Freeware, FTP Utilities
www.tucows.com

ITV Terminology

The Interactive Television Business Index
www.itvdictionary.com

Digital Event Marketing
www.digitaleventmarketing.com/dem_pages/acronyms.html

ETV Cookbook
http://ETVcookbook.org/glossary

Digital TV and Public Television
www.ptvdigital.org/Glossary.htm

News and Discussion

Tracy Swedlow's Interactive TV Today
www.itvt.com

ITV Report
www.itvreport.com

Van Dusseldorp and Partners TV Meets the Web
www.tvmeetstheweb.com/index.php

Cahners TVinsite
www.tvinsite.com/multichannelnews

The McKinsey Quarterly
www.mckinseyquarterly.com

STATISTICS AND RESEARCH

Strategy Analytics
www.strategyanalytics.com

Nielsen Media Research
www.nielsenmedia.com

Forrester Research
www.forrester.com

Oftel, the UK's Office of Telecommunications
www.oftel.org

Datamonitor
www.datamonitor.com

Durlacher
www.durlacher.com

STANDARDS AND FORUMS

Advanced Television Enhancement Forum
www.atvef.com

ATV Forum
www.atvforum.org

Federal Communications Commission, DTV standards
www.fcc.gov/dtv

Digital Video Broadcasting, DTV standards
www.dvb.org

Multimedia Home Platform
www.mhp.org

European Telecommunications Standards Institute
www.etsi.org

The World Wide Web Consortium
www.w3.org

INSIGHTFUL READING

Tube, The Invention of Television, David Fisher and Marshall Jon Fisher, Harcourt Brace and Company, 1996.

Hamlet on the Holodeck, Janet H. Murray, Free Press, 1997.

The Art of Innovation, Lessons in Creativity from IDEO, America's Leading Design Firm, Tom Kelley with Jonathon Littman, Doubleday, 2001.

The Language of New Media, Lev Manovich, Massachusetts Institute of Technology, 2001.

TV dot Com, The Future of Interactive Television, Phillip Swann, TV Books L.L.C., 2000.

APPENDIX C

About the CD-ROM

The CD accompanying this book provides useful demonstrations, lesson files, and trial software to help you start developing enhanced TV content.

The CD includes:

- The lesson files necessary to complete the projects in Chapter 10, *Hands-On*.
- A click-through Flash demonstration of Wisconsin Public Television's Wisconsin Vote ITV project.
- Fully functioning, 30-day trial versions of Macromedia's Flash 5.0 and Dreamweaver 4.0 software. Dreamweaver 4.0 is recommended to complete the lessons in Chapter 10, and is required in order to use Spin TV's ITV Dreamweaver extensions.
- The SpinTV Studio Suite, Basic Version 1.0 (pre-release), Interactive Television Extensions for Macromedia Dreamweaver. For updated and advanced versions of the SpinTV Studio Suite, visit www.spin.tv.

SYSTEM/SOFTWARE REQUIREMENTS FOR SPINTV'S DREAMWEAVER ITV EXTENSIONS

Dreamweaver 4.0, Extension Manager 1.2 (included with Dreamweaver 4.0), and PC running Windows 98/NT/2000. For installation instructions, refer to the README file included in the SpinTV folder.

SYSTEM REQUIREMENTS FOR HANDS-ON LESSONS, DEMONSTRATIONS, AND MACROMEDIA TRIAL SOFTWARE

Macintosh: System 8.0 or higher, 32MB of RAM, CD-ROM drive, navigation device (mouse), the Flash Player (included on the CD), and a Web browser such as Microsoft Internet Explorer or Netscape Navigator.

Dreamweaver 4.0 and Photoshop 5.5 or higher recommended.

PC: Windows 95 or higher, or NT, 32MB of RAM, CD-ROM drive, navigation device (mouse), the Flash Player (included on the CD), and a Web browser such as Microsoft Internet Explorer or Netscape Navigator.

Dreamweaver 4.0 and Photoshop 5.5 or higher recommended.

Installation instructions and trial versions for Macromedia's Dreamweaver 4.0 and Flash 5.0 can also be found at www.macromedia.com.

You can find updates and additional information for the book and CD-ROM at www.swaydesign.com/itvbook.

Glossary

A selection of terms commonly used in this book.

Advanced Television Enhancement Forum (ATVEF) A nonprofit, cross-industry alliance that promotes HTML-based enhanced television standards and deployment. The foundation for ATVEF content is existing Web standards.

analog data/video Analog data/video is expressed in the form of continuously variable waves (e.g., amplitude, or frequency of sound waves or electromagnetic waves). Analog information is susceptible to noise and is not easily compressible.

Analog is used by most conventional video equipment for input or output. NTSC and PAL are both analog video formats (as opposed to **digital data/video**).

announcement An announcement describes the details of an interactive enhancement, such as the location of triggers and data streams, and informs a viewer that a TV show is going interactive.

AOLTV A set-top box-based Internet / television service provided by America Online, Inc.

Application Programming Interface (API) A set of building blocks, and procedures that software developers use to write programs for specific computer operating systems.

aspect ratio The width-to-height ratio of the picture frame. NTSC TV broadcasts at a 4:3 aspect ratio; digital TV broadcasts at a 16:9 ratio.

ATV Forum (Advanced Television Forum) A nonprofit, member-driven organization of worldwide electronic media industries that provides an open forum to promote the development of content for interactive and enhanced television, and serves the needs of ITV content providers.

back channel A two-way data connection, typically via the Internet, from the receiver to the broadcaster or ISP. The back channel is necessary to add transactional features or to provide access to interactive content not included in a one-way, data broadcast (see **front channel**).

back-end Back-end describes an infrastructure of servers, databases, and software that supports the navigational and front-end elements of interactive content. Usually developed using procedural-type programming and applications (see **front-end**).

binding The specifications that define an interoperable relationship between a set of standards and how those standards run on a given network.

bit The smallest unit of information in computer language; a bit has a single binary value of either 0 or 1.

broadband A technology that offers high-speed Internet access to homes and businesses. Example broadband technologies are DSL and cable modem, and are offered by Internet and cable television providers. For cable, the bandwidth of broadband ranges from 550 MHz to 1 GHz; in contrast, a single-channel TV broadcast requires 6 MHz. Note: While bandwidth is measured using hertz (Hz) for a TV signal, in the Internet environment, bandwidth is measured in bits per second (BPS).

cable A network system for the distribution of analog and digital television signals by cable (hybrid fiber/coaxial).

cache A temporary storage of data in the RAM or disk of a computer or STB to improve access speed. A cache stores most recently accessed data by a user, and new data that the system anticipates the user will be accessing soon. A cache's available storage space varies depending on the device, with new content replacing the oldest content, usually without the knowledge of the user.

Cascading Style Sheets (CSS) A cornerstone to DHTML (Dynamic HTML), CSS is a type of HTML that provides precise control over Web page layout, formats multiple pages, and creates faster, more efficient code.

Cathode Ray Tube (CRT) Developed by German inventor Max Dieckmann in 1906, the cathode ray tube is an underlying hardware component of television and computer systems. Its purpose is to focus incoming electrons into precise beams of light. Striking a fluorescent screen, these beams produce the thousands of pixels of light necessary to create an image.

chroma-crawl A television screen artifact that occurs when two high-contrast (high-chrominance) colors are placed next to each other, causing a visual "crawling" of color.

GLOSSARY

codec The term *codec* is an acronym for "compression/decompression." A codec is an algorithm that reduces the number of bytes consumed by large files and programs. MPEG is a type of codec.

data broadcasting Data broadcasting offers the capability to deliver both programming and data files over a one-way broadcast, such as digital broadcasting and in the use of the Transport B delivery method.

declarative The term *declarative* describes the use of a computer simply as a display mechanism, a means to present static information. The declarative format is defined by front-end protocols such as HTML or JavaScript, where a line of code represents a "given" instruction (as opposed to **procedural**).

Document Object Model (DOM) A platform- and language-neutral interface that allows programs and scripts to dynamically access and update the content, structure, and style of documents. DOM and ECMAScript together are equivalent to JavaScript 1.1.

Digital Television (DTV) Providing a new era in television viewing, DTV can support a variety of new and increased programming services, including interactive content, Internet access, and higher picture quality and sound, as compared to today's analog systems.

digital data/video Digital data/video is where all of the information representing images has been digitized into the language of 0s and 1s (bits), allowing content to be more flexible, rapidly manipulated, and displayed by a computer or digital television.

ECMAScript Internationally standardized, ECMAScript is a general-purpose, cross-platform programming language used to provide scripting of events, objects, and actions. (Prior to standardization, ECMAScript was known as Netscape JavaScript.) ECMAScript plus DOM are equivalent to JavaScript 1.1.

electronic programming guide (EPG) An interactive channel selection service, allowing a user to navigate, on demand, through current programming choices, and search for a particular program by theme or other category.

encoding The process of converting analog electronic signals into digital format for storage, manipulation, and display by a computer or television.

Enhanced Television (ETV) A type of interactive television that combines television programming with supplementary Web-like elements (or enhancements).

Flash A Macromedia software program used to create efficient, scalable, vector-based Web graphics and animation. (See the companion CD-ROM for a trial version of the software).

frameset A type of Web site structure used to create multiple, independently controllable sections of a Web or Enhanced TV presentation.

front channel The front channel is the unidirectional TV signal—either analog or digital—that is transmitted by terrestrial, cable, or satellite from the broadcaster to the receiver.

front-end A term used to describe the visual design and basic interface functionality of interactive content (as opposed to **back-end**)

head-end The facility in a cable system that aggregates the various signals that will be sent to all viewers in the cable system.

HyperText Markup Language (HTML) A standard markup language used to create Web pages, including standard WWW pages, and ITV and digital content.

image map An image used on Web pages that contains multiple *hotspots*—clickable hyperlinks.

Interactive Television (ITV) A combination of television with interactive services and enhancements that offers the viewer additional programming choices, and a more personalized, customized, and "active" alternative to passive TV viewing.

ITV encompasses a wide range of services in addition to traditional TV viewing, including the pay-per view (PPV), video on-demand (VOD), enhanced, Web-like content, electronic programming guides (EPGs), and the use of personal video recorders (PVRs).

interlace scanning A system of video scanning whereby the odd- and even-numbered lines of a picture are transmitted consecutively as two separate interleaved fields. A common visual artifact of interlaced scanning is *flickering* (as opposed to **progressive scanning**).

Internet Protocol (IP) The universal protocol for delivery of data resources, IP is the translator of information from one computer system to another. On a two-way network, IP works with TCP (Transmission Control Protocol) to assemble data into efficient, transferable chunks, and route the data to its requested destination.

IP multicast See **multicast**.

JavaScript A scripting language, JavaScript is used to enhance the look and functionality of Web pages. ECMAScript and DOM are equivalent to JavaScript 1.1

link and pull Another name for the Transport A delivery method, currently the most common method of providing interactive content. A "link" or trigger is sent through the VBI of a broadcast signal indicating a show's interac-

tivity, and when requested, the content is "pulled" or fetched from a Web server.

multicast To multicast is to transmit digital content in a one-to-many, one-way broadcast.

Multimedia Home Platform (DVB-MHP) The Multimedia Home Platform, developed by the Digital Video Broadcasting (DVB) project, is an open application programming interface (API) for the creation and broadcast of interactive television programming.

Multiple Systems Operator (MSO) A company that owns multiple broadcast systems. Also, broad term for cable operators.

NTSC (National Television Standards Committee) The committee formed by the FCC in 1940 to determine the guidelines and technical standards for black/white and color television. Also used to describe the 525-line, 6Hz color television signal used in North America and several other parts of the world.

Operating System (OS) The base program that manages a computer and gives control of the functions designed for general-purpose usage, such as Windows for PCs, Mac OSX for Apple Macintosh, and Unix (and its variations IRIX and Linux).

operator Referred to as one component of the three-part relationship required for the deployment of ITV content (creator, operator, receiver). The operator is the deliverer—the network or broadcast station—of an ITV program.

overlay Overlays are interactive elements that lay over a full-screen television picture.

overscanning Overscanning is a TV specific phenomenon, where 10–20% of a television image is frequently lost due to the curvature and border areas of a television set.

Overscanning is taken into consideration when shooting a television program or determining the design area of an interactive content interface.

procedural The term *procedural* exemplifies the intrinsic power of the computer, and the computer's capability to process and calculate complex behaviors or scripts (a series of instructions and rules).

programming The word *programming* can have two meanings depending on the field—TV or Web—in which it is used. For the TV industry, it is used to refer to a line-up of shows, or "programs." For the Web industry, programming means to develop front-end or back-end Web content and applications using a "programmatic language."

progressive scanning A system of video scanning whereby lines of a picture are transmitted consecutively, as in a computer image. Progressive scanning provides a clearer, more stable picture than interlace scanning does (see **interlace scanning**).

receiver Referred to as one component of the three-part relationship required for the deployment of ITV content (creator, operator, receiver). The receiver is the user, the viewer or client, of an ITV program.
Note: A receiver can also be referred to as the actual hardware, receiving device, of ITV services, such as an STB.

resolution Depending on the context, the term *resolution* can have two different meanings. 1) Resolution can refer to the overall dimensions—width and height—of a screen or image display measured in pixels. 2) Resolution can also be used to describe the clarity, sharpness, or quality of a screen image.

satellite A type of broadcast where signals are amplified and carried long distances by an orbiting satellite, and then captured and decoded by a satellite receiver dish.

2-screen A way of viewing interactive TV content where the TV show is displayed via the television set, and its enhanced content is displayed, and synchronized to the TV program, via a personal computer.

Set-Top Box (STB) A type of receiver that decodes and makes possible the viewing of interactive content on a standard television set.

streaming media Multimedia content—such as video, audio, text, or animation—that is displayed to a user as it is received from the Internet or broadcast network (versus content that is preloaded and then displayed).

synchronization A process in enhanced content development by which data and video are synched together, timed precisely, for accurate delivery on both the receiving and sending ends.

teletext Developed in the UK, teletext was one of the first attempts at providing localized textual data—such as up-to-date news, weather, and sports—through the VBI of a TV signal.

telewebbing A phenomenon where individuals are simultaneously viewing TV and Web content between two different devices, the TV and the personal computer.

terrestrial A type of broadcast whereby TV signals are sent "over the air" and are captured by an antenna on a roof or a TV box.

thin client A term used to describe the development of programs and services that work well on all types of hardware systems without using a great deal of memory or processing power on the client, consumer end.

Transmission Control Protocol/ Internet Protocol (TCP/IP) See **Internet Protocol**.

Transport A Currently, Transport A is the most commonly used transport method for ITV delivery. An analog-based solution, Transport A is sometimes called the "link and pull" method—it sends out links (triggers) along the unidirectional front path, and pulls data from a required return path.

Transport B Transport B, also called data broadcasting, offers the capability to deliver both triggers *and* data by the forward channel. An Internet connection as a return path, however, might be desired if the viewer wants the capability, for instance, to send form information, purchase items, or surf the Web.

trigger A trigger, sometimes called a TV link or broadcast data link, contains the timing and syncing instructions and the URLs of requested Internet data. A trigger is encoded into line 21 of the VBI signal, the same signal used for closed-captioning, subtitling, or teletext, and sent via satellite, terrestrial, or cable.

TV Object A TV Object is the space defined (usually with a 4:3 aspect ratio) in an enhanced content design for the insertion of TV video; its functionality is indicated in HTML code as "tv:".

TV tuner card TV tuner cards are based on the PCI capture-card technology, which merges video from external sources; hence, a TV signal (or camcorder or digital camera) with the normal display system of the computer. Using a TV tuner card is a way of viewing interactive television content via the personal computer.

Vertical Blanking Interval (VBI) A part of the TV signal that is not used for video information and is available to transmit other data such as captions, Web pages, stock market prices, and so forth. Visually, the VBI is the black stripe at the top and bottom of a TV picture, and makes up 21 lines of the total 525 lines transmitted per second in an NTSC TV signal.

W3 Consortium The World Wide Web Consortium (W3C) is the leading standards body and industry collective for the development of specifications, guidelines, software, and tools for the WWW environment.

walled garden Interactive content that is designed specifically to be available to a subset of users, and not generally available on the WWW.

widescreen A term given to picture displays with a wider aspect ratio than NTSC 4:3. Digital HDTV and motion pictures use a 16:9 widescreen. A process called *letterboxing* is used to view widescreen pictures on an NTSC television, where the image appears more vertical with black bars above and below.

Index

A

Acceptance. *See* Consumer acceptance
Acronyms, 277–279
ACTV/HyperTV, 2-screen technology provider, 134
Administration phase of webRIOT project, 224
Adobe Atmosphere, 89
Adoption of new technologies, 29
Advanced Research Projects Agency (ARPA), 13
Advanced Television Enhancement Forum (ATVEF), 120 n. 2, 129–130
 Transport A delivery method, 147–155
 Transport B delivery method, 155–158
 trigger recommendations, 155
Advanced Television Forum (ATV Forum), 130–131
Advanced Television Systems Committee (ATSC), 22–23
Advertising
 as interactive content, 101–102, 259
 projected changes in, 49
 Web advertising as model, 91
Advice. *See* Suggestions from industry experts
AFI Enhanced Television Workshop, 236, 246–247

Alpha testing, 115
American Film Institute. *See* AFI Enhanced Television Workshop
America Online (AOL)
 AOLTV, 132
 Time Warner, collaborative partnership with, 47
Analog transmission, *vs.* digital transmission, 20
Andreesen, Marc, 14
Animations, download times and, 143
Anker, Danny (Anker Productions), 187
 Music from the Inside Out project, 238–241
Announcements in IP multicasts, 158
AOL. *See* America Online (AOL)
AOLTV, 132
Approval processes during production, 114
ARPA (Advanced Research Projects Agency), 13
ARPANET, 13–14
Aspect ratios
 of HDTV, 25
 Liberate CT-500, 237
 pixel shape and, 138
 for TV objects, 139
Attributes of triggers, 153

ATVEF (Advanced Television Enhancement Forum). *See* Advanced Television Enhancement Forum (ATVEF)
ATV Forum, 130–131
Audience
 children as viewers, 98–99
 content and, 73
 education of, 91–92
 feedback from, 224–225
 focus groups, 232
 market share, 84–85
 for *Music from the Inside Out,* 239
 platform selection and, 106–107
 Showtime Network's ITV projects, 267–268
 Away Games Two Way TV project, 258–259

B

Back channels, 119–121
Background design elements, 171
Bandwidth, broadband defined, 20–21
Bangerter, Eric (University of Wisconsin), 187, 206
 interview with, 210–215
Baran, Paul, 13
Barbash, Louis, 108–110
Barid, John, 4–5
Berners-Lee, Tim, 14
Beta testing, 115
Boxes. *See* Set-Top Box (STB) technology
Boxing, interactive, 269–273
Brainstorming, 112–113, 162–163
Briefs, technical and creative, 113–114
Broadband, defined, 20–21
Broadcast Data Links. *See* Triggers
Bronislaw, Malinosky, 51–55

Browsers
 browser systems, 14
 Dreamweaver default browser setting, 181
Bruckland, Heidi (Two Way TV), 256–263
Budgets, 113
 for Wisconsin Vote project, 210

C

Cable television
 MMDS wireless cable, 19
 transmission method described, 17–18
Cable transmission, 8, 22
Canal +, 132
Carmine, Carolyn (PushyBroad), 236–238
Cascading Style Sheets (CSS)
 defined and described, 136
 tutorial, 180–181
Cathode Ray (cartoon), 72
Cathode ray tubes, 7 n. 2
CD-ROM contents, 285–286
 mock ITV demonstration, 176
 SpinTV Studio Suite (pre-release version), 199
Chat rooms as interactive TV feature, 71–72
Checksums of triggers, 153
Children's programming
 audience, 98–99
 The Eddie Files, 250–252
 Winky Dink and You, 37, 98–99
 ZOOMnoodle trivia game, 99
Close captioning, 37
Coded Orthogonal Frequency Division Multiplexing (COFDM), 23
 vs. 8-VSB, 24
Codification periods, of television, 7–8

INDEX

COFDM. *See* Coded Orthogonal Frequency Division Multiplexing (COFDM)
Collaboration and collaborative partnerships, 239–240, 247–248
 Anker Productions and PushyBroad, 236–244
 Direct TV and Sky Global, 47
 Spiderdance and MTV, 219–220, 228–229
 Time Warner and AOL, 47
 UW-Extension and WPT, 214
Color
 choosing background colors, 167
 chroma-crawl, 141
 HSB (Hue Saturation Brightness) color space, 140–141
 NTSC safe colors, 141
 RGB color, 140
 testing, 174
 tips for successful, 141
 YUV color space, 140
Company-specific developer sites, 281–282
Compression
 data compression explained, 21
 downloads and, 143
Constant elements, 105
Consumer acceptance
 adoption of new technologies, 29
 of Internet, 14–15
 skepticism about DTV, HDTV technologies, 84–85
 of television, 6–7
 See also Market research
Content
 advertising, 101–102, 259
 advice from Dan Silberberger, 73–75
 assembly phase of production, 115
 audience and, 73
 challenges during development, 224, 237–238
 combining television and web programming elements, 96–97
 creation during development cycle, 116–117
 creative process, 107–108, 112–114
 declarative content, 128
 delivery of, 119–121
 design and, 87–88, 134–143
 equipment for creation of, 121
 experiments, 103–104
 "eye candy" on Web pages, 87
 feedback and evaluation in process, 90–91
 game shows, 100–101
 genres, 98–103
 IP multicast content, 158
 IP multicasts for Transport B, 158
 linking and timing, 117–118
 procedural content, 128
 purpose, clarifying, 97
 resources for development, 40–41
 sports programming, 269–273
 standards for, 126–131
 talk shows, 103
 testing, 118
 trial-and-error process, 87–89
 Web content and design, 87–89
Convergence Lab, Nielsen Media Research, 59–60
Corporation for Public Broadcasting
 digital technology initiatives, 109
 interview with Louis Barbash, 108–110
Costs
 of HDTV, 24
 Set-Top Box systems, 66
Creative process, 107–108
 brainstorming, 112–113
 collaboration and, 239–240, 247–248
 napkin sketch tutorial, 162–163
 Showtime's Interactive Boxing project, 270–271

Creative process (*cont.*)
 "spiderdancing," 218–219
 technical and creative briefs, 113–114
Cringely, Robert X., 92
A Cringely Crash Course, 92
CSS (Cascading Style Sheets). *See* Cascading Style Sheets (CSS)

D
Dalton, Craig, 51–55
DASE standards, 130
Data jams, 142–143
Davis, Rob (Spiderdance), 186–187, 226–233
Declarative content, defined, 128
Delivery methods
 compared, 156
 timing and, 146–159
 Two Way TV's Central Computer System technologies, 257–258
Delivery platforms, 106–107
Design
 challenges, 210, 214, 237–238
 color considerations, 140–141
 distance from screen as consideration, 139–140
 file dimensions, 165
 navigation tools, 141–142
 tutorial in ITV design specifics, 163
 TV objects, 139
 webRIOT project design phase, 223
Development cycle
 content creation, 116–117
 content testing, 118
 linking and timing of content, 117–118
 of webRIOT project, 222–223
Digital Applications Software Environment (DASE) standards, 130
Digital communities, 30

Digital technology, impact on television, 12
Digital Television (DTV), 15–16
 implementation concerns, 28–29
 international development, 16
 public awareness, 29–30
 standards, 22–23
Digital Terrestrial Transmission (DTT), 16–17
Digital transmission
 vs. analog, 20
 data compression, 21
 signal consistency, 22
 signal type described, 20
Digital Video Broadcasting (DVB) project, 23, 128–129
Digital Video Recorders. *See* Personal Video Recorders (PVRs)
Direct broadcast satellite transmission, 18
DirecTV, collaborative partnership with Sky Global, 47
DISHPlayer, 42
Distance from screen as design consideration, 139–140
Documentaries, 98
DOM 0, defined and described, 135–136
Downloads
 animations, 143
 compression and, 143
 delays and, 67–68
 file size and, 143
 framesets, 143
 minimizing load times, 142–143
 scale definition and speed of, 181–182
 Set-Top Box (STB) technology, 66, 67–68
Dramas, 103
Dreamweaver, interface development tutorial, 178–185

DTV 2003, 109
DTV (Digital Television), 15–16
DVB (Digital Video Broadcasting) project, 23, 128–129
DVB-MHP (Multimedia Home Platform), 23, 128–129
DVRs (Digital Video Recorders). *See* Personal Video Recorders (PVRs)
Dynamic HyperText Markup Language (DHTML), defined and described, 135

E
ECMAScript, defined and described, 135–136
E-commerce as content, 101–102
The Eddie Files, 250–252
Educational programming, 98–99
 The Eddie Files, 250–252
 Music from the Inside Out, 236–244
EIA-746 trigger standard, 150
8-VSB (vestigial sideband), 23
 vs. COFDM, 24
Elections, Wisconsin Vote project, 207–216
Electronic Programming Guide (EPG), 42
E-mail newsletters, 206
Encyclopedic property of digital environments, 36
Enhanced TV (ETV), 43–44
 feedback and evaluation, 91
 platforms for delivery, 60–69
 Set-Top Box (STB) technology, 60–66
 telewebbing, 58–59
 tuner card technology, 61–62, 66–67
 2-screen synched technology, 62, 68–69
Enhancement elements, 104–105
Equipment lists, 121, 123
 for encoding triggers, 155
ETV Cookbook, 282
Evaluation of content, 90–91
Explorer E-cliner, 45–46
Extreme Rides, Discovery Channel, 248–250

F
Farnsworth, Philo T., 5
FCC, 7
 digital transmission requirement, 15
Feature creep, 97
Feedback
 on content, 90–91
 focus groups, 232
 on innovative CPB programming, 109–110
 webRIOT project, 224–225, 231–232
File Transfer Protocol (FTP), content publishing and delivery, 148
Financial models, 47–49
Finland, 30
Flowcharts, 114
Fonts, 173–174
 sizes and styles, optimum, 139
Formats for shows
 live shows, 106
 taped shows, 105–106
Forums, web addresses, 283
Framesets, 143
 designing, 167–168
 viewing source code for, 182–183
Front channels, 119–121
FTP (File Transfer Protocol)
 content publishing and delivery, 148
 resources, 282
Fullerton, Tracy (Spiderdance), 218–233
Full-screen links, 174, 183
Full Service Network (Time Warner), 40

G
Games
 as interactive TV feature, 70–71, 99
 video game channels, 35
 video games synched to drama programming, 103
Game shows, 100–101
Genres
 drama programming, 103

Genres (cont.)
 game shows, 100–101
 news and weather programming, 102
 shopping programming, 101–102
 sitcom programming, 103
 sports programming, 99–100
 talk shows, 103
Glossary, 287–294
Gold Pocket Interactive, 2-screen technology provider, 134
Grand Alliance members, 27

H

(HDTV) High Definition Television, 24–25
 aspect ratios, 25
 Grand Alliance members, 27
 resolution specifics, 26
 surround sound, 26
Helsinki Virtual Village (HVV), 30
High Definition Television (HDTV), 24–25
Hot spots, 178
HTML. *See* HyperText Markup Language (HTML)
HyperText Markup Language (HTML), 14
 defined and described, 135
 guide, 282
 text in interfaces, 184–185
HyperVideo (clickable video), 45

I

Iconoscope, 5–6
Image maps, 172, 183–184
Immersive nature of television, 53–54
Individualized Television, 45
Industry
 business models, 50, 194
 business sector chart, 48

 collaborative partnerships, 47
 market share (audience), 84–85
 open standards for, 127–128
 profitability of ITV, 47–50
 value chain, 50
 See also Suggestions from industry experts, 73–75
Integrated Services Digital Broadcasting (ISDB), 23
Interactive elements
 combining television and web programming elements, 96–97
 constant elements, 105
 Internet links, 104–105
 "karaoke" play along at home feature, 236
 synchronous elements, 103, 105
Interactivity
 early experiments in, 37–41
 Interactive TV (ITV) described, 28, 34–36
 Main Street, 38–39
 narrative flow and, 252
 QUBE project, 37–38
 television as social activity, 53
 See also Interactive elements
Interfaces
 designing, 114
 full-screen links, 183
 hotspots (clickable items), 178
 image maps as links, 183–184
 layout options, 175–177
 NASA case study, 201–202
 samples of, 201–204
 text, HTML and graphical, 184–185
 trigger receiving objects, 185
 tutorial in functionality of, 175–185
Internet
 acceptance of, 14–15
 access via television, 44–45
 history of development, 13–14

INDEX

links as interactive elements, 104–105
market research over, 91
packet switching technology, 13
Internet Protocol (IP)
 as common binding for ITV content delivery, 146–147
 defined and described, 147
Internet Service Providers (ISPs), 14
InterNIC, 14
Interviews, Louis Barbash, 108–110
IP multicasts
 announcements, 158
 content, 158
 triggers, 158
ISDB (Integrated Services Digital Broadcasting), 23
ISPs (Internet Service Providers), 14

J

Japan, 23
 MUSE high resolution television, 8
JavaScript, defined and described, 135–136

L

Launch phase, 115, 223–224
Layouts
 framesets, 175–177
 overlays, 175–177
La-Z-Boy Explorer E-cliner, 45–46
Letterboxing, 25
Liberate, 132
 Liberate CT-500 application, 237
Lillig, Scott and Brian (SpinTV), 187, 192–193
Link and pull delivery method. *See* Transport A delivery method
Links
 full-screen links, 174, 183
 image maps as, 183–184
 as interactive elements, 104–105
 See also Triggers

Live shows, 106
 challenges presented by, 272
Load times, minimizing, 142–143
Local Identifiers (LIDs) for triggers, 152

M

Mac system requirements, 285
Mac TV, 66
Marconi, Guglielmo, 4
Mariano, Bob (Steeplechase Media Inc.), 93
Market research, 35
 commercial trials, 256
 fees for services, 39
 interest in ITV, 260
 Internet, 91
 Nielsen Media Research, Inc., 90
 Nielsen Media's Convergence Lab, 59–60
 2-screen ETV, 68–69
 web sites, 283
Mergers, business, 47
MicrosoftTV, 132–133
 Content Developer Program, 151 n. 2
Microwave multipoint distribution system (MMDS), 19
Mixed Signals, TV Link Creator Software, 118, 237
MMDS (microwave multipoint distribution system), 19
Mosaic, 14
Movies, enhancing broadcasts of, 268
Moving Pictures Experts Group (MPEG), 21
MPEG (Moving Pictures Experts Group), 21
Multicasting, 26–27
 IP multicasts, 156–158
Multimedia Home Platform (DVB-MHP), 23, 128–129
Multiple system operators (MSOs), 117
Multitask viewing, 58–59

MUSE (high resolution television), 8
Music from the Inside Out, 236–244

N
NASA interface case study, 201–202
National Association of Broadcasters (NAB), 24
National Television Standards Committee (NTSC), 7
Navigational tools
 design of, 141–142
 Electronic Programming Guide (EPG), 42–43
 full-screen links, 174, 183
 image maps as links, 172
 remotes and keyboards as interface, 141
 spatial property of digital environments, 35–36
Netscape, 14
News and discussion about ITV, 282
News programming, 102
New Voices, New Media, 109
NHK Laboratories, 23
Nielsen Media Research, Inc., 59–60, 90
Nipkow, Paul, 5
Nipkow disks, 5
Norpak analog encoder, 118
NSFNET, 14
NTSC color
 safe color palette, 141
 testing for, 174

O
OpenTV, 133
Opinion polls, 102, 206
Opportunities for developers and designers, 227–228
Overlays, 175
 viewing source code for, 178–179
 z-index attribute of image source code, 181

P
Packet switching, 13
Paley, William, 7
Participatory property of digital environments, 34–35
Pay Per View (PPV) services, 38, 39, 42
PC system requirements, 286
Personal Video Recorders (PVRs), 36, 42, 274
Piersimoni, Anna Marie (AFI Enhanced Television Workshop), 187, 246–253
Planning phase
 approval of project specifications, 114
 brainstorming, 112–113
 budgeting, 113
 technical/creative brief, 113–114
 timelines for projects, 113
Platform Guides, Spin TV Studio Suite tool, 196
Platform Preview, Spin TV Studio Suite tool, 197
Platform Profile, Spin TV Studio Suite tool, 196
Platforms
 Enhanced TV (ETV), 60–69
 evaluating and choosing ITV delivery platforms, 106–107
 Interactive TV (ITV), 69
 for *Music from the Inside Out* project, 237
 products in development, 86
 of Showtime Network's interactive projects, 268–269
 SpinTV Studio Suite tools related to, 196–197

Two Way TV and, 258
 web sites about, 163
Polls as interactive elements, 102, 206
Porting applications, open standards and, 127–128
Positioning, absolute and relative, 182
Preisman, David (Showtime Networks), 266–275
Pre-production phase
 production studio set-up, 114, 122
 prototype interface design, 114
 storyboarding and flowcharting, 114
 team development, 114
Pricing research, 39, 49
Procedural content, defined, 128
Procedural property of digital environments, 34
Process outline, 112–123
 evaluation phase, 115
 launch phase, 115, 223–224
 planning phase, 112–114
 pre-production phase, 114, 122
 testing phase, 115
 See also Production phase
Production phase, 114–115
 challenges encountered, 249–250
 content assembly, 114–115
 timing implementation, 115
 of webRIOT project, 223–224
Production studio set-up, 114, 122
Production teams, roles in, 121
Profitability
 audience skepticism of new technologies, 84
 of ITV, 47–50
 programming and, 85
Programming
 children's programming, 98–99, 250–252
 documentaries, 98
 dramas, 103
 educational, 98–99, 236–244, 250–252
 formats for shows, 105–106
 market share (audience) and, 85
 news and weather, 102
 planning, 106
 shopping, 101–102
 sitcoms, 103
 sports, 99–100
 See also Content
Project specifications, 114
Proprietary ITV services, 45
Prototypes, 106
Public awareness phase, of ITV, 36
Public Broadcasting Station (PBS)
 educating viewers about ITV, 92
 Music from the Inside Out project, 236–244
 tuner card technology experiment, 62
PushyBroad, 241, 244
PVRs. *See* Personal Video Recorders (PVRs)

Q

Quantum video-on-demand service (Time Warner), 39

R

Radio, 4
RCA (Radio Corporation of America), 7
Remote controls, navigation and, 141
ReplayTV, 42, 86
Resolution, 26
 defined and described, 136–139
 design dimensions and resolution areas, 165
Resources
 content and development web sites, 281
 ITV terminology, 282
 news and discussion, 282
 suggested reading, 284
 Web/HTML Guides, 282

Reusability, 106
RGB color, 140

S
Safe areas, 166
Sarnoff, David, 7
Saslow, Nancy (PushyBroad), 236–238
Satellite transmission systems, 18–19, 22
Scale definition tutorial, 181–182
Scoping phase, of webRIOT project, 222–223
Screen resolution, 137–139
Screens
 usable area, 165
 viewable area, 165
Scripted and unscripted shows, 105–106
Scripts, for triggers, 150
Scrolling, 142
Set-Top Box (STB) technology, 60–61, 65–66
 accessing services, 63
 automatic resizing of images, 182
 connecting systems, 63
 costs of systems, 66
 device manufacturers, 44
 downloading strategies, 66, 67–68
 front- and back-channel content, 119–121
 manufacturers of hardware, 132
 products in development, 86
 providers, 131–133
 set-up, 62–65
 signing up for services, 63
Shopping programming, 49–51, 101–102
Showtime Networks, 266–275
Silberberger, Dan, 73–75
Sitcoms, 103
"Smart" TV, 34

Smell, Web experiences, 85
Software
 content development resources, 40–41
 SpinTV development tools, 195–197
Specifications, ATVEF Enhanced Content Specifications, 129–130
Speed
 of communications, 12
 of digital signal transmission, 21
 of transmissions and transactions, 12
 See also Downloads
Spiderdance, 91, 100–101
 TruSync Interactive television system, 219
 2-screen technology provider, 134
 WebRIOT, 218
SpinTV
 Studio Suite development software, 195–197
 suggestions from Scott and Brian Lillig, 187, 195
SpinTV Dashboard, Spin TV Studio Suite tool, 197
Sports programming, 100–101
 boxing, 269–273
Standards
 Advanced Television Systems Committee (ATSC), 22–23
 ATVEF Enhanced Content Specifications, 134–135
 content standards, 126–131
 DASE standards, 130
 digital television (DTV), 22–23
 dual standards (Web and TV) for ITV, 126–127
 for *Music from the Inside Out* project, 237
 National Television Standards Committee (NTSC), 7

INDEX

open standards for ITV, 127–128
for trigger creation, 150
web site resources, 283
Web standards, 134–135
Star Wars, interactive viewing experience, 70–72
Statistics, web sites about, 163
STB. *See* Set-Top Box (STB) technology
Steeplechase Media, Inc., 93–94
Storyboards, 114
Studio. *See* Production studio set-up
Suggestions from industry experts
 Danny Anker, 187, 240–241
 Eric Bangerter, 187, 215
 Rob Davis, 186–187
 Scott and Brian Lillig, 186–187, 192–195
 Anna Marie Piersimoni, 186–187
 David Preisman, 275
 Dan Silberberger, 73–75
Surround sound, 26
Synchronization
 beta testing, 115
 of content, 117–118
 content pacers, 133–134
 of content with programming, 115
 synchronous elements, 103
 triggers and, 148–150
 TruSync television system from Spiderdance, 219
 See also 2-screen synched technology
Synchronous elements, 105
 Star Gate SG-1 example, 103
System requirements, 285–286

T

Talk show programming, 103
Taped shows, 105–106
TCP/IP (Transmission Control Protocol/Internet Protocol), 13–14
Teams
 development during pre-production phase, 114
 roles in production teams, 121
Telecommunications, history, 4–10, 76–79
Telecommunications Act of 1996, 84
Teletext, 37, 43, 102
Television
 analog *vs.* digital transmission, 20
 business opportunities, 6–10
 cable transmission, 8
 color technology, 8
 content programming, 7–8, 9
 digital technology and, 12
 digital transmission, 15–16
 history of development, 4–10, 76–79
 Internet and, 15
 mechanical television system pictured, 5
 networks, 7
 screen resolution, 138–139
 timeline of events, 9
 transmission methods, 16–19
Televisor, 5
Telewebbing, 58–59
Terminology
 glossary, 287–294
 web sites, 282
Testing
 alpha testing, 115
 beta testing, 115
 during development cycle, 118
 equipment for, 121
 NTSC color, 174
 triggers, 155
 webRIOT project, 223, 231
Text
 adding to designs, 173–174
 HTML *vs.* graphical text, 184–185
Timelines
 for projects, 113
 television and Internet events, 76
 television events, 9
Time Warner, collaborative partnership with AOL, 47
Timing. *See* Synchronization

TiVo, 42
Transmission Control Protocol/Internet Protocol (TCP/IP), 13–14
Transmission methods, television
 cable, 17–18
 satellite systems, 18–19
 terrestrial, 16–17
Transport A delivery method, 147–155
 content publishing via FTP, 148
 described, 148
 triggers, 148–155
Transport B delivery method, 155–158
 content, 158
 described, 155–156
 IP multicasts, 156–158
 triggers in, 158
Trigger Creator, Spin TV Studio Suite tool, 197
Trigger Inserter, Spin TV Studio Suite tool, 197
Trigger Manager, Spin TV Studio Suite tool, 197
Triggers
 attributes of, 153
 ATVEF recommendations for, 155
 checksum for, 153
 component parts of, 151–154
 creating, 150–151
 defined and described, 148–150
 encoding, 117–118, 154–155
 equipment for encoding, 155
 Local Identifier (LIDs), 152
 network acceptability of, 118–119
 networks and etiquette of, 155
 receiving process, 152
 role in synchronization, 148–150
 sequencing, 154
 SpinTV Studio Suite tools for, 197
 testing of, 155

Transport B delivery method, 158
trigger receiver objects, 153–154, 185
Trigger Sequencer, Spin TV Studio Suite tool, 197
Trivia games
 Starwars enhanced broadcast, 70–71
 zoom, 99
TruSync Interactive television system (Spiderdance), 219
 described, 226–227, 233
Tuner card technology, 61–62, 66–67
 costs, 66
Tutorials
 design specifics for ITV, 163–175
 napkin sketch (creative process), 162–163
tv:
 syntax tutorial, 179–180
 unified resource identifier, 139
TV Embed, Spin TV Studio Suite tool, 196
 tutorial on, 197–200
TV Embed Inspector, Spin TV Studio Suite tool, 196
TV Links. *See* Triggers
TV objects, 139
 positioning, 168–171
TV Pilot Images, Spin TV Studio Suite tool, 196
TV Safe Trace, Spin TV Studio Suite tool, 196
TV Translator, Spin TV Studio Suite tool, 196
TWIN Entertainment, 99
2-screen synched technology, 62, 68–69
 feedback and evaluation of content, 91

INDEX

providers, 134
Two Way TV, 256–263

U
UltimateTV (Microsoft), 34, 36, 42
Unified resource identifier, 139
Unscripted and scripted shows, 105–106
URLs, in triggers, 151–153

V
Vertical Blanking Interval (VBI), 37
Viacom Cable, ITV experiment in Castro Valley, CA, 39
Video game play, 35
Video on Demand services, 42
Viewer-Controller TV (VCTV), 39
Viewers. *See* Audience
Virtual Reality Markup Language (VRML), 88

W
Weather programming, 102
Web addresses
 ABC's Enhanced TV, 91
 Advanced Television Systems Committee (ATSC), 22
 Advanced TV (ATV) Forum, 131
 AFI Enhanced TV Workshop, 253
 Anker Productions, 241
 AOLTV, 132
 AromaJet, 85
 Atmosphere (Adobe), 89
 ATVEF Enhanced Content Specifications, 129
 Canal +, 132
 Corporation for Public Broadcasting, 99
 DASE standards, 130
 Digital Video Broadcasting (DVB) project, 129
 educational programming information, 99
 Enhanced Dinner and a Movie web site (TBS), 70
 enhanced TV traffic statistics, 68
 forums, 283
 ITV terminology, 282
 Liberate, 132
 MicrosofTV, 133
 Mixed Signals TV Link Creator Software, 118
 MPEG information, 21
 Multimedia Home Platform (DVB-MHP), 129
 news and discussions about ITV, 282
 NHK laboratories (ISDB), 23
 Nielsen Media Research, 60
 Norpak analog encoders, 118
 OpenTV, 133
 platform information, 263
 Public Broadcasting Station, 99
 PushyBroad, 244
 Ruel.Net Set-Top Page, 281
 statistics and research resources, 283
 TBS Superstation enhanced programming, 91
 TriSenx, 85
 Two Way TV, 263
 UltimateTV, 34
 Veon HyperVideo (clickable video), 45
 Wink, 133
 Wisconsin Vote project information, 216
 WorldGate, 133
 World Wide Web Consortium, 126 n. 1
 W3 Television and the Web, 281
Web Monkey, developer's resource, 282
WebRIOT project, 218, 219–222, 228–231
WebTV
 content developer information, 151 n. 2
 products in development, 86
Wink, 133
Winky Dink and You, 37, 98–99
Wireless cable (MMDS), 19

Wisconsin Gardener, 206–207
Wisconsin Vote Project, 207–216
WorldGate, 133
World Wide Web
 access via television, 44–45
 developed, 14
 HyperText Transmission Protocol (HTTP), 148
 World Wide Web Consortium, 126 n. 1

Y
YUV color space, 140

Z
Z-index attribute of overlay image source code, 181
ZOOMnoodle trivia game, 99
Zworykin, Vladimir Kosma, 5–6